PICTURING
POWER

March 2013

for Jules ~
With admiration & gratitude ~
Karl

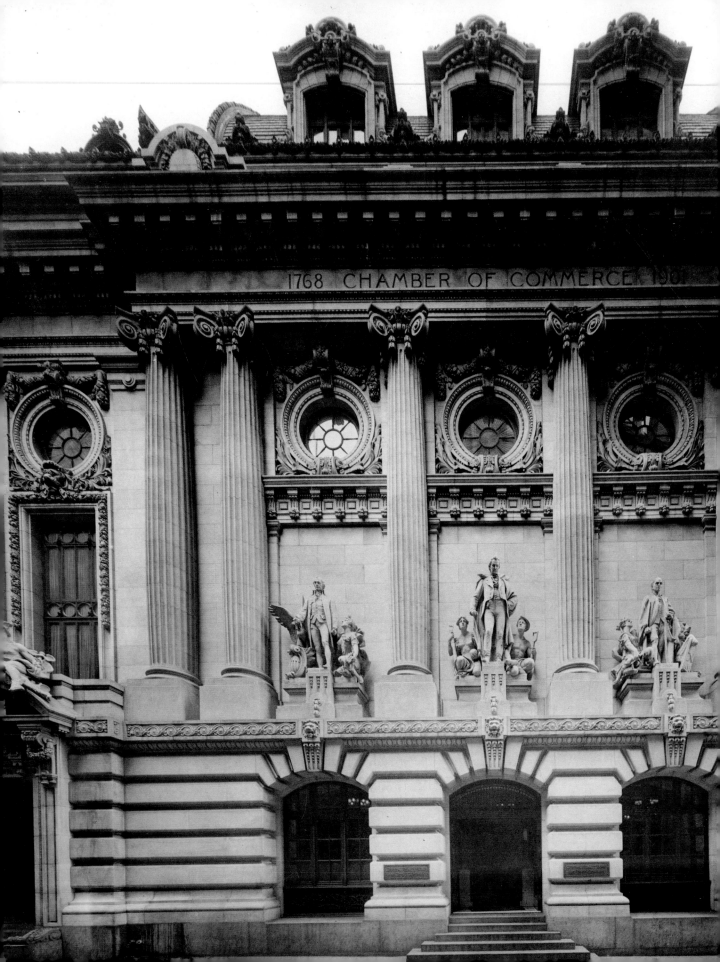

PICTURING POWER

Portraiture and Its Uses in the
New York Chamber of Commerce

KARL KUSSEROW

WITH CONTRIBUTIONS BY

ELIZABETH BLACKMAR, PAUL STAITI,

DANIEL BLUESTONE, AND DAVID L. BARQUIST

COLUMBIA UNIVERSITY PRESS NEW YORK

COLUMBIA UNIVERSITY PRESS
PUBLISHERS SINCE 1893
NEW YORK CHICHESTER, WEST SUSSEX
CUP.COLUMBIA.EDU

Library of Congress Cataloging-in-Publication Data
Kusserow, Karl.
 Picturing power : portraiture and its uses in the New York Chamber of Commerce /
Karl Kusserow ; with contributions by Elizabeth Blackmar, Paul Staiti, Daniel Bluestone,
and David L. Barquist.
 pages cm
 Includes bibliographical references and index.
 ISBN 978-0-231-12358-7 (cloth : alk. paper)
 1. Businessmen—New York (State)—New York—Portraits. 2. Portrait painting, American—
New York (State)—New York. 3. New York Chamber of Commerce—Art collections. 4. Social
status in art. I. Blackmar, Elizabeth, 1950– II. Staiti, Paul J. III. Bluestone, Daniel M.
IV. Barquist, David L. V. Title.
 ND1329.3.B87K87 2012
 757.09747′1—dc23
 2012008530

⊗
Columbia University Press books are printed on permanent and durable acid-free paper.

Printed by Brilliant Graphics in the United States of America
c 10 9 8 7 6 5 4 3 2 1

References to Internet Web sites (URLs) were accurate at the time of writing. Neither the editor
nor Columbia University Press is responsible for URLs that may have expired or changed since the
manuscript was prepared.

Portions of Karl Kusserow, "Memory, Metaphor, and Meaning in Daniel Huntington's *Atlantic Cable
Projectors*," and Paul Staiti, "The Capitalist Portrait," appeared as "Technology and Ideology in
Daniel Huntington's *Atlantic Cable Projectors*," *American Art* 24, no. 1 (2010): 94–113, and "The Capi-
talist Portrait: Collecting at the New York Chamber of Commerce," *Common-Place* 7, no. 2 (2007),
http://www.common-place.org/vol-07/no-02/lessons/.

CONTENTS

ILLUSTRATIONS

PREFACE AND ACKNOWLEDGMENTS

A number of years ago, in a review of an exhibition of portraits by French Neoclassical artist J. A. D. Ingres, the late *Time* magazine art critic Robert Hughes began with a typically sweeping rhetorical flourish: "You can't look at great portraits today without a certain nostalgia," he observed. "The painted portrait is a form that, like blank-verse drama in the theater and the caryatid in architecture, would seem to be on its last legs. Indeed, with few exceptions it has no legs and seems unlikely to grow new ones." Hughes ascribed portraiture's broad decline to the advent of photography, which surely did constitute a paradigm-shifting threat, setting in motion—at least as traditional representational portraiture goes—the genre's gradual eclipse.[1]

Picturing Power tells a similar story of portraiture's rise and fall, but on a more intimate scale, transpiring within the context of a single institution. Photography had already been invented by the time the portrait collection of the New York Chamber of Commerce was fully under way, and its effect on the organization's collecting was small. Yet the ascent-and-decline narrative of portraiture before and after photography broadly anticipates the genre's trajectory at the Chamber, where it was social and cultural rather than technological factors that caused the group to embrace and then let go of a mode of representation that, in portraying individuals, also allowed it to render itself. It was a picture that changed over time, as the collection, the institution and its agenda, the status of business and businessmen, the genre of portraiture itself, and the world around it continued to evolve.

While we may now feel, as Hughes would have it, a certain nostalgia in contemplating portraits that construct an appearance of uncomplicated confidence and placidity—a veneer that lent the Chamber's paintings what would later be called an "almost foreign distance"[2]—at the Chamber those images constructed more than individual appearances, playing a crucial role in the institution's larger story as both an agent in its rise and a mirror to its decline.

In recuperating some of the portraits' changing use and meaning in and beyond the Chamber of Commerce, *Picturing Power* aims to elucidate the genre's historic appeal to institutions of all kinds through an enhanced understanding of one of its most compelling American manifestations.

Like its subject, this book has a long history of its own, although not for lack of support from both individuals and institutions, each of which—appropriately, for a study of institutional portraiture—have been crucial to its completion. The contributions of the four invited essayists, collectively comprising nearly half the book, cannot be overstated: to David L. Barquist, H. Richard Dietrich Jr. Curator of American Decorative Arts, Philadelphia Museum of Art; Elizabeth Blackmar, professor of history, Columbia University; Daniel Bluestone, professor of architecture and director of the Historic Preservation Program, University of Virginia; and Paul Staiti, Alumnae Foundation Professor of Fine Arts, Mount Holyoke College, I express sincere gratitude for exemplary scholarship and for patience in awaiting its appearance. *Picturing Power* was originally conceived as a larger, edited volume, intended to additionally feature brief essays on individual portraits in the Chamber of Commerce collection. Although due to practical exigencies that initial vision could not be realized, I am similarly indebted to the scholars whose research and insight nonetheless beneficially informed the project: Carrie Rebora Barratt, Valentijn Byvanck, Joseph J. Inguanti, Marni Reva Kessler, David M. Lubin, Robert S. Lubar, the late David M. Meschutt, and Nadia Tscherny.

Picturing Power had its genesis while I served as a consultant to the Donaldson, Lufkin & Jenrette (DLJ) Collection of Americana, a distinguished corporate art collection formed under the auspices of Richard H. Jenrette, himself a noted collector, who in 1983 and 1984 arranged for DLJ's purchase of a large group of the Chamber's portraits. He later endorsed this project on the larger Chamber of Commerce collection, including the extensive research that informs it, as did DLJ's former curator, Margize Howell, without whose steadfast support over its long gestation this book would not have been possible. I am exceedingly grateful to them, as well as to Kathy Healy-Gillen, Monica LaStaiti, and former DLJ executives Michael A. Boyd, John S. Chalsty, Anthony F. Daddino, and Joe L. Roby for authorizing crucial funding. I am appreciative as well of the continued support of Credit Suisse following its acquisition of DLJ.

Additional generous support came from the J. M. Kaplan Fund, in connection with which I thank Richard D. Kaplan, as well as Angela D. Carabine and Arthur E. Imperatore Jr. Two anonymous donors—one of them via the kind intervention of essayist Elizabeth Blackmar—provided equally significant support, sustaining and enabling the project through a critical period of development.

AXA Equitable housed and restored many of the Chamber of Commerce portraits and archival records at a time when their fate was unclear. I am grateful to

Elizabeth Cacciatore, Jeremy Johnston, and most especially Pari Stave for caring for them so ably, and for assistance of many kinds with numerous aspects of this project.

I express gratitude as well to individuals who variously provided research, technical, scholarly, editing, and not least practical and moral support: Gavin Ashworth, Kevin Avery, Sam Burrell, John Dixon, Jeffrey Evans, Morrison H. Heckscher, Rachel Madison, Jo Ann Neman, Jeffrey Richmond-Moll, Linda Secondari, John Wilmerding, and especially Martin A. Berger and Nicola Knipe.

At the Partnership for New York City, the Chamber's successor organization, archival research was enabled by Robert R. Kiley, the late Evelyn Ortner, and particularly Steve Scoppetta. The donation of Chamber of Commerce materials to the New York State Museum in Albany and Columbia University's Rare Book and Manuscript Library was facilitated by Brad Hoylman, Jaye Pershing Johnson, and Kathryn S. Wylde. Additional thanks to Ronald J. Burch at the museum and Jean Ashton, formerly at Columbia; Bernard R. Crystal; and, again, Elizabeth Blackmar.

For their ongoing support of my work on this project, I am grateful to former Princeton University Art Museum director Susan Taylor, former acting director Rebecca Sender, and current director James Christen Steward, who additionally authorized the accompanying exhibition, "Picturing Power: Capitalism, Democracy, and American Portraiture," held from March 9 to June 30, 2013. The exhibition was realized by the museum's talented and devoted staff, and enabled primarily through funding from William and Judith Scheide and the Kathleen C. Sherrerd Program Fund for American Art. Gratitude is extended as well to the lenders of Chamber of Commerce portraits, Credit Suisse and the New York State Museum.

Finally, thanks to Peter Dimock, who acquired the book for Columbia University Press, and to Jennifer Jerome, Chang Jae Lee, Philip Leventhal, Irene Pavitt, and Kerri Cox Sullivan—all of whom saw it through to completion.

NOTES

1. Robert Hughes, "The Faces of an Epoch," *Time*, March 8, 1999. For an examination of the evolution of portraiture after the introduction of portrait photography in 1839, see Heather McPherson, *The Modern Portrait in Nineteenth-Century France* (New York: Cambridge University Press, 2001).
2. Peter P. Grey, *The First Two Centuries: An Informal History of the New York Chamber of Commerce* (New York: New York Chamber of Commerce, 1968), 42.

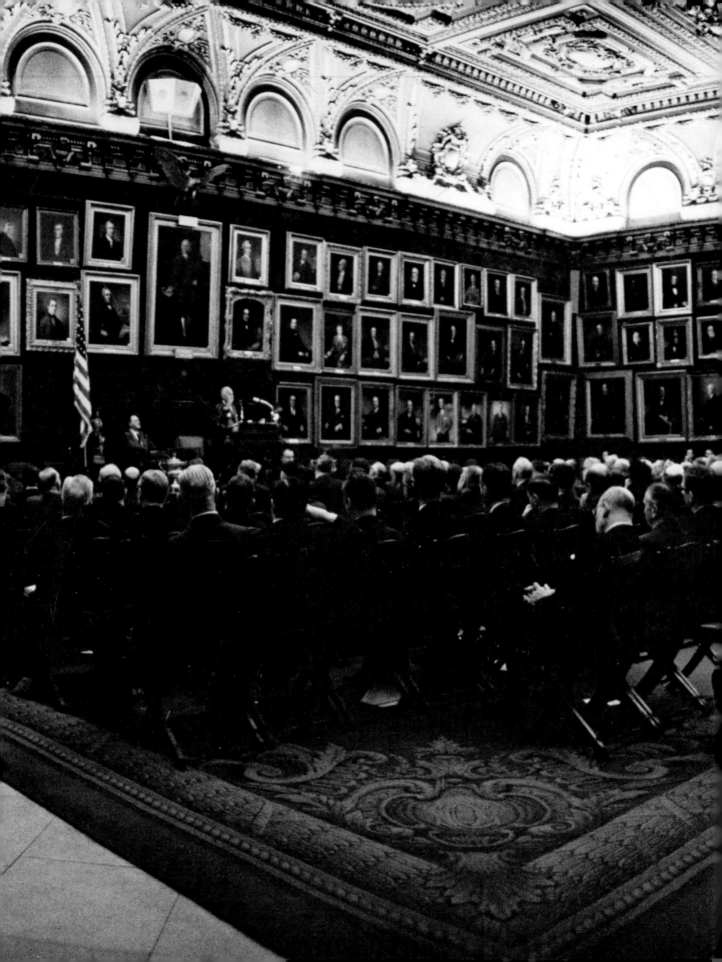

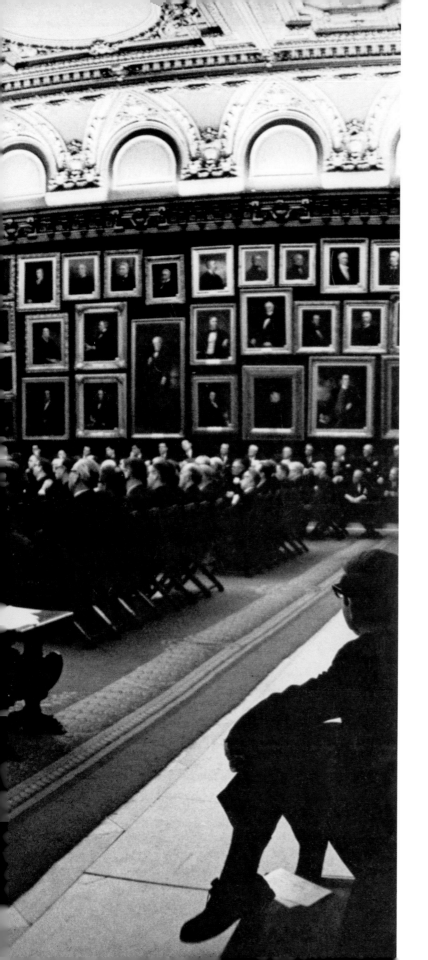

PICTURING
POWER

INTRODUCTION

KARL KUSSEROW

The first decade of the new millennium was a supremely unsettling time for American business. Bracketed on one end by high-profile corporate scandals, culminating in the conviction of senior executives for deliberately misleading investors, and on the other by the epic collapse of the subprime mortgage market, with its dire implications for economies worldwide, these years witnessed a pronounced decline in the image of businessmen and a corresponding increase in demands for public accountability. Distinct as the economic debacles of the period may be, they are similarly rooted in the essential—and normally productive—self-interest of business, abetted by what the *New York Times* termed an "orgy of deregulation" during the previous quarter-century.[1] The freedom of the market to follow its own unfettered path has seemed for many to be as fundamental to the American dream as the right of citizens to forge their destiny unhindered by anything but their own personal limitations. The notion that success, in business as in life, is freely earned and not ordained, regulated, or appointed is in keeping with a capitalist system driven by market economics, a meritocratic order that places business and businessmen—not hereditary aristocrats, religious leaders, or military chieftains—near or even at the center of power.

For more than two centuries, the centrality of business in the determination of American power, and the way that power was portrayed, coalesced at the New York Chamber of Commerce. The Chamber's renowned collection of portraits of civic leaders and leading members played a vital role in the establishment, definition, growth, and, eventually, decline of the institution, advancing and reflecting its profile as the nation's first and most important business organization—and even, for a time, as among the most influential of all American institutions. Before the Chamber's portraits were dispersed and put to new uses, the collection that the group assembled to embody its past and promote

its present and future constituted perhaps the most significant example of institutional portraiture in American history—not for the aesthetic quality of the images, which is uneven, but for their integral role in the life of the group that assembled them and the broader interests it represented. Other institutions—colleges and universities, medical and law schools, voluntary clubs and associations, political institutions, museums and athenaeums, and reform, historical, and learned societies—formed collections of equivalent age, some even of equal size; none, however, played such a pivotal role in their parent organization's conceptualization and development.[2]

Founded in 1768, the New York Chamber of Commerce received its charter guaranteeing "perpetual succession" from King George III, one of only four institutions in the city afforded such notice. The group functioned to regulate and codify commercial practice, to provide business interests with a unified means of formulating and advancing their agenda in the spheres of local and later national government, and to consolidate and elevate the reputation of its members and the profession generally—in part by linking commerce's development to social and cultural progress. The portrait collection served to support these ends. How it did so—beginning with a single image in 1772 and growing to include by 1972 almost three hundred of them—is the subject of this book.[3]

Running throughout *Picturing Power*, obliquely but persistently, is the concept that gives the volume its title and that, in an American context, constitutes a paradox of long standing. How, exactly, is power pictured in a culture avowedly devoted to—indeed, defined by—a rhetoric of democratic, egalitarian ideals? a culture founded in opposition to the princely trappings of European precedent and ushered into maturity by the homogenizing forces of industrialization and immigration, with their imperative toward assimilation? The notion of equality is so firmly ingrained as the nation's originary and essential feature that Tocqueville observed early in his travels, "The more I advanced in the study of American society, the more I perceived that this equality of condition is the fundamental fact from which all others seem to be derived and the central point at which all my observations come to a head." In such a climate, the inherently aggrandizing act of commissioning, posing for, and collecting portraits seems at odds with the core national values—however episodically or irregularly applied—of a culture set against the hierarchical traditions manifest in Continental modes of representation.[4]

From its inception, the Chamber of Commerce collection engaged this tension. Its first two portraits—of Cadwallader Colden, British leader of New York Colony, and Alexander Hamilton, founding father of American capitalism—recapitulate the distinction between European and American prototypes even as the latter expresses the new nation's professed aversion to overt portrayals of position and power. As depicted by Matthew Pratt in 1772, the stolid Colden is dressed, posed, and situated within a pictorial space that everywhere accords

with the dictates of Continental Grand Manner portraiture (see figure 1). Bewigged and wearing formal baroque attire, replete with ornamental sword (traditional symbol of appointive, autocratic authority), Colden directly and rather haughtily addresses the viewer, surrounded by elaborate classical architecture framing a glimpse of New York Harbor, over which he wields dominion. Shipmasts signify the city's maritime economy and serve more particularly as metonyms of the fledgling Chamber of Commerce (then limited exclusively to shipping interests), through Colden's agency recently granted a royal charter—perhaps the very paper on which his hand proprietarily rests.

Twenty years later, John Trumbull rendered Hamilton with subtle differences that betoken the nascent conundrum of picturing power in an American context (see figure 2). Also set in a classical space (though this one romantically evocative, neither as specific nor as severe as Colden's), the fresh-faced Hamilton gazes away less formally—less powerfully—but more idealistically, and, it seems, hopefully, to the future. Unlike Colden, whose foursquare, confrontational aspect sets up a barrier between subject and viewer, Hamilton is oriented diagonally to the picture plane, and his outward energies are distinctly softer, radiating not rank and social distance but a soulful optimism. His portrayal, though impressive, is devoid of overt connotations of power and is more an expression of forward-looking potential—his own and the nation's—than of entrenched authority. In rendering Hamilton, then Secretary of the Treasury, in such a way, Trumbull was acting in accordance with the sitter's explicit wish to be portrayed, as he requested, "unconnected with any incident of my political life. The simple representation of their fellow Citizen and friend will best accord with my feelings."[5]

In expressing such sentiments, Hamilton, whose portrait is rooted in the pictorial mode of meritorious republicanism characteristic of early depictions of American power, begins to question even that relatively egalitarian manner of representation. In this, he anticipates the coming age, when the received visual vocabulary, fundamentally mimetic of European aristocratic models, gave way to the democratic template inspired by the Jacksonian ideal of the common man and, later, by the comparatively undifferentiated social culture of the postbellum era. At the Chamber of Commerce, where collecting did not begin in earnest until this time (during, and especially after, the Civil War), and where there always existed the pressure of confraternity to subsume representations of individual authority under the mantle of the common cause, the question became how to properly accommodate these divergent impulses—how to assimilate a desire to picture power within an immediate fraternal context and a broader cultural milieu at least putatively espousing individual, and pictorial, reticence. One solution was to represent the self not through grandiose allegorical forms, which interpret the subject via a related attribute—elaborate costume, setting, and other trappings of wealth and power—but through a

salient detail *of* the sitter—a physical feature connoting a particular personality trait—as a more modest means of representing character. In the end, the resolution of the Chamber's dilemma, as it evolved, was its large collection of surprisingly understated, relatively similar images, which achieved their impressive effect only collectively, en masse, thereby sidestepping the paradox of picturing American power even as the impact of hundreds of portraits lining the organization's walls transmitted the desired message of authority and sanction, and bolstered group unity and identity in the bargain.[6]

Further complicating the representation of powerful businessmen was the shifting and ambivalent relationship that Americans have always had with business itself. In diverse yet historically specific ways, this relationship reflects crucial and enduring tensions in American culture—contests between the pursuit of individual wealth and self-interest as against the common or (significantly) "greater" good, between egalitarianism and the social hierarchies engendered by the accumulation of capital. From the beginning of the nation's history, citizens wrestled with the conflict between a respect for self-made individuals and a fear of creating a moneyed class that would simply supplant the hierarchical aristocracy left behind in England. In representing the human face of business, and directly inflecting the construction and maintenance of its reputation, the Chamber portraits—both in the representational strategies they individually adopt and in the various uses to which they were collectively put—situate themselves at the very intersection of these tensions.

The essays in *Picturing Power* consider the portraits from a variety of perspectives, examining businessmen's fluctuating fortunes, the Chamber paintings' influence on them, and a wide range of issues the collection engages. Most take a diachronic approach to the Chamber of Commerce and its eventual collection of several hundred portraits, focusing on the institution itself and on the use and function of the portraits in terms of their evolving historical circumstances. The book's initial essay, "Portraiture's Use, and Disuse, at the Chamber of Commerce and Beyond," divides the collection's history into distinct epochs, documenting and interpreting the growing collection throughout its unusually long history, and showing how the portraits functioned differently, even antithetically, in different institutional, social, and cultural eras. Three subsequent chapters more particularly chart the collection's trajectory across the later nineteenth and early twentieth centuries, during the height of its influence, and take up the significance of the Chamber's several architectural settings—its institutional frame—as well as the literal, gilded frames surrounding the portraits. Paul Staiti's "The Capitalist Portrait" critically assesses the collection's social and cultural role for the organization at its zenith, additionally investigating the historical antecedents of the portraits, the distinct typologies adopted by the artists who produced them, and the implications of their mass installation at the Chamber. Daniel Bluestone's "Portraits in the

Great Hall: The Chamber's 'Voice' on Liberty Street" recounts the institution's various homes and elucidates the import and meaning of the group's desire to create in the New York Chamber of Commerce Building a civic monument that would stand apart from the commercial structures surrounding it. And David Barquist's "'The Whole Lustre of Gold': Framing and Displaying Power at the Chamber of Commerce" details the wide range of historical styles adopted to frame the Chamber's portraits, probing their significance individually, collectively, and symbolically. Together these essays reveal how the collection in its various guises performed a variety of roles in actuating and reflecting the concerns of the group and its milieu over time. As such, they are productively informed by the volume's comprehensive account of the Chamber's history: Elizabeth Blackmar's "Exercising Power: The New York Chamber of Commerce and the Community of Interest," which illuminates the institutional backdrop against which the portraits were set and illustrates how the organization's prolonged historical sweep both recapitulated and helped engender important transformations in American business culture. Finally, and by contrast, *Picturing Power*'s last essay, "Memory, Metaphor, and Meaning in Daniel Huntington's *Atlantic Cable Projectors*," offers an extended analysis of a single image: the Chamber's prized group portrait, produced by the institution's "house" artist at the moment of its greatest power and influence. The essay investigates a variety of social, cultural, and art-historical issues to show how the painting overtly and covertly engages central concerns of the organization, its members, and the wider interests they represented.

In assessing the collection from these different points of view, *Picturing Power* demonstrates in macrocosm and microcosm the ways in which portraiture generated meaning in and beyond the Chamber. The broad accounts of institutional and collection history, fundamentally concerned with understanding portraiture's function in relation to larger social structures—particularly its hegemonic strategies for bolstering group and class authority—apply the tools of social art history, with its focus on the circulation of power and meaning within institutions as a means of exploring art in social practice. These essays examine the collection's role and effect in and on society, and by and large do not engage the internal mechanics of specific works. The analysis of the Chamber's most significant painting, on the contrary, attends more to culture than to society, especially to the ways in which often veiled cultural attitudes and concerns can be shown to be embedded within pictures. It proceeds from the premise that paintings, like other creative fictions, provide a complex negotiation rather than a straightforward transcription of culture, addressing issues and generating meanings unintended by their producers and often not consciously recognized by their consumers.[7]

Distinct as these approaches may be, they are cohered by their engagement with the largely noncanonical, conservative, and, in later years, even retrograde

Chamber of Commerce portraits. In this sense, *Picturing Power* is informed by the emerging concerns of the field of visual studies, whose mandate to democratize the artistic canon through attention to the circumstances of production, use, and meaning of a wide range of imagery adds to the aesthetic concerns of conventional art history an interest in the cultural value of traditional works of art that, like the Chamber's portraits, held great resonance for their audience. In restoring something of the meaning these portraits had over the course of time, *Picturing Power* returns to the Chamber's collection a measure of its own pictorial power even as it reflects the predicament of portraying power in a democracy.[8]

NOTES

1. "The Next President" [editorial], *New York Times*, November 5, 2008 (the day following Barack Obama's election).

2. For collections related to the Chamber's, both preceding and contemporary to it, see the section "Ideology," in Paul Staiti, "The Capitalist Portrait" (this volume). See also Valentijn Byvanck, "Public Portraits and Portrait Publics," *Explorations in Early American Culture / Pennsylvania History* 65 (1998): 199–242.

3. The other organizations granted colonial charters of similar scope include the municipal corporation, Trinity Church, and King's—now Columbia—College. For the history and functioning of the Chamber, see Elizabeth Blackmar, "Exercising Power: The New York Chamber of Commerce and the Community of Interest" (this volume). See also Joseph Bucklin Bishop, *A Chronicle of One Hundred & Fifty Years: The Chamber of Commerce of the State of New York, 1768–1918* (New York: Scribner, 1918); and Peter P. Grey, *The First Two Centuries . . . : An Informal History of the New York Chamber of Commerce* (New York: New York Chamber of Commerce, 1968).

4. Alexis de Tocqueville, "Democracy in America," in *The Tocqueville Reader*, ed. Olivier Zunz and Alan S. Kahan (Oxford: Blackwell, 2002), 64. The dilemma of power in egalitarian America is explored in Steve Fraser and Gary Gerstle, eds., *Ruling America: A History of Wealth and Power in a Democracy* (Cambridge, Mass.: Harvard University Press, 2005).

5. Alexander Hamilton to Gulian Verplanck and others [Roger Alden, Brockholst Livingston, Joshua Waddington, and Carlile Pollock], January 15, 1792, in *The Papers of Alexander Hamilton*, ed. Harold C. Syrett (New York: Columbia University Press, 1961), 10:515.

6. On the post–Civil War imperative toward the erasure of social difference in the name of democratic ideals, see Philip Fisher, "Democratic Social Space: Whitman, Melville, and the Promise of American Transparency," *Representations* 24 (1988): 60–101. On the different pictorial strategies for conveying information about

portrait sitters, see Richard Wendorf, *The Elements of Life: Biography and Portrait-Painting in Stuart and Georgian England* (Oxford: Clarendon, 1990). For a meditation on issues of portraiture and representation as they relate to American ideals generally, see Richard Brilliant, "Self-Portraiture and the American Self," *Common Knowledge* 4, no. 3 (1995): 48–63, part of a volume reproducing papers from the symposium "The Individual and the Herd: The Public Secret of Self-Fashioning." And for an extended discussion of the Chamber portraits' collective power, see Staiti, "Capitalist Portrait," especially the section "Installation."

7. The two divergent sorts of methodology outlined here—which art historian Alan Wallach has pithily characterized as reducible to two words: Marx and Freud—have been seen as representing the major critical streams of Americanist art-historical practice. See the section "Methods: Object, Vision, Culture, Society," in John Davis, "The End of the American Century: Current Scholarship on the Art of the United States," *Art Bulletin* 85 (2003): 544–580; and Jules David Prown, "Art History vs. the History of Art," *Art Journal* 44 (1984): 313–314, and "In Pursuit of Culture: The Formal Language of Objects," *American Art* 9 (1995): 2–3. For Wallach's characterization, see "The Word from Yale," *Art History* 10 (1987): 261.

8. For the ecumenical impulse of visual studies, see Norman Bryson, Michael Ann Holly, and Keith Moxey, eds., *Visual Culture: Images and Interpretations* (Middletown, Conn.: Wesleyan University Press, 1994), esp. the introduction. On the "cultural" as against the "aesthetic" value of images, see Keith Moxey, "Animating Aesthetics," *October* 77 (1996): 56–59.

PORTRAITURE'S USE, AND DISUSE, AT THE CHAMBER OF COMMERCE AND BEYOND

KARL KUSSEROW

On April 2, 1771, at a meeting of the recently formed New York Chamber of Commerce, Treasurer William Walton moved that, "as there is now a good Limner in Town," the group arrange to have a portrait painted of its patron, New York Colony lieutenant governor Cadwallader Colden, which "when finished," Walton further suggested, "be hung up in the Chamber in memory of their Gratitude for granting them a Charter of Incorporation." In so doing, he unwittingly initiated a tradition of portrait commissioning, collecting, and displaying that was to continue for precisely two centuries. Between 1772, when Matthew Pratt's full-length portrayal of Colden was deposited with the Chamber, and 1972, when the faltering institution commissioned its final portrait of outgoing president George Bates, the organization amassed a collection of nearly three hundred images of members and other notables with whom the group identified, or wished to, installing the portraits en masse, tier upon tier, in the vast Great Hall of the sumptuous building erected in 1901 in large part to accommodate them.[1]

Approaching the Chamber's collection across time, from the perspective of its changing role in the life of the institution, this essay offers a historically contextualized and analytic "portrait" of how the genre was used by a wealthy and powerful group to fashion an identity that promoted its corporate, civic, and ultimately ideological agendas, even as the collection reflected, in its evolving use, the successive concerns of the organization, its members, and the wider culture they inhabited. Interpreting the Chamber's paintings in terms of their shifting functions and significations, the essay presents the collection as a model for the means through which groups employ portraits in the production and regulation of identity, as well as for the multiple ways that changing institutional concerns and agendas are both reflected and actualized in portrait collections.

Given the distinctive role of the Chamber's collection in institutional self-definition, and equally as a result of its unusually long history, the portraits have produced a singularly rich legacy of uses and meanings, one that continues beyond its elaboration at the Chamber of Commerce to include the paintings' afterlife in a completely different context. Acting as both an agent in and a reflection of the life of the institution that created it and that it served, the Chamber of Commerce's collection divides into six sometimes overlapping but distinct epochs, assessed chronologically in what follows as named and adumbrated here: "totemic," providing a sense of unity and conferring legitimacy on the young and struggling institution; "rhetorical," facilitating its construction, internally and externally, as a major civic and ultimately national force; "corporatized," mirroring and accommodating Chamber members to emergent forms of business and social organization; "aestheticized," more passively reflecting the institution's ascendancy and resulting refined and gentlemanly complacency; "burdensome," surviving as a vestigial, even onerous reminder of the group's anachronistic later circumstances; and "rhetorical again," revitalized, like the Chamber itself, in another guise entirely.[2]

Totemic (1772–1844)

Though two hundred years in the making, the Chamber's collection was actually quite small for much of its first century, consisting solely of two full-length portraits: Matthew Pratt's stately rendering of Colden (figure 1) and, later, John Trumbull's elegant portrayal of Chamber hero Alexander Hamilton (figure 2). Nonetheless, these were of profound significance to the nascent organization, functioning as a means of establishing and strengthening group affiliation and serving to underscore its authority both within and without the institution. As portable symbols of the Chamber's legitimacy, moved from one location to another during its early years of roving tenancy in such unprepossessing places as communal coffeehouses, the portraits communicated an image of power and sanction for an institution whose interest in favorably influencing government policy and decisively arbitrating commercial disputes made such associations desirable. In this sense, they functioned much like the countless images of leaders routinely displayed in courthouses and government offices today, which establish and make public the vested rights and privileges of those who link their authority to them.

At the same time, in asserting a common, quasi-ancestral relationship to the individuals depicted, the portraits acted to unify the group's members into a clanlike kinship, with concomitant duties of recognition and rectitude toward one another. The belief in kinship through mutual, symbolic ancestral

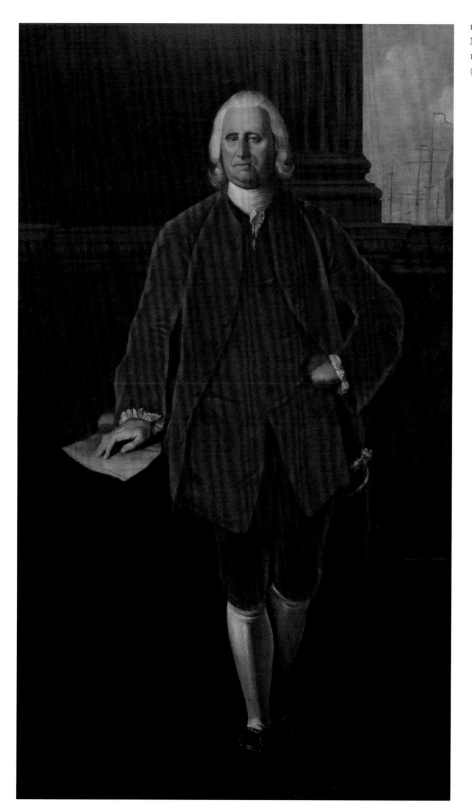

FIGURE 1
Matthew Pratt, *Cadwallader Colden*,
1772. Oil on canvas, 78¼ × 46¾ in.
(New York State Museum, Albany)

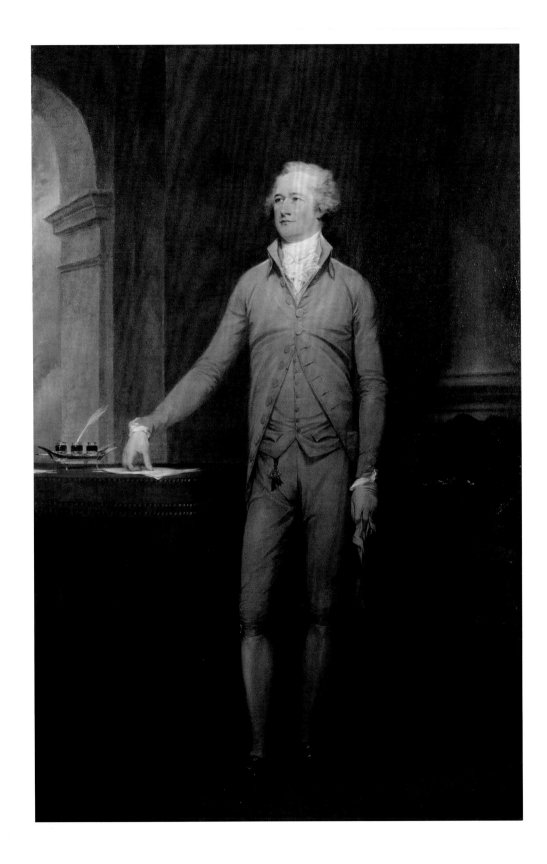

affiliation, a central tenet of totemism, further served to proclaim the institution's origins and lineage. And the unimpeachable gravitas of the persons from whom this descent was claimed in turn reinforced its bid for status and power.[3]

The air of both endorsement and unity conferred by the initial portrait of Colden must have been a particularly useful rallying device during the Chamber's first several years, when despite a royal charter providing for its existence in perpetuity, its actual future was anything but guaranteed. In name as well as intent, organizations like it—independent of either government control or guildlike association with a specific trade—were scarcely known, anywhere. The twenty New York merchants who gathered in the Long Room of the inn now known as Fraunces Tavern (figure 3) to, "by voluntary agreement, associate themselves for the laudatory purpose of promoting trade and commerce" were indeed charting new territory.[4]

FIGURE 2
John Trumbull, *Alexander Hamilton*, 1792. Oil on canvas, 86 × 58 in. (Credit Suisse, New York)

FIGURE 3
Fraunces Tavern, Pearl and Broad Streets, New York. The Long Room extends along the second-floor side of the building. (From Joseph Bucklin Bishop, *A Chronicle of One Hundred & Fifty Years: The Chamber of Commerce of the State of New York, 1768–1918* [New York: Scribner, 1918])

Still, publicly linking their authority to Colden through his portrait was by no means unproblematic. In so doing, the group declared, if not its uncontested political allegiance, then at least its general deference to the authority of the royal government at a time of widespread dissatisfaction with it, not least among the very merchants from whose ranks the membership was drawn. When, at the Chamber's meeting on October 6, 1772, "The President exhibited Mr. Pratt's account amounting to thirty-seven pounds for taking Governor Colden's portrait," the members tapped to pay for it must have had to dig a little deeper than usual to come up with their share, as merchants throughout the colonies had until two years earlier been involved in a long and bruising nonimportation protest against imperial tax policy—a movement supported, albeit unofficially, by the Chamber itself. Nor was Cadwallader Colden particularly beloved. Petty and dogmatic (though also deeply learned), he had a tumultuous career as a high-ranking colonial administrator, serving in a variety of posts that culminated, in 1761, in his appointment as lieutenant governor and a subsequent fourteen-year on-again, off-again incumbency as New York Colony's leading British official. For the Chamber to have linked their warrant to his, and by extension the Crown's, at the time they did underscores the overall Tory sympathies of the membership and suggests a degree of strategic calculation that an affiliation with Colden, pictorial or otherwise, would continue to have purchase in the complex and shifting political climate of pre-Revolutionary New York.[5]

Following its delivery in late 1772, the portrait of Colden was duly displayed in the large upstairs hall of the Royal Exchange on Broad near Water Street (figure 4), the space specifically mandated for meetings of the Chamber in its

FIGURE 4
Unidentified artist, *Royal Exchange*, n.d. Watercolor. (From Joseph Bucklin Bishop, *A Chronicle of One Hundred & Fifty Years: The Chamber of Commerce of the State of New York, 1768–1918* [New York: Scribner, 1918])

charter—an unusual requirement perhaps intended as a means of, at least symbolically, drawing the group closer within the British government's orbit. Completed in 1752, the exchange was under municipal control, the corporation of the city having supplied a grant to enable its completion after the independent merchants who projected it failed to raise sufficient funds. In what, during a period of increasingly contested relations, Chamber members may have thus regarded as rather uncomfortable surroundings, Colden's portrait must have reminded them—and other users of the multipurpose room—that they yet had friends in high places, just as would another portrait in the same space of William Pitt, British prime minister at the time of the group's founding and an ardent supporter of the American colonies.[6]

Lest these inferences about the messages transmitted and received by portraits and their audiences in late-eighteenth-century America seem overdetermined, it is worth recalling that "likenesses" such as Colden's were taken seriously, and often quite literally, as symbols of and surrogates for those they represented. On July 9, 1776, four years after Colden's portrait was installed in the exchange, a boisterous crowd of patriots toppled and beheaded the equestrian statue of George III that had recently been installed a few blocks north on Bowling Green (figure 5)—a metaphorical regicide foreshadowing first the pictorial, in countless cartoons, and then the actual fate of France's Louis XVI not long after. Indeed, the portrait of Colden itself was attacked by a group of Hessian soldiers, who ran "a bayonet throo one of the eyes and several parts of the Body (no doubt supposing it to Represent some Rebell as they call'd all Americans)" and who were, according to the account of Colden's son, in the process of breaking

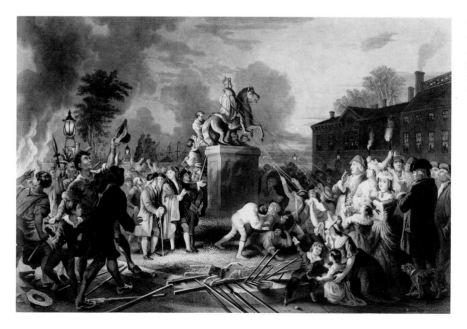

FIGURE 5
John McRae (after Johannes Oertel), *Pulling Down the Statue of George III by the "Sons of Freedom,"* 1859. Engraving, 11½ × 16¼ in. (Library of Congress, Washington, D.C.)

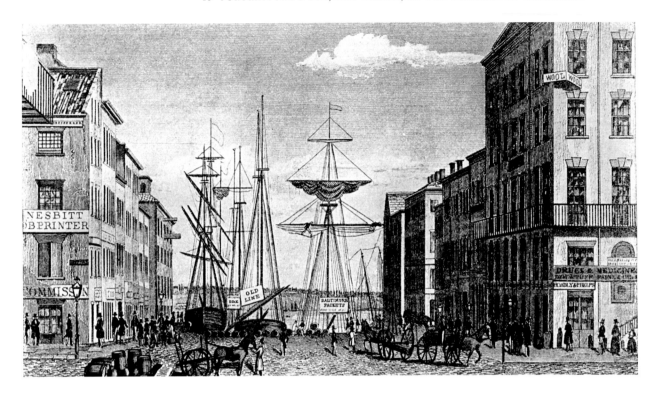

FIGURE 6
Unidentified artist, *Wall and Water Streets*, n.d. Engraving. (From Joseph Bucklin Bishop, *A Chronicle of One Hundred & Fifty Years: The Chamber of Commerce of the State of New York, 1768–1918* [New York: Scribner, 1918])

up the frame in the street when Anthony Van Dam, founding secretary of the Chamber, persuaded them to desist, later delivering the painting to the sitter's family for safekeeping. While such gestures may seem slightly inane now, saturated as we are with virtual representations of people in all manner of forms and contexts, in Revolutionary-era America the paucity of images must have made the few that existed relatively more significant and compelling as signifiers of the presence of those depicted, commensurately magnifying their representational power. (Nor have we moved entirely beyond this mind-set, as the more recent toppling of statues of Lenin, Stalin, and, later, Saddam Hussein would indicate.)[7]

The Chamber ceased meeting for several years during the Revolution, until 1779, when a much-diminished group of loyalists reconvened the group in the busy Merchants' Coffee House, established in 1737 on the southeast corner of Wall and Water Streets (figure 6 [at right]). They continued to meet there until the cessation of hostilities, after which the Tory membership was largely supplanted by patriots returning to the city, replacing the majority of British sympathizers who had left with the king's troops. Reconstituted in 1784 as the Chamber of Commerce of the *State* of New York, the organization set about reestablishing its presence in the city, a project no doubt assisted by the news of February 1, 1791, that "a picture of Cadwallader Colden, Esq., Lieut. Governor of the late Province of New York, who originally incorporated this Chamber,

and which had been drawn by order and at the desire of its members, was now in good preservation and in hands which were willing to restore it to the former owners." The hands alluded to were those of Colden's son Cadwallader Jr., still resident in the city and presumably eager to ingratiate himself to the new order. Long assumed lost in the tumult of war, portrait was reunited with patron, and the former was installed at the new site of the group's meetings.[8]

But the picture of Colden meant something different now. No longer a token of governmental sanction, the image was charged instead with a new kind of signifying power, more classically totemic in nature. Still serving as a symbol of group affinity, it also began to assume the role it would later strongly have of ancestral relic, becoming an artifact of history, not politics. Years hence, the portraits of both Colden and Hamilton, neither of whom were members of the Chamber, would nonetheless be repeatedly referred to as representations of its institutional progenitors, as in a newspaper article, "Portraits with Careers," written a century later, in which they are termed the group's "patriarchal portraits."[9]

In a more general sense, the painting of Colden as installed at the Merchants' Coffee House added a dignifying cachet to the inn's already upscale Long Room—the name generically given the larger, better-appointed rooms increasingly found in the city's finer public houses—a distinction that would have beneficially accrued to the Chamber and its reputation among public users of the place. It must also have in some way marked the actually communal space as the Chamber's own, carving a small piece of virtual territory for the group out of the city's lively business district. This was important, for one of the most persistent, even chronic, leitmotifs in the institution's history is the repeated calls of its members for a place of their own, underscoring their sense that the lack of a dedicated space rendered the organization's future tenuous and uncertain.[10] Anything that seemed to work toward that end (not truly achieved until the group rented quarters on Wall Street in 1836) was thought to bolster its prospects. Finally, even though Cadwallader Colden was no longer a person of genuine authority in New York, he was a recent historical figure to be reckoned with, and his imperial visage would still have exuded an aura of power, despite the otherwise unofficial, multipurpose environment, granting the organization affiliated with him a measure of associative credibility.

The venerative use of portraiture to strategically manipulate and in effect colonize even the most unsympathetic spaces has its own long history. Not surprisingly, it has lately been most prevalent in totalitarian political cultures, in which representations of authority are taken with a special seriousness—as, for example, in Communist China, where the cult of Chairman Mao infiltrated even a country courtyard wedding (figure 7), and Stalinist Russia, where the general secretary's portrait was mounted on the front of the Moscow metro's first train, so he could lead the march of progress through the tunnels below the city (figure 8).

FIGURE 7

Yan Han, *The Bride Speaks*, 1951. Colored
ink. (From *China Pictorial*, January 1952)

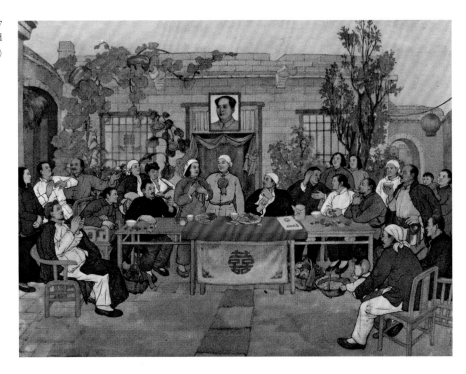

FIGURE 8

First Train to Run on the Moscow Metro, 1935.
(From Matthew Cullerne Bown, *Art
Under Stalin* [Oxford: Phaidon, 1991])

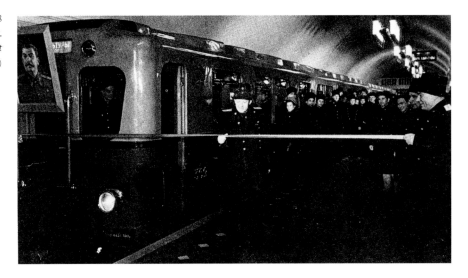

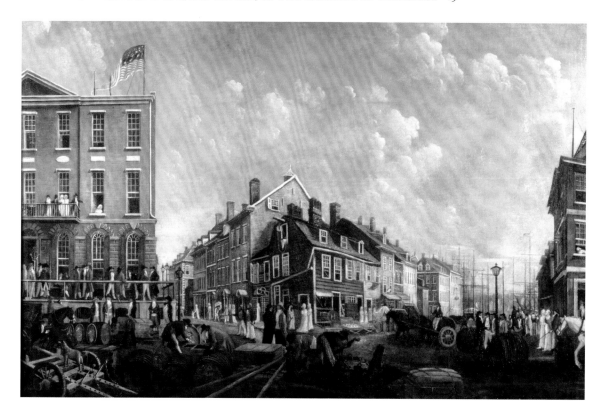

With the completion, in New York in 1793, of the grander Tontine Coffee House (figure 9 [at left]) across the intersection of Wall and Water Streets from the Merchants' Coffee House, *Cadwallader Colden* was carried across the street to the new building and the Chamber of Commerce joined the numerous social, political, business, and benevolent organizations that called the elegant brick structure at the heart of the city's commercial life their home. Not long thereafter, probably around 1805, the image of Colden was joined by another full-length, Grand Manner portrait: John Trumbull's *Alexander Hamilton*, commissioned in 1792 not by the Chamber, as often thought, but by "A number of your fellow Citizens"—chiefly merchants and including members *of* the Chamber—"desirous of expressing the sense they entertain of the important Services you have rendered your Country," as the letter requesting Hamilton to sit for the portrait put it. Hamilton acceded, and when the completed painting left Trumbull's studio later that year, it was "for the present, placed in the City Hall," according to the *Daily Advertiser* of July 4, 1792, where it could be seen with the artist's *George Washington* (1790) and *George Clinton* (1791), both recently commissioned by the Common Council. *Hamilton* must have remained there until around thirteen years later, when Trumbull received another commission from the city, now for five portraits, including a full-length of the

FIGURE 9

Francis Guy, *Tontine Coffee House*, ca. 1797. Oil on linen, 43 × 54 in. (Collection of the New-York Historical Society)

recently slain Hamilton, which would seem to have made the continued display of the first at City Hall redundant. Hence, apparently, its eventual affiliation with the Chamber. However it got there, the addition of Hamilton's portrait to the Chamber's budding collection could not have been more apt, as it updated the by-then obsolete message about institutional orientation conveyed by *Cadwallader Colden*, a relic of British mercantilism, to express instead a more apposite allegiance to American federalism, with which members of the Chamber were, of course, very much in sympathy.[11]

As it happened, the subtly but meaningfully contraposed portraits of Hamilton and Colden had little time to register the Chamber's shifting alignment at the Tontine Coffee House. After scarcely a decade hanging together there, the portraits were again on the move, this time to a venue not directly associated with the Chamber. In April 1817, following a period of inactivity by the group, both paintings were deposited with the American Academy of the Fine Arts, an organization founded in 1802 to offer New Yorkers an edifying exposure to art. The ubiquitous John Trumbull had just taken charge of the struggling academy, recently relocated to the New York Institution of Learned and Scientific Establishments in City Hall Park, and was seeking to reenergize it through the installation of annual exhibitions, a change in name, and an infusion of new works for long-term display (figure 10 [the American Museum was another tenant in the building]). The two portraits were apparently a part of this project in institutional vitalization, as they had been for the Chamber. The patrician Trumbull was the most powerful figure in the city's emerging art world, and would have had leverage with the Chamber in obtaining the loan, along with—as creator of one of the two works comprising it—a certain self-interest in its occurrence. In any event, the savvy New Yorkers who frequented the patron-oriented academy and the other establishments clustered in the New York Institution would surely have recognized the two paintings as belonging to the Chamber, and their display in such elevated confines would have boosted the group's profile, as would the implicit association of the portraits with the paintings of municipal and national worthies—many also by Trumbull—hung in the Governor's Room at City Hall, recently opened just across the park.[12]

Upon construction of the Merchants' Exchange, erected from 1825 to 1827 on Wall between William and Hanover Streets (figure 11), the two portraits were carted back down Broadway to the extravagant white marble, Grecian-style building and again called more directly into the service of the organization. Installed near the entrance to a space dedicated, for the first time, to the Chamber's exclusive use—a ground-floor room off the building's foyer (figure 12)—the portraits must have functioned there not unlike totem poles, signifying through symbols of mutual, quasi-ancestral affinity the group's presence, history, identity, and significance to all who entered the exchange, itself the emblematic manifestation of New York's recent ascendancy, eclipsing Philadelphia as the

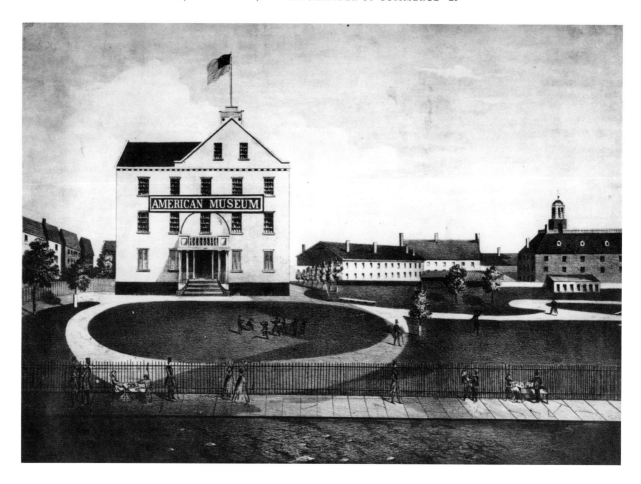

country's leading financial and commercial market. Indeed, the portraits would have been especially noticeable in the grandly scaled structure, which contemporary illustrations show otherwise devoid of imagery (Robert Ball Hughes's colossal statue of, again, Alexander Hamilton was not unveiled in the building until the final few months of the installation of the Chamber's portraits there; for a view of the interior, see figure 13). If the imposing new exchange, designed by leading architects Josiah R. Brady and Martin Euclid Thompson at a cost of $100,000, immediately became the vital center of New York's commercial life, sending the message that the city had come of age as a financial center, the conspicuous display of the Chamber's portraits within it suggested that the Chamber had arrived as well, and belonged—literally—on the ground floor, near the main entrance, as an institution of note in the burgeoning city.[13]

The splendor was short lived. Soon after, the Merchants' Exchange was among the more than six hundred buildings lost in the Great Fire of December 16, 1835. As the flames raged, heroic efforts were made to save the structure and its contents—trade records were salvaged, but attempts to rescue the statue

FIGURE 10
Alexander Jackson Davis,
New York City Hall Park, North End, 1825.
Lithograph, 14 × 17⅜ in.
(National Academy Museum,
New York, 1980.21)

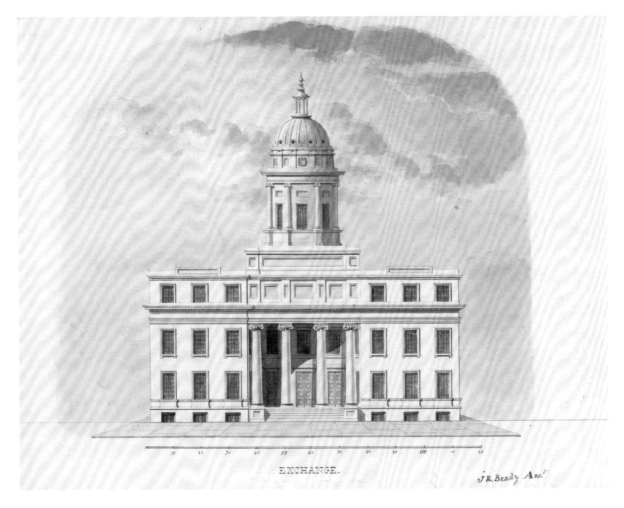

EXCHANGE.

J. R. Brady Arct

FIGURE 11
Alexander Jackson Davis (artist),
First Merchants' Exchange (completed
1827; Josiah R. Brady and Martin
Euclid Thompson, architects),
ca. 1826. Watercolor and ink over
graphite, 8½ × 10½ in.
(Image copyright © The Metropolitan
Museum of Art / Art Resource, N.Y.)

FIGURE 12
Alexander Jackson Davis (artist),
First Merchants' Exchange (floor plan),
ca. 1829 ("Burnt Dec. 1835." added later).
Ink and wash, 11¼ × 8¹⁵⁄₁₆ in.
The Chamber's portraits were installed
in the foyer beneath the cupola.
(Image copyright © The Metropolitan
Museum of Art / Art Resource, N.Y.)

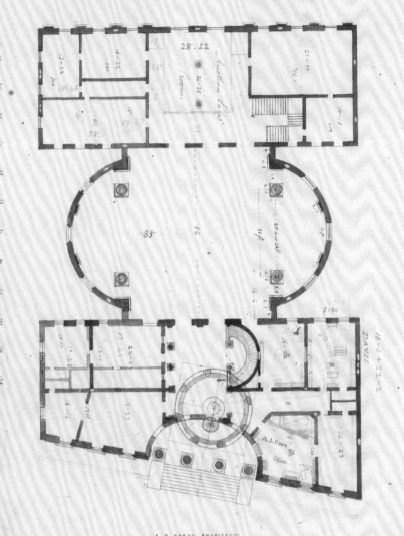

28.22

J. R. BRADY, ARCHITECT.

MERCH'TS EXCHANGE, N.Y.

BURNT DEC. 1835.

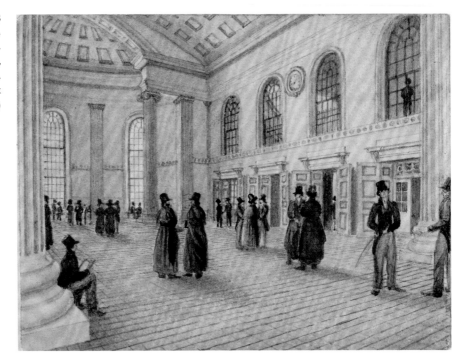

of Hamilton wound up nearly burying those inside when the 60-foot cupola, set directly above the place where the Chamber pictures hung, suddenly collapsed. In the days following the conflagration, the exchange would come to stand as a symbol for all that had been lost, with numerous popular prints quickly appearing showing it in ruins (figure 14). While members of the Chamber, along with the rest of the city's commercial class, quickly retooled and, astonishingly, within a few years had not only rebuilt but greatly improved the devastated area—including construction of an even more impressive exchange where the old one had stood—the Chamber's portraits were nowhere to be found.[14]

Eight years later, in 1843, recently appointed Chamber secretary Prosper Wetmore, "possessing," as he wrote, "something of an antiquarian disposition," set out in search of additional records relating to the group. While so engaged, he was alerted to the existence, in a Wall Street garret, of two large frames thought to belong to the organization. Recounting his story in a letter to Charles King, author of the first published history of the Chamber, Wetmore continued, "Upon removing the canvass covering and the coat of mildew and dust within, I had the great satisfaction of discovering two fine historical portraits"—rather miraculously, *Colden* and *Hamilton*. The much-traveled relics were duly repaired and probably for a time displayed in the Chamber's latest accommodations, in the substantial Merchants' Bank at 43 Wall Street, where the institution's quarters could at last be said to approach its needs.[15]

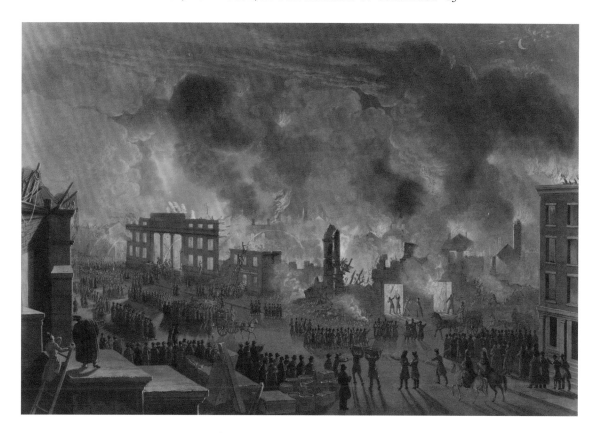

FIGURE 14
William James Bennett (after Nicolino Calyo), *View of the Great Fire in New York*, 1836. Hand-colored aquatint, 16¼ × 24 in. The distinctive façade of the Merchants' Exchange is visible at left. (The New York Public Library, Astor, Lenox, and Tilden Foundations)

Unexpectedly, it was at this very moment that the Chamber, finally in possession of both the portraits and a suitable place to display them, let them go: the minutes of the group's February 6, 1844, meeting record a resolution that "the Secretary be authorized to deposit for safe keeping and due preservation" the full-lengths of Colden and Hamilton "in the Library of the New York Historical Society . . . to be returned to the possession of the Chamber whenever it shall desire to reclaim them." As the language of the declaration suggests, the members of the Chamber always intended to take the portraits back. Indeed, unlike their prior loan, made a quarter-century before at the behest of the American Academy, this one seems to have been initiated by the group itself, and with a particular stress on the paintings' "safe custody," as Wetmore put it elsewhere, in the Historical Society's fireproof building.[16]

In a sense, the portraits' "biography" reflected the group's own history—locatively, experientially, ideologically. By the time the paintings were placed on loan at the New-York Historical Society, the group had achieved an age and a respectability independent of them. Instead of totems to establish the institution's legitimacy, they had become talismans of its survival, to be put away and carefully preserved from harm. As their use by the evolving organization

shifted, they became emblems of, rather than substantiating factors in, the lengthening history of the Chamber of Commerce.[17]

Rhetorical (1845–1902)

Colden and *Hamilton* were soon missed, as sometime between 1845 and 1848, just a few years after their departure for the New-York Historical Society, the Chamber's seventeenth president, James Gore King (figure 15), issued the first of what became a crescendo of calls for the group to establish a true collection of portraits. In proposing a deliberate expansion of the Chamber's existing "collection," King signaled the beginning of an era in which portraiture exerted a growing influence within, and on behalf of, the organization. With its original "patriarchal portraits" securely stowed away, the group determinedly and programmatically set about augmenting them such that, between the Civil War, when the successive motions of Chamber officials were actualized and collecting began, and World War I, when the pace of acquisition started to diminish, the collection would grow to number more than two hundred portraits—nearly three-quarters of its ultimate size—and enjoy wide renown. Whereas during the early nineteenth century the Chamber's two paintings had been of limited utility in articulating the potency and tenor of a group itself in the making, during the following half-century and beyond the expanding collection came increasingly to enhance and define the institution's power and image, and that of the business world at large. The forces that induced this development were both broadly cultural and narrowly institutional, but it was factors specific to the organization that provided the initial impetus in the mid-century calls for the collection's establishment and abetted its materialization over the second half of the nineteenth century.[18]

Institutional Invigoration

Like the rest of the country, the Chamber entered the 1840s eager to shake off the inertia that followed as the financial Panic of 1837 turned into depression and systemic malaise. Faced with a dwindling membership, declining activity, and diminished influence, the group issued numerous appeals for increased attendance at meetings, relocation to more commodious and impressive quarters, and the overall professionalization of the organization. A special committee, appointed to "consider what steps should be taken to extend the usefulness of this corporation," made as its primary recommendation a major expansion in

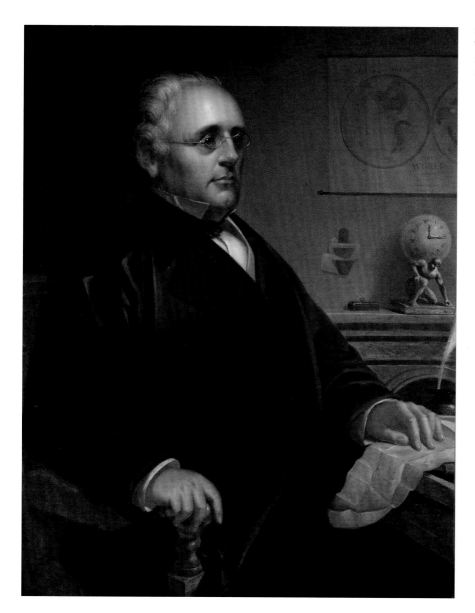

membership, an initiative enabled by the revision of the bylaws to accommodate members with interests beyond the strictly mercantile. The Chamber's efforts in this regard bore fruit, as membership grew to 205 in 1849, to 303 in 1856, and by 1858 had more than doubled to 424—70 percent of whom had joined in the previous eight years. Yet while New York recovered to see Wall Street become by the mid-1850s a legitimate world commercial center, there remained a sense that the Chamber was failing to keep pace. As *The New York Chamber of Commerce, with Suggestions for an Enlarged Sphere of Action*, a pamphlet published in 1857, worriedly noted, "There has been a less degree of activity in our Chamber of Commerce, and less reliance on associated efforts in New York for some years than in many other cities."[19]

Seen in the light of the group's sensitivity to, and efforts toward, revitalizing itself, the calls for the establishment of a collection issuing forth from Chamber officials at the same time appear of a piece with the general self-conscious interest in the invigoration of the organization. And it seems not just coincidence that Secretary Prosper Wetmore, the collection's major early proponent, was at the same time president of the American Art-Union and hence well aware of the power and appeal of art. Having himself located the Chamber's cherished original portraits, it was he who rather hopefully urged that they "should be regarded as the beginning, only, of a gallery of portraits illustrating our history as a commercial people." His plea for a retrospective of business greats was energetically reinforced by Abiel Abbot Low (figure 16), from 1863 to 1867 the group's twenty-first president. Low repeatedly returned to the idea, and in his presidential address of 1865 asked, "And now, is it not right that Commerce should do something in its own honor; to perpetuate its own history; to hand down the portraiture of men who have been distinguished in the walks of business for moral worth and lives of usefulness?" Such concern for the past, as studies of nostalgia have shown, suggests even greater concerns about the present, and it is in this regard noteworthy that Low's collection appeal, made during a time of acknowledged fears of institutional weakness, followed by just a few sentences his lament that "the commercial character of New York has not always found just expression" at the polls, in the press, or in the councils of local, state, and national government.[20]

Wetmore and Low each evidently envisioned something expansive for the Chamber's collection, yet as first constituted during the 1860s and 1870s, its scope was more circumscribed; the initial intent was, according to John Austin Stevens, a later secretary and institutor of the collection, only "to obtain portraits of the Presidents of the Chamber, from its early organization to the present time." In so defining its efforts, the Chamber reflected the prevailing trend in institutional collecting away from the acquisition of images depicting both affiliated and unaffiliated (yet otherwise distinguished) individuals, and toward more orderly and programmatic systems of group representation,

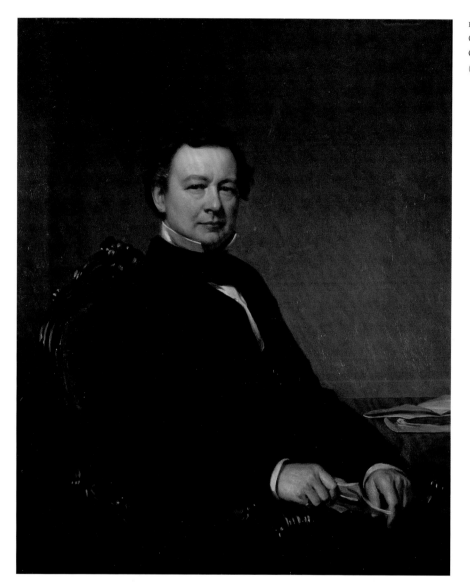

FIGURE 16
George A. Baker, *Abiel Abbot Low*, 1864.
Oil on canvas, 42 × 34 in.
(Credit Suisse, New York)

FIGURE 17
Unidentified artist, *William Denning*,
n.d. Oil on canvas, 36 × 28 in.
(New York State Museum, Albany;
photo Gavin Ashworth)

themselves a consequence of the era's increasing specialization of the professional bourgeoisie and the resulting multiplication of institutions to serve them. In 1866, Low recounted at the Chamber's annual meeting that eleven new portraits had entered the collection: seven portrayed past presidents and another a key member, while three represented men sympathetic to, but not directly associated with, the organization.[21]

The Chamber's determination to focus acquisitions on past presidents presented certain problems: existing images had first to be identified and then either copied or solicited for donation, usually from descendants or surviving family members. As time passed and the collection gained in stability, scope, and stature, the group would become more successful at persuading families to part with their pictures, providing most of its early—and best—portraits (figure 17). In the beginning, it relied heavily on posthumous copies made from "authoritative sources" by a few reliably conservative, establishment artists, notably Thomas Hicks, Daniel Huntington, Thomas Waterman Wood, and Huntington's student Henry Peters Gray (figure 18). Indeed, among the seventeen portraits of pre–Civil War presidents in the Chamber's collection, all but one date from after 1863, and fully eleven were copies by one of these "house" artists. The financing of acquisitions during the collection's infancy was similarly uniform: eight of the eleven portraits described in Low's address were acquired by means of subscription among members, with a group of ten or twenty typically contributing to the cause, the normal procedure until the collection received its own dedicated funding to defray costs.[22]

Once serious collecting began, the Chamber did not wait long to reclaim its portraits from the New-York Historical Society. An illustration from the November 11, 1874, issue of the *Daily Graphic* (figure 19) shows *Colden* and *Hamilton* prominently hanging in its meeting room in the Underwriters' Building on Williams Street, where the group had moved some years before, after outgrowing its quarters in the Merchants' Bank. By that time well on the way to obtaining a complete set of presidential portraits—and perhaps inspired by the return of *Colden* and *Hamilton*, neither of whose subjects were members, let alone presidents—the Chamber changed course and significantly broadened its collecting program during the 1880s to encompass, as the ample *Portrait Gallery of the Chamber of Commerce of the State of New-York: Catalogue and Biographical Sketches*, published in 1890, put it, "men of national and even world-wide reputation; great merchants . . . whose names are inseparable from the history of the Republic; statesmen, whose name is known in every land; financiers, who met a Nation's emergencies with unparalleled skill and success; patriots, whose fidelity to their country was never doubted; philanthropists, who consecrated their wealth to the elevation of their fellow men, and others who originated or were identified with many of the great enterprises of the nineteenth century." This apparently wholesale expansion of the collection's parameters neatly solved the problem of

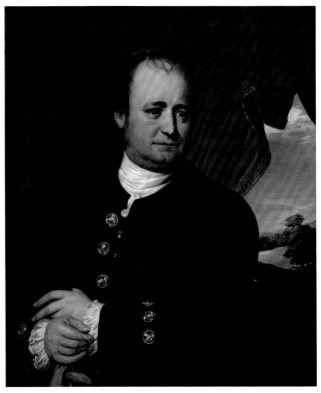

FIGURE 18
Henry Peters Gray (after John Singleton
Copley, ca. 1784), *Henry White*, 1867.
Oil on canvas, 30 × 25 in.
(New York State Museum, Albany)

FIGURE 19
"Chamber of Commerce Meeting Room,
Underwriters' Building, William Street."
Pratt's *Colden* and Trumbull's *Hamilton*
are visible in their distinctive frames
at center left. (From *New York Daily
Graphic*, November 11, 1874)

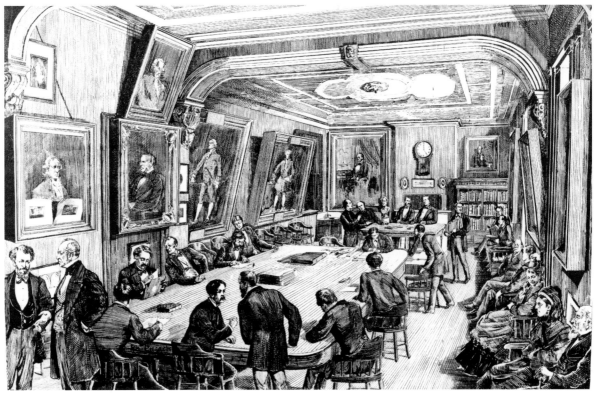

what the Chamber was to do when its popular and successful portrait initiative achieved its initial objective, freeing it up to accept (figure 20), solicit (figure 21), and commission (figure 22) images of eminent individuals not only from outside the Chamber's membership but beyond the realm of commerce itself.[23]

The Power of Portraiture

Orchestrating the growth and management of the collection in its enlarged purview was George Wilson (figure 23), who in an impressive forty-year tenure as secretary of the Chamber (1868–1908) more than met the challenge, issued in the announcement of his predecessor Stevens's retirement, that the latter's "zealous and persistent efforts to obtain . . . portraits . . . be followed with equal success on the part of those who are to come after him." An 1891 *Harper's* illustration (figure 24), showing every available space of the institution's walls lined with paintings, reveals the degree to which the collection had been transformed from its comparatively modest beginnings. While still maintaining aspects of the earlier, programmatic orientation—portraits of presidents and distinguished officers continued to be regularly and systematically acquired—the collection had come to embrace a grander ambition, more in keeping with Wetmore's and Low's calls for a larger gallery to also include esteemed members of the group's rank and file as well as selected nonmember luminaries.[24]

Even before advancing this more elaborate plan, Chamber leaders seem to have grasped the political significance of image and the potential connection of history and portraiture to it. As early as the 1840s, during the crucial period of institutional consolidation preceding the Chamber's rise to genuine power, the ability of the organization's past to fortify its present was noted by newspaper editor and longtime member Charles King. In the conclusion to his history of the group, written with precisely that in mind, King wrote, "In later years the Chamber has been less attractive to the commercial body . . . and as a consequence the influence of the Chamber has declined. . . . My hope and aim in thus reviving the past . . . [is] to revive interest in, and the energy and importance of, the Chamber of Commerce." Significantly, King's statement, itself a reflection of the group's broader mid-century revitalization crusade, was made in the same year—indeed, in the same publication—as Wetmore's initial proposal to build a collection. The Chamber's portraits, as first constituted during the campaign to acquire images of the presidents, and later when portrayals of the membership at large were added, functioned like King's written history to rhetorically bolster the group's status and influence through reference to its past. Moreover, as the accumulated portraits took on their own impressive qualities, the collection itself, as an entity apart from the biographies of its components, commanded respect and, with it, authority.[25]

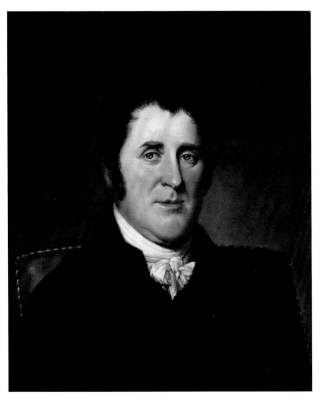

FIGURE 20
Charles Willson Peale, *Daniel Tompkins*,
1819. Oil on canvas, 21 × 17 in.
(Richard H. Jenrette Collection)

FIGURE 21
Unidentified artist, *Kinloch Stuart*, n.d.
Oil on canvas, 36 × 29 in.
(New York State Museum, Albany;
photo Gavin Ashworth)

FIGURE 22
Daniel Huntington, *James Lenox*, 1900.
Oil on canvas, 50 × 40 in.
(Richard H. Jenrette Collection)

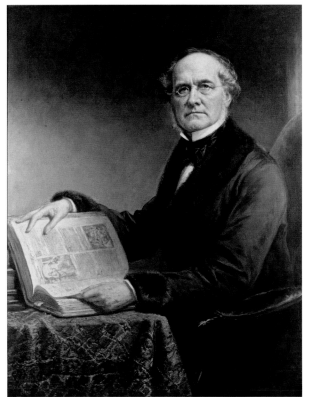

The link between the portrait collection and enhanced institutional appeal and influence—even today a rather subtle conception—can be intuited through the Chamber's actions and increasingly recognized in the growing awareness of that link among its members. Speaking in 1858, a decade after the publication of his institutional history, King, by then president of Columbia University, marked the Chamber's move to the Underwriters' Building in an address that looked beyond the occasion at hand to a time when "intent on fulfilling the just expectations of the present . . . a sufficient building shall be erected . . . in which shall find place . . . a gallery of pictures . . . thus furnishing to Commerce, what it has not, a place where its voice can be heard." Deeds as well as words confirm the group's sense of the promise of portraiture: King's address elsewhere makes reference to George Wilson's appointment as the Chamber's first full-time employee, one of whose primary duties was to "extend the influence of this Chamber." With the enthusiastic support of the membership, Wilson went on to accomplish this through his intense involvement with the collection, an efficacious strategy acknowledged forty years later at his memorial service, where, after noting, "We are especially indebted to him for his efforts in securing the fine collection of portraits which adorn these walls," it was claimed, "No one, officer or member . . . has done more to build up this Chamber than Mr. Wilson." Unsurprisingly, perhaps the clearest expression of the power of portraiture at the Chamber was that of one of its greatest champions and among the group's most beloved leaders, Abiel Abbot Low, who declared in his annual address of 1865, "The influence of the Chamber will be enlarged when it can point to a home of its own. . . . We want, and should have, an edifice wherein our Merchants can meet on public occasions, with a separate hall for the gatherings of this Society, and a gallery

FIGURE 23
Thomas Waterman Wood, *George Wilson*, 1889. Oil on canvas, 30¼ × 25¼ in. (New York State Museum, Albany)

FIGURE 24
"Interior of the Chamber of Commerce." (From *Harper's New Monthly Magazine*, September 1891)

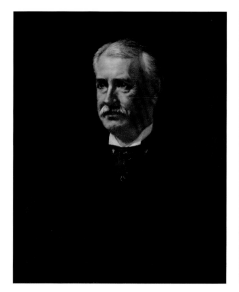

for the exhibition of the portraits of eminent Merchants of our own and other lands." The effect of obtaining these, Low concluded, would be "the reconstruction of the Chamber of Commerce of the State of New-York on a broader foundation than that our forefathers laid." Subsequent leaders took Low's assertion to heart. When the Chamber at last made plans to erect the extravagant building of which he prospectively spoke, a feat that was to be the culmination of its institutional life, the current president, Morris K. Jesup, described it as "a building that will be constructed primarily for these portraits."[26]

The Anatomy of Portrait Rhetoric

If there existed an increasing awareness at the Chamber that it had identified in portraiture a potent vehicle for stimulating interest in the institution internally, among its previously disinterested membership, while rhetorically staking a claim for the group's importance externally, in the commercial, political, and social realms beyond, the actual means by which the collection functioned to that effect remained unexpressed. Understandably, the mechanics of portraiture and collecting as rhetoric, as institutional propaganda, lay outside the group's conscious concern. And yet in assembling, conceptualizing, and promoting the collection in the way they did, Chamber leaders beneficially tapped into received associations about both portraiture and collecting even as their particular use of each worked more specifically to enhance the collection's effectiveness for the group.

The decision to amass a collection in the first place provided the organization with a sense of institutional wherewithal and suggested an air of robust self-confidence at a time when such associations were actively sought. This was especially so with the Chamber's decision to greatly expand the scope of the collection, not only implying the dynamism to do so but also insinuating the group's license to decide who was to be included in the commercial pantheon it was forming. In adopting the mantle of arbiter, the Chamber subtly articulated its own authority while naturalizing the inclusion of its members among the select group. This was a move facilitated by the inherently iconicizing nature of portraiture: representing Chamber members served to elevate their status— and they, in turn, reciprocally enhanced the institution they constituted. The aggrandizing associations of portraiture extended as well to past and present traditions of collecting it, from such antecedents as the royal collections of the Continent, the seventeenth-century galleries of Dutch burghers, and the aristocratic collections of England—with any of which those in the Chamber's orbit may or may not have been familiar—to more local manifestations at universities, medical and law colleges, voluntary clubs and associations, political institutions, museums and athenaeums, and reform, historical, and learned

FIGURE 25
Charles Burton, *Governor's Room, City Hall*, ca. 1830. Watercolor, 2¹¹⁄₁₆ × 3½ in. (Collection of the New-York Historical Society)

societies—with which they certainly were familiar. It could not have escaped notice—and flattering comparison—that just up Broadway from the Chamber's emerging gallery, the portraits at City Hall enshrined municipal and national heroes in grand style (figure 25), or that one of the most esteemed Chamber portraits, of Daniel Tompkins (see figure 20), had originally formed part of Charles Willson Peale's venerable Philadelphia Museum, the remnants of which had since become the nucleus of the collection at Independence Hall (figure 26). With the establishment of collections such as these, American institutions like the Chamber signaled that they, along with select others, had attained sufficient age and significance to present themselves as historical entities on their own terms, in the process conferring prestige and an aura of authority and sanction on their varying enterprises.[27]

In the case of the Chamber, the serial portraits of the presidents played a specific and particularly useful role in bolstering the institution's pedigree. Arrayed along the group's walls for the contemplation of members and visitors alike, they fallaciously but persuasively constructed its past as linear, stable, even dynastic, when in fact it had been punctuated by years-long periods of inactivity and decline. The Chamber was sensitive to its spotty history: in 1866, President Low admitted that it had been "characterized by alternating seasons of activity and indifference." The chain of presidential portraits seemed to

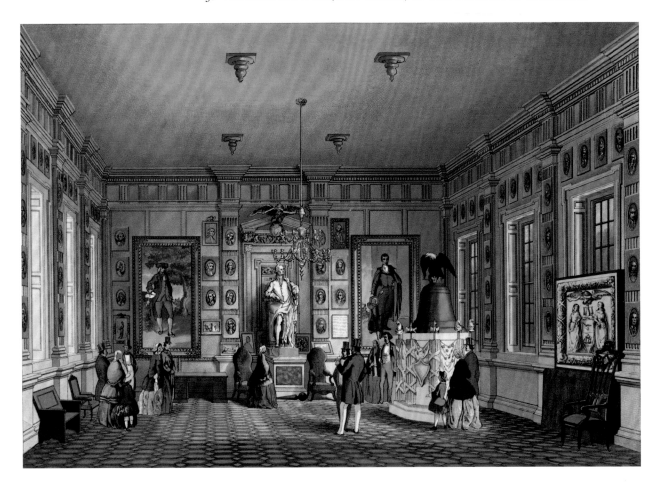

FIGURE 26
Max Rosenthal, *Interior View of
Independence Hall, Philadelphia*, 1856.
Lithograph, 13 × 18½ in.
(The Library Company of Philadelphia)

smooth over Low's indifferent seasons. Oliver Lay's portrayal of Cornelius Ray (figure 27), a posthumous copy made in 1889, shows the Chamber's "president" from 1806 to 1819 looking much like his official peers, even though his leadership was more virtual than real. When he convened the dispersed group—hobbled first by Jefferson's trade embargo in 1807 and then by naval blockade during the War of 1812—on March 4, 1817, "for the purpose of reviving this once eminent and highly useful institution," it had not met in fully a decade. Yet the gilded placard beneath Ray's portrait (figure 28) makes no reference to the interruption, stating simply, "Cornelius Ray, 12th President of the Chamber of Commerce, 1806–1819."[28]

On a larger scale, the presidential portraits together imparted an impression of continuity that the group sought to strengthen by masking the contemporaneity of the collection and deceptively implying its age, as in a speech delivered before the membership in 1881: "The practice of adorning the walls of the Chamber with representations of those who have promoted the objects for which it was founded is as old as the institution itself." The statement was true

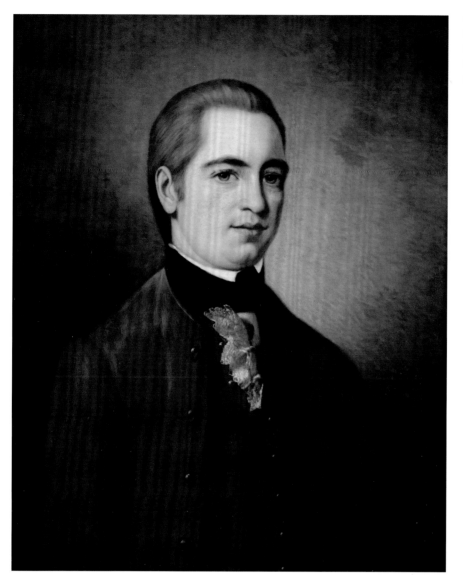

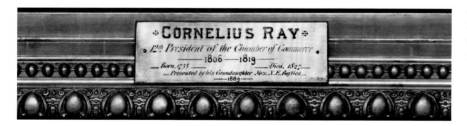

FIGURE 27
Oliver Lay, *Cornelius Ray*, 1889.
Oil on canvas, 29½ × 25 in.
(New York State Museum, Albany;
photo Gavin Ashworth)

FIGURE 28
Frame of *Cornelius Ray*,
detail showing the nameplate.
(Photo Gavin Ashworth)

only in the case of the portrait of Cadwallader Colden, but it was in keeping with the outright fallacy contained in the introduction to a later collection catalogue, which maintained, "the Chamber has functioned continuously for one hundred and fifty-six years." Like the group's charter, which technically sustained its existence during times of inactivity, the portraits of Chamber presidents staked a claim for the institution's seamless perpetuation, even against evidence to the contrary. That it did so through the trustworthy and reassuring image of human dynastic succession only heightened the illusion. Indeed, it was the very materiality of the portraits and the actual lives they represented that allowed the Chamber to convincingly sell its euphemized version of its history.[29]

Notwithstanding—indeed, in part because of—its discontinuous history, the set of presidential portraits provided a means for the organization to visually and materially manifest, and thereby attempt to render clear, its complicated past and, through it, the institution itself. A sort of capitalist echo of such earlier exegetic cataloguing projects as Peale's pictorial litany of generic virtue in his Gallery of Illustrious Personages, the more specific Chamber portraits served a similar impulse to impose order, sequence, and unity on a small corner of an unruly world. In this way, they were like any number of ordering discourses to emerge between 1850 and 1875, as the growing class of urban professional men instituted processes of organization (and later regulation) in the face of sweeping social change, and as grander, all-encompassing explanatory narratives appeared—the Great Exhibition of 1851, Darwin (*The Origin of Species*, 1859) and Marx (*Capital*, 1867), the foundation of encyclopedic museums in Boston (1870) and New York (1870)—to simultaneously contain and elucidate an increasingly complex reality. The Chamber's comparatively modest effort to reify its history through portraiture, thereby defining and giving it shape, represented its contribution to this overarching trend. It actually mattered little that the presidential images were mostly contemporary copies: the appearance of "system and plenitude" served just as well as quality to symbolically complete and explain the institution.[30]

In articulating a genealogy for the Chamber, the portraits also provided a link to the storied past, enabling the organization and its members to bask in the reflected aura of men held in high regard for rectitude and to affirm their association with them and with an era thought nobler than the present. Speaking in 1862, just as the portrait initiative was gathering steam, twentieth Chamber president Pelatiah Perit—himself memorialized two years later in one of its first commissions (figure 29)—expressed an oft-stated reverence for the group's merchant forebears, "men who in that day held a prominence which, at the present time, is not accorded to those of the same position. There was some remnant of aristocracy at that time, which has since become obliterated." Perit's preoccupation with the perceived deterioration in professional esteem betokened a broader nostalgia for the commercial past—a desire soon diminished by businessmen's rising postbellum status—to which the Chamber's

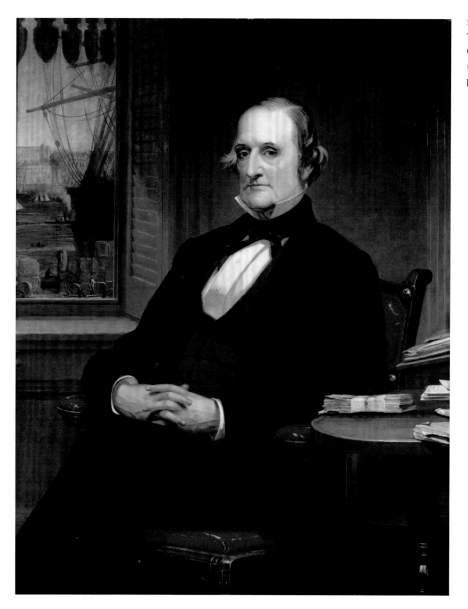

collection of portraits connected its members even as it restored to them a measure of its putative glories.[31]

As the collection expanded during the 1880s beyond the presidents to include officers and respected members, the indistinct and figurative notion of joining up with the past through the portraits became in some instances literal and specific, as family dynasties such as the Astors, the Lows, the Vanderbilts, and later the Rockefellers grew to populate the Chamber's walls in sets of two, three, and more related images, giving material form to the preponderant family capitalism of the collection's early years. "Generations of Portraits," an item published in the *New York Times* in early 1897, picked up on the theme, detailing "How Members of the Chamber of Commerce Can Trace Their Ancestry." A less direct but more pervasive and powerful associationalism was effected when the Chamber shifted gears and began adding portraits of distinguished outsiders whose actual affiliation with the group, merely honorary or completely nonexistent, was nevertheless implied by their presence, allowing it to leverage a portion of their power, reputation, and influence. Whereas the collection as initially constituted had legitimated and empowered the institution by establishing and celebrating its own lineage, the inclusion of judges, inventors, military heroes (figure 30), and foreign dignitaries, as well as mayors (figure 31), governors (figure 32), congressmen, cabinet secretaries, and even presidents (figure 33), opened up a whole new realm of possibility in pictorial rhetoric. That the portraits of men like Washington, Hamilton, and Lincoln were hung on the walls alongside members with names such as Vanderbilt, Carnegie, and Morgan subtly endorsed the latter's worldly pursuits and methods, placing them and their capitalist ideology on literally the same plane as the most revered Americans and insinuating their affinity and sanction. Moreover, in incorporating a selection of individuals bound together only by regard and renown, the Chamber stepped outside the normative boundaries of institutional portraiture, increasingly limited to images closely related to a given concern, and instead situated itself in the more elevated company of broad-based collections like the one at City Hall, which evolved under the Common Council a policy of "securing the portraits of distinguished men, not officially connected with the State or City, but who by conspicuous public service had won the admiration of its inhabitants"—an aggrandizing move by the Chamber that was in itself rhetorical.[32]

With the publication in 1890 of its first comprehensive catalogue (figure 34), the collection was firmly established as a—even *the*—major element in the Chamber's identity. Extending the group's substantial investment in portraiture, *Portrait Gallery of the Chamber of Commerce* contained specially commissioned hagiographical sketches of the collection's eighty-two subjects, printed on thick stock on three hundred gilt-edged pages by the "Press of the Chamber of Commerce" and bound in an embossed cover, altogether weighing several pounds. As such, it supplied a written, and mutually reinforcing, analogue to the portraits'

visual declamation. Its format drew on the tradition of prototypes like James Longacre and James Herring's estimable *National Portrait Gallery of Distinguished Americans* (published, at first serially, beginning in 1833), with the Chamber's catalogue referring to the actual portraits instead of the usual engraved reproductions. That the *Portrait Gallery of the Chamber of Commerce*—to say nothing of the collection it documented—could come to such elaborate fruition, mirroring earlier publications' mingling of various types of notables while maintaining a distinct focus on its own mercantile membership, is revealing of the era's increasingly broad acceptance of capitalistic, business-oriented conceptions of virtue and success.[33]

The century's steady erosion of republicanism in favor of liberal capitalism, and with it a thoroughgoing transformation in the conception of ideal masculinity, had produced an inversion of the previous orientation around public-mindedness to one celebrating individualism, creating an environment in which mercantile elites could be valorized for their economic achievement. No longer revered for adherence to the allegedly disinterested values of the "public man," members of the Chamber and beyond were now esteemed for the materialistic self-interest implicit in commercial accomplishment. Against the charge of heedless pursuit of personal gain leveled against businessmen by an array of writers and intellectuals, apologists advanced a sort of trickle-down defense, insisting that individual gain led in a roundabout way to the greater good, because of the sound character it supposedly required and instilled. To qualify for veneration, now it was enough, as the preface to the Chamber's catalogue put it, to "show those types of enterprise and judgment which have raised the character of the New-York merchant to its high standard"—a development which suggests that the portraits, as part of the larger battery of business propaganda, were doing their job well. With the new paradigm providing the conceptual space for the portraits to perform their cultural work, and as if aware of the political asset that the collection had become, in a bequest of 1894 President Low, long one of its most ardent proponents, established a substantial fund for the portraits' care and increase, ensuring the continuation of the collection after his own demise.[34]

History as Biography

As the impressive biographical project of the *Portrait Gallery of the Chamber of Commerce* suggests, through the end of the nineteenth century the Chamber constructed itself and its history more through men than deeds or events. Such a concept was natural for an organization that prided itself on the character and quality of its members, and the portraits reinforced this orientation perfectly. In doing so, they reflected a persistent means of both comprehending the past

FIGURE 30

Daniel Huntington, *Ulysses S. Grant*,
1890. Oil on canvas, 30 × 25 in.
(Credit Suisse, New York)

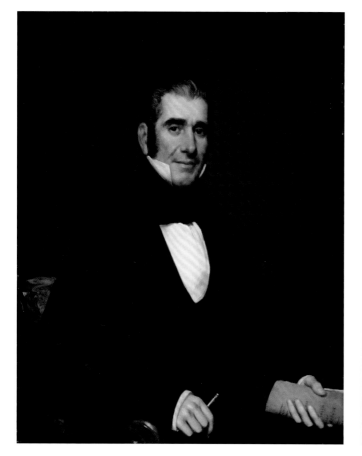

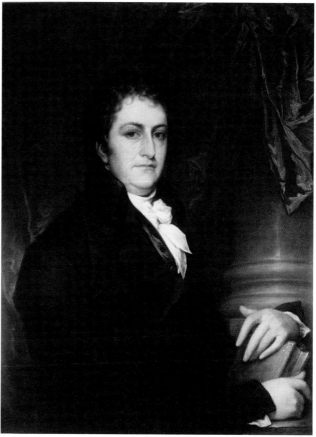

and constituting its institutions, one that crested in America at mid-century in what the *Yale Literary Magazine* referred to as a "rage for biography." This "biographical mania" was an international phenomenon of particular strength and longevity in England, where it helped produce the National Portrait Gallery in 1856 and was given influential expression by Thomas Carlyle in his lecture "The Hero as Divinity" (1840): "Universal history, the history of what man has accomplished in this world, is at bottom the History of the Great Men, those great ones; the modellers, patterns, and in a wide sense creators, of whatsoever the general mass of men has contrived to do or to attain." At the Chamber, the construction of history as biography dovetailed with the growing cultural approbation of businessmen to help produce its own portrait gallery, which in turn provided a powerful vehicle to rhetorically assert and confirm commerce's rising status.[35]

The imbrication of history, biography, and portraiture had its roots in the mid-eighteenth century, when James Granger's *Biographical History of England* (1769) combined the three, establishing an epistemology in which biography

FIGURE 31
Samuel Lovett Waldo and William Jewett, *Gideon Lee*, 1833.
Oil on panel, 36 × 28 in.
(New York State Museum, Albany)

FIGURE 32
John Trumbull, *DeWitt Clinton*, 1807.
Oil on canvas, 30 × 25 in.
(U.S. State Department, Washington, D.C.)

FIGURE 34

Title page of George Wilson, ed., *Portrait Gallery of the Chamber of Commerce of the State of New-York: Catalogue and Biographical Sketches* (New York: Press of the Chamber of Commerce, 1890)

PORTRAIT GALLERY

OF THE

CHAMBER OF COMMERCE

OF THE

STATE OF NEW-YORK.

CATALOGUE AND BIOGRAPHICAL SKETCHES.

COMPILED BY

GEORGE WILSON, SECRETARY.

NEW-YORK:

PRESS OF THE CHAMBER OF COMMERCE.

1890.

and its visual correlative, portraiture, could be systematized into a coherent national history, and more generally into a discourse through which the past could be ordered to make sense of the present. Such a system, it was felt, and as Carlyle later claimed, would provide a view into "the very marrow of the world's history" through the lives—and countenances—of those deemed to have effected it. The appearance in this country of Longacre and Herring's *National Portrait Gallery of Distinguished Americans* along with numerous successors like William H. Brown's *Portrait Gallery of Distinguished American Citizens* (1845) and Charles Lester Edwards's *Gallery of Illustrious Americans* (1850) indicates the appeal in the United States of similarly structuring the past through the complementary genres of portraiture and biography, just as publications like John Frost's *Lives of American Merchants, Eminent for Integrity, Enterprise, and Public Spirit* (1844) suggest the new willingness of Americans to view businessmen in those terms.[36]

Appearing nearly half a century later, the Chamber's catalogue, like the collection it represented, comprised the group's contribution to this phenomenon as it evolved to serve increasingly self-referential, rhetorical ends. For although modeled after comparatively disinterested productions like those just noted and later analogues such as Oscar Houghton and George Mifflin's multivolume series "American Statesmen" and "American Men of Letters," both from the 1880s, *Portrait Gallery of the Chamber of Commerce* differed in being produced by the very organization whose subjects it celebrated, making it more an artifact of propaganda than of history. By presenting itself in the guise of objective projects in historical biography, the Chamber insinuated its own stature under the same mantle of impartiality. Hence both catalogue and collection not only served to construct the institution's past in a persuasively tangible way but also enabled the group to constitute itself, through its members, as an effectual, historically significant entity. Such an important political function helps to explain the catalogue's disavowal of a concern for quality: "The purpose of this collection has not been so much to gather fine specimens of the art of portraiture in painting or sculpture, although many of the works were executed by some of the most eminent artists of their time, but to preserve the lineaments of those men who have illustrated the commerce of New-York." While the aesthetic quality of the portraits would later come very much to the fore at the Chamber, during this phase in the collection's evolving use, quality was not the point. In a world where the commercial history of New York—then, as now, viewed as a critical component in the development of the metropolis— could seem to be adequately accounted for through the "lineaments of those men who have illustrated" it, rather than by larger, more impersonal forces, the collection had more important things to do. It made the case that the individuals it represented and the institution they embodied were key factors in the construction of that history.[37]

The Reputation of Business(men)

In order for the "history as biography" formulation to be effective, business and businessmen in general, and not just the luminaries of the Chamber, had to be regarded as worthy potential bearers of major social and historical change. Much of the groundwork for this esteem was already in place by the time the collection entered its heyday, abetted by broader transformations in ideals of success, manhood, and citizenship. The wide acceptance of the self-made, rags-to-riches paradigm of personal achievement perfectly expresses the shift toward a more worldly, business-friendly model of virtue. But a cultural disposition toward such individualistic, materialistic archetypes did not necessarily translate into steady or universal approbation of their adherents. Indeed, sorting out the reputation of businessmen during the postbellum era is a vexed undertaking, characterized by rapid fluctuations over brief periods and complicated by the divergent perceptions of varying subject positions, the breadth of the profession itself, and the simple fact that commerce and therefore businessmen lay at the heart of most of the sweeping changes, good and ill, transfiguring the nation by the end of the nineteenth century.[38]

For decades, the major determinant of business's image had been the overall health of the country's economy, regional and industry-specific variations notwithstanding. Throughout the postbellum era, however, and despite substantial aggregate economic growth, the nation's fortunes seesawed rapidly, obscuring a clear sense of direction and confounding modern assumptions about the "Gilded Age." Far from the consistently prosperous time it is commonly portrayed to have been, the period was in temporal terms typified more by recession and outright depression than by expansion (fourteen of the twenty-five years between 1873 and 1897 were characterized by contraction, not growth). Also buffeting the reputation of business and its practitioners were topical issues and events, such as the highly publicized clashes between labor and capital—the Great Railroad Strike of 1877, the Haymarket bombing of 1886, and the Homestead strike of 1892 chief among them. Moreover, the nature and practices of the handful of highly prominent businessmen whose activities set the tone for the profession's broad standing—men like Daniel Drew, Jim Fisk, and Jay Gould, and later George F. Baker, Jacob Schiff, and above all J. Pierpont Morgan—also changed over time, and changed radically. The swashbuckling and unprincipled, if engagingly colorful, habits of the earlier generation were supplanted by the quiet order and statesmanlike authority of the all-powerful "morganizers." This new breed of tycoon conformed more closely to the Chamber's standard. While Drew, Fisk, and Gould were not welcomed as members, Baker, Schiff, and Morgan served the institution as vice presidents, possessing as they did the sober aura of respectability that the group sought to project, not least through its portraits (figure 35).[39]

In addition, different types of business pursuits fared differently in the calculus of reputation: speculators—of whom Drew, Fisk, and Gould were particularly notorious examples—were reviled for their predatory ways, destabilizing influence, and perceived separation of wealth from work, anathema to the prevailing Protestant moral code. Wealth was fine, and deserved if acquired by dint of honest toil, but it was ideally meant to be regarded as incidental to other, character-based satisfactions of success, and not entirely as an end in itself. Respectable riches, it was thought at the Chamber and beyond, were amassed through the production of actual goods and services, a view that held sway into the last years of the nineteenth century, when rising corporatization and the spread of finance capitalism turned "speculators" into "investors" and "financiers," endowing them with new reputability. Although the Chamber kept the early, more freewheeling sort of speculators out, their notoriety tarnished the entire business community and provided those inclined to criticize it with ample ammunition against the profession at large.[40]

As this suggests, the ideological vantage point of critics factored heavily into the equation. Then, as now, subject position played a determinative role in business's estimation. While the general hostility of labor and agrarian interests, and the agitation of populist political movements like the Greenback Party and later the People's Party was to be expected, a less predictable but more lasting critique came from America's literary world. Foreshadowed in Melville, Whitman, and Twain before beginning in earnest with William Dean Howells's *The Rise of Silas Lapham* (1885), the withering account to which writers subjected the business profession continued for decades, though its emphasis and point of reference changed as the nature of commerce evolved. The negative literary treatments of business and businessmen was a manifestation of a broader anti-materialist strain in American letters that obscures the actually more balanced and diversified popular reputation of businessmen at the close of the nineteenth century—as any representative sampling of documentary sources would suggest. In fact, business and attitudes toward it were controversial and contested, by their very scope and scale difficult to categorize in a period where they resided so close to the major upheavals—urbanization, industrialization, immigration—animating the nation.[41]

Still, the broad outlines can be adumbrated, and despite the elements disposed against them, the reputation of businessmen, responding to the more powerful cultural transitions in models of American selfhood then afoot, was on the rise as the Chamber's collection came into its own. The portraits effectively contributed to the trend, embodying the positive attributes of the profession's social identity and aspirations—sobriety, sagacity, industry, probity—and thereby both stabilizing and bolstering the image of members and their occupation. The collection served as an apology for and a confirmation of businessmen's reputational rise, rhetorically advancing the prevailing tendency while consolidating its gains.[42]

Social Climbing

However great the collection's part in sanctioning and elevating Chamber members' commercial pursuits, occupation alone did not determine their status. It was but one ingredient in the complex recipe for reputation, which included ethnicity, pedigree, wealth, education, marriage, and general cultivation. In this, as in so many other ways, postbellum New York was in a state of transition, as received methods of deciding rank and station were strained by the need to accommodate the city's enlarged and rapidly transforming social landscape, one placed in motion in great part by the economic changes wrought by Chamber members and their peers.

Through the middle of the century, the upper echelons of metropolitan society had been occupied by a Knickerbocker-maritime-mercantile enclave, an amalgam of vestigial colonial and landed aristocracy, old-line shipping interests, and more recent upstate- and New England–born merchants. With the introduction of bigger wholesale-retail economies and new manufacturing-industrial wealth, abetted by wartime exigencies, the old elites were challenged as, at least economically, their position was eroded by a newer, larger order, which soon grew to include finance and insurance, two additional spheres of capital accumulation. Whereas existing elites in other American cities had made a largely successful transition from trade to manufacturing—from the old to the new economy—thereby maintaining their social hegemony, in New York the shift in economic focus occasioned a corresponding transformation in the social fabric, creating a new privileged class.[43]

The newly rich sought social legitimation through acceptance into the world of the very patriciate at whose expense their success in the emerging arenas of economic power had often come. Not surprisingly, they frequently found the doors to that world closed, as the embattled old guard clung to what social authority it retained through the zealous privileging of the one thing that distinguished its wealth from that of the arrivistes—its age. A related rearguard action involved the patriciate's attempt to draw an invidious distinction between the supposedly genteel source of its own wealth—land and mercantile exchange—and the comparatively proletarian pursuits of manufacturers, who were judged tainted by their association with labor. For the parvenus of industry, membership in the august Chamber of Commerce, where they could mingle on equal footing with constituents of the old order—and be represented alongside them in the elevating and historicizing guise of portraiture—helped bridge the divide. Just as the depictions of presidents and military heroes hanging together with those of businessmen afforded one type of purposeful association, the confluence on the Chamber's walls of representatives of old money with new—of a Bayard with an Astor, an Astor with a Vanderbilt, a Vanderbilt with a Rockefeller, and so on—furnished another, equally meaningful correlation.[44]

Eventually, the new moneyed interests prevailed, as emergent corporate forms of organization increasingly drew members of both camps into common territory, and as a pragmatic patriciate generally saw the wisdom and inevitability of combining forces to form a single, more powerful elite, which coalesced in the postbellum years into a diverse but stable and enormously influential bourgeoisie. Art and art collecting played a significant part in the acculturation and acceptance of New York's rising class of newly wealthy businessmen—and not just at the Chamber. In contrast to the rigidly circumscribed social climate of Philadelphia and Boston, where patronage was an activity largely reserved for an ingrained aristocracy, a relative openness prevailed in New York, where aspiring individuals could hope to facilitate their reception into select society by virtue of conspicuous collecting. Over the course of the nineteenth century, the Chamber could count among its members many, perhaps most, of New York's major collectors, including Philip Hone (figure 36), Gideon Lee, and Luman Reed in the 1820s and 1830s; James Lenox, Jonathan Sturges (figure 37), and Charles Leupp at mid-century; Peter Cooper, Marshall O. Roberts (figure 38), A. T. Stewart, and Robert L. Stuart in the postbellum years; and Cornelius Vanderbilt II (figure 39) and J. Pierpont Morgan at the century's end. Significantly, with the exception of Lenox, Stuart, Vanderbilt, and Morgan, these were all self-made men. Gideon Lee, for example, began as a tanner, a distinctly unsavory trade centered

FIGURE 36
Rembrandt Peale, *Philip Hone*, 1827. Oil on canvas, 30 × 25 in. (Collection of the New-York Historical Society)

FIGURE 37
Daniel Huntington, *Jonathan Sturges*, 1889. Oil on canvas, 38 × 32 in. (New York State Museum, Albany; photo Gavin Ashworth)

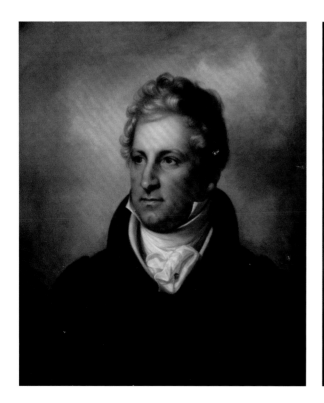

FIGURE 38
Thomas Hicks, *Marshall O. Roberts*, 1872.
Oil on canvas, 76 × 50 in.
(New York State Museum, Albany)

FIGURE 39
Daniel Huntington, *Cornelius
Vanderbilt II*, 1900. Oil on canvas,
50 × 40 in. (Credit Suisse, New York)

FIGURE 40
Herman von Herkomer,
Joseph H. Choate, 1904.
Oil on canvas, 56¼ × 46¼ in.
(New York State Museum, Albany;
photo Gavin Ashworth)

in the city's swampy, lowbrow Five Points, and rose to become a major leather merchant and even the mayor of New York before leaving his business to his son-in-law, Charles Leupp, another poor boy made good "by his own industry," in the common phraseology. Both collected extensively, and both were represented in the Chamber's collection—as, remarkably, were every one of the other self-made businessmen just named, indicating how art in general, and portraiture in particular, served a socially uplifting role. The perceptible link between art collecting and the social legitimation of these individual men further suggests a similar role for the Chamber's overall collecting project, which sought a broader legitimation—of an entire profession—through the representation of its successful members.[45]

Underlying the conspicuous collecting by the Chamber and its members lay a pervasive desire among the rich to sacralize gains won in the profane marketplace through the ennobling properties of art. However much business interests worked to dispel the baser connotations of commerce, business remained an ineluctably worldly pursuit, and collecting art was an effectual means of dignifying its gains and elevating the patron in the process. Renowned society toastmaster Joseph H. Choate, later an honorary member and vice president of the Chamber (figure 40), referred to this capacity when he appealed to a gathering of business leaders for their patronage at the opening of the Metropolitan Museum of Art's new building in 1880:

> Think of it, ye millionaires of many markets—what glory may be yours, if you only listen to our advice, to convert pork into porcelain, grain and produce into priceless pottery, the rude ores of commerce into sculptured marble, and railroad shares and mining stocks—things which perish without the using, and which in the next financial panic shall surely shrivel like parched scrolls—into the glorified canvas of the world's masters, that shall adorn these walls for centuries.

Such a function for art and collecting helps explain the Chamber's growing allocation of resources to its portraits, which assisted in the sanitization and exaltation of businessmen in a wonderfully direct way—by constituting a collection that consisted precisely of themselves.[46]

Prescriptive Portraits

Despite the trend toward individualism in paradigms of success and social conduct attending—indeed, accommodating and enabling—the rise of the Chamber's project in professional and institutional rhetoric, in mid-nineteenth-century New York, when calls for the collection began, and in subsequent years,

while it flourished, there remained sufficient vestiges of the old republican ideal of altruism and effort toward the common good that a portrait collection of prosperous businessmen could seem something other than solely an exercise in self-promotion. Indeed, the collection took on another dimension as references to the portraits espoused their ability to favorably influence current and succeeding generations through the example of the Chamber's heroes. Such a high-minded concept was somewhat undermined by a Gilded Age business culture predominantly given over to materialism and self-celebration, but somehow the Chamber, and the fittingly understated portraits with which it continued to augment its collection, managed to maintain an aura of being above the fray.

Throughout its existence, the institution effectively promoted a vision of itself and business in general as uncomplicatedly positive—benign, beneficial, principled, moral. The stern-faced portraits of revered, upright (literally and figuratively) men reinforced this image and offered emulatory models in an era when perceiving "the mind's construction in the face" was still commonly thought possible. The *Portrait Gallery of the Chamber of Commerce* presents numerous examples of how the path to sound character and right living could be found by studying the lives—and countenances—of the men highlighted within it. Of Gideon Lee (see figure 31), it said that he "was one of the finest types of this [self-made man] class, and every step in his useful and honorable career may be studied with advantage by the young men of later generations who are to compete for the prizes of thrift and industry." Later follows a reference to visuality: "In person, Lee was a man of commanding appearance. There was a blending of amiability with firmness in his countenance which gave it a peculiar fascination. Strangers when they met him were very apt to look at him intently as if impressed with his striking personality." Exemplary character, reflected in exemplary appearance, was thus advanced as a means of inspiration and instruction.[47]

The didactic function of the portraits allowed the institution to promote its ideas of how business should be not only perceived but conducted. The use of portraiture as a tool for inducing correct behavior, originally a product of Enlightenment thinking, was given a boost in the mid-nineteenth century by Thomas Carlyle. His famous lecture series, "On Heroes, Hero-Worship, and the Heroic in History," delivered in 1840 in London and printed in the United States six years later—precisely as the Chamber's collection was first being proposed—relied heavily on the visual. Carlyle considered himself a "physiognomic reader" and believed that, as the face is the index of the mind, heroism and other traits of character imprint themselves on it, offering unique access to the heroic or otherwise emulable constitution. In his own historical investigations, Carlyle claimed that he found "a Portrait superior in real instruction to half-a-dozen written Biographies." Such an understanding, combined with a long-held belief in portraiture's ability to inspire through example, produced a highly effective discourse for the inculcation of desired behavior and pro-

vided a potent rationale for the creation and display of portrait collections. The genre's didactic potential was central to Carlyle's 1853 plan for England's National Portrait Gallery, an idea first put forward in 1845 (again, just as a collection for the Chamber was initially called for) and ardently supported by Lord Palmerston, who argued in Parliament: "There cannot, I feel convinced, be a greater incentive to mental exertion, to noble actions, to good conduct on the part of the living, than for them to see before them the features of those who have done things which are worthy of our admiration, and whose example we are more induced to imitate when they are brought before us in the visible and tangible shape of portraits."[48]

In America, Charles Willson Peale's Gallery of Illustrious Personages had for decades performed a similar service, one adopted by civic authorities in 1855 when the city of Philadelphia purchased much of the collection. Although the Chamber's portraits were available for contemplation only to those who knew where to find them, by century's end the institution had achieved such prominence that the collection was widely known, by reputation if not through direct experience. Besides, its target audience—those for whom the portraits "have left to us and those who follow us an incentive to carry out the activities they inaugurated," as one Chamber president put it—were the city's most powerful men and, in the lingering tradition of family capitalism, their sons. For the collection's promoters, it was enough to inspire right behavior among its own, especially as their number came to include those who more or less ran the city, and much of the country as well. When one Chamber president, Charles S. Smith, said to his successor, Alexander E. Orr, as he moved the adoption of a resolution against police corruption in February 1895, "Mr. President, the portraits of the men who founded the commercial supremacy of this City and State look down upon us from these walls, and if those pictured lips could speak, I am sure we would hear nothing but words of approbation and commendation for the spirit which I hope will be exhibited in this meeting to-day," his words reflected the collection's hortatory job of ensuring that the sons of business would act in accordance with the tried-and-true methods of the fathers.[49]

The Chamber's Chamber

On November 11, 1902, with the dedication, by none other than President Theodore Roosevelt, of the Chamber's lavish new Liberty Street headquarters (figure 41), the group at last acquired accommodations commensurate with its status at the pinnacle of power and influence among New York institutions. In the presence of a stellar cast of American and foreign dignitaries, Chamber members celebrated the completion of their impressive French Renaissance monument to themselves, constructed at substantial cost almost entirely of

Vermont marble, with the likes of J. Pierpont Morgan, John D. Rockefeller, Cornelius Vanderbilt, and Andrew Carnegie (all current or recent vice presidents of the group) among the building fund's chief subscribers. Prodigious on-site speechifying followed by a sumptuous banquet at the Waldorf-Astoria marked the occasion, at which encomiums to the members and to business in general often referred to the Chamber's achievements in the same terms of patriotic beneficence that had characterized the official biographies in the *Portrait Gallery of the Chamber of Commerce*. Former president Grover Cleveland culminated his oratory by asserting that "no architectural finish and no ornate decoration befits this beautiful edifice so well as . . . the splendid achievements proudly borne by those who now enter upon its occupancy."[50]

With the possible exception of the portraits. For located at the spatial and ceremonial center of the new building was its Great Hall (figures 42 and 43), the Chamber's chamber, 60 feet by 90 feet, by 30 feet high, not only purpose-built to accommodate the literal body of the group during monthly meetings, but conceived more particularly to house its symbolic body, represented by the now approximately 150 portraits of members past and present, most of them destined for the room's walls. Ranged in tiers on burgundy damask above Honduran mahogany wainscot and carved, leather-upholstered seats and below a gilded, skylit ceiling with inset painted cloud panels, cartouches, and horns of plenty, the portraits as majestically installed in the Great Hall constituted the fullest expression of the collection's rhetorical ends. Surely here was the apotheosis of the American businessman, his pantheon. Aiding and abetting the institution's rise to become, during the last quarter of the nineteenth century and into the twentieth, one of the nation's most powerful organizations, the collection had also served, more diffusely but as significantly, to encourage and naturalize the acceptance of business and its practitioners at a crucial period in their historical development, helping draw them more securely into the fold of bourgeois approval, appreciation, and even admiration. In the half-century since it was called into active existence, the collection had moved beyond its totemic heritage to assume, with the Chamber, a truly formidable presence in the professional, social, and cultural landscape of Gilded Age New York.[51]

Even as the Chamber was finalizing plans for its architectural paean to the giants of Wall Street, on the opposite end of town, across the Harlem River in the Bronx, construction was nearing completion on Stanford White's Hall of Fame for Great Americans (figure 44), a monumental outdoor colonnade punctuated by bronze busts of national icons, which formed a central part of the architect's Beaux-Arts satellite-campus complex for New York University (now occupied by Bronx Community College). Airy and, at 630 feet, impressively elongated, the serpentine exterior "hall" offered a stark contrast to the Chamber's Great Hall in all but purpose, in which sense they were much alike: each was intended to make an ideological, even didactic, argument for the virtue and

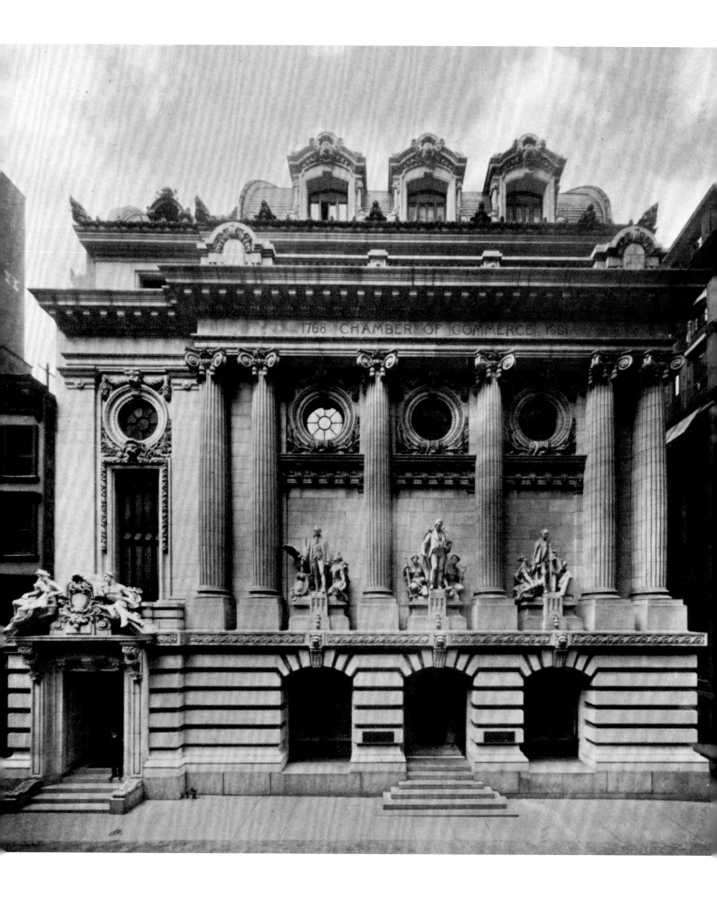

1768 · CHAMBER OF COMMERCE · 1881

FIGURE 42
Great Hall, New York Chamber
of Commerce Building, ca. 1968.
(New York Chamber of Commerce
Archives, Columbia University
Rare Book and Manuscript Library)

FIGURE 43
Great Hall, New York Chamber
of Commerce Building, looking
northeast. (Photo Wurts Brothers
Company; from *Architectural
Record*, January 1903)

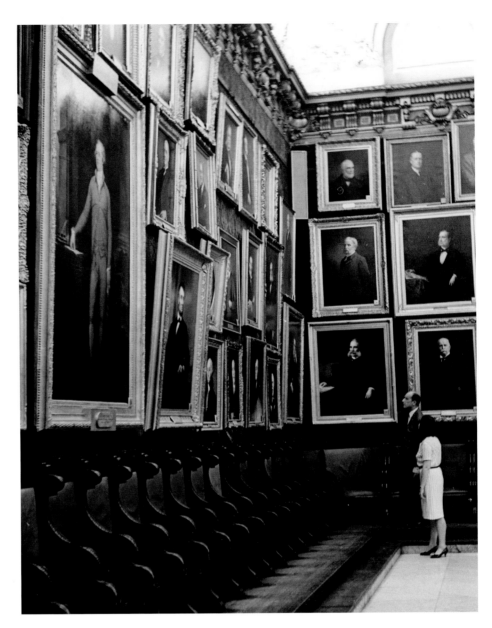

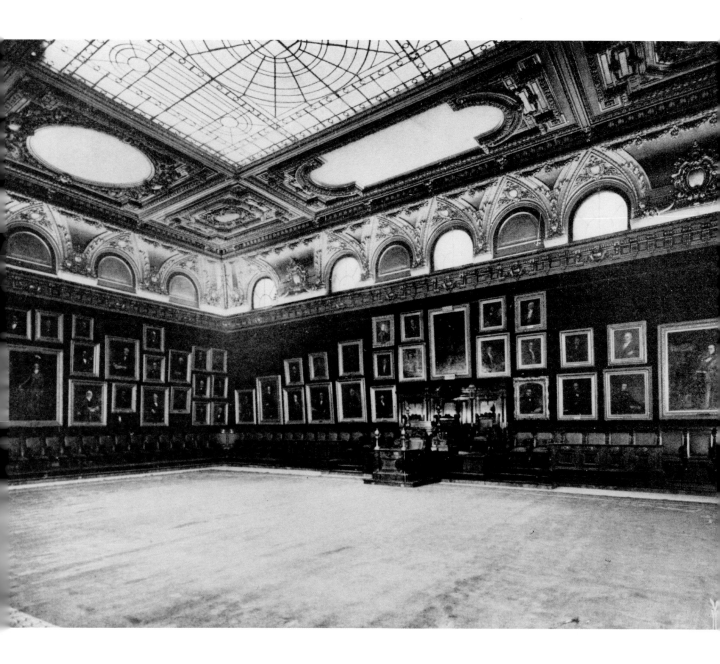

significance of those populating it—men of business in the Chamber's case, individuals of national renown in the university's appropriately more encompassing program. But whereas the Bronx Hall of Fame announced its project overtly, by name, the Chamber achieved its political ends more indirectly, by insinuation. The openly hagiographic orientation of White's colonnade, and the development of the two at the same time—probably by some of the same civic leaders—sheds revealing light on what the Chamber was really up to with its collection on Liberty Street, just as the inclusion in the Bronx of one of the group's own businessmen, Peter Cooper (others were to come later), among that hall's original twenty-nine Civil War heroes, founding fathers, and other impeccably distinguished citizens, suggests how well they were succeeding.[52]

Corporatized (1880–1910)

In August 1902, a few months before the installation of the portraits en masse in the Chamber's new Great Hall gallery, an affecting item appeared in "The Point of View" column of *Scribner's Magazine*. Some Chamber members may even have read it; many must have subscribed to this highbrow publication, perhaps the leading magazine of the day, and for them the column's section "The Passing of the Individual" may have held a particular interest. It relates the story of the columnist's anonymous "friend," an older, successful gentleman

who fears the effect of the era's rampant corporatization on his future: "'I suppose,' he says grimly, 'that it will be fairly well with me if I die soon enough.'" The columnist continues,

> From his point of view, he is one of a multitude of victims of the "modern tendency." He holds that the combinations of capital and of enterprise on a large scale have impaired and threaten to destroy the importance of the individual. . . . The trail of organization is over all. Men are becoming, not mere machines, but minute parts of mere machines. . . . From all this my friend predicts the slow deterioration and final decay of that free and varied intellectual energy the exercise of which is a delight in itself, and the love of which in the past made the professions what they were, and are no longer.[53]

Editorializing through the distancing device of a nameless friend, the *Scribner's* columnist expressed a potent turn-of-the-century fear among the urban bourgeois, one evidently impolitic to address openly in the pages of an establishment publication, lest one appear to be grousing at the expense of progress and efficiency. Far preferable were upbeat assessments of the corporate phenomenon, those emphasizing its positive effects and historical inevitability, especially when delivered by masters of the game, as here with complete certainty by Standard Oil founder and Chamber stalwart John D. Rockefeller: "This movement was the origin of the whole system of modern economic administration. It has revolutionized the way of doing business all over the world. The time was ripe for it. It had to come. . . . The day of combination is here to stay. Individualism has gone, never to return."[54]

Corporatization, with its acknowledged diminution of the distinctive autonomy by which Americans were so defined—the very word "individualism" had been coined by Alexis de Tocqueville in *Democracy in America* (1835) to describe the nation's novel social philosophy—was an unsettling trend for a citizenry convinced of the virtues of independent action. What to think of corporatization and how to deal with it was a fraught issue, particularly within the professional class that felt its effects most directly. Some resisted, like Chamber member George W. Perkins, who resigned the vice presidency of New York Life and a partnership with the House of Morgan to devote himself to describing the conflict in men "nurtured on the precepts of self dependence and self help only to become ensnared . . . in the bureaucratic processes of conference, consultation, and compromise." Others, such as Wall Street attorney James B. Dill, were more sanguine. Addressing the undergraduates at Williams College, with a peculiar logic that must have given some in the audience pause, Dill claimed, "Individualism is not dead. On the contrary, individualism is still more strongly called for in the development of combinations. The corporation problem of today calls for

a development of character, of education, and of brains, which no other phase of social evolution has demanded. In the great corporate combinations of today, individualism of character, individualism of brains and training, individualism of mind, are at a premium, and constantly demanded."[55]

Whatever the fate of individualism, no one contested that beginning in earnest around 1880, and with increasing and then astonishing rapidity, the structure of American business radically changed. Industrialization generated an insatiable demand for capital and replaced an economy based on proprietary merchants in control of modestly scaled networks of exchange, distribution, and credit with one dominated by much larger corporate manufacturing and transportation concerns and the investment banks established to meet their fiscal needs. Unlike the preexisting orientation toward family- and individually held firms or simple partnerships, corporate organization diluted ownership, encouraging larger-scale undertakings and limiting an individual's liability to the amount invested in a given enterprise. A corporate economy was far more appealing to investors, even as it made available through the expedient of equity financing potentially limitless capital with which to grow. Moreover, the enhanced management professionalism it brought promised to steady perilously volatile markets and the gouging competition within them. In the fullest sense, corporatization transformed American business, and in so doing transformed the economy and much of American society itself. Over time, it was both to remake the Chamber of Commerce and, ultimately, to play a major role in its unmaking—transformations at once encouraged and reflected by its collection of portraits, which as individual portrayals of businessmen collectively conceived and displayed lay at the heart of the contest between individual and collective identity at stake in the conversion to corporate structure, a shift particularly relevant within the organization whose members had played a central role in enacting it.[56]

The official rationale for the new corporate paradigm, rooted in the prevailing pragmatism of the period, was to exchange the unbridled competition of laissez-faire economics for a system of organization in which incorporation, consolidation, and centralization would in some degree replace antagonistic business rivalry, supplanting an entrepreneurial model prone to individualistic caprice with a pluralized corporate one held to be more reasoned and utilitarian. Not all agreed that the change was worthwhile. Even Herbert Croly, prophet of progressive collectivism, in his seminal *The Promise of American Life* (1909) decried corporations' production of men "who could do one or two things remarkably well, and who did not pretend to much of anything else." And in his novel *The Octopus: A Story of California* (1901), Frank Norris drew a distinction between proprietary capitalists, who in a telling departure from previous literary appearances are favorably portrayed, and corporate capitalists, who are not, suggesting that what had become most worrisome was the specter not of business and capitalism per se, but of their corporate manifestations.[57]

One response was to naturalize, and thereby render benign, the corporate transformation. In his speech at Williams, James Dill offered a justification that situated the trend within the disposition toward social concentration world-wide. Driving his point home with an example both reassuringly familiar and perfectly tailored to his audience, many of whom would soon take up lives in similar settings, he stated, "We see this exemplified in the tendency of mankind to live and mingle in the activities of growing cities. We see the tendency to the [*sic*] aggregation and centralization in the erection of huge hotels, apartment houses, and, more especially, in the erection of huge office buildings, bringing under one roof huge bodies of men, engaged in every form of activity and of business." Dill went on to invoke the nation's destiny itself, asserting that cor-poratization "is a necessary concomitant and result of the progress, prosperity, and growth of the country."[58]

James Dill was not a member of the Chamber, but he might have been. His corporate boosterism was of a piece with the Chamber's own rhetoric, and his attempts to represent that mode of organization as the natural, inevitable orientation for business were underscored there by the example of the institu-tion itself, which provided a compellingly historicized model of commercial corporate association not only to the membership but to the world beyond, as suggested in an article on the Chamber published in *Munsey's Magazine* in 1901 whose title, "New York's Oldest Corporation," implied its sanction of the corporate model while stressing that such means of affiliation had long existed. A similarly naturalizing historicization was at work when the Chamber had as a speaker at its annual banquet the minister R. Herbert Newton—the veracity of his pronouncements no doubt secured by his status as a man of the cloth, which was precisely the point—on the subject "Old Time Guilds and Modern Commercial Associations." Another tack was to humanize the corporation by describing it in literally corporeal terms (a strategy on some level facilitated, of course, by the derivation of both words from the Latin *corpus*, meaning "body"). At the 1908 memorial service for Secretary George Wilson, Vice President George Seward concluded his eulogy by linking the revered secretary with the institution he served, noting "a corporation is always the lengthened shadow of a man." In casting the corporation as an entity derived from "a man," and moreover as dependent on and determined by a single individual, Seward's aphorism indicates a desire to conceive of the new order in familiarly human terms while also expressing a reluctance to cede the old model of individual agency for the coming one of pluralistic corporate control.[59]

The Chamber's portraits helped, too, as the expanding collection's progres-sively "corporate" display—portraits of individuals collectively constituting a single entity whose sum outshone its discrete parts—mirrored the contempo-rary move in business from an individuated to a consolidated focus, visually naturalizing and accommodating members to the shift whereby corporations

assumed an existence and identity beyond the persons comprising them. The collection grew particularly rapidly during the flood of incorporation from the 1880s into the new century, as illustrated by an article in the January 24, 1897, issue of the *New York Times* that included photographs (figure 45) of seemingly innumerable portraits densely installed in the group's suite of rooms in the Mutual Life Insurance Company Building, its home from 1884 to 1902. As the *Times* described it, "With the pictures the walls of the rooms are covered, and many others stand about on easels, the wall space not being sufficient to accommodate them all." The effect of such growth, and the collection's subsequently packed presentation at the Chamber, was transformative and intensifying, as each new portrait incrementally shifted attention away from the people in the collection to the collection itself. The *Times* photographs suggest this metamorphosis, presenting the collection in broad installation views, in its totality, and not in terms of the discrete sitters, as had been usual before. A comparison of the collection catalogues roughly bracketing the period vividly illustrates the point: in *Portrait Gallery of the Chamber of Commerce of the State of New-York*, published in 1890, each member is represented singly and at length in a laudatory biography that transitively imparts credit to the Chamber (figure 46); by 1924, however, when *Catalogue of Portraits in the Chamber of Commerce of the State of New York* appeared, sitters are conceptualized not so much as

FIGURE 45
"President's Desk, New York Chamber of Commerce."
(From *New York Times*, January 24, 1897)

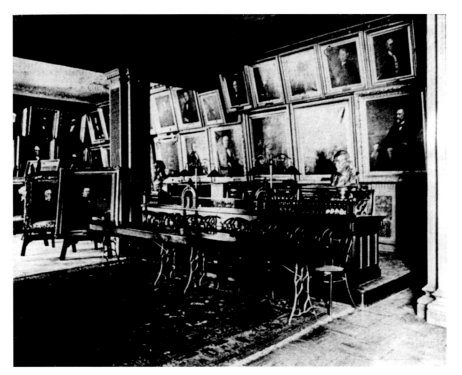

FIGURE 46
Entry for John J. Phelps, in George Wilson, ed., *Portrait Gallery of the Chamber of Commerce of the State of New-York: Catalogue and Biographical Sketches* (New York: Press of the Chamber of Commerce, 1890)

individuals to be separately celebrated but as part of a group together comprising a larger whole—that is, corporately (figure 47).[60]

The Chamber itself underwent a similar transformation, as authority within it gravitated from a few individual officers toward a more corporate style of management. An executive committee was established in 1858, and by 1918 governance was shared by more than twenty committees, a transition in turn paralleled by the widening scope of the collection, broadened to include portraits of members alongside Chamber officials. The move to a more collective identity as reflected in the Chamber's increasingly diluted power structure, and reified visually by its portrait collection, can similarly be seen in other social and cultural productions of the era. Theodore Dreiser's *Trilogy of Desire*, for example, a series of naturalist novels begun in 1912 with *The Financier*, explores the limits of individualism and shares with the author's other works an increasing tendency to define the self in terms of its relation to the group. This was a noteworthy development coming on the heels of a culture that had produced and lionized the tropes of the rags-to-riches, self-made man and the lone robber baron.[61]

But that was exactly the point of the collection during this crucial period in the nation's business (and economic and social) evolution: it eased the transition from merchant prince to corporate capitalist, and more generally from self- to

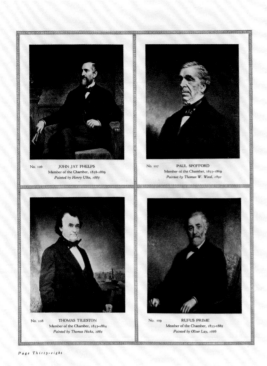

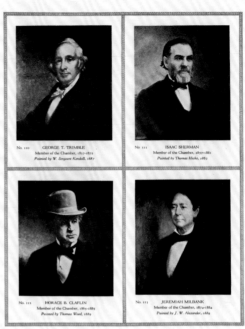

FIGURE 47
Entries in *Catalogue of Portraits in the Chamber of Commerce of the State of New York, 1768–1924* (New York: Chamber of Commerce of the State of New York, 1924), with John J. Phelps at upper left.

group-directed orientations, through recourse to the language of the very individualism that was under siege, turning to its ultimate visual manifestation—the painted portrait—to show how the individual presence might still be accommodated within the group without the loss of distinctive identity. As if on cue, the collage-like illustration produced for the 1897 *New York Times* article, captioned "Twenty-five Representative Members of the New York Chamber of Commerce" (figure 48), imparts the same effect, with photographs of leading Chamber personages shown separately but bunched together and cohered into a single entity through the surrounding organic decorative motif. Men may be becoming constituent parts of corporate machines, both seem to say, but not at the expense of their discrete identities. As members sat through meetings in the increasingly crowded Great Hall (for, like the collection, the Chamber itself had grown, with membership capped first at fifteen hundred and then, in 1917, two thousand), the portraits surrounding them—each representing a deliberate decision to expend time, effort, and funds to commemorate a specific person—affirmed the value of the individual and must have reassured the assembled businessmen below of their own continued relevance within a rapidly corporatizing culture (figure 49).[62]

Similarly encouraging would have been the knowledge that many of the faces comprising the collection's now corporate-style display were those of the old-line proprietary capitalists who had laid the business economy's foundations, suggesting that the new order evolved naturally from the old—which in a sense it

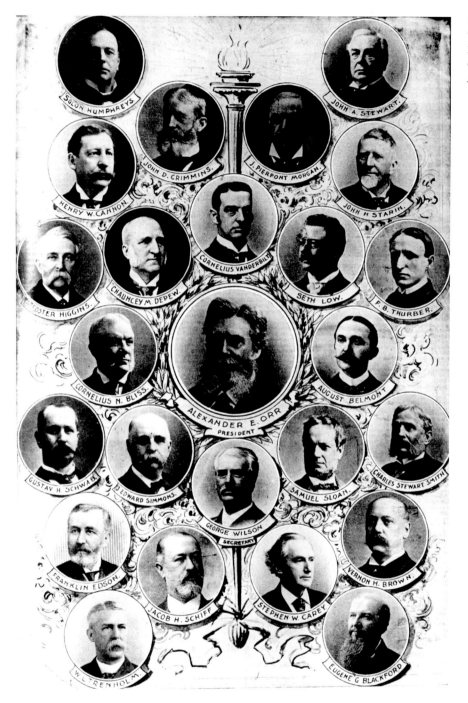

FIGURE 48
"Twenty-five Representative Members of the New York Chamber of Commerce." (From *New York Times*, January 24, 1897)

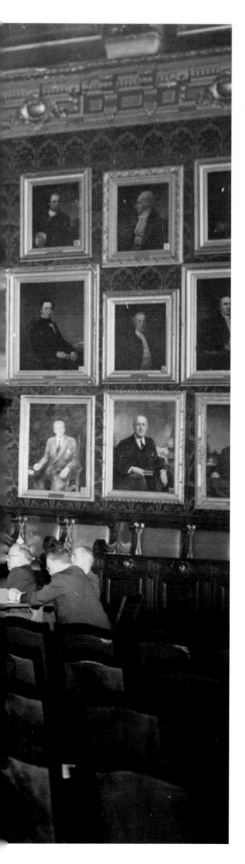

FIGURE 49

Meeting in the Great Hall, later photograph from ca. 1955. (New York Chamber of Commerce Archives, Columbia University Rare Book and Manuscript Library)

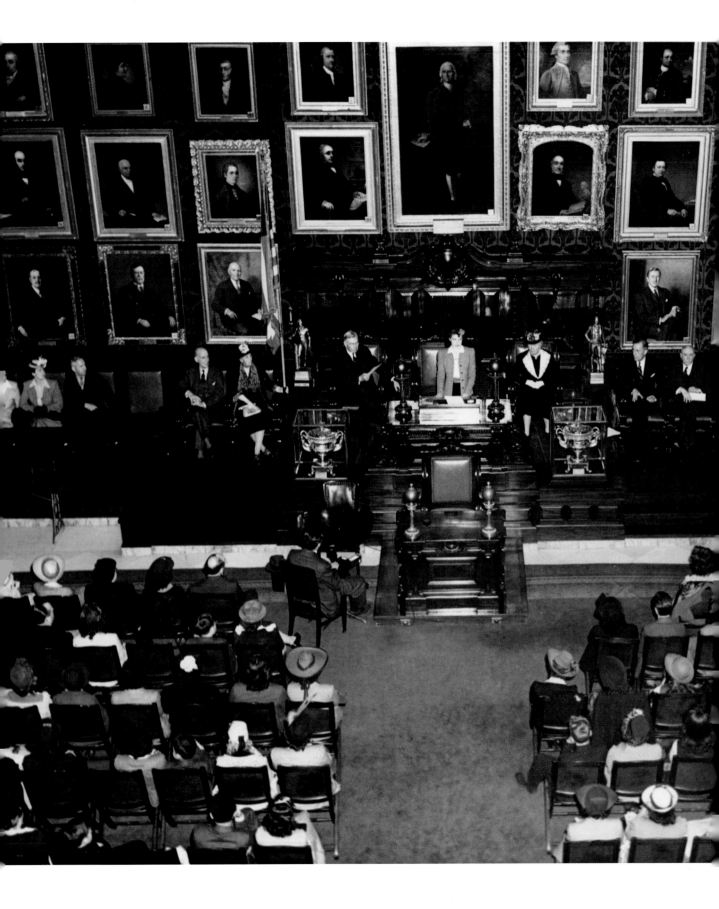

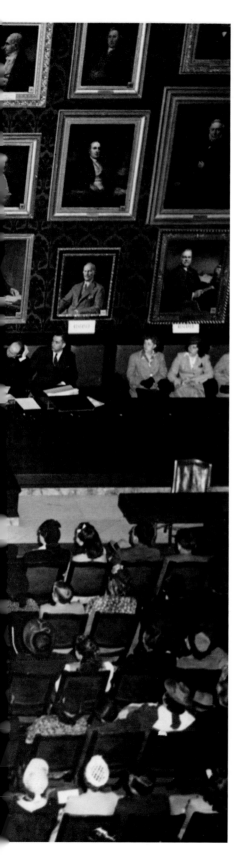

FIGURE 50

Meeting of women in the Great
Hall, ca. 1945. (New York Chamber
of Commerce Archives, Columbia
University Rare Book and Manuscript
Library)

had, since the proprietary interests, recognizing the futility of resistance, joined up with the emergent corporate class, assimilating themselves into it through a mingling of capital, personnel, and social exchange to produce a unified ruling economic order. In showing portraits of proprietary forebears in corporate fashion, and blended in with those of the new breed, the collection recapitulated the succession of one type of capitalism for another, using the reassuring visages of the past as pieces constituting the new mosaic. Indeed, Great Hall installations often offered a sort of declension of capital, with images of proprietary antecedents hanging above their corporate descendants, as if in a family tree. In one such example (figure 50 [fourth column from right]), import-export merchant Henry White (1732–1786) hangs above shipbuilder and China trader Abiel Abbot Low (1811–1893), beneath whom is installed Chase National Bank president Winthrop Aldrich (1885–1974), whose name and title alone succinctly make the point about the adjustment of the old proprietary to the new corporate order.[63]

The Chamber's collection at the turn of the twentieth century existed, like the institution itself, in a moment of equipoise, at once defined by the individualism of the past and anticipating its replacement in the future. By shifting the primary function of the portraits away from their usual roles of individual placeholders in the institution's history, the Chamber's paintings, in their new use as comparatively interchangeable contributors to a greater whole, began to fundamentally subvert portraiture's basic orientation as purveyor of individual presence and identity, reversing the "history as biography" formulation that had worked so well in the collection's growth phase. The seeds of its diminishing relevance were hereby sown, and in succeeding years the collection would never recapture its vital role in facilitating the Chamber's ascendance—once again reflecting and anticipating the fate of the institution it represented.

Aestheticized (1910–1929)

Before commencing its inexorable fadeout at the Chamber, the collection, along with the organization and the business interests it represented, enjoyed a long day in the sun. The formidable Pujo Committee's congressional investigation of the "money trust" and its stranglehold on the nation's fiscal affairs had resulted—rather ineffectually, in light of the seriousness of its findings—in the institution of the Federal Reserve Act (1913), establishing a national banking system for the first time since Andrew Jackson's era, and the Clayton Antitrust Act (1914), which tightened the provisions of the quarter-century-old Sherman Antitrust Act (1890). But after these initiatives, the progressive reform ongoing since the turn of the twentieth century shifted from an economic to a social focus, leaving the business community more or less at large as the movement lost momentum. Moreover, national unification in the face of World War I

quelled commerce's critics, and the conflict itself spurred enormous economic growth, as the nation's manufacturers supplied the Allies and its bankers financed them. The war shifted the world's financial center from London's Lombard Street to New York's Wall Street. The historic changeover was reinforced after the war's end by America's central role in underwriting Europe's recovery, which vaulted the nation from its prewar status as world's largest debtor to its postwar place as the largest creditor.[64]

The soldiers of business were thus also "heroes" of the war. They were "the dictators of our destinies," replacing the "statesman, the priest, the philosopher, as the creator of standards of ethics and behavior," in the observation of economist and social critic Stuart Chase (Chase, who would go on to write *A New Deal* [1932], the book from which Franklin Roosevelt was to borrow the term, did not intend the statement as a compliment). But as opinion polls ranked Henry Ford just behind Jesus and Napoleon in the public's perception of the greatest men in history, the assertion of Chamber (and Chase National Bank) president A. Barton Hepburn in 1910 that "commerce is king, and the whole world bows down before its power," had the ring of both current truth and just prophecy. It was soon fulfilled by a string of three of the most business-friendly presidential administrations in American history: Warren Harding (author of the campaign slogan "Less Government in Business and More Business in Government"), Calvin Coolidge ("The business of America is business"), and Herbert Hoover ("The sole function of Government is to bring about a condition of affairs favorable to the beneficial development of private enterprise").[65]

In such a climate, the Chamber could afford to let down its political guard, remaining content to monitor and help shape the favorable environment for commercial regulation and to bask in the broader cultural approbation of its members' pursuits. With business interests firmly entrenched at the forefront of American economic and political culture, the Chamber began a period of relative institutional complacency, operating increasingly like a gentleman's club in its elaborate building with dining facilities, portrait gallery, and library. During the same period, perceptions about the collection changed along similar lines, as it came to be used less as a rhetorically empowering device and was more valued for its aesthetic aspects and historical connotations (although each of these had rhetorical implications as well). Imparting a dignified tone of refinement, the collection in its new orientation capitalized on the heightened contemporary interest in historical American portraiture, which formed part of a broader awareness of the nation's past ongoing since the Centennial, when citizens deemed the country sufficiently aged to have a history worth investigating. Portraits were prominently featured in the Metropolitan Museum's exhibition of eighteenth- and nineteenth-century American art mounted in 1909 in conjunction with the Hudson-Fulton Celebration, and in 1917 the Brooklyn Institute of Arts and Sciences devoted a show solely to them. On the art market, demand for early American portraits soared, even stimulating a brisk trade in

forgeries. For the Chamber, whose portraits the *New York Times* valued in 1924 at a staggering (and implausible) $10 million, its "historic" collection—a *Times* feature in 1927 described it as possessing "the dignity of age," notwithstanding that most of its depictions of early leaders were later copies—conveyed a desirable cachet while confirming, in its retrospective aspect, the group's cultural conservatism. Indeed, much of the era's preoccupation with visibly reconstituting the American past, from Wallace Nutting's tinted photographs of "Old America" to Chamber member John D. Rockefeller Jr.'s bankrolling its actual re-creation at Colonial Williamsburg, can be seen as the rearguard action of a conservative culture rocked by waves of change to seek nostalgic refuge in a time conventionally thought simpler and more navigable. In this light, historicizing the Chamber's collection provided a means for the group to negotiate a comforting link to the very past that it had helped obscure through its embrace of corporatization and other aspects of modern economics.[66]

At the same time as the collection's historical character was being promoted, aesthetics also came to the fore, with new consideration given to the portraits as works of art. Press references for the first time began to be oriented around the artists represented, as in a 1924 *New York Times* notice that described "the collection of the Chamber of Commerce of the State of New York, consisting of 233 portraits by Gilbert Stuart, John Wesley Jarvis, Bonnat, Huntington, Trumbull, and other well-known American [*sic*] artists." Such accounts reflected a broader apprehension of American portraits as aesthetic in addition to documentary artifacts. At the Pennsylvania Academy of the Fine Arts, portrait exhibitions devoted to the work of individual artists—Cecilia Beaux in 1907; Thomas Eakins in 1917; Thomas Sully, the Peales, and John Neagle in the early 1920s—similarly underscored the shift, one that allowed the Chamber to accrue desirable associations of cultural sophistication and provide tangible evidence of its long-standing association of commerce with civilization.[67]

In keeping with the aestheticization of the collection, in 1920 Chamber members appointed the Advisory Committee on Portraits, whose function was to oversee the care of the paintings and especially to regulate the quality of new acquisitions, a topic only recently of concern but one that greatly exercised the group throughout the decade, perhaps partly because in such halcyon days for commerce the members had more time to devote to burnishing their pictorial pedigree. In any case, whereas a place on the Chamber's walls was formerly a matter of biographical suitability, with a portrait committee now dedicated "to pass upon the artist to be selected and finally upon the picture itself," as its mandate was described, suddenly art became at least as large a concern, a consideration "that the Executive Committee has regarded . . . as one of particular importance to which more attention should be given in the future." Former president and current vice president Darwin Kingsley agreed: "We want a large collection, but we want good portraits, and the Executive Committee could go so far as to recommend . . . that . . . the Chamber in the future may not use any

but certain artists designated by the [Portrait] Committee." The membership apparently required proof positive that the committee—which included such authorities as New York art world dean and leading gallerist Roland Knoedler— was taking its duties seriously: "It was understood that this portrait would be placed on an easel in the Great Hall at the meeting on May 7th so that the members may observe that the Advisory Committee is looking after the portrait collection." The Chamber even got itself into the exhibition of works of art that were not portraits, were not its own, and were not shown on the premises: "Mr. [Vice President Irving T.] Bush presented for the inspection of the Committee a painting by George Inniss [sic], Jr., entitled 'The Only Hope' and made the suggestion that a Committee of members be appointed to arrange for showing the picture in various parts of the country—particularly before schools and colleges." Amazingly, the Executive Committee concurred. All of which illustrates how substantially conceptions about the Chamber's proper role and image, and the relationship of art and its portrait collection to them, had changed since the turn of the century to reflect the organization's current complacency.[68]

The appearance in 1924 of the Chamber's second full-dress publication on the collection, *Catalogue of Portraits in the Chamber of Commerce*, confirmed the ascendance of art over biography as the portraits' primary means of shaping perceptions about the group. Its predecessor, the imageless *Portrait Gallery of the Chamber of Commerce*, had in fact devoted only fourteen of its nearly three hundred pages to cataloguing the Chamber's art, the remaining 95 percent being given over to sitters' biographies, with no further mention of portraits or artists. In 1890, the collection supplied the pretext for vaunting the significance and worthiness of those included in it and implicitly of the institution they constituted. By 1924, only thirty-four years later, a complete inversion had taken place, as that year's presentation of the collection shifted the focus decidedly toward image and art. More than two-thirds of the catalogue's pages were allocated to reproductions of the portraits, whose subjects are only briefly identified, along with attributions to the artists (see figure 47). Such biographical detail as does exist is restricted to an abbreviated section at the back, "Biographical Notes," in which the lives of presidents and patriarchs are reduced to a mere few lines (figure 51). Continuing the trend, in 1941 the Chamber issued the *Supplement to the Catalogue of Portraits in the Chamber of Commerce of the State of New York*, which like the catalogue of 1890 includes an index—but to artists, not sitters, indicating a reversal in the way the collection was not only accessed but also, it seems, assessed (figures 52 and 53). Even the comparative facture of the catalogues is revealing: the first edition, of 1890, appears more like a biographical dictionary than the art catalogue it ostensibly is; as a material artifact, its role was to impress in a ponderous and unsubtle way—much like the biographies it contains. Its successor, of 1924—a far thinner, lighter, more pliable affair—bespoke elegance and sophistication over rhetorical bombast, just as the collection when it appeared performed its

BIOGRAPHICAL NOTES

AINSLIE, ROBERT—No. 203 (1777–1851). Ship chandler and dealer of naval stores in New York; later entered insurance business and became President of the North American Fire Insurance Co. Portrait presented by his granddaughter, Ann E. Hasbrook, painted by Rembrandt Peale.

ALSOP, JOHN—No. 8 (unknown–1794). Charter member of the Chamber; Treasurer, 1773–74; Vice-President, 1774–79; President, 1784–85; one of the foremost merchants of his day; active in measures of resistance to British laws; delegate to First Continental Congress; portrait presented by members of the Chamber, painted by Thomas Hicks, 1865, after an original by an unknown artist.

ANDREWS, LORING—No. 98 (1799–1875). Member of the Chamber, 1865–1875; hide and leather merchant, established in New York in 1829; associated with Gideon Lee and Sheppard Knapp; first president of the Shoe and Leather Bank; portrait presented by his family, painted in 1886 by Robert Gordon Hardie.

APPLETON, DANIEL F.—No. 102 (1846–1904). Member of the Chamber, 1875–77; 1892–1904; entered business with Royal E. Robbins, importer of watches; in 1857 organized and established American Waltham Watch Co.; portrait presented by his sons, painted in 1905 by Joseph DeCamp after Eastman Johnson. ‖

ARTHUR, CHESTER A.—No. 201 (1830–1886). Honorary member of the Chamber, 1885–1886; President of the United States, 1881–1885; practiced law; conducted noted legal cases in defense of the colored race; served in the Civil War; Collector of the Port of New York; portrait presented by the Arthur Memorial Association, painted in 1907 by John W. Alexander.

ASTOR, JOHN JACOB (1st)—No. 77 (1763–1848). Came to New York 1784; engaged in fur trade; attempted to settle post on Pacific coast, Astoria; invested largely in real estate in New York; established the Astor Library; portrait presented by his grandson, John Jacob Astor, painted in 1890 by Jacob H. Lazarus after an original by Gilbert Stuart.

ASTOR, JOHN JACOB (2nd)—No. 79 (1822–1890). Member of the Chamber, 1861–1864; director and trustee of many business institutions; increased family fortunes immensely by dealing in real estate; portrait presented by his son, William Waldorf Astor, painted in 1890, replica by Jacob H. Lazarus.

ASTOR, WILLIAM B.—No. 78 (1792–1875). Member of the Chamber, 1833–1862; merchant and capitalist; gave up business to attend to his large estate; one of the greatest builders of his day, having erected 700 stores and dwellings in New York; portrait presented by his grandson, William Waldorf Astor, painted from life in 1872 by George A. Baker.

ATLANTIC CABLE PROJECTORS—No. 187. The painting represents a meeting of the Atlantic Cable projectors at the residence of Cyrus W. Field, Gramercy Park, New York City. Left to right, they are: Peter Cooper, David Dudley Field, Chandler White, Marshall O. Roberts, Samuel F. B. Morse, Daniel Huntington (the artist), Moses Taylor, Cyrus W. Field, Wilson G. Hunt.

Page Seventy-two

INDEX TO BIOGRAPHICAL SKETCHES.

FIGURE 51
"Biographical Notes." (From *Catalogue of Portraits in the Chamber of Commerce of the State of New York, 1768–1924* [New York: Chamber of Commerce of the State of New York, 1924])

FIGURE 52
"Index to Biographical Sketches." (From George Wilson, ed., *Portrait Gallery of the Chamber of Commerce of the State of New-York: Catalogue and Biographical Sketches* [New York: Press of the Chamber of Commerce, 1890])

political function through a less direct, more refined appeal to art. Although nominally dedicated to the same subject, the institutional work of the two publications differed dramatically, the first proclaiming the greatness of the Chamber's members and by insinuation its own, and the second offering nebulous but attractive connotations of culture and cosmopolitanism.[69]

The Chamber's ample pride in its portraits, and its new aesthetic conceptualization of them, prompted the organization to send copies of its catalogue far and wide, "to Museums and Chambers of Commerce all over this country and abroad," effectively making a mass-marketing tool out of a collection that, although its existence was widely known and reported, had largely been directly experienced by members. The distribution of the catalogue was followed by a decision to exhibit the portraits to the general public. During the last week of November 1924, the Chamber opened the doors of its Great Hall to any and all interested in a glimpse of the collection. Notices for the exhibition appeared in the arts pages of the *New York Times*, which ran two stories and a special collage of portraits in its Rotogravure Picture Section (figure 54).

The two articles focused their coverage of the Chamber's "art collection" on its history and the artists represented as much as on the subjects of the portraits. While this change in emphasis again reflects the broader increase in the appreciation of American portraiture as art, in the context of the Chamber it more pointedly betokened the collection's new role. Functioning increasingly like a long-established club, the Chamber reoriented its presentation of the collection along suitable lincs of history and aesthetics. The portraits retained vestiges of their rhetorical aspect, to be sure, but now delivered differently and toward different ends. Crucially, the historicizing and aestheticizing of the collection also allowed the group to begin to insert some distance between its contemporary self and the one constructed by the portraits, for the world represented by the collection—one of abstemious bewhiskered individuals, of patriarchs and family firms—was no longer the members' own. By transitioning away from the comparatively direct and literal association of a biographical orientation to become more generally associated with history and aesthetics, the collection once again became what the Chamber wanted and needed it to be.[70]

Burdensome (1930–1980)

As it happened, many Chamber members would gladly have returned to that former world and its sense of certitude. Instead, they suffered the aftermath of the Great Crash of 1929 and the subsequent Great Depression—events whose shared intensifier only begins to suggest their seismic import. No mere "panic," as market collapses of 1907, 1893, 1873, and before had been called, the Crash of '29 wrought such damage to the financial engine of business that recovery was measured in decades, not years. And to an extent not seen since the Civil War, the effects reverberated throughout American society, setting in motion economic, social, and political transformations that still influence the nation. For the Chamber, the twin cataclysms of crash and depression delivered blows from which it never fully recovered and introduced destabilizing elements of tenuousness and doubt to its self-image as a group of wise, civic-minded, fundamentally benevolent plutocrats. Moreover, as the Dow plummeted from a stratospheric 381 in September 1929 to an abysmal 41 three years later, a drop of 89 percent, and unemployment rocketed in the opposite direction, increasing sevenfold from 3.2 to 23.6 percent, Chamber members were not alone in their misgivings. Partly because good economic times and the seeming prospect of risk-free gain had lured a newly wide segment of society into the market, but even more because of the crash's far broader economic aftereffects, business—the financial sector in particular—was held to account for the desperate state of affairs. The events of the 1930s had a profoundly leveling effect on businessmen, who only recently had been the toast of the Jazz Age—to the enjoyment of many who had been suspicious from the start. As Edmund Wilson noted, "It gave us a new sense of freedom and it gave us a new sense of power to find ourselves still carrying on while the bankers, for a change, were taking a beating." The political implications of such a shift, following the business sycophancy of the Harding, Coolidge, and Hoover administrations, were even more far-reaching. As a majority came to feel that the ruling class was unfit to rule, government decisively stepped in to do what business interests could not, instituting in the New Deal an interventionist, Keynesian capitalism managed in Washington, not on Wall Street. Franklin Roosevelt was no friend of the Chamber's, and vice versa. When the time came for his administration to select a business association to facilitate its initiatives in New York, it bypassed the Chamber in favor of the upstart but more democratic Merchants' Association—a far cry from the Chamber's treatment by another president of the same name, who thirty years before had ushered the triumphant organization into its extravagant new Liberty Street headquarters.[71]

Throughout these severe business doldrums, the Chamber continued to expand its portrait collection (figure 55), though not as rapidly as before. The thin *Supplement to the Catalogue of Portraits in the Chamber of Commerce*, published in 1941, reveals that the acquisition habits of the institution had

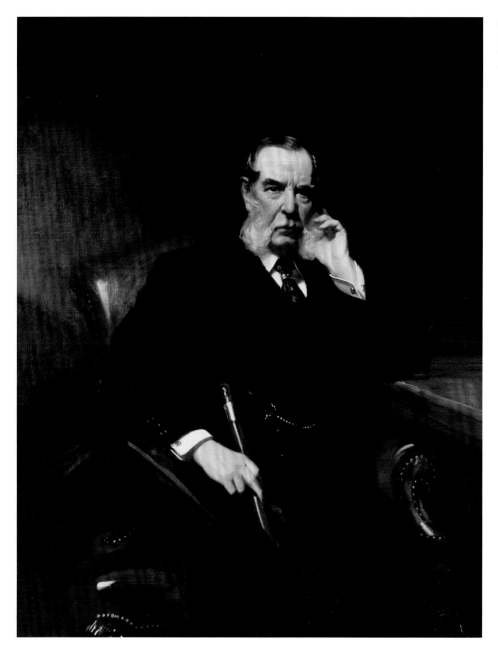

FIGURE 55
Frank O. Salisbury,
George F. Baker, 1931.
Oil on canvas, 56¾ × 44 in.
(Richard H. Jenrette Collection)

substantially retrenched, reverting to the practices of an earlier period, during the 1860s and 1870s, when the collection was just gaining momentum. No longer were ordinary members routinely granted a place on the walls of the Great Hall; rather, the collection now mainly grew only as Chamber presidents and senior officers retired, in apparent recognition of the inaptness of monumentalizing the heroes of a discredited enterprise. Even when the economy rebounded, once more spurred by wartime exigencies, and studies showed attitudes toward business and businessmen were again becoming favorable, the Chamber's collecting activity was henceforth to remain largely limited to commissions for its high-ranking officials—the minimum required to sustain the portraits' role as markers of the institution's lineage.[72]

A major factor in this slackened acquisitional interest was the cluster of related changes in contemporary business culture identified during the postwar years by numerous social commentators, which collectively created an inhospitable environment for the Chamber's project in representation. David Riesman's study *The Lonely Crowd* described Americans' evacuation of an internally rooted selfhood informed by "the ancestors within" (parents and authority figures from the past) in favor of an externalized, of the moment, peer-based orientation. Riesman set forth a social model in which the vertical, transgenerational influence of historical persons was replaced by the peers of the horizontal present, just the opposite of the vertically linear, patriarchal focus of the Chamber's collection. A year later, another sociologist, C. Wright Mills, anticipating the claims of more recent studies of American masculinity, discussed in *White Collar* the period's valuation of personality over character, relating that "with anonymous insincerity the Successful Person . . . makes an instrument of his own appearance and personality"—hardly a recipe for the production of incisive portraiture of abiding insight and interest. Finally, William H. Whyte, picking up where the *Scribner's* columnist's "Passing of the Individual" left off, portrayed in *The Organization Man* a corporate business world of stultifying orthodoxy, distrust of individualism, and faith only in the group. Substituting the past's "Protestant Ethic" with a contrary, communalistic "Social Ethic," Whyte detailed "that contemporary body of thought which makes morally legitimate the pressures of society against the individual," describing those "who have left home, spiritually as well as physically, to take the vows of organization life."[73]

The transformation of business culture from one that had construed itself in terms of individual leaders to one that was structured by the group, a development ongoing since the advent of corporatization, is illustrated in period business novels by a similar shift in orientation. Gilded Age fiction such as William Dean Howells's *Silas Lapham* and *A Hazard of New Fortunes* (1890) typically revolve around a lone and willful character, someone either the head of his own firm or recently enriched through speculation; early-twentieth-century

works like Sinclair Lewis's *Babbitt* (1922) often feature a weak or an insecure protagonist and as such occupy a sort of middle ground; by the 1940s and 1950s, however, books like Cameron Hawley's *Executive Suite* (1950) and Sloan Wilson's *The Man in the Gray Flannel Suit* (1955) reversed the equation, moving from a top–down to a bottom–up focus on the aspiring young businessman struggling to survive in a dehumanized corporate rat race. The world of commerce described in such works, like Whyte's emphasis on consensus and conformity, is fundamentally at odds with the aims of portraiture as the art of the individual, and neither the Chamber's collection as a concept nor the portraits produced for it during this period had much traction. While Chamber portraiture was never distinguished by profound psychological insight—that was not its objective—most portraits from preceding years at least achieved a certain gravitas (figure 56). This was a quality in scant supply in the collection's post–World War II paintings (figure 57), which collectively suggest that businessman's portraiture in the mid-twentieth century had lost its point.[74]

The vacant, oddly interchangeable character of the portraits from this period was reinforced and compounded by the increasingly crowded conditions of display in the Chamber's quarters (figure 58). With nearly three hundred portraits on view in the New York Chamber of Commerce Building, well over half of them packed into the Great Hall and dozens more dispersed throughout the premises, the collection had exceeded its critical mass. It was too big to sustain itself—its very fulfillment paradoxically causing it to tip the balance from a spectacle whose strength lay in numbers to one whose great numbers formed its weakness, subverting portraiture's key roles of distinguishing the individual portrayed and offering the possibility of communion with that presence. As portraits were added to the collection—more slowly now but still and inexorably—the sheer number of faces caused the businessmen to seem increasingly "faceless" in the vast crowd, as if in unwelcome confirmation of their subjects' fears about becoming undifferentiated cogs in a depersonalized corporate machine. By vigorously advancing the collection and elaborately enshrining the portraits in the Great Hall, the Chamber had ultimately served to undermine and destabilize it, making it the victim of its own success.[75]

Besides, the portrait collection was no longer the most convincing or strategic way to represent the institution as a dynamic contemporary entity. In the 1960s, a room exclusively displaying scores of white male business professionals was not without its problems, clearly projecting an image at odds with current social trends, albeit one still more or less accurately reflecting the group's constitution (figure 59). Representational portraiture itself, as a genre, had come to have distinctly antiquated associations, to which the Chamber was especially sensitive as its own status in the globalizing world of commerce came increasingly into question. Photography and the rise of abstraction had long since pushed avant-garde portraiture away from mimetic delineation toward more

FIGURE 56
Daniel Huntington, *Moses Taylor*,
1888. Oil on canvas, 50 × 37 in.
(Credit Suisse, New York)

FIGURE 58
Meeting in the Great Hall, 1966.
(New York Chamber of Commerce
Archives, Columbia University Rare
Book and Manuscript Library)

experimental, often nonfigurative, modes of expression, a direction in which
the Chamber could hardly follow. Caught between the desire to appear vibrant
and the pull of conforming to tradition, the institution responded by retaining
its allegiance to the sort of conservative portraiture it had always patronized
but doing so halfheartedly, perhaps sensing that clinging to such hidebound
precedent was doing its image no good. Commissions slowed to a trickle, with
only presidents now being memorialized.[76]

For fresh generations of Chamber members and their peers, coming of age
in modernism's heroic era, it was the look and language of that brave new
world that bespoke power, not examples of historic styles divulged through
works of art from a genre itself perceived as outmoded (figure 60). In forward-
minded New York, in the years following the demolition of Pennsylvania
Station (modeled in part on the Roman Baths of Caracalla) and the rise of
the sleek new Madison Square Garden in its place, appreciation for the past
was scarce indeed. Still, the group attempted to make a virtue of its age. In
1968, as the new Garden opened its doors, the Chamber commemorated its
bicentennial with the production of a brief but animated *Informal History*, as
the booklet was subtitled, whose content reified the institution's struggle to
accommodate past with present in a compelling way. Following nine sections
on aspects of the Chamber's history, the publication somewhat disjunctively

FIGURE 59
African American woman addressing
an audience in the Great Hall, ca. 1965.
(New York Chamber of Commerce
Archives, Columbia University Rare
Book and Manuscript Library)

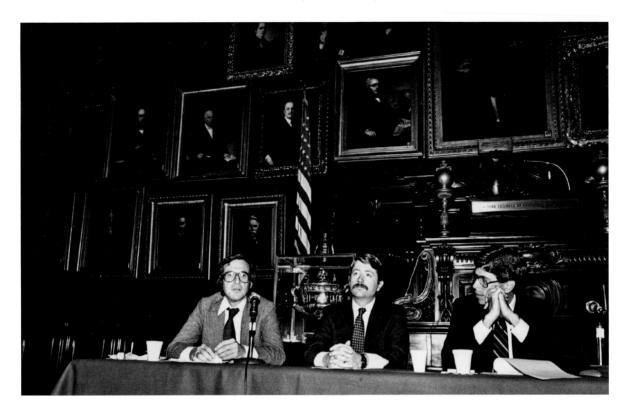

FIGURE 60
In the Great Hall, ca. 1970.
(New York Chamber of Commerce
Archives, Columbia University Rare
Book and Manuscript Library)

ends with two sections on its present and future, as if reluctant to conclude on a retrospective note. A similar sense of dichotomy pervades even the cover illustration (figure 61), which features two cherished artifacts of the organization's past—its historic gavel and the first volume of meeting minutes, its cover visibly singed in the Great Fire of 1835—set before a contemporary panorama of Midtown Manhattan skyscrapers. Clearly intended to suggest a continuum between past and present, the image actually articulates the opposite, encapsulating the disunion between the two that even the interceding drapery cannot ameliorate.[77]

Elsewhere inside the booklet, author Peter Grey, a public-relations specialist tellingly hired by the Chamber to produce it, takes on the issue of the portraits' anachronism directly. Seeking to account for their lack of contemporary resonance while asserting the collection's continued significance, Grey writes,

In the peculiar national climate of the present, a conviction of innate self-importance is hard for even the great to maintain. The certainty of superior knowledge, superior attainment, evident in so many of the nineteenth-century faces portrayed around the Hall, is basically a quality of times gone by. Today these faces have an almost foreign distance, removed

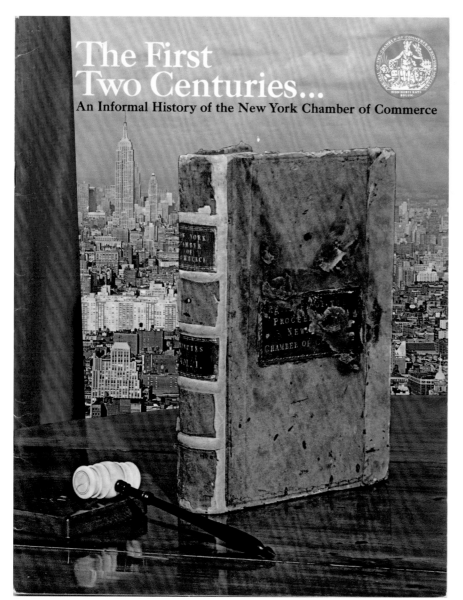

FIGURE 61

Cover illustration of Peter P. Grey, *The First Two Centuries . . . : An Informal History of the New York Chamber of Commerce* (New York: New York Chamber of Commerce, 1968)

utterly from contemporary self-doubt. As the subjects recede further into history, the tradition built by these men—the huge effort, the risk-taking, the optimism, the adventure—becomes clearer and more alive. . . . The Great Hall of today retains their energy latently.[78]

What Grey sensed and strove to somehow positively portray was the portraits' fundamental ill-suitedness to an era of irony, anti-heroism, and doubt. One can appreciate the difficulty, in such a climate, of promoting the collection and the history it represented, which must have appeared decidedly archaic as movements for civil rights and equality came to the fore, war raged in Vietnam, and a counterculture rose to challenge the ascendancy of the very interests depicted in the portraits. Just as the world seemed to be coming apart, the Chamber's bicentennial retrospection required that it explain and defend its representation by portraits whose seamless air of confidence and gravity evoked a premodern, pre-Freudian conception of selfhood, one whose "foreign distance" had indeed caused them to "recede further into history."

At the same time, reflecting now fully entrenched modes of business organization, the Chamber as an institution was in structural transition from a predominantly individual to a largely corporate-based membership, which also had implications for the collection. Since the early 1950s, the group had allowed companies to pay the membership dues of executives who represented them at the Chamber, and as a result large corporations sending successive employees to meetings increasingly came to outnumber individual members, diminishing long-term involvement with the organization and causing dissension among elements of opposite constituencies. The minutes of a 1972 Executive Committee meeting record that "there appeared to be a polarization between representatives of the large corporations and the small firms," but in the end it was clear that although some felt the Chamber "already too dominated by the large corporations," those interests would hold sway over smaller, less powerful concerns, both within and certainly beyond the organization. With the shift from individual- to corporate-oriented affiliation, what a particular member brought to the Chamber became more a function of company association than personal accomplishment in the world of commerce, further undercutting the rationale for and comprehensibility of a portrait collection representing achievement in business. In 1972, the same year as the dominance of corporations over individuals was decried at the Chamber, the group commissioned its final portrait.[79]

A photograph in the Chamber's archives captures the historic moment, apparently unrecognized as such, when that portrait was unveiled (figure 62), exactly two hundred years after Matthew Pratt's image of Cadwallader Colden was first placed in the Royal Exchange a few blocks away. With one of the gems of the collection hovering behind them (a portrait by Asher B. Durand of his patron, Luman Reed), a representative of the Chamber joined artist and sitter in celebrating the institution's own last act of patronage. Just as Durand and Reed constituted one

FIGURE 62
Unveiling of *George Wallace Bates*, Great Hall, 1972. (New York Chamber of Commerce Archives, Columbia University Rare Book and Manuscript Library)

of nineteenth-century America's great artist–client relationships, the last installation in the Great Hall was also the product of a close relationship, as the portrait of retiring president George Wallace Bates was painted by his wife, Frances Trump Bates. A far more modest artistic achievement than either Durand's painting of Reed or Pratt's portrait of Colden, the Chamber's last commission in fact resembles the first (see figure 1) to a remarkable degree, despite the intervening two centuries. Indeed, if the portrait of Colden is reduced to three-quarter length to match that of Bates, the sitters' poses become nearly identical. And if one considers the images' few props and the messages they transmit, the similarities are likewise striking, with the paper beneath Colden's right hand, signifying his intellectual pursuits, finding its counterpart in the books ranged behind Bates, and the view of ship masts over the colonial governor's left shoulder, suggesting that he is a man of the world, matched by the globe in Bates's portrait. While such pictorial congruency across time might be viewed as a strength of the Chamber's collection, propounding the constancy of personal attributes demanded of leading men of affairs, it seems instead to have played out as a liability, becoming evidence of the bankruptcy of conservative representational portraiture in the modern era and its inability to convey the desired contemporary message. Likewise, although selecting Frances Bates to paint the portrait of her husband was undoubtedly seen as charming—and seems a fitting way to end the portrait tradition in an institution made great by family capitalism—it also reveals how far the

Chamber had come from the days when Daniel Huntington, P.N.A. (President of the National Academy of Design), as the group's house artist, could be counted on—and was, forty-three times—to produce the requisite images.[80]

Although the Chamber had now removed itself from the business of commissioning portraits, the question remained of what to do with the existing 291, an issue that was to exercise the organization for some time, as it related to the matter of how to deal with an ever more burdensome past. The Chamber itself, and not just the trappings of its history, was increasingly anachronistic and out of step with the economic and social times. When New York governor Nelson Rockefeller addressed the group in May 1966 (with portraits of his father and grandfather in full view of the Great Hall podium), he was careful to revert to a past tense when characterizing its contributions. Although he used action words like "active" and "dynamic," he was describing times gone by: "I know of no organization that has played a more active, dynamic role in the history of this City and this State than the New York Chamber of Commerce. In fact, one might go so far as saying in the history of this country." Yet it was not achievement in the past that was the problem; it was relevance in the future.[81]

Complicating the fate of both the organization and the portraits was the long-debated merger with the Commerce and Industry Association, as the Merchants' Association had been renamed in a move to update its own profile. When for strategic and financial reasons the merger finally took place in 1973, the bonds of tradition seemed broken. Short on both space (as a result of the merger) and cash, three years later the Chamber of Commerce and Industry, in an act of institutional apostasy, had its extensive and important archives appraised with a view toward selling portions or even all of the historic collection. While it ultimately retained its records (even, in a reflection of the group's conflicted stance, for a time promoting the idea of properly cataloguing and preserving them), it hesitantly decided to shift most of its operations from the Liberty Street building to more modern quarters uptown, which the group optimistically hoped "may be viewed as further evidence of the revitalization."[82]

It was, however, the beginning of the end. By giving up the signature building that it had so proudly inhabited for more than seventy years, the Chamber signaled its determination, appropriately businesslike, to trump history and tradition with modernism and efficiency. For the portrait collection, the implications were profound. With the Great Hall potentially no longer available to display the collection, a new debate arose over its future. Chamber officials suggested converting it to a "National Portrait Gallery of American Business Leaders" and approached the Smithsonian Institution with the idea, to no avail; the group considered leasing the Great Hall in perpetuity from whomever might otherwise occupy the building, but this was an impractical solution that left more than a hundred portraits unaccommodated. Thus sometime around 1976, just as the nation was celebrating two hundred years of its history, the Chamber began the delicate process of determining which portraits—which pieces of its

past—merited retaining, always balanced against the reality of their uneven quality and hence widely varying value on the art market. A sheet from the archives titled "Portraits We Should Keep" suggests the sort of calculus this entailed, enumerating fifteen paintings—ten depicting early officers—to be kept, but indicating as well, by also including their sale value, at what price history was to be indulged. This led to some undoubtedly painful decisions, perhaps none more so than the one to sell the collection's artistic masterpiece and the group's guiding spirit: John Trumbull's *Alexander Hamilton*. In 1980, the portrait of Hamilton was ignominiously carted off to an uptown gallery (figure 63), one among seventy paintings—roughly one-quarter of the collection—ultimately sold, lent, or in a few instances simply given away.[83]

Although practical exigencies had factored into the institution's judgment to relinquish the best of its collection, had the portraits—or for that matter the Chamber of Commerce Building, which went on the block as well—still been perceived as indispensable assets, the group would surely have found another way out of its predicament. But they were not perceived that way at all. On the contrary, once the resolution had been made to appear more "current" and "cutting edge," the portraits no longer fit the institutional bill. For an organization once so heavily defined and represented by its past, such an iconoclastic, even patricidal, undertaking illustrates the degree to which the Chamber now felt itself imprisoned—weighed down, crowded out, and subsumed (figure 64)—by its own history. Such concerns came pointedly to the fore when the group

FIGURE 64
Address in the Great Hall,
showing the speaker surrounded by
historical paraphernalia.
(New York Chamber of Commerce
Archives, Columbia University Rare
Book and Manuscript Library)

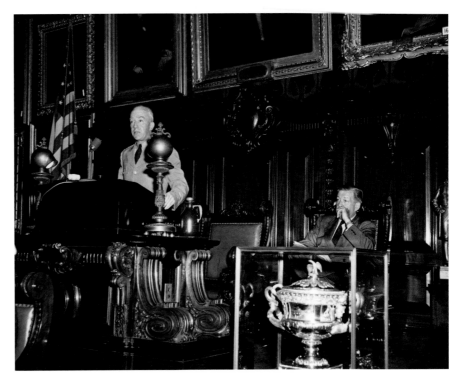

became affiliated with a new organization, the New York City Partnership. This was founded in 1979 by David Rockefeller, who as head of both Chase Manhattan Bank and the Chamber itself (and, of course, as a Rockefeller), was the consummate representative of the corporate power elite. The Partnership arose out of the frustration, and desperation, of New York City's recent fiscal crisis in an effort to—as the name implies—reach across the public–private, government–business divide and "address broader social and economic problems in a 'hands on' way." It was an uneasy match for the Chamber, which was, despite its pretensions to civic-mindedness, fundamentally a business advocacy group. The Partnership conceived its mission less parochially and operated in a nearly opposite way: rather than work primarily to promote the business climate on behalf of its members, as the Chamber did, it sought donations *from* business—large corporations, mostly—to more indirectly enhance metropolitan conditions for all stakeholders, primarily through youth programs, school improvement, and affordable housing. As it became apparent that the two group's futures were to be closely linked, with the Chamber not necessarily playing the leading role, the traditions of the older organization, with its portraits of colonial merchants and Gilded Age tycoons, receded even farther from view.[84]

All the more reason, then, for the Chamber to enact its institutional, art-historical variant of a Freudian family romance, overthrowing its pictured

fathers in a desire to substitute in their place a more appealingly progressive image. For the newly reinvented organization, which in 1980 vacated 65 Liberty Street entirely, the shift in orientation—from serving and valorizing individual businessmen to bestowing corporate largesse—made the heroicizing, personality-driven portrait collection irrelevant. Still, the Chamber clung symbolically to a vestige of its proud history, selecting a modest group of portraits to be displayed in its new quarters while the rest hung in the lifeless Great Hall awaiting an uncertain fate. And in a poignant gesture, the Chamber had a smaller, modern copy of the Hamilton portrait made to replace the one that was sold to subsidize the institution's makeover.[85]

Rhetorical Again (1983–Present)

Before the Great Hall was dismantled in the mid-1980s, its appearance was broadcast to a large public in two very different films that used the dramatic space to evoke a mood of entrenched tradition and power. The first was *Serpico* (1973), Sidney Lumet's adaptation of the true-life drama of police officer Frank Serpico, an honest cop trying to ferret out corruption in the New York City Police Department. A culminating scene of a hearing takes place in the Great Hall, where Serpico's testimony includes words that might just as easily have been applied to the collection and its effect on the Chamber. As the camera positioned over his shoulders slowly pans across the ranks of portraits (figure 65), Serpico says of his superiors, "I was made to feel I had burdened them with an unwanted past." The oppressive atmosphere of the ponderous hall (what better

FIGURE 65
Still from *Serpico*, directed by Sidney Lumet © 1973 by Paramount Pictures Corporation. All Rights Reserved. (Courtesy of Paramount Pictures)

place to evoke the past and its burdens?) suggests the ultimate futility of Serpico's quest for change, and in the following, final scene, he quits the force and leaves New York.

Ten years later, in John Landis's comedy *Trading Places* (1983), the Great Hall is the setting of the smug and hidebound "Heritage Club (Founded 1776)" (figure 66), where the main character is accused of stealing from a fellow club member. As he is dragged out of the hall, the camera cuts to a sequence of close-ups of the antique faces of Chamber sitters—figures from *The Atlantic Cable Projectors*, Andrew Mellon, J. Pierpont Morgan—as if to imply their censure. Communicated as well throughout the long scene is the ossified and freighted nature of the club's surroundings, an effect largely produced by the portraits (figure 67).

It was connotations like these that the Chamber sought to escape. But the collection's rhetorical role was not yet over. In 1983 and 1984, the New York investment securities firm Donaldson, Lufkin & Jenrette (DLJ) purchased nearly fifty of the Chamber's portraits, fully 80 percent of the group's total deaccessions. A relative newcomer to the world of big-league investment banking (the firm was founded in 1959), DLJ had collected historic Americana for years, largely because one of its founders, Richard H. Jenrette, is a noted collector in his own right.[86]

DLJ had to supply a compelling rationale for electing to expend on art corporate funds that might otherwise be distributed to shareholders. With many financiers (Richard Jenrette at DLJ, David Rockefeller at Chase Manhattan, Donald Marron at PaineWebber), such collecting seemed as much an instance of executive fiat as strategic consideration. But the motivation for most corporate collecting turns out to be much like the Chamber's—using art to project a positive image. The difference is that the intended benefactor is not an entire class of individuals, like "businessmen" at the Chamber, but only the particular firm involved—in fact, in a competitive economic environment, that is one of its major appeals. Internally, corporate collecting is similarly advanced as a means to promote identity through shared symbols and the creation of an identifiable institutional culture, thus bolstering employee pride, satisfaction, and integration within the firm as a whole. Again, much like at the Chamber.[87]

At DLJ, however, the historical ambiance the Chamber pictures could impart was something singular among the preponderance of companies collecting more contemporary art, and it addressed particularly desirable needs for the young firm. Financial institutions have traditionally sought to convey messages of stability and permanence in order to inspire confidence in their judgment over the long haul. This practice is evident in the structures erected to house them, from the overtly historicizing banking buildings of nineteenth-century Wall Street (figure 68 [image]) to the Transamerica Pyramid (figure 69), with its evocation of solid Egyptian architecture in earthquake-prone San Francisco. Unable to lay claim to the extended institutional pasts of most of its competitors, DLJ chose to adopt and project a corporate image that made clear its respect for history and tradition, both aesthetically, through the collection, and by promotion in the same context of a "consistent and non-speculative manner, based on thorough analysis and research . . . that is classic capitalism" (see figure 68 [ad copy]). As former president John Castle said in 1986 of the company's historical art collection, itself displayed in a historicizing setting (figure 70), "As a younger firm, having an attachment to older America gave us roots," a sentiment echoed by Jenrette, who stated, "I felt that DLJ's offices should reflect stability and continuity." The addition of the Chamber's portraits to such an environment both confirmed and extended that aim.[88]

FIGURE 68
"DLJ: Classic Capitalists."
(Donaldson, Lufkin & Jenrette
print advertisement, ca. 1980s)

Our goal at DLJ is to make your capital more productive in a consistent and non-speculative manner, based on thorough analysis and research.

In our view that is classic capitalism. We apply it throughout DLJ.

It has made our investment management division, Alliance Capital Management, Wall Street's largest money manager, with more than $20 billion in assets under management.

Pershing, our correspondent services division, participates in 11% of the reported daily volume on the New York Stock Exchange even in these times of record-shattering volume.

In the bond markets, DLJ's fixed-income strategies, built on a strong capital position, conservative management and effective research, consistently help our clients meet their objectives.

DLJ's investment banking division can help throughout a company's development. We raise venture capital for start-ups, underwrite initial public offerings, and arrange debt and equity financings for a company's on-going needs. That's classic capitalism, too.

In independent surveys, DLJ, the house that research built, consistently ranks among the top 10 firms in the quality of its research.

DLJ concentrates on serving institutions, corporations and high-net-worth families and individuals. For a copy of our annual report, write: Corporate Communications Department, Donaldson, Lufkin & Jenrette, Inc., 140 Broadway, New York, NY 10005. Or telephone (212) 902-2613.

DLJ is classic capitalism at work today.

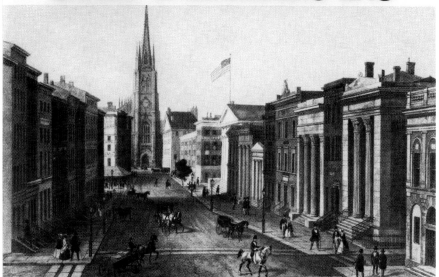

DLJ: CLASSIC CAPITALISTS

Classic capitalism at DLJ means improving capital productivity through superior investment management, investment banking, debt and equities securities trading, venture capital investments, correspondent brokerage, commodities merchanting and brokerage, and unparalleled underlying research. "New York, Wall Street, 1850." A hand-colored lithograph from the Donaldson, Lufkin & Jenrette Collection of Americana.

Donaldson, Lufkin & Jenrette

FIGURE 69
Transamerica Pyramid, San Francisco
(completed 1972; William Pereira,
architect). (Photo Phil Wherry)

The Chamber portraits were no mere generic signifiers of age and tradition, like the historical prints of New York and the Duncan Phyfe furniture comprising the rest of the firm's collection. On the contrary, they seemed tailor-made to transmit a message of affinity not just with the past but with the triumphant story of capitalism told through the images of its worthy heroes. Just as the depictions of renowned individuals not formally affiliated with the Chamber had served there to inflect the meaning of those who were, so the presence of some of the same portraits at DLJ could only elevate the firm's profile by association. As Jenrette noted, "I wanted to get the greatest bankers up on our walls." And by hanging modern portraits of DLJ's leaders in proximity to the historic ones from the Chamber, the firm was even more directly afforded the benefits of associative—or, to employ the sociologist's term, "quasi-ancestral"—use that the Chamber had capitalized on repeatedly with its collection.[89]

The commingling of past and present, and the affiliation of DLJ's leaders with portraits from the Chamber, took on its most apparent form in posed photographs taken for the firm's glossily impressive annual reports. In one such example (figure 71), DLJ's top executives are pictured interstitially among the Chamber's portraits of William T. Sherman, Abraham Lincoln, and Ulysses S. Grant. While the intent was surely not to imply literal equivalence with these national icons, such illustrious company lent the executives a distinct authority. A similar strategy was at work in August 2002, when George W. Bush delivered an address on national security framed against the backdrop of Mount Rushmore (figure 72), a move that seemed calculated to communicate

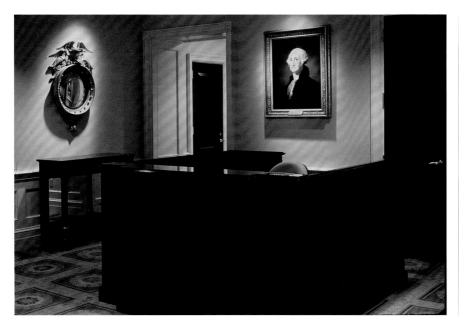

FIGURE 70
Executive offices of DLJ, 277 Park Avenue,
New York (completed 1997;
Mancini Duffy, interior design)

FIGURE 71
President and chairman of DLJ, in front
of Chamber of Commerce portraits.
(From DLJ annual report, 1977)

FIGURE 72
George W. Bush delivering an address,
with Mount Rushmore as a backdrop,
August 15, 2002. (Photo
White House Photo Office)

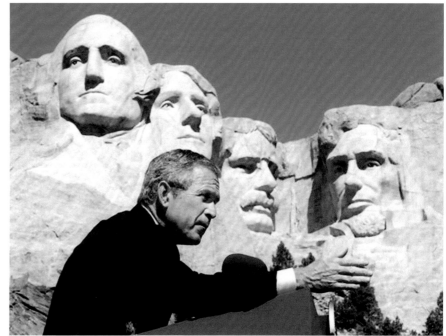

the confraternity of the current president with some of his most esteemed predecessors, instilling a sense of continuity and permanence, and a measure of the very security he was addressing.[90]

While the Chamber portraits purchased by DLJ were accorded new respect and attention, the remaining two hundred–plus paintings from the collection languished in storage until 1990, when arrangements were made to place them on long-term loan at the Equitable Financial Companies (formerly the Equitable Life Assurance Society of the United States), the venerable insurer of which DLJ had become a subsidiary five years earlier. As one of the oldest and most revered names in American business, Equitable already possessed a smaller collection of portraits of past leaders and advisers, and these were interlaced with the Chamber's pictures on the expansive "neo-Jeffersonian"–style executive floors at the top of the firm's Manhattan skyscraper. In the soaring space of the Equitable boardroom, portraits of Chamber men who had also been affiliated with Equitable were displayed in the company's own great hall (figure 73), where, unlike at DLJ, the sitters' actual link to the firm allowed for their literal, as opposed to symbolic or associative, deployment. In other ways, Equitable's use of the Chamber's collection echoed DLJ's. Formal photographs in the company's annual reports similarly connected the two, as in an image of the board of directors set before *The Atlantic Cable Projectors* (figure 74) that seems to re-create the historic meeting pictured in the painting (leading to the first transatlantic cable), even repeating its massing into two groups of figures

FIGURE 73
Boardroom of the Equitable Financial Companies, 787 Seventh Avenue, New York (completed 1986; Kohn, Pedersen, Fox, Conway, interior design)

enlivened by the hand gestures of those centrally placed, one of whom in both pictures holds a piece of paper—in this way subtly relating the modern heroes of business with those certified by time.[91]

Meanwhile, in August 2000, DLJ was again sold, now to Credit Suisse First Boston (CSFB), the investment-banking division of Switzerland's second-largest bank and one of the giants of international finance. Unlike the situation around the firm's purchase fifteen years earlier by Equitable, whose unrelated sphere of operation allowed that transition to proceed with DLJ's distinct corporate culture intact, Credit Suisse was in very much the same business, and it was clear that the two institutions would have to be merged into a single entity. As the larger, acquiring concern, Credit Suisse held sway, and the DLJ name was dropped as the firm vacated its Park Avenue building for the CSFB headquarters on Madison Avenue. Before doing so, however, its chief executive paused for a staged photograph with a senior CSFB official beneath the pride of DLJ's Americana collection, the Chamber's portrait of Alexander Hamilton (figure 75). That portrait was not supposed to have been there, as it had been slated to be shipped uptown the previous week for an exhibition at the Metropolitan Museum of Art. Its departure was delayed specifically so the photographs of the transfer of

FIGURE 75
"Joe Roby, Donaldson's chief, left,
with Richard Thornburgh, First
Boston's chief financial officer,"
in front of *Alexander Hamilton*.
(From *New York Times*, August 31, 2000)

power could be taken and announced in the press beneath Hamilton's confident figure. The decision to postpone the painting's departure so that it might form the visual backdrop to the public presentation of the sale suggests how central to DLJ's identity the Chamber portraits had become. The choice of *Hamilton*, in particular, was especially meaningful: as the patron saint of American capitalism and the figure from the nation's early history most revered on Wall Street, his presence implied a blessing of the transaction. This was particularly useful in the context of yet another foreign takeover of a domestic financial institution, an issue then much in the news. Even the composition of the photo supported the sense of endorsement of the enterprise, with Hamilton's benediction appearing to flow gracefully down his outstretched arm onto the corporate chiefs below.[92]

Once the sale was effected, it was unclear how, or if, CSFB would avail itself of DLJ's esteemed and valuable artworks. For a firm whose very name references another country, the appeal of a collection of Americana crowned by portraits of hometown heroes might seem questionable. Yet CSFB (apparently recognizing that in New York, arguably still the financial center of the world, displaying portraits of the likes of Alexander Hamilton, J. Pierpont Morgan, and Felix Warburg might not be such a bad idea) installed them prominently in the spacious lobby of its Art Deco building on Madison Square Park, continuing to do so even following its name change from Credit Suisse First Boston to simply Credit Suisse, signaling a desire to promote its global orientation. All of which suggests that, given the right context, the Chamber of Commerce's portraits of long-deceased businessmen have life in them yet.[93]

Coda (Not Rhetorical, Again)

The rest of the Chamber's portraits had a different fate, although the fortune of their corporate guardian, also taken over by a foreign multinational, was similar. In 1991, AXA, a large Paris-based insurer, purchased control of cash-starved Equitable in a friendly bailout. This had initially meant little as far as the portraits were concerned. They continued to be displayed in the Equitable building while the firm, now an AXA subsidiary, kept its name and external profile. In 1999 and 2000, however, as cost-cutting measures caused Equitable to vacate most of its headquarters for less expensive offices nearby, and in the wake of the company's change in name to AXA Financial, there was no longer room—literally or figuratively—for a large collection of portraits of American businessmen, particularly since those displayed by Equitable were of individuals with a connection to that firm rather than the more famous subjects comprising DLJ's group of portraits. While DLJ (and later CSFB) had portraits of

Andrew Carnegie and Cornelius Vanderbilt on view, Equitable had Alfred Van Santvoord and George F. Vietor—names and visages that lacked recognition outside the company. When even that connection was deemphasized, they had precious little purchase or appeal.

Nor was the Chamber, now tellingly known as the New York City Partnership and Chamber of Commerce (note sequence), interested in reclaiming them. Since its affiliation with the Partnership in 1979, the newer organization, with its broader agenda and corporate orientation, had effectively subsumed the increasingly anachronistic Chamber, which finally managed to sell its elegant but unwieldy building a decade later and now gathered, in an apt metaphor of its reversed circumstances, in "outside meeting places, often those of corporations," according to its president in 1989. The Partnership itself had experienced a gradual decline in relevance since its originary activity in the days following the municipal fiscal crisis of the 1970s. It sprang back to life, however, after the terrorist attacks of 2001, successfully lobbying Washington for aid on behalf of the larger city and its diverse interests. Not long thereafter, the organization made official what had effectively been the case for years when, having operated with a single administration and board of directors since 1997, early in 2003 the New York City Partnership and Chamber of Commerce became the Partnership for New York City, a group, according to its new co-chairman, financier Henry Kravis, "focused on what the business community can do *for* [emphasis in original] New York . . . rather than advocating for industry and business interests."[94]

The same year, the Partnership agreed to donate the 216 portraits remaining from the Chamber of Commerce collection to the New York State Museum in Albany, an institution charged with collecting and preserving important aspects of the state's history and, moreover, one with the wherewithal to properly store and care for the large group of images, a selection of which are displayed at the museum while others are made available to lend to interested organizations. All that remains in the Partnership's offices of the collection that had once defined the formidable Chamber of Commerce is Adrian Lamb's modern copy of *Alexander Hamilton*, suitably bracketing, with the more than two-centuries-old original by Trumbull on view at Credit Suisse, the rise and fall of a collection that had effectively served its institutional parent but ultimately, like the organization itself, survived beyond its usefulness. As for the Chamber, though its charter, granted by King George III and later reaffirmed by the nascent state of New York, confers immortality, in reality the group's slow passing was complete when its name was deemed an unnecessary appendage to its successor. Having sold its custom-built marble home, relinquished its archives, and sold or given away its portraits, the Chamber of Commerce retained nothing but its name, and even that was of little value in New York at the beginning of the new millennium.[95]

Epilogue

If you go to 65 Liberty Street, the 110-year-old New York Chamber of Commerce Building still stands, protected since 1966 by landmark status and in 1989 occupied, in an expression of the globalized economy that ultimately rendered the organization obsolete, by the International Commercial Bank of China. The walls of the Great Hall on which the Chamber's portraits once hung have also been preserved, but beneath them, instead of a congress of businessman plutocrats collectively advancing commerce's interests, a warren of cubicles covers the floor, metaphor of another kind of collectivism, the corporate mode of business that similarly undermined the group's efficacy and relevance.[96]

For 235 years, the New York Chamber of Commerce served the interests of its powerful and influential members, providing a unified institutional voice to promote their agenda and, in so doing, that of business and businessmen in America at large. At once reflecting and advancing those constituencies and concerns, the portraits in their turn played a crucial role in establishing the legitimacy, fashioning the reputation, shaping the behavior, and witnessing and contributing to the decline of an institution whose utility, like those of the portraits, was outstripped by the very forces of progress it was founded to encourage.

NOTES

1. Walton's proposal is recorded in John Austin Stevens Jr., *Colonial Records of the New York Chamber of Commerce, 1768–1784* (New York: Trow, 1867), 125–127. The size of the collection, more specifically, numbered 291 portraits at its greatest extent, the majority dating from 1850 through 1910. Artists represented include Charles Willson Peale, John Trumbull, Gilbert Stuart, Rembrandt Peale, John Wesley Jarvis, Samuel Lovett Waldo and William Jewett, Asher B. Durand, Henry Inman, Charles Loring Elliot, Daniel Huntington, Eastman Johnson, Thomas Waterman Wood, William Merritt Chase, John White Alexander, and Philip de Laszlo. Sitters comprise a virtual pantheon of New York—and, to a significant degree, American—business and finance, principally including officers and leading members of the Chamber; American government and military leaders, as well as selected sympathetic foreigners, are also represented.

2. As the particular kind of cross-historical approach outlined here—one in which the function and meaning of a group of images is seen as dialogically linked and responsive to an institution's evolving culture—is unusual, and as it perhaps provides an avenue toward the study of other collections, a discussion of the rationale underlying this approach may be useful. Indeed, the notion of charting shifting

meaning over time in an aggregated and fluid entity like a growing portrait collection might appear unduly complex and problematic: most art-historical studies seek meaning from unitary objects and link their culturally expressive capacity to a single time and place (often their locus of production). Yet with certain types of objects—symbols such as the American flag, or icons like George Washington— whose meaning is held to be expansively metaphoric, we more readily accept such cross-historical approaches, because as fixed and relatively unchanging objects their changing reception offers insight into the culture experiencing them at a particular time, and in comparison with other cultures at other times. Several art histories have addressed individual works of art in such a way, notably Richard Brilliant, *My Laocoön: Alternative Claims in the Interpretation of Artworks* (Berkeley: University of California Press, 2000), which explores the various meanings attributed to that iconic work by diverse, cross-historical parties. The approach taken in this essay, however, differs from such studies both in focusing on a subject that is plural and changing, as opposed to single and static, and in concerning itself as much with that subject's active functionality and use by its owner as with the more "passive" concerns of meaning and reception by its beholders. Moreover, these beholders—the audience—in previous studies have represented different cultural groups, whereas here a single institution is largely the focus and is seen to experience the same material entity differently.

The critical basis for this particular approach is woven from several theoretical strands, one economic and anthropological in derivation, the others drawn from literary studies, but each rooted in an attention to context and concerned with how changes in it lead to changes in meaning. The Marxian construct of "use value" supplies an initial critical frame for understanding the highly contextual nature of value and ultimately of meaning. Marx theorized two fundamental aspects of a commodity: its use value and its exchange value. Whereas exchange value denotes a purely objective and quantitative measure of the proportion in which commodities of one sort are exchanged for another based on the amount of labor power contained in them, use value refers, on the contrary, to the subjectively based desire for a commodity by a given person or group at a certain time. Following Marx, sociologist and philosopher Georg Simmel posited that value and the meaning attached to it are not inherent properties of objects but rather are relationally determined by judgments made about them by subjects. More contemporarily, anthropologist Arjun Appadurai has applied Simmel's insights to his exploration of "regimes of value," examining the conditions under which similar objects circulate differently over space and time. Another anthropologist, Igor Kopytoff, has pursued the concept of "cultural biography" to investigate the changing meaning and valuations of specific things as they move through different contexts, uses, and circumstances. And similarly, James Clifford, also from an anthropological perspective, has discussed the crucial, determinative significance of context for the interpretation of cultural artifacts that remain themselves unchanged. All of which suggests that value and meaning

are not constant but fluctuate and evolve according to use and context. This concept, ultimately derived from Marx's theory of use value, explains how the same, relatively unchanging entity—such as an institutional collection of portraits—can assume a variety of meanings according to the changing contexts in which it exists.

If artifacts of culture are seen to *mean* different things at different times in different contexts, then their *role* within a given culture—the "cultural work" that they perform—must be seen to change as well. The notion of cultural productions working—both expressing *and* shaping the social contexts from which they arise—has been powerfully advanced by literary theorist Jane Tompkins, for whom such productions are "instruments of cultural self-definition": agents of cultural formation that actively mold, rather than passively reflect, their particular environment, influencing and even redefining the social order. Although originally and still most often a text-based paradigm, with the subsequent "pictorial turn" in cultural studies (the term is W. J. T. Mitchell's), Tompkins's theory and the interpretive possibilities it affords have more lately been applied to imagery. Drawing and expanding on the cultural work concept, the critical practice of cultural iconography postulates the dynamic role of images in constructing, sustaining, and disseminating social values and identities. Such a conception of the active potential of culturally resonant visual artifacts is central to the idea that a material object like the Chamber's portrait collection might do more than hang inertly on its walls—that it might itself have agency in the life of the institution.

Finally, if the cultural work of both texts and artifacts is understood to affect and modify existing social realities, a complete and adequately nuanced critical account of the process must accommodate the wide spectrum of reception for such transformation. That is, if a cultural product like the Chamber of Commerce's portrait collection is seen to engender social and cultural change, then the nature and effect of that change must vary according to the diverse and evolving features of the affected audience, including the institution itself. This notion, complementing the theory of use value in its sensitivity to changes in context, underlies my contention that the description and meaning of the collection's cultural work evolved over time, as both the institution it served and the culture surrounding it also evolved. Three related bodies of critical work account for such differences and developments in subject position and their effect on interpretation: reader-response, reception, and communications theory. When I apply aspects of these to the Chamber and its collection, what can be seen is that during the course of the organization's evolution over its unusually long life, both subject position (the Chamber of Commerce itself) and context (the institution's cultural milieu) developed and changed, and so along with them the Chamber's use and understanding of the collection and the meanings generated by it developed and changed as well. Of particular relevance to my argument along these lines is the work of reader-response critic James Machor, whose call for "a return to history in criticism" and close attention to the differing construction of subjects according to highly specific and themselves evolving his-

torical circumstances is especially apt. Like the other theoretical models reviewed here, such socially situated criticism is attuned to both the varied and shifting nature of historically embedded subjects and the implications of that diversity for the role and meaning of the cultural products with which they interact.

On Marx and use value, see Frederic L. Bender's brief but lucid commentary introducing the theme in *Karl Marx: The Essential Writings*, 2nd ed. (Boulder, Colo.: Westview Press, 1972), 327–328. For the complete original text, see Karl Marx, *Capital* (1867), ed. Frederick Engels, trans. Samuel Moore and Edward Aveling (1906; repr., Chicago: Kerr, 1932), 1:41–48. For Simmel, see Georg Simmel, *The Philosophy of Money* (1907), ed. David Frisby, trans. Tom Bottomore and David Frisby (London: Routledge, 1978). Anthropologically based theses are discussed in Arjun Appadurai, ed., *The Social Life of Things: Commodities in Cultural Perspective* (New York: Cambridge University Press, 1986), esp. Appadurai, "Introduction: Commodities and the Politics of Value," 3–63; and Igor Kopytoff, "The Cultural Biography of Things: Commodization as Process," 64–91. See also James Clifford, "On Collecting Art and Culture," in *The Predicament of Culture: Twentieth-Century Ethnography, Literature, and Art* (Cambridge, Mass.: Harvard University Press, 1988), 215–251. For "cultural work," see Jane Tompkins, *Sensational Designs: The Cultural Work of American Fiction, 1790–1860* (New York: Oxford University Press, 1985), esp. intro. On cultural iconography, see Larry J. Reynolds and Gordon Hutner, eds., *National Imaginaries, American Identities: The Cultural Work of American Iconography* (Princeton, N.J.: Princeton University Press, 2000), whose introduction offers a useful overview of the background, growth, and concerns of the field. Two anthologies of reader-response criticism—each with contextualizing introductory essays and featuring a range of reader-based approaches, including reception theory—are Jane Tompkins, ed., *Reader-Response Criticism: From Formalism to Post-Structuralism* (Baltimore: Johns Hopkins University Press, 1980); and Susan R. Suleiman and Inge Crosman, eds., *The Reader in the Text: Essays on Audience and Interpretation* (Princeton, N.J.: Princeton University Press, 1980), with an especially valuable introduction by Suleiman. For Machor's position in particular, see its initial expression in his "Introduction: Readers/Texts/Contexts," in *Readers in History: Nineteenth-Century American Literature and the Contexts of Response*, ed. James L. Machor (Baltimore: Johns Hopkins University Press, 1993), vii–xxix, subsequently elaborated in several books and edited volumes. For communications theory focusing on the social subject, including synopses of some of its key texts, see John Fiske, "Active Audiences," in *Television Culture* (London: Methuen, 1987), 62–83.

3. For the account of totemism most relevant to my argument, see Emile Durkheim, *Elementary Forms of Religious Life* (1912), trans. and intro. Karen E. Fields (New York: Free Press, 1995); and N. J. Allen, W. S. F. Pickering, and W. Watts Miller, eds., *On Durkheim's Elementary Forms of Religious Life* (London: Routledge, 1998). While many of its conclusions are discredited today, the basic features of totemism on which I draw (providing group identity, authority, and cohesion through mutual

symbolic affiliation) are not disputed. For the theory's most incisive critique, see Claude Lévi-Strauss, *Totemism* (1962), trans. Rodney Needham (Boston: Beacon Press, 1963); for a historical review of totemism's contested tenets, see Robert Alun Jones, *The Secret of the Totem: Religion and Society from McLennan to Freud* (New York: Columbia University Press, 2005).

4. Preamble to the Chamber's charter, granted by George III on March 13, 1770, and reprinted as an appendix in the most recent book-length history of the organization: Joseph Bucklin Bishop, *A Chronicle of One Hundred & Fifty Years: The Chamber of Commerce of the State of New York, 1768–1918* (New York: Scribner, 1918), 233–241. Some confusion exists regarding the name of the tavern where the Chamber was founded, although the actual location of the site referenced, at the corner of Broad and Pearl (then Canal and Queen) Streets, is in all accounts the same. Most sources identify the place as Fraunces Tavern; in others, it is called Bolton & Sigel's (or Sigell's), said to precede Fraunces at the same location. What is known with certainty is that Samuel Francis (who later spelled his name Fraunces) had owned the building housing the tavern, the former De Lancey mansion, since 1762. For years before the Revolution, he operated a comparatively highbrow place there known as the Queen's Head, or Queen Charlotte's Tavern, after the wife of George III, whose representation appeared on the inn's sign. Following the war, the name was for obvious reasons changed, to Fraunces Tavern, after its owner. In 1768, when the Chamber was organized, Francis had apparently leased the space to the individuals Bolton and Sigel, who ran it as his tenants at the time. See Bishop, *Chronicle of One Hundred & Fifty Years*, 144–145; and Robert I. Goler, "Fraunces Tavern," in *The Encyclopedia of New York City*, ed. Kenneth T. Jackson (New Haven, Conn.: Yale University Press, 1995), 438.

5. Minutes, October 6, 1772, quoted in Stevens, *Colonial Records*, 167. For a sense of the sociopolitical milieu in which the Chamber first operated, see the section "Merchants in a Revolutionary Era," in Elizabeth Blackmar, "Exercising Power: The New York Chamber of Commerce and the Community of Interest" (this volume). On the nonimportation campaign, see Edwin G. Burrows and Mike Wallace, *Gotham: A History of New York City to 1898* (New York: Oxford University Press, 1999), 207, 212–213; for the Chamber's role in the boycott, see Bishop, *Chronicle of One Hundred & Fifty Years*, 10–11. On Colden, whose leadership of the colony was intermittent due to the sporadic presence of superseding governors, see Alice Mapelsden Keys, *Cadwallader Colden: A Representative Eighteenth Century Official* (1906; repr., New York: AMS Press, 1967); and Alfred R. Hoermann, *Cadwallader Colden: A Figure of the American Enlightenment* (Westport, Conn.: Greenwood Press, 2002).

6. For the relevant section of the charter, see Bishop, *Chronicle of One Hundred & Fifty Years*, 240. On the Royal Exchange, see Bishop, *Chronicle of One Hundred & Fifty Years*, 149–150; for the portrait of Pitt in the Royal Exchange, see Kenneth John Myers, "The Public Display of Art in New York City, 1664–1914," in *Rave Reviews: American Art and Its Critics, 1826–1925*, ed. David B. Dearinger (New York: National Academy of Design, 2000), 32.

7. Cadwallader Colden Jr. to the Chamber, April 1791, recounting the vicissitudes of his father's portrait, quoted in Waldo Walker, "Chamber of Commerce Has Its Hall of Fame," *New York Times*, July 3, 1927. For a sense of the scarcity of images in early New York, see Myers, "Public Display of Art," 31–51; and Carrie Rebora Barratt, "Mapping the Venues: New York City Art Exhibitions," in *Art and the Empire City: New York, 1825–1861*, ed. Catherine Hoover Voorsanger and John K. Howat (New York: Metropolitan Museum of Art, 2000), 47–81. For an account of the situation in Philadelphia as well as New York, including information on the uses of and audience for portraiture, see Valentijn Byvanck, "Public Portraits and Portrait Publics," *Explorations in Early American Culture / Pennsylvania History* 65 (1998): 199–242; and Brandon B. Fortune, "Portraits of Virtue and Genius: Pantheons of Worthies and Public Portraiture in the Early Republic" (Ph.D. diss., University of North Carolina, 1987). The substitutive symbolic role of period portraiture suggested by the soldiers' attempted destruction of Colden's portrait by bayonet assault on his depicted body is further illustrated by the colonists' earlier transformation of the lead-sculpted figure of the statue of George III into musket balls for use against his troops. Similarly, the version of Charles Willson Peale's famous *George Washington at Princeton* executed for display in Nassau Hall at the fledgling College of New Jersey (now Princeton University) was explicitly conceived to occupy the place and the very frame of a portrait of George II "torn away," according to the school's trustees, "by a ball from the American artillery in the battle of Princeton." Such instances, in which the pictorial body during the late eighteenth century is meaningfully treated as a stand-in for the actual one, are explored psychoanalytically with regard to revolutionary France in Lynn Hunt, *The Family Romance of the French Revolution* (Berkeley: University of California Press, 1992). On the statue of George III, see Burrows and Wallace, *Gotham*, 232. For the Peale portrait, see Donald Drew Egbert, *Princeton Portraits* (Princeton, N.J.: Princeton University Press, 1947), 322; and Karl Kusserow, "Memory and Meaning in the Faculty Room," in *Inner Sanctum: Memory and Meaning in Princeton's Faculty Room at Nassau Hall*, ed. Karl Kusserow (Princeton, N.J.: Princeton University Press, 2010), 59–65.

8. Stevens, *Colonial Records*, 332.

9. "Portraits with Careers: Two Venerable Relics of the Chamber of Commerce's Early Days," *New York Times*, December 27, 1896.

10. Although coffeehouses were more civil places than taverns, they too served alcohol and, moreover, were by nature given over to public, mixed-use activities that would have made it difficult for the Chamber to truly claim a home in them. Indeed, in the early 1780s, petitions were circulated in the city calling for "the annihilation of taverns, coffee-houses, billiard tables, ale-houses, and theaters," suggesting that behavior within such establishments was not always reputable (quoted in Burrows and Wallace, *Gotham*, 269). A particularly plaintive example of the many appeals for a permanent home for the Chamber was issued by one of its early secretaries, Prosper Wetmore, who in 1848 wondered, "Whenever the merchants of New York shall

evince enough of public spirit to provide a suitable building for the accommodation of the chamber, and thus secure a local habitation for so ancient and honorable an association" (quoted in Charles King, *History of the New York Chamber of Commerce* [New York: New York Chamber of Commerce, 1849], 78).

11. Gulian Verplanck, Roger Alden, Brockholst Livingston, Joshua Waddington, and Carlile Pollock to Alexander Hamilton, December 29, 1791, in *The Papers of Alexander Hamilton*, ed. Harold C. Syrett (New York: Columbia University Press, 1966), 10:482; *Daily Advertiser*, quoted in I. N. Phelps Stokes, *The Iconography of Manhattan Island* (New York: Dodd, 1928), 5:1290. The city's commission for the second Hamilton full-length was issued in November 1804 and completed the following spring. At the time of both paintings' initial exhibition, City Hall was located on Wall Street in the original Federal Hall, at the same site as the building currently bearing that name (which was not constructed until 1842). The earlier structure, remodeled in 1788 by Pierre L'Enfant for use, until 1790, as the seat of the federal government, reverted after that to its municipal function until the completion in 1812 of the present City Hall farther uptown. For information on the Chamber's portrait of Hamilton, see the entry on the National Gallery of Art's bust-length version: Ellen G. Miles and Cynthia J. Mills, "*Alexander Hamilton*," in *American Paintings of the Eighteenth Century: The Collections of the National Gallery of Art, Systematic Catalogue*, ed. Ellen G. Miles (Washington, D.C.: National Gallery of Art, 1995), 303–306. Although the entry repeats the error that it was the Chamber that issued the commission, it does parse the complex relationship of Trumbull's numerous similar portraits after the Chamber of Commerce's original. For the Trumbull paintings of Washington, Clinton, and others at City Hall, see Art Commission of the City of New York, *Catalogue of the Works of Art Belonging to the City of New York*, 2 vols. (New York: Art Commission of the City of New York, 1909); and Edith Holzer and Harold Holzer, "Portraits in City Hall, New York," in *Portrait Painting in America: The Nineteenth Century*, ed. Ellen Miles (New York: Universe, 1977), 15–24.

12. The New York Institution, established in 1816 in the former Chambers Street almshouse, was for a time the city's most important place for the display of art and numbered several museums as tenants, including the American Academy, which was managed by genteel New Yorkers specifically for public uplift and to enhance civic virtue. On the loan of the portraits to the academy, see King, *History*, 87. On the academy itself, see Carrie Rebora, "The American Academy of the Fine Arts, New York, 1802–1842" (Ph.D. diss., City University of New York, 1990); Barratt, "Mapping the Venues," 50–55, 66; and Myers, "Public Display of Art," 35–36. For the New York Institution of Learned and Scientific Establishments, see Burrows and Wallace, *Gotham*, 467–468; and Myers, "Public Display of Art," 35–36. On the portraits in City Hall, see Art Commission, *Catalogue of Art Belonging to New York*; and Holzer and Holzer, "Portraits in City Hall."

13. The Merchants' Exchange was first proposed by Stephen Whitney and William Backhouse Astor, John Jacob's son and a longtime Chamber member. See Burrows

and Wallace, *Gotham*, 438–439. For a discussion of the building in the context of New York architecture of the period, see Morrison H. Heckscher, "Building the Empire City: Architects and Architecture," in Voorsanger and Howat, *Art and the Empire City*, 169–188. On the installation of the portraits there, see Bishop, *Chronicle of One Hundred & Fifty Years*, 15. Regarding totem poles, which were often set up prominently on beaches or in front of houses to announce and establish a clan's place, Hilary Stewart notes, "The function of totem poles varies somewhat among the different peoples, but overall they were historical monuments . . . of great meaning and value to the cultures that carved them. They displayed images that represented a people's origins and lineages, their rights and privileges, . . . gave the people cultural identity, and proclaimed their wealth and status in the village and within their nation" (*Looking at Totem Poles* [Seattle: University of Washington Press, 1993], 25–26). On New York's ascension as the nation's major financial center, see Burrows and Wallace, *Gotham*, 446. For additional depictions of the interior of the Merchants' Exchange, see "Works in the Exhibition: Ceramics," in Voorsanger and Howat, *Art and the Empire City*, 537, cat. no. 251; and, reproducing a print after Charles Burton's drawing (see figure 13), Gloria Deák, *Picturing New York: The City from Its Beginnings to the Present* (New York: Columbia University Press, 2000), 99. On the sculpture of Hamilton, see Thayer Tolles, "Modeling a Reputation: The American Sculptor and New York City," in Voorsanger and Howat, *Art and the Empire City*, 140–141, 144–145, 147 (the last for a description of one of the periodic exhibitions in the exchange, which drew large and diverse audiences to the building, providing further exposure for the Chamber's portraits).

14. On the Great Fire and reconstruction after it, including of the Merchants' Exchange, see Burrows and Wallace, *Gotham*, 596–601. In addition to his aquatint after Nicolino Calyo's original gouache (see figure 14), which shows the exchange as it burned, William James Bennett produced a second print, also from a gouache by Calyo, depicting the ruins of the building in the aftermath of the fire, from the opposite, Exchange Place, side. Further, the young Nathaniel Currier (later of Currier & Ives fame), just set up in the city as a printmaker that year, established his reputation with his own rendering of the exchange in flames.

15. Prosper Wetmore to Charles King, 1843, quoted in King, *History*, 77–78. An expanded and revised edition of King's history of the Chamber appeared in 1855, during the longtime Chamber member's tenure as president of Columbia University. On the Chamber at the Merchants' Bank, see Bishop, *Chronicle of One Hundred & Fifty Years*, 153–154.

16. Minutes 3:267–268 (February 6, 1844), New York Chamber of Commerce Archives, Columbia University Rare Book and Manuscript Library [hereafter, NYCC Archives]; Wetmore, quoted in King, *History*, 78.

17. An indication of the iconic treatment later accorded the Chamber's initial portraits is given by a newspaper account describing an incident in 1899 in which *Hamilton* was damaged: "The portrait is not only a work of art, but it has had an extraordi-

nary history which enhances its historic value. . . . To injure Alexander Hamilton's portrait . . . [i]s to injure one of the most sacred historic treasures in New York" ("Hamilton's Portrait Damaged," *New York Times*, May 23, 1899).

18. King's original proposal of the collection is referred to in a memorial to a later Chamber president, Abiel Abbot Low, also a major promoter of the idea. See Minutes 10:74 (February 2, 1893), NYCC Archives. The local artistic milieu in which the collection came to life factored in its creation as well, particularly the existence of P. T. Barnum's American Museum—which included a portrait gallery of great Americans—on Broadway south of City Hall Park. For a sense of the period art scene in New York, see Myers, "Public Display of Art"; and Barratt, "Mapping the Venues."

19. On the recommendations of the special committee, see Bishop, *Chronicle of One Hundred & Fifty Years*, 61. Membership information is from Bishop, *Chronicle of One Hundred & Fifty Years*, 64, 68; and Sven Beckert, *The Monied Metropolis: New York City and the Consolidation of the American Bourgeoisie, 1850–1896* (New York: Cambridge University Press, 2001), 58. The Chamber's drive for increased membership ultimately succeeded almost too well: by the mid-1870s, its ranks had swollen to 750 and eventually had to be capped at 1,000. Pliny Miles, *The New York Chamber of Commerce, with Suggestions for an Enlarged Sphere of Action* (New York: Press of Hunt's Merchants' Magazine, 1857), also appeared in the June 1857 edition of that periodical.

20. For Wetmore's collection appeal, see King, *History*, 78; for Low's, see *Eighth Annual Report of the Chamber of Commerce of the State of New York* (1865–1866) (New York: Amerman, 1866), 7 [hereafter, 8 AR (1865–1866), etc.]. On nostalgia and its implications, see Eric Hobsbawm and Terence Ranger, eds., *The Invention of Tradition* (New York: Cambridge University Press, 1983); and David Lowenthal, *The Past Is a Foreign Country* (New York: Cambridge University Press, 1985).

21. Stevens (the namesake, somewhat confusingly, of his father, himself secretary of the Chamber from 1827 to 1832), quoted in 7 AR (1864–1865), 109. For Low's enumeration of portraits acquired, see 9 AR (1866–1867), 8.

22. The first commissions were announced to the Chamber in a formal letter from Stevens—perhaps read aloud at a monthly meeting—containing biographical information on the sitter and enumerating the portrait's subscribers. See *Letters of J. A. Stevens: Portraits of Presidents of the New York Chamber of Commerce* (New York: Chamber of Commerce of the State of New York, 1865).

23. George Wilson, ed., *Portrait Gallery of the Chamber of Commerce of the State of New-York: Catalogue and Biographical Sketches* (New York: Press of the Chamber of Commerce, 1890), iv–v. The archival files for the Chamber's collection contain dozens of letters to and from portrait donors, including those making unsolicited gifts, such as Thaddeus Markley's of Charles Willson Peale's *Daniel Tompkins* (see figure 20), in the letter accompanying which Markley writes, "I therefore tender as a gift this valuable Souvenir, to your Honorable body; to be preserved and placed in your gallery of distinguished Men of this Commonwealth" (Markley to George Wilson,

November 29, 1892, New York Chamber of Commerce Collection Curatorial Files, New York State Museum, Albany [hereafter, NYCC Curatorial Files]). In other letters, such as that from Mrs. R. L. Stuart regarding a portrait of her late husband's father, Kinloch Stuart (see figure 21), it is clear that the portrait has been asked for: "I am much gratified by the request and send the portrait with pleasure" (Stuart to Chamber of Commerce, October 6, 1886, NYCC Curatorial Files).

24. 12 AR (1869–1870), 145. Wilson's significance to the collection was great, as attested by the testimonial of former Chamber president Charles S. Smith in a tribute book published after the secretary's death: "It is his collection in fact, as it is largely owing to him that the portraits now number over two hundred" (quoted in *Tribute of the Chamber of Commerce of the State of New York to the Memory of Mr. George Wilson, Secretary, 1868–1908* [n.p., 1908], 8).

25. King, *History*, 103. For the Chamber's mid-century consolidation, see the section "Engagements in Public Affairs," in Blackmar, "Exercising Power"; and Bishop, *Chronicle of One Hundred & Fifty Years*, 61–70.

26. King, quoted in *Proceedings of the Chamber of Commerce of the State of New York, at the Opening of Their New Rooms, June 10, 1858* (New York: Douglas, 1858), 5–7. For Wilson's appointment, see also *Proceedings*, 4; for the quotes from his memorial service, see *Tribute . . . to the Memory of Mr. George Wilson*, 7–8, 14. The establishment of the full-time position of Chamber secretary was one of several efforts to professionalize the organization made as part of the drive to enhance its profile and effectiveness. Another, instituted the same year as Wilson's engagement (1858), was the revision of the bylaws to establish an executive committee in addition to the officers. See 1 AR (1858), 336. A third was the publication, also beginning in 1858, of an annual report. For Low's address, see 8 AR (1865–1866), 6–8, quote on 8. For Jesup's description of the Chamber building, see Morris K. Jesup to Mr. Pinchot, April 24, 1900, NYCC Curatorial Files.

27. The arrival of the Tompkins portrait at the Chamber was announced in "Daniel D. Tompkins's Portrait," *New York Times*, December 12, 1892. On the development of American portrait galleries, actual and printed, see Paul Staiti, "The Capitalist Portrait" (this volume); Fortune, "Portraits of Virtue and Genius"; and Byvanck, "Public Portraits." For British precedents and a generally excellent account of portraiture's social embeddedness, see Marcia Pointon, *Hanging the Head: Portraiture and Social Formation in Eighteenth-Century England* (New Haven, Conn.: Yale University Press, 1993), esp. chap. 1 ("Spaces of Portrayal: Hanging and Framing"), chap. 2 ("Illustrious Heads)," and the epilogue ("'Saved from the housekeeper's room': The Foundation of the National Portrait Gallery"). Numerous specific analogues to the Chamber's collection might be adduced; one that accords closely with it, chronologically and descriptively, is Princeton University's, formed the year in which the Chamber collection was first proposed (1848) and essentially coinciding with it in terms of scope and motivating rationale. See Egbert, *Princeton Portraits*; and Kusserow, "Memory and Meaning in the Faculty Room."

28. The listing of the Chamber's leaders in its official history of 1918 promotes a similar misimpression of continuity: the tenure of its officers during periods of inactivity is extended through until replaced in the revived organization by new ones. See Bishop, *Chronicle of One Hundred & Fifty Years*, 262–265. Low's characterization of the Chamber's uneven past appeared, perhaps not coincidentally, in the same speech in which he repeatedly urged the establishment of the portrait collection. See 9 AR (1866–1867), 7. On the Chamber's inactivity during the early nineteenth century, see Bishop, *Chronicle of One Hundred & Fifty Years*, 50–52; and Walter L. Hawley, "New York's Oldest Corporation," *Munsey's Magazine* 26, no. 1 (1901): 43–44; on the political and economic reasons for it, see Burrows and Wallace, *Gotham*, 410–413, 423–428. Ray's summons to reconvene the Chamber is quoted in Bishop, *Chronicle of One Hundred & Fifty Years*, 52.

29. The 1881 statement attempting to historicize the collection was made, appropriately, by the venerable John Austin Stevens, former secretary of the Chamber and the figure responsible for the accumulation of most of the presidential portraits. See "Extract from the Proceedings of the Chamber of Commerce at a meeting held April 7, 1881," bound in "Pamphlet Publications, Chamber of Commerce, 1881," NYCC Archives. For the fallacious quote regarding the Chamber's continuous operation, see *Catalogue of Portraits in the Chamber of Commerce of the State of New York, 1768–1924* (New York: Chamber of Commerce of the State of New York, 1924), 7.

30. For Peale's gallery, see Lillian B. Miller and David C. Ward, eds., *New Perspectives on Charles Willson Peale: A 250th Anniversary Celebration* (Pittsburgh: University of Pittsburgh Press, 1991), esp. Roger B. Stein, "Charles Willson Peale's Expressive Design: The Artist in His Museum," 167–218; Charles Coleman Sellers, *Mr. Peale's Museum: Charles Willson Peale and the First Popular Museum of Natural Science and Art* (New York: Norton, 1980); David R. Brigham, *Public Culture in the Early Republic: Peale's Museum and Its Audience* (Washington, D.C.: Smithsonian Institution Press, 1995); and Fortune, "Portraits of Virtue and Genius." On the trend toward organization as a social means of attempting to control an American culture undergoing rapid change, see Robert H. Wiebe, *The Search for Order, 1877–1920* (New York: Hill and Wang, 1967). The emergence of comprehensive ordering discourses and their relation to collecting in the mid-nineteenth century are discussed in Susan M. Pearce, *On Collecting: An Investigation into Collecting in the European Tradition* (London: Routledge, 1995), 132. In regard to the importance of conformity and regularity in portrait collections with historicizing agendas, Pointon notes, "system and plenitude are always pre-eminent over and above questions of likeness" (*Hanging the Head*, 62). On collecting as a means of symbolic completion, see Russell W. Belk, "Possessions and the Extended Self," *Journal of Consumer Research* 15 (1988): 139–168, esp. 154.

31. Perit, quoted in 6 AR (1863–1864), 35.

32. "Generations of Portraits," *New York Times*, February 7, 1897; Art Commission, *Catalogue of Art Belonging to New York*, 1:ix. The Chamber's strategy of associating

itself with unaffiliated but highly reputed individuals in order to bolster its profile reflected a habit of taking credit for itself where it was not entirely due. A prime example is the group's ex post facto affiliation with Cyrus Field and the transatlantic telegraph, discussed in Karl Kusserow, "Memory, Metaphor, and Meaning in Daniel Huntington's *Atlantic Cable Projectors*" (this volume).

33. For an account of American illustrated biographies, see the section "Ideology," in Staiti, "Capitalist Portrait"; and Gordon M. Marshall, "The Golden Age of Illustrated Biographies," in *American Portrait Prints*, ed. Wendy Wick Reaves (Charlottesville: University Press of Virginia, 1984), 29–82. For changing cultural ideals of integrity and success as related to nineteenth-century businessmen, see "Ideology," in Staiti, "Capitalist Portrait"; and the section "Quotations and Sources, Pictorial and Ideological," in Kusserow, "Memory, Metaphor, and Meaning."

34. On shifts in masculinity, see the section "A Capital(ist) Character," in Kusserow, "Memory, Metaphor, and Meaning"; and, from the extensive literature on nineteenth-century American masculinity, E. Anthony Rotundo, *American Manhood: Transformations in Masculinity from the Revolution to the Modern Era* (New York: Basic Books, 1993), esp. 1–9, 10–30; David G. Pugh, *Sons of Liberty: The Masculine Mind in Nineteenth-Century America* (Westport, Conn.: Greenwood Press, 1983); and J. A. Mangan and James Walvin, eds., *Manliness and Morality: Middle-Class Masculinity in Britain and America, 1800–1940* (Manchester: Manchester University Press, 1983), esp. intro. The fluctuating reputation of businessmen, itself heavily dependent on subject position, is discussed in the following section, "The Reputation of Business(men)," of this essay. Of the general trend toward individualism, Scott Casper writes, "Virtue, once seen in civic terms as the sacrifice of private interest for the public good, was refocused as self-interest in a society where individual pursuit of self-interest was considered the highest public good" (*Constructing American Lives: Biography and Culture in Nineteenth-Century America* [Chapel Hill: University of North Carolina Press, 1999], 354n.22). See also Daniel T. Rodgers, "Republicanism: The Career of a Concept," *Journal of American History* 79 (1992): 11–38; and Richard Sennett, *The Fall of Public Man* (New York: Knopf, 1977). The quote from the portrait catalogue's preface can be found in Wilson, *Portrait Gallery*, vi. On the Abiel Abbot Low Portrait Fund, see Minutes of Committees 1:315–316 (February 27, 1894), NYCC Archives.

35. Written in 1849, in the midst of the efflorescence in biographical approaches to history, Charles King's *History* reinforces the formulation, organizing its treatment of the institution around individual leaders; only with the group's second official narrative, Joseph Bishop's *Chronicle of One Hundred & Fifty Years*, published in 1918, do issues and events come to the fore. On the use of biography to structure history, see Casper, *Constructing American Lives*; for its relationship to portraiture, see Pointon, *Hanging the Head*, esp. 53–78, and, on the formation of England's National Portrait Gallery, 227–244. On the development of an American cultural readiness for biographical projects specifically celebrating businessmen, see the section

"Merchants, Artisans, and Candidates: Biographical Manhood and the Construction of the 'Public,'" in Casper, *Constructing American Lives*, 88–106, esp. 88–91. *Yale Literary Magazine*, quoted in Casper, *Constructing American Lives*, 1; Carlyle, quoted in Pointon, *Hanging the Head*, 227.

36. On Granger, see Pointon, *Hanging the Head*, 53–78, and on Carlyle, 232. The close affinity between printed portrait galleries such as Longacre and Herring's and actual ones like the Chamber's is underscored by the former's original intent that the portraits painted in preparation for their publication's engravings form the nucleus of a national portrait gallery in Washington, D.C. As it happened, the American Academy of the Fine Arts supported the *National Portrait Gallery of Distinguished Americans* with the understanding that the portraits go instead to it. See Ellen Miles, "Collections," in Miles, *Portrait Painting in America*, 14; and Michael Quick, "Introduction," in *Artists by Themselves: Artists' Portraits from the National Academy of Design* (New York: National Academy of Design, 1983), 13.

37. Wilson, *Portrait Gallery*, vi. On major late-nineteenth-century biographical projects such as Houghton and Mifflin's "American Statesmen" and "American Men of Letters," as well as for an account of the more locally produced—and nakedly self-serving—"mug books" that derived from them, see Casper, *Constructing American Lives*, 271–318. Combining the high-toned respectability of the former with the rhetorical aspect of the latter, the Chamber's catalogue was an effective amalgam of the two types.

38. Of the tentative and variable nature of attitudes toward business during the Gilded Age, Alan Trachtenberg has noted, "The popular image of the business world held unresolved tensions: on the one hand, it seemed the field of just rewards, on the other, a realm of questionable motives and unbridled appetites" (*The Incorporation of America: Culture and Society in the Gilded Age* [New York: Hill and Wang, 1982], 81). On the rags-to-riches, self-made man, see John G. Cawelti, *Apostles of the Self-Made Man* (Chicago: University of Chicago Press, 1965); Richard M. Huber, *The American Idea of Success* (1971; repr., Wainscott, N.Y.: Pushcart Press, 1987); and Irvin G. Wyllie, *The Self-Made Man: The Myth of Rags to Riches* (New York: Free Press, 1954). For the relationship of that archetype to the Chamber and its portraits, see the section "Typology," in Staiti, "Capitalist Portrait." On the broader reputation of the American businessman—a largely disappointing literature, perhaps resulting from the topic's unwieldy nature—see Earl F. Cheit, ed., *The Business Establishment* (New York: Wiley, 1964); Sigmund Diamond, *The Reputation of the American Businessman* (Cambridge, Mass.: Harvard University Press, 1955); Louis Galambos, *The Public Image of Big Business in America, 1880–1940* (Baltimore: Johns Hopkins University Press, 1975); Edward C. Kirkland, *Business in the Gilded Age: The Conservatives' Balance Sheet* (Madison: University of Wisconsin Press, 1952); and, most usefully, even though it deals with only a segment of the business community, Steve Fraser, *Every Man a Speculator: A History of Wall Street in American Life* (New York: HarperCollins, 2005).

39. On the "prosperity" of the Gilded Age, see Fraser, *Every Man a Speculator*, 111–112. For an extended treatment of the transition from crass speculator to esteemed financier, see 70–192, 248–249.

40. On the distinction between legitimate and illegitimate wealth, see Fraser, *Every Man a Speculator*, 108–111.

41. The subjectivity of views about business is foregrounded in Kirkland, *Business in the Gilded Age*, which assesses contemporary perceptions of late-nineteenth-century businessmen from three divergent but representative perspectives; in *Public Image of Big Business*, Galambos analyzes the same topic more quantitatively among various socioeconomic groups over time. The pervasively negative image of literary representations of American businessman is treated in Emily Stipes Watts, *The Businessman in American Literature* (Athens: University of Georgia Press, 1982). See also Walter Benn Michaels, *The Gold Standard and the Logic of Naturalism* (Berkeley: University of California Press, 1987); and Henry Nash Smith, "The Search for a Capitalist Hero: Businessmen in American Fiction," in Cheit, *Business Establishment*, 77–112. The latter addresses in particular the disparity between businessmen's "high status in American popular culture" as against the "hostility or derision" with which they were usually treated in literature, and seeks to account for the difference. For examples of the profession's generally solid esteem among the broad public, see virtually any of the mainstream postbellum periodical publications; *The Century*, *Cosmopolitan*, and *Munsey's*, among numerous others, were especially laudatory.

42. Writing of similarly rhetorical portraits of doctors and scientists, Ludmilla Jordanova has noted, "[Portraiture] constructs not just the identity of the artist and sitter, but that of institutions with which they are associated" (*Defining Features: Scientific and Medical Portraits, 1650–2000* [London: Reaktion Books, 2000], 19–20). See also Ludmilla Jordanova, "Medical Men, 1780–1820," in *Portraiture: Facing the Subject*, ed. Joanna Woodall (Manchester: Manchester University Press, 1997), 101–115.

43. For a thorough account of New York's social evolution during the nineteenth century, including its comparison with that of other cities, see Frederic Cople Jaher, *The Urban Establishment: Upper Strata in Boston, New York, Charleston, Chicago, and Los Angeles* (Urbana: University of Illinois Press, 1982), esp. 157–315.

44. The story of the rise of the new rich over the protests of the old in nineteenth-century New York has been told both in the literature of the period and in later historical accounts of the era. Among the latter, it is rehearsed in brief in Burrows and Wallace, *Gotham*, 712–734, esp. 712–714; further discussed in Jaher, *Urban Establishment*, 250–281; and more fully described in Beckert, *Monied Metropolis*, 17–97, esp. 51–75.

45. The larger narrative of the bourgeoisie's consolidation, as analyzed from economic, political, and social vantage points, is the subject of Beckert, *Monied Metropolis*. See also Sven Beckert and Julia B. Rosenbaum, eds., *The American Bourgeoisie: Distinction and Identity in the Nineteenth Century* (New York: Palgrave Macmillan, 2010), whose essays—esp. Beckert, "Bourgeois Institution Builders: New York in the Nineteenth Century," 103–117—collectively demonstrate that economic

status proved the decisive factor in bourgeois class formation, trumping finer distinctions. On the social constitution of art patrons in New York versus those of Philadelphia and Boston, see Neil Harris, *The Artist in American Society: The Formative Years, 1790–1860* (New York: Clarion, 1966), 275–282. For the early linkage of art patronage with establishing social position, see Wayne Craven, "Introduction: Patronage and Collecting in America, 1800–1835," in Ella M. Foshay, *Mr. Luman Reed's Picture Gallery: A Pioneer Collection of American Art* (New York: Abrams, 1990), 11–18. The practice of newly rich businessmen attempting to legitimize themselves by acquiring art was widely recognized, even appearing in the literature of the period, as discussed in Watts, *Businessman in American Literature*. Pierre Bourdieu has been an essential theorizer of collecting as a means of acquiring social capital; in *Distinction: A Social Critique of the Judgment of Taste*, trans. Richard Nice (Cambridge, Mass.: Harvard University Press, 1984), he considers material possessions as representing an individual's or an institution's claim to cultural power. More generally, the literature on the economic, cultural, and especially social implications of collecting has lately burgeoned; for a brief but useful historiography, see Leah Dilworth, introduction to *Acts of Possession: Collecting in America* (New Brunswick, N.J.: Rutgers University Press, 2003), esp. 5–6.

46. Of the social motivations for collecting, Russell W. Belk and Melanie Wellendorf have noted, "Those who acquire money through what are regarded as evil sources may try to culturally 'launder' it by putting it to sacred uses" ("The Sacred Meanings of Money," *Journal of Economic Psychology* 11 [1990]: 56). Choate, quoted in Russell W. Belk, *Collecting in a Consumer Society* (London: Routledge, 1995), 116–117, in which Belk also discusses Theodore Dreiser's *Trilogy of Desire* (*The Financier* [1912], *The Titan* [1914], and *The Stoic* [begun 1920s]), whose protagonist, Frank Algernon Cowperwood, collects art in an attempt to "cleanse" riches obtained in the still "dirty" business of banking and finance.

47. Of the Chamber's idealized self-conception, Thomas Kessner writes, "From its early days, the Chamber of Commerce had always seen itself as a group of principled city leaders who happened to be merchants. They recognized no conflict between high-minded public interest and their exclusively commercial makeup" (*Capital City: New York City and the Men Behind America's Rise to Economic Dominance, 1860–1900* [New York: Simon and Schuster, 2003], 198). On Gideon Lee, see Wilson, *Portrait Gallery*, 110–114, quotes on 111, 114. On the instructive uses of biography during the period, see Casper, *Constructing American Lives*. The phrase "the mind's construction in the face" is from Shakespeare's *Macbeth* (1.4.14).

48. For an account of Carlyle's conception of portraiture and physiognomy as indices of character, see Michael K. Goldberg, introduction to Thomas Carlyle, *On Heroes, Hero-Worship, and the Heroic in History*, ed. Michael K. Goldberg, Joel J. Brattin, and Mark Engel, Norman and Charlotte Strouse Edition of the Writings of Thomas Carlyle (Berkeley: University of California Press, 1993), xxxv–xxxix. For more on

Carlyle and portraiture's didactic use, particularly as it relates to the establishment of the National Portrait Gallery, see Paul Barlow, "Facing the Past and Present: The National Portrait Gallery and the Search for 'Authentic' Portraiture," in Woodall, *Portraiture*, 219–238, and "The Imagined Hero as Incarnate Sign: Thomas Carlyle and the Mythology of the 'National Portrait' in Victorian Britain," *Art History* 17, no. 4 (1994): 517–545. Palmerston, quoted in Susan Foister et al., *The National Portrait Gallery Collection* (London: National Portrait Gallery, 1988), 112. See also Lord Stanhope's speech on the same subject, in "The National Portrait Gallery, London, Comes into Being in 1856," in *The Collector's Voice: Critical Readings in the Practice of Collecting*, vol. 3, *Imperial Voices*, ed. Susan Pearce et al. (Burlington, Vt.: Ashgate, 2002), 23–26.

49. For Peale's gallery, see Miller and Ward, eds., *New Perspectives on Charles Willson Peale*; Brigham, *Public Culture in the Early Republic*; Fortune, "Portraits of Virtue and Genius"; and, especially on its later history, Sellers, *Mr. Peale's Museum*, 330–331. Alexander E. Orr, quoted in *Tribute . . . to the Memory of George Wilson*, 15; Smith, quoted in 37 AR (1894–1895), 95.

50. Quoted in Peter P. Grey, *The First Two Centuries . . . : An Informal History of the New York Chamber of Commerce* (New York: New York Chamber of Commerce, 1968), 33. For the building's opening ceremonies, see George Wilson, ed., *Opening of the Building of the Chamber of Commerce of the State of New York and Banquet in Honor of the Guests Who Attended the Dedicatory Ceremonies . . .* (New York: Press of the Chamber of Commerce, 1902). On the building itself and the implications of its style, scale, and plan, see Daniel Bluestone, "Portraits in the Great Hall: The Chamber's 'Voice' on Liberty Street" (this volume); and Bishop, *Chronicle of One Hundred & Fifty Years*, 155–163.

51. On the Great Hall, see Bluestone, "Portraits in the Great Hall"; and Grey, *First Two Centuries*, 38–42. For the installation of the portraits there, see the section "Display," in David Barquist, "'The Whole Lustre of Gold': Framing and Displaying Power at the Chamber of Commerce" (this volume). On the Chamber's significance within New York's power structure, see David C. Hammack, *Power and Society: Greater New York at the Turn of the Century* (New York: Russell Sage Foundation, 1982), 52; Hammack quotes municipal advocate Albert Shaw's assertion, made in 1897, that New Yorkers "are governed in this city today, and governed splendidly, by the New York Chamber of Commerce" (13).

52. Interestingly, the Hall of Fame ceased electing new members in 1976, only a few years after the Chamber commissioned its final portrait, an additional parallel between the two indicating that, in the wake of the 1960s, conceptions about individual "greatness"—how to define it, and how (or whether) to acknowledge it—had moved irretrievably beyond such monumental protocols. For White's University Heights campus and its Hall of Fame, see Leland M. Roth, *McKim, Mead & White, Architects* (New York: Harper & Row, 1983), 185–190; Mimi Sheraton, "Yesterday's

Heroes, Up on Pedestals," *New York Times*, December 15, 2000; and, especially, Sally Webster, "America Celebrates Its Past: The Hall of Fame of Great Americans," *CRM: The Journal of Heritage Stewardship* 18, no. 1 (1995): 5–7.

53. "The Point of View," *Scribner's Magazine*, August 1902, 252–253.

54. Quoted in Trachtenberg, *Incorporation of America*, 86. The corporatization of the United States, among its most profound historical developments, has produced a broad literature: a good summary is Galambos, "The Large-Scale Organization in Modern America," in *Public Image of Big Business*, 3–21; for book-length treatments focusing generally on the shift, see Olivier Zunz, *Making America Corporate, 1870–1920* (Chicago: University of Chicago Press, 1990); and, especially, Martin J. Sklar, *The Corporate Reconstruction of American Capitalism, 1890–1916* (New York: Cambridge University Press, 1988); a critical overview, with a useful focus on the legal history and framework pertaining to modern corporations, is Ted Nace, *Gangs of America: The Rise of Corporate Power and the Disabling of Democracy* (San Francisco: Berrett-Koehler, 2003); on the cultural implications, see Trachtenberg, *Incorporation of America*; for a discussion focusing on Wall Street's role, but also providing a sense of Americans' vastly divergent views on the movement, see Fraser, *Every Man a Speculator*, esp. chaps. 5–7; on the social consequences in New York City, see Beckert, *Monied Metropolis*, esp. chap. 8; and as it related to and was played out within the Chamber of Commerce, see the section "Corporate Officers," in Blackmar, "Exercising Power."

55. On Tocqueville and "individualism," and for a larger treatment of the theme as against organization in American culture, see John William Ward, "The Ideal of Individualism and the Reality of Organization," in Cheit, *Business Establishment*, 37–76. Of course, the effects of corporatization on individualism were but a part of the era's broader debate on the diminished autonomy resulting from the urban-industrial transformation. On this and the antimodernism it spawned, see T. J. Jackson Lears, *No Place of Grace: Antimodernism and the Transformation of American Culture, 1880–1920* (Chicago: University of Chicago Press, 1981). Information on Perkins is from William Miller, "The Business Elite in Business Bureaucracies," in *Men in Business: Essays in the Historical Role of the Entrepreneur*, ed. William Miller (1952; repr., New York: Harper & Row, 1962), 292–293; it should be noted that a less high-minded reason for Perkins's resignation may have been widespread suspicion about the unseemly conflict of interest that his dual positions at the two firms aroused. Dill's speech, delivered in June 1900, was adapted and reprinted as "The College Man and the Corporate Proposition," *Munsey's Magazine*, October 1900, 148–152, quote on 152.

56. A major stimulus to the corporatization juggernaut occurred in 1886, when a business-friendly United States Supreme Court ruled in *Santa Clara v. Southern Pacific Railroad* that commercial corporations were legal "persons," as such vested with many of the rights and protections accorded actual American citizens. The Court's ruling, a perversion of the Constitution's Fourteenth Amendment on behalf of cor-

porate interests to expand their power, helped produce an environment in which corporations were assured a widening range of constitutional rights—an unsurprising development in light of several justices' previous work as attorneys for railroad corporations and the particular support of Justice Stephen J. Field, who in an 1882 opinion stated, "There is nothing which is lawful to be done to feed and clothe our people, to beautify and adorn their dwellings, to relieve the sick, to help the needy, and to enrich and ennoble humanity, which is not to a great extent done through the instrumentalities of corporations" (quoted in Nace, *Gangs of America*, 87; see also, more generally, "The Judge: Stephen Field and the Politics of Personhood [1868–1885]," 87–101; Nace deals extensively as well with *Santa Clara v. Southern Pacific Railroad*). With the supportive legal framework and political wherewithal in place for the incorporation of America, business interests set about doing just that, in the decade between 1895 and 1904 alone causing eighteen hundred firms to vanish in corporate mergers. Corporations affiliated with other corporations, forming trusts and cartels that further stifled competition, a situation only momentarily complicated by the passage of the Sherman Antitrust Act in 1890, which technically prohibited them but stood unenforced for years—and which had been more or less obviated anyway by judicial acceptance of a law (drafted by the same James B. Dill mentioned earlier) legalizing still larger corporate holding companies in place of trusts. By 1909, 1 percent of the nation's industrial firms produced an astounding 44 percent of the value of manufactured goods, and in that same year 5 percent of those firms employed an equally incredible 62 percent of wage earners. For these figures on incorporation and its effects, see Fraser, *Every Man a Speculator*, 171. With corporate dominance of the economy and the country's workers on such an unheard-of scale, it actually made a certain sense for its leaders to cast the nation itself in those same terms, as when railroad tycoon and Chamber officer James J. Hill referred to the president as a sort of board chairman of "a great economic corporation known as the United States of America" (quoted in Fraser, *Every Man a Speculator*, 177). For Dill's solution to antitrust legislation, see Frederick Lewis Allen, *The Big Change: America Transforms Itself, 1900–1950* (Piscataway, N.J.: Transaction, 1993), 75–76; and Burrows and Wallace, *Gotham*, 1045.

57. On pragmatism, see Louis Menand, *The Metaphysical Club* (New York: Farrar, Straus and Giroux, 2001), esp. 371, for its influence on modes of business. On the move from laissez faire toward increased organization and regulation, see Harold U. Faulkner, *The Decline of Laissez Faire, 1897–1917* (1951; repr., White Plains, N.Y.: Sharpe, 1977); and Wiebe, *Search for Order*. Croly, quoted in Zunz, *Making America Corporate*, 13. On *The Octopus*, see Watts, *Businessman in American Literature*, 103–113, esp. 104.

58. Dill, "College Man," 149.

59. Hawley, "New York's Oldest Corporation"; Newton's speech is noted in 27 AR (1884–1885), 57; Seward, quoted in *Tribute . . . to the Memory of Mr. George Wilson*, 5.

60. "The Chamber of Commerce," *New York Times*, Magazine Supplement, January 24, 1897, 8–11, quote on 11.

61. For a listing of the Chamber's many committees in its sesquicentennial year (1918), see Bishop, *Chronicle of One Hundred & Fifty Years*, 266–270. The observation about the progression toward collective identity in Dreiser's novels is from Philip Fisher: "Being 'one of' is a more precise matter than being [an individual]. . . . Experiencing oneself as 'one of' this or 'one of' that is the primary way of constituting a self" (*Hard Facts: Setting and Form in the American Novel* [New York: Oxford University Press, 1986], 143); Eric Sundquist states of the period's naturalist works, generally, that "naturalism dramatizes the loss of individuality" ("The Country of the Blue," in *American Realism: New Essays*, ed. Eric Sundquist [Baltimore: Johns Hopkins University Press, 1982], 13). Trachtenberg has observed the paradox inherent in the era's successive, even simultaneous embrace of both the robber baron archetype and corporate capitalism: "Within the age of the robber barons, another age and another form took shape, that of the giant corporate body. The age of celebrated individualism harbored the decisive decline of proprietors, family businesses, simple partnerships: the familiar forms of capital" (*Incorporation of America*, 82).

62. Of the comprehension, ironically, of corporatism in terms of individualism, Trachtenberg has noted, "Corporate life . . . was still too new for Americans to recognize except in the familiar but already outmoded language of individualism" (*Incorporation of America*, 5). Sarah Burns, in the context of the art of Winslow Homer, has written compellingly of the reconciliation of the two:

 [Incorporation] was the refitting of the individual to function effectively as part of an intricate, bureaucratic, and strongly hierarchical system while being reassured that his singularity counted for something. The process of centralizing and systematizing work, management, professions, and government represented a mode of modernity engaged in retooling society as a smoothly running engine in which consoling vestiges of individual autonomy meshed soundlessly with an enveloping corporate authority. . . . [T]he essence of modernity was a harmonious blend of 'incorporated' structures and pursuits, judiciously played against insistent proclamations of individuality. (*Inventing the American Artist: Art and Culture in the Gilded Age* [New Haven, Conn.: Yale University Press, 1996], 31)

 On this, see also Miller, "Business Elite."

63. On the assimilation of proprietary interests into corporate culture, see Beckert, *Monied Metropolis*, esp. 331–332.

64. For the Pujo Committee and the Federal Reserve and Clayton Antitrust Acts, as well as for a sense of the atmosphere in the Chamber's Wall Street environs and attitudes toward business generally during World War I and into the 1920s, see Fraser, *Every Man a Speculator*, 281–408.

65. Chase, quoted in Fraser, *Every Man a Speculator*, 375. For Henry Ford in opinion polls, see Jack Beatty, "The Business of America," in *Colossus: How the Corporation Changed America*, ed. Jack Beatty (New York: Broadway Books, 2001), 256.

Hepburn, quoted in 53 AR (1910–1911), 57. Calvin Coolidge's famous quote is from "The Press Under a Free Government" (speech delivered before the American Society of Newspaper Editors, Washington, D.C., January 17, 1925); Hoover, quoted in Stephen L. Elkin, *Reconstructing the Commercial Republic* (Chicago: University of Chicago Press, 2006), 58.

66. The historicization of the collection both advanced and recapitulated a similar process ongoing in the institution itself, one reflected in the publication in 1918 of its major sesquicentennial history: Bishop's 311-page *Chronicle of One Hundred & Fifty Years: The Chamber of Commerce of the State of New York, 1768–1918*. On the surge of interest in historical American portraiture cresting during the 1910s and 1920s, and for the market in fakes during that period, see Richard H. Saunders, "The Eighteenth-Century Portrait in American Culture of the Nineteenth and Twentieth Centuries," in *The Portrait in Eighteenth-Century America*, ed. Ellen G. Miles (Newark: University of Delaware Press, 1998), 138–152. The Hudson-Fulton Celebration jointly commemorated the tercentennial of Henry Hudson's discovery of the river that bears his name and the centennial of Robert Fulton's first successful navigation by steamship on it. The Chamber's collection was trumpeted as "Valued at More Than $10,000,000," in "The Founders of Industrial America," *New York Times*, Rotogravure Picture Section, November 23, 1924. "Dignity of age," quote from Walker, "Hall of Fame." For a discussion of Wallace Nutting's cultural implications, see Thomas Andrew Denenberg, *Wallace Nutting and the Invention of Old America* (New Haven, Conn.: Yale University Press, 2003); for information on Colonial Williamsburg and the broader Colonial Revival that flourished between 1880 and 1940, see Alan Axelrod, ed., *The Colonial Revival in America* (New York: Norton, 1985). On certain contemporary art that addressed some of the concerns indicated by the period's embrace of historical portraiture, see Sarah Burns, *Pastoral Inventions: Rural Life in Nineteenth-Century American Life and Culture* (Philadelphia: Temple University Press, 1989), esp. pt. 3 ("The Anxieties of Nostalgia"); and David M. Lubin, "Masculinity, Nostalgia, and the Trompe-l'Oeil Still-Life Paintings of William Harnett," in *Picturing a Nation: Art and Social Change in Nineteenth-Century American Culture* (New Haven, Conn.: Yale University Press, 1994), 273–320. For America's development of its historical past, see Michael Kammen, *Mystic Chords of Memory: The Transformation of Tradition in American Culture* (New York: Vintage, 1991), esp. pt. 3, on the period 1915 to 1945; and, for the related antimodernism during the era in question, see Lears, *No Place of Grace*.

67. "Art: Exhibitions of the Week—Chamber of Commerce Portraits," *New York Times*, November 9, 1924; Susan Danly, *Facing the Past: Nineteenth-Century Portraits from the Collection of the Pennsylvania Academy of the Fine Arts* (Philadelphia: Pennsylvania Academy of the Fine Arts, 1992), 24.

68. The Advisory Committee on Portraits is proposed, is reported as established, and has its duties described ("to pass upon the artist . . . ") in, respectively, Minutes of Committees 4:177 (Executive Committee Meeting, April 27, 1920); Minutes of

Committees 4:182 (Executive Committee Meeting, May 25, 1920); and Minutes of Committees 5:91–92 (Executive Committee Meeting, September 23, 1924), all in NYCC Archives; see also 63 AR (1920–1921), 2. For the Executive Committee–Darwin Kingsley exchange ("more attention should be given"/"we want good portraits"), see 67 AR (1924–1925), 64. Kingsley's statement offers an instructive contrast to the one in the preface to the Chamber's 1890 collection catalogue beginning: "The purpose of this collection has not been so much to gather fine specimens of the art of portraiture" (Wilson, *Portrait Gallery*, vi). For "easel in the Great Hall," see Minutes of Committees 5:144 (Executive Committee Meeting, April 28, 1925), NYCC Archives. The Advisory Committee's other members were Michael Friedsam and A. Augustus Healy, both noted collectors. The proposal of "Mr. Bush" is recorded in Minutes of Committees 5:149 (Executive Committee Meeting, April 28, 1925), NYCC Archives; the painting by "Inniss" (George Inness Jr. [1853–1926], son of the better-known artist of the same name) referred to—a moralizing religious picture—was recorded during the 1930s as owned by the Church of the Good Shepherd, Tarpon Springs, Fla.; according to a *Time* magazine article appearing after Inness's death the year following Bush's proposal, the Executive Committee may have regretted its decision: "Last year one of his pictures, *The Only Hope*, an elaborate cartoon of the world's return to Christ, set the New York Chamber of Commerce simmering. Chamberman Irving T. Bush wanted to send the picture on tour as a tract, but some of his fellow members insisted that the title, applied to a pale Christ lifted above a shrapnel-spattered court, would be an insult to the Jews. Newspapermen described the controversy; divines dealt with the subject; critics alone kept silent" ("Inness," *Time*, August 9, 1926). Along with the new concern for quality, systematic conservation—or, in contemporary parlance, "renovation"—of the portraits began as well during the 1920s, part of the larger initiative to more professionally manage the collection. See "Chamber Repairs Pictures," *New York Times*, July 14, 1928.

69. For the catalogues discussed here, see Wilson, *Portrait Gallery*; *Catalogue of Portraits*; and *Supplement to the Catalogue of Portraits in the Chamber of Commerce of the State of New York* (New York: Chamber of Commerce of the State of New York, 1941). Between the 1890 and 1924 catalogues, the Chamber also distributed several brief checklists of the collection. In asserting that the 1890 catalogue's exclusion of images as against the 1924 edition's inclusion of them was conceptually (as opposed to technologically) determined, it should be noted that when the former appeared, newspapers had been running halftone photographic illustrations for a decade—hence the decision not to include them in the Chamber's otherwise lavish publication was a matter of choice, not technical (or financial) exigency.

70. Quote from "The Portrait Catalogue," *Monthly Bulletin* [of the New York Chamber of Commerce], January 1925, 35. The connection between the Chamber's 1924 catalogue and exhibition initiatives is indicated by a notice announcing the latter in *Monthly Bulletin*, November 1924, 2; both should be considered in the context

of Thorstein Veblen's contemporary observation that "esteem is awarded only on evidence" (*The Theory of the Leisure Class: An Economic Study of Institutions* [1925], quoted in Pointon, *Hanging the Head*, 13). For the *Times*'s coverage of the exhibition, see "Art: Exhibitions of the Week"; "Nation Makers' Portraits on Public View This Week," *New York Times*, November 23, 1924; and, for the portrait collage, "Founders of Industrial America."

71. With regard to the crash's long-term influence on the market, Fraser notes that it was a quarter of a century before the Dow Jones average regained its 1929 levels, and more than three decades until trading volume surpassed the highs of that year, in *Every Man a Speculator*, 479; for Dow Jones Industrial Average and unemployment figures, see 415; for Wilson, 420; for the crash and its effects on the Chamber's Wall Street milieu generally, pt. 3 ("The Age of Ignominy"), esp. chaps. 12 and 13.

72. On polls and surveys investigating the postwar reputation of business, see Joseph W. McGuire, *Business and Society* (Lawrence: University Press of Kansas, 1963), 193.

73. David Riesman, with Nathan Glazer and Reuel Denney, *The Lonely Crowd: Study of the Changing American Character* (New Haven, Conn.: Yale University Press, 1950), was a best seller, indicating the broad resonance of the book's argument. C. Wright Mills, *White Collar: The American Middle Classes* (New York: Oxford University Press, 1951), 182; see also Mills's related, but less influential, *The Power Elite* (New York: Oxford University Press, 1956). On the transition from character to personality postulated by Mills as later described in terms of masculinity, see Warren Susman, "'Personality' and the Making of Twentieth-Century Culture," in *New Directions in American Intellectual History*, ed. John Higham and Paul Conkin (Baltimore: Johns Hopkins University Press, 1979), 212–226, and *Culture as History: The Transformation of American Society in the Twentieth Century* (New York: Pantheon, 1984); and Tom Pendergast, *Creating the Modern Man: American Magazines and Consumer Culture, 1900–1950* (Columbia: University of Missouri Press, 2000). William Whyte, introduction to *The Organization Man*, in *The Essential William H. Whyte*, ed. Albert Lafarge (Bronx, N.Y.: Fordham University Press, 2000), 79, and *The Organization Man* (New York: Simon and Schuster, 1956), 3. When Whyte's book was published, he was an editor at the business magazine *Fortune*, which lent his account an insider's credibility.

74. On changing constructions of businessmen in literature, see Smith, "Search for a Capitalist Hero." Of the nature and objective of official portraiture, Jean-Paul Sartre said that it "defends a man against himself" and his "too human reflection" ("Official Portraits," in *Essays in Phenomenology*, ed. Maurice Natanson [The Hague: Nijhoff, 1966]).

75. The ponderous atmosphere created by the roughly 190 portraits crammed on all sides into the single space cannot be adequately captured in a single photograph, but the experience of it must have been quite different from the days when only a hundred or so paintings were installed there.

76. For the confrontation of representational portraiture with the advent of both abstraction and photography—which threatened to render it respectively stylistically passé and functionally obsolete—going back to its mid-nineteenth-century roots (and for citations to brief discussions of the conundrum during the twentieth century), see Heather McPherson, *The Modern Portrait in Nineteenth-Century France* (New York: Cambridge University Press, 2001), esp. 1–13, 198–202; and Van Deren Coke, *The Painter and the Photograph: From Delacroix to Warhol* (Albuquerque: University of New Mexico Press, 1972). Reflecting the prevailingly dim view of the genre in the postwar era, on August 4, 1952, *Time* declared, "Few artists prefer portraiture to other forms of painting; very few excel at it. Portraits afford little opportunity for imagination or self-expression"; a quarter-century later, the magazine's verdict was the same: "The social [as against avant-garde] portrait seems exhausted now, a cultural irrelevance" (Robert Hughes, "Mirror, Mirror on the Wall," *Time*, December 3, 1979).

77. For a discussion of American modernism in terms of the interrelationship between visuality and corporate and political interests, see Terry Smith, *Making the Modern: Industry, Art, and Design in America* (Chicago: University of Chicago Press, 1993). For the "Informal History," see Grey, *First Two Centuries*; the use of the ellipsis in the publication's title seems also to insinuate a desired continuity.

78. Grey, *First Two Centuries*, 42.

79. Executive Committee Minutes 10:359 (April 20, 1972), NYCC Archives.

80. It is possible that one portrait, that of Gilbert Fitzhugh, who succeeded Bates as president, postdates Frances Bates's painting of her husband. The Fitzhugh portrait, which the Chamber gave, around 1985, to the Metropolitan Life Insurance Company, of which he was also president, is signed "C. J. Fox." As such, it is one of scores of works probably executed by Russian émigré artist Irving Resnikoff for Miami "entrepreneur" Leo Fox, who for decades passed himself off as painter Charles J. Fox, allegedly the son of a distinguished Austrian artist. Through this persona, the well-connected Fox garnered portrait commissions from the likes of Louis Brandeis, William Randolph Hearst, and both President John F. Kennedy and Robert Kennedy, only to have Resnikoff or another artist execute the paintings from photographs for a small fraction of the fee charged by Fox, who could not paint. The con was ultimately discovered, and Fox was brought to trial in 1978 on charges of having evaded $40,000 in taxes on the income it produced. See "The Sly Fox," *Time*, March 13, 1978. Since Fox had been working the scam for more than forty years when he was found out in the mid-1970s, the portrait of Fitzhugh was most likely produced before the 1972 painting of Bates (whose attribution to Frances Bates is presumably secure).

81. Rockefeller, quoted in Grey, *First Two Centuries*, 43.

82. Throughout the late 1970s, as the Chamber wrestled with its future, it entertained numerous scenarios for the archives, the portraits, the building, and of course for itself—the often antithetical nature of the propositions suggesting the severity of

the institution's identity crisis. In 1980, after it declined to sell its archives, a plan was proposed for professionally organizing and restoring them at a projected cost of $242,000. Only $8,000 was actually expended, to cover the costs of an initial survey of the collection conducted by Jo Ann Neman, a student in New York University's Program in Archival Management and Historical Editing. On at least two occasions, Michael Lutzker, the program's director, wrote to Chamber of Commerce chairman David Rockefeller (a new title, reflecting the group's now corporate board–style organization) requesting additional funding, apparently never receiving a response. (Information on archive restoration project from NYCC Archives.) In 1997, while conducting research for this volume in the Chamber's archives, then languishing in a non-climate-controlled Brooklyn storage space, the author and Columbia University historian Elizabeth Blackmar, recognizing their significance, initiated an effort to have them donated to Columbia's Rare Book and Manuscript Library. With the encouragement and assistance of Jean Ashton, then the library's director, this was finally accomplished in 2004, and the materials, which constitute a unique record of New York's commercial evolution over two centuries, have now been catalogued and conserved. See, for a sampling, Jim Rasenberger, "The Art of the Deal, Gilded Age Style," *New York Times*, December 26, 2004; see also "New York Chamber of Commerce Archives Come to Columbia University Libraries," http://library.columbia.edu/news/libraries/2005/20050303_chamber_archives .html; http://processingnycc.blogspot.com/, a blog devoted to the cataloguing project; and http://www.columbia.edu/cu/lweb/archival/collections/ldpd_6621724/ index.html, the library's index to the materials. "Evidence of the revitalization" from Oscar Dunn, "Review of the New York Chamber of Commerce Office Location Issue," July 11, 1977, NYCC Archives. For the later institutional history of the Chamber generally, see the section "'The Power Elite' and the Decline of the Chamber of Commerce," in Blackmar, "Exercising Power."

83. For the "National Portrait Gallery of American Business Leaders," see Daniel B. Curll III (vice president, Chamber of Commerce) to Marvin Sadik (director, National Portrait Gallery, Smithsonian Institution), November 9, 1977; and Sadik to Curll, November 16, 1977, both in NYCC Archives. The Chamber's "perpetual" lease on the Great Hall is noted in Michael Brenson, "For Business Group, Art Is a Moving Problem," *New York Times*, June 9, 1982. Memorandum, "Portraits We Should Keep," n.d., NYCC Archives. The Hamilton portrait was offered for sale in 1980 in a catalogue issued by Hirschl & Adler Galleries; the Chamber's disposal of it elicited some unfavorable press, as seen in "Rockefeller Group's Artful Sales," *New York Magazine*, October 3, 1983, 13.

84. The Chamber's self-conscious effort to update its image to a more "current" and "cutting edge" profile was described to the author in an October 3, 1996, conversation with Steve Scoppetta, the organization's longtime director of facilities. "Address broader social and economic problems" from Partnership for New York City, "History," http://www.nycp.org/history.html. The entry for the Partnership

in *The Encyclopedia of New York City* illustrates how differently it operates (and is perceived) from the Chamber: "A coalition of leaders in business, nonprofit organizations, and education formed in 1979 by David Rockefeller to work with government agencies on economic development, education, and housing" (Rosalie Genevro, "New York City Partnership," in Jackson, *Encyclopedia of New York City*, 827). Similarly, Rockefeller's autobiography features a section on the organization that constructs it quite differently from the Chamber, including a telling characterization of the Chamber's relationship to the Partnership, which Rockefeller apparently considered the senior entity from the start: "[W]e decided to retain the New York City Chamber of Commerce as a subsidiary in order to legally lobby in New York, Albany, and Washington"; Rockefeller's gloss on the move uptown is also revealing: "[T]o symbolize our new citywide vision [that is, one not tethered to Wall Street], we moved our headquarters from the Chamber's old building in lower Manhattan to a new office in Midtown" ("Creating a Lasting Partnership," in David Rockefeller, *Memoirs* [New York: Random House, 2002], 400–403, quotes on 401). Around the same time as the Chamber "affiliated" with the Partnership, it joined with another more broad-based group, the Economic Development Council, a union that, like the one between Rockefeller's Chamber and Partnership, must have been facilitated by the circumstance of both groups having once been led by the same person: George Champion, another Chase executive.

85. Sigmund Freud described the "family romance" as a child's fantasy of "getting free from the parents of whom he now has a low opinion and of replacing them by others" ("Family Romances," in *The Standard Edition of the Complete Psychological Works of Sigmund Freud*, trans. James Strachey [London: Hogarth Press, 1959], 9:238–239). The term has, however, been more liberally used in literary criticism to refer not just to individual psyches but to the broader (social, institutional) collective unconscious; for an example of this sort of adaptation, see Hunt, *Family Romance*. The sale of the Hamilton portrait prompted a comment from "a Chamber insider" that suggests that the portraits' deaccessioning was indeed viewed negatively by some as a callous means of advancing its new associate's agenda: "The Chamber's patrimony is being sold off to sustain the Partnership" ("Rockefeller Group's Artful Sales," 13).

86. DLJ purchased the Chamber's portraits of Hamilton and Washington from art dealers in 1983; the rest were bought the next year directly from the organization. The firm had been collecting American art—mostly nineteenth-century works on paper but also paintings, decorative art, and historical documents—since 1967, ultimately amassing a museum-quality collection of 8,000 objects. (This and other information on DLJ and its collection derives from my status as an art consultant there during the 1990s.)

87. Encapsulating the common incentives for the practice, Annamma Joy writes, "Corporate art collections . . . are one of many ways in which management attempts to construct and manage meaning within and outside the organization. Art objects thus come to be used as a visual statement of the essence of the organization";

relating corporate collecting to past traditions, she continues, "Insofar as image management through art collections is viewed as critical to organizational functioning, corporations today are not unlike the wealthy patrons of the past" ("The Modern Medicis: Corporations as Consumers of Art," in *Research in Consumer Behavior*, ed. Janeen Arnold Costa and Russell W. Belk [Greenwich, Conn.: JAI Press, 1993], 6:50). Similarly, if more darkly, Belk notes, "Where once merchants sought to launder their individual reputations through ownership and eventual donation of art to public museums, now corporations seek to sanitize their reputations by ownership and display of art which they hold as an investment. Such collections do for corporations what museums do for municipalities and nations" (*Collecting in a Consumer Society*, 117). See also Rosanne Martorella, *Corporate Art* (New Brunswick, N.J.: Rutgers University Press, 1990). Regarding the impetus for DLJ's and many other corporations' collecting, while it may originally have been provided by individual executives, its extenuation and growth beyond their tenure (as at DLJ) indicates the acceptance and appeal of a particular "look" and the identification of its role and value within the company.

88. Interestingly, many of the old-line firms with which DLJ competed in the financial sector now collect contemporary art, as if enabled by their lengthy pedigrees to appear more cutting edge, secure in the knowledge and perception of their longevity. Castle, quoted in Nancy Marx, "Art, Inc.: Mergers & Acquisitions," *Manhattan, Inc.*, June 1986, 154; Richard Hampton Jenrette, *Adventures with Old Houses* (Charleston, S.C.: Wyrick, 2000), 211; elsewhere in his book, writing of the effect of the historical print collection of a DLJ subsidiary (already long established when purchased by the firm), Jenrette notes of them, "When times are bad in the market, they send a soothing message to clients that 'we've been around a long time and this too shall pass'" (216–217). Regarding the use of historical art to project a venerable image, Martorella writes, "The role of art in corporate image-making has evolved into the 'thematic' approach, which has more to do with art's ability to 'mass communicate' than with its fulfillment of historical or aesthetic values. . . . Consequently, companies that wish to portray the image of being long-established will have selected nineteenth-century works of art, Oriental rugs, and antiques" (*Corporate Art*, 31–32).

89. Jenrette, quoted in Marx, "Mergers & Acquisitions," 154. The term "quasi-ancestral" is used by David Halle to define images "that appear to be ancestral portraits, but in fact depict persons unrelated to the residents" (*Inside Culture: Art and Class in the American Home* [Chicago: University of Chicago Press, 1993], 106–107). DLJ's adoption of the Chamber portraits recalls the collecting habits of Benjamin Altman (himself a Chamber member and represented in its collection), who, as one of the greatest collectors of the late nineteenth and early twentieth centuries, spurned the fashionable taste for stylish portraits of British aristocracy and concentrated instead on the "severe, tight-lipped bankers and merchants of the Low Countries and Germany" out of a sense of "spiritual kinship." In so doing, Francis Haskell argues, he was really assembling a "gallery of ancestors" ("The Benjamin Altman

Bequest," in *Past and Present in Art and Taste* [New Haven, Conn.: Yale University Press, 1987], 186–206, quotes on 187).

90. The DLJ photograph appeared in the first few pages of the firm's annual report for 1997. Bush's introduction to his Mount Rushmore speech made explicit the appeal to history and tradition the setting was meant to evoke: "I mean, after all, standing here at Mt. Rushmore reminds us that a lot of folks came before us to make sure that we were free" (for the full text and additional photos, see White House, "President Talks Homeland/Economic Security at Mt. Rushmore," http://www.dhs .gov/xnews/speeches/speech_0030.shtm).

91. As had been the case at DLJ, Richard Jenrette, who joined Equitable following his firm's acquisition by it, instigated the move to bring the Chamber portraits there, in an arrangement that called for the company to house and gradually restore the collection in exchange for the right to display it. According to his autobiographical *Adventures with Old Houses*, Jenrette had been prompted to approach the Chamber with the proposal by a series of *New York Times* articles detailing the appalling storage conditions at the New-York Historical Society, where many of the Chamber's pictures had been placed (and where some of them had been exhibited in 1986 and 1987); see Jenrette, *Old Houses*, 218; Douglas C. McGill, "Hundreds of Art Works Damaged by Mildew in Museum Warehouse," *New York Times*, July 10, 1988, and "Much of Damaged Art at Society Is on Loan," *New York Times*, July 13, 1988; and, on the historical society's exhibition, John Gross's negative review, "Why Our Men of Power Failed to Inspire Powerful Portraits," *New York Times*, May 3, 1987. As a serious and historically minded collector, Jenrette's motivation in twice involving his company with the Chamber portraits was partly to ensure their continued viability as a coherent group of related paintings that superseded their significance as individual works of art; as a master image-maker, he also understood the symbolic effect and value of the display of such objects in their new corporate settings. In any event, Equitable had an established record of bolstering its image through art, as it had done lavishly in the public spaces of its new Midtown building. On the satellite branch of the Whitney Museum of American Art located there, see Victor J. Danilov, "Museum Pieces," *Public Relations Journal*, August 1986, 12–16, 30–31; and, for the building's public artwork, Suzanne Stephens, "An Equitable Relationship?" *Art in America*, May 1986, 116–123. Moreover, the company had a prior relationship to the Chamber collection, which for unknown reasons had in 1966 given it one of its best portraits, that of Equitable founder Henry B. Hyde by Leon J. F. Bonnat, a painting described in the press when given to the Chamber as having cost a stupendous $10,000 to paint in 1882. See "Hyde Portrait Comes 'Home,'" *Insurance Advocate*, January 1, 1966; and "Portrait of H. B. Hyde: A $10,000 Picture for the New York Chamber of Commerce," *Commercial Advertiser*, January 24, 1900. "Neo-Jeffersonian" is the designer's term for the grandly classicizing interiors of the Equitable Building's executive floors.

92. For the photograph and an account of the sale, see Patrick McGeehan, "Wall Street Primed for More Deals Like the Latest," *New York Times*, August 31, 2000. The executive mandate that *Hamilton*'s deinstallation be delayed until the photograph could be taken was communicated by DLJ personnel in conversation with this author. The painting did eventually leave the building for the Metropolitan Museum's landmark exhibition, "Art and the Empire City: New York, 1825–1861," which opened on September 19 of that year. See "Works in the Exhibition: Paintings," in Voorsanger and Howat, *Art and the Empire City*, 378, cat. no. 1. Contemporary concerns about the spate of foreign acquisitions of American financial companies (including Deutsche Bank's purchase of Alex. Brown the previous year and the Union Bank of Switzerland's takeover of PaineWebber only weeks before the DLJ sale) were voiced in the lead of the same *Times* article in which the photograph appeared, which notes that the consolidation of such firms into "a handful of global giants . . . has become accepted wisdom on Wall Street but figuring out who the eventual rulers will be—and how many of them will be based in the U.S.—is not getting much easier."

93. On the integration of CSFB more closely into the parent organization, Credit Suisse Group, see Mark Landler and Jenny Anderson, "Credit Suisse Tries to Sell Itself to Its Bankers," *New York Times*, February 24, 2005, in which the possibility of dropping the storied First Boston name (the product of an earlier acquisition) is first mentioned.

94. Ronald Shelp (president of the New York Chamber of Commerce and Industry), quoted in Christopher Gray, "The Chamber of Commerce Building: New Owner for a 1902 Landmark," *New York Times*, April 23, 1989. On the Partnership's revivification and post–September 11 activity, see Robert Kolker, "The Power of Partnership," *New York Magazine*, November 26, 2001. Kravis, quoted in Partnership for New York City, "Henry Kravis and Jerry Speyer Elected as Co-chairmen of the New 'Partnership for New York City,'" press release, January 22, 2003.

95. The donation of the portraits to the New York State Museum was instigated by the author in cooperation with Brad Hoylman, executive vice president and general counsel at the Partnership, and Ron Burch, former senior historian and curator of art and architecture at the museum. See http://www.nysm.nysed.gov/research_collections/collections/history/nycc/index.html.

96. In 2006, the bank changed its name to Mega International Commercial Bank Company. In a sense, the foreign firm's purchase of the building for its U.S. headquarters recalls DLJ's use of the Chamber's portraits, in that both allowed an organization without local roots to graft itself onto those of an institution with them and thereby become a part of its history.

THE CAPITALIST PORTRAIT

PAUL STAITI

All honor must be paid to the architects of our material prosperity, to the great captains of industry who have built our factories and our railroads, to the strong men who toil for wealth with brain or hand; for great is the debt of the nation to those of their kind.
—THEODORE ROOSEVELT

At the end of the Civil War, the president of the New York Chamber of Commerce, Abiel Abbot Low, announced a bold plan to build for the century-old institution an art gallery that would be "for the exhibition of the portraits of eminent merchants of our own and other lands."[1] What eventually emerged in the form of the Great Hall of the architect James Barnes Baker's Beaux-Arts extravaganza of 1902 was a collection of hundreds of portraits of the most prominent American businessmen of the nineteenth century (figure 76). For the Chamber's purposes, the collection was a monumental way of articulating the institution's economic and political ascendance, as well as declaring the Chamber and its members to be heroes of the modern business world. But by the time the collection was published in an illustrated catalogue in 1924, its significance—like the significance of New York itself—had reached far beyond the parochial interests of the institution and the city. For by enshrining in one room the biggest and most influential merchants, industrialists, and financiers of New York, the Chamber had assembled nothing less than the Valhalla of American capitalism.

This essay examines a cluster of related issues regarding the history and rhetoric of the Chamber of Commerce's collection. It asks: What were the ideological traditions and precedents for such a project in visual biography? Into what typological categories did the images fall? What traits of character were promoted? According to what criteria were artists chosen? And what ideological purposes did the images serve, both individually and collectively? Installed massively into the Great Hall of the Chamber's headquarters, the arrangement calls into question the degree to which a portrayed individual signified himself solely or acquired significance in relation to the aggregate. As an exclusively male gathering, the installation also raises the question of what it meant to be a successful professional man in late-nineteenth-century America. And if the

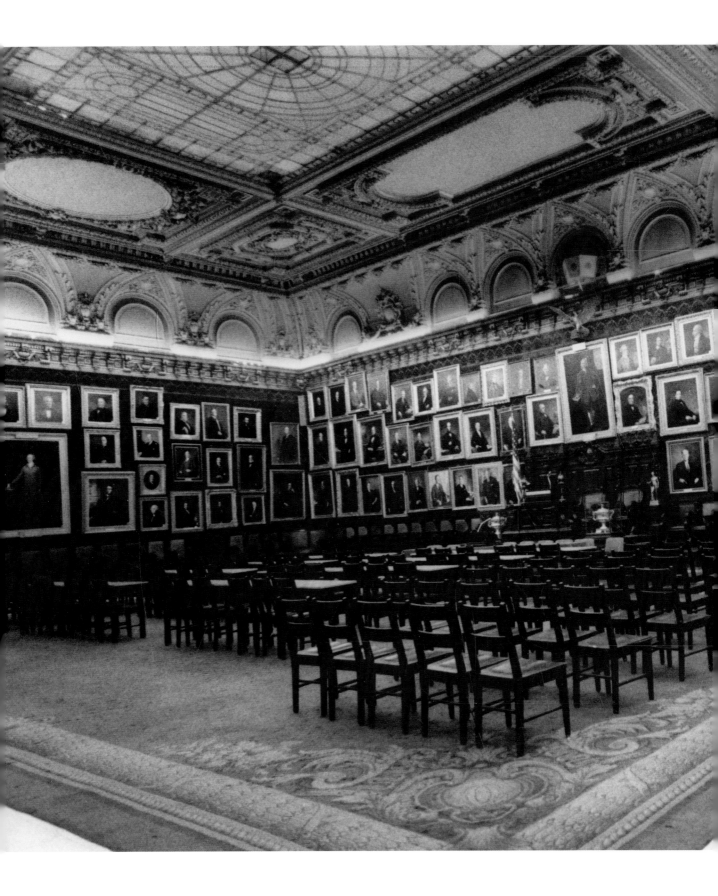

FIGURE 76
Great Hall, New York
Commerce Building. (New York
Chamber of Commerce Archives,
Columbia University Rare Book and
Manuscript Library)

Chamber's portraits did fulfill a businessman's dream image of himself, then what were the nightmare counterimages as they appeared in American literature, caricature, and mass media?

Ideology

A portrait collection specifically of businessmen and for businessmen was unprecedented in the United States before the New York Chamber of Commerce began its project. But the idea of honoring eminent men came from a long and diverse history dating back to Plutarch's *Lives* in antiquity and Petrarch's *De viris illustribus* and Castagno's frescoes of *uomini famosi* in Renaissance Florence.[2] That iconizing tradition became popular again in eighteenth-century Britain, where it often took the form of printed biographies accompanied by engraved portraits of famous men.[3] Perhaps the one most avidly purchased was the Reverend James Granger's *Biographical History of England*, which sought to tell history through the lives and images of individuals. The British continued into the nineteenth century to buy illustrated commemorative biographies, such as Thomas Birch's *Heads of Illustrious Men of Great Britain* (1813). Ultimately, the biographical trend culminated in 1856 in the founding of the National Portrait Gallery in London, which was dedicated to collecting likenesses of famous men.[4]

In America, a similar line of development evolved from Puritan ecclesiastical histories, such as the Reverend Cotton Mather's *Magnalia Christi Americana* (1702), which catalogued the "Lives of the Governours," the "Lives of Sixty Famous Divines," and the "Lives of Some Eminent Persons" educated at Harvard College.[5] Particularly noteworthy as an ideological ancestor for the Chamber of Commerce's portrait gallery was Mather's interest not only in identifying those whom he thought "eminent," but, more significantly, in classifying them, which was an arbitrary reckoning that divided society into ranks of constituent occupations that seemingly stand discrete from one another. In eighteenth-century America, colleges regularly commissioned or were given portraits of their presidents, trustees, and benefactors, and colonial cities typically assembled portrait collections of English kings, queens, and governors that could be seen in legislative chambers. The council room of the Town-House in Boston, for example, contained twelve royal portraits by 1763.

Collections of *civic* fame, however, were rare in the eighteenth century, except for the one in Boston's Faneuil Hall, which started in 1742 when John Smibert was commissioned to paint a portrait of the merchant Peter Faneuil (figure 77), who was being honored by the city for his gift of the exchange building bearing his name. Four years later, Boston's merchants, including Thomas

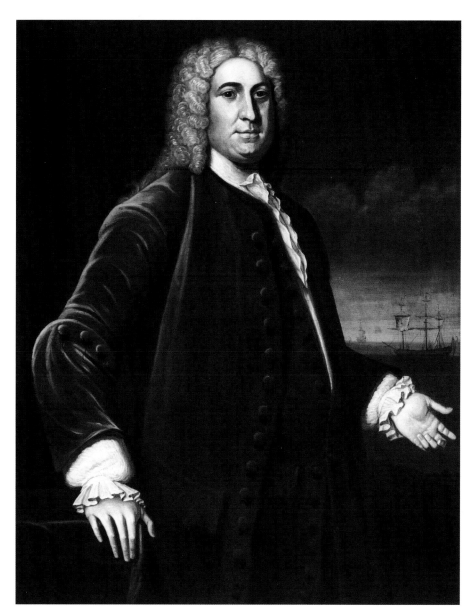

Hancock, raised money to commission Smibert to paint a second portrait for Faneuil Hall, of Governor William Shirley, in acknowledgment of Shirley's contribution to the British victory at the Battle of Louisbourg in 1745, a key event in King George's War.[6] Located in the heart of the commercial district, Faneuil Hall's portrait collection expanded during and after the Revolution, and came to include John Singleton Copley's portraits of Samuel Adams and John Hancock, both of whom were businessmen as well as politicians. The collection's development was unsystematic, however, and, as such, bore little resemblance to nineteenth-century projects, which tended to be programmatic and comprehensive. Nonetheless, Faneuil Hall set a precedent for the New York Chamber of Commerce by establishing the idea that a civic portrait collection in America could be linked to the commercial self-interests of a city's merchant elite.

During the Revolution, Charles Willson Peale began the most celebrated and polemical biographical project of painting portraits of Revolutionary heroes and other "worthy Personages" of public merit. Eventually accumulating more than two hundred, he installed the portraits in the Long Room of his Philadelphia Museum, at the highest tier of a vertical declension that descended from worthies to stuffed mammals and birds (figure 78).[7] Peale's overall plan and various taxonomies were artifacts of the Enlightenment. And like the work of his contemporary, the Swedish naturalist Carolus Linnaeus, they attempted to sort knowledge into rational categories that, in Peale's thinking, proved the indisputable cosmology of the universe, which for him placed learned human endeavor at the summit of knowledge and history.[8] Moreover, Peale, who was a supreme nationalist, felt that as much as America was home to unique species of animals, so too was it home to a peerless strain of heroic men.

Of course, the purpose of the New York Chamber of Commerce's collecting was different, for its portraits were not meant to be seen as part of an exhaustive enterprise in universal knowledge. In some ways, the Chamber's gallery was the opposite of Peale's encyclopedism, for it was a biographical niche disconnected from any but the most professionally specific cultural context and represented no more than a fraction of universal knowledge. Its iconographic exclusivity, rather than relating to Peale's Enlightenment theories, was instead a material artifact of nineteenth-century modernity in two ways: first, it participated in the trend of modernity to separate knowledge into constituent parts, such as philosophy, science, art, politics, and business; and second, it participated in the corresponding effort to define and represent each category of society by its own specialists, professionals, and institutions.[9]

An antecedent less polemical and more proximate to the Chamber's project was the collection of the city of New York, which began in the late eighteenth century commissioning portraits that honored military leaders. When it moved in 1811 to City Hall (figure 79), only blocks away from the Chamber of Commerce, the collection quickly grew to number thirty-three pictures, and it

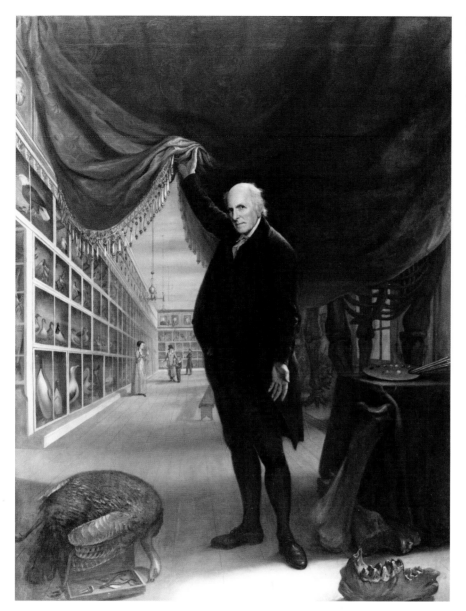

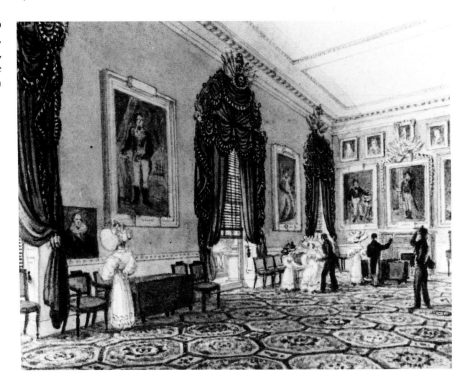

eventually included portraits of men who were neither attached to the city nor in the military, but were regarded as "great," such as John Vanderlyn's *James Monroe* and Charles Wesley Jarvis's *Thomas Jefferson* and *Henry Clay*.[10]

Nineteenth-century illustrated books paralleled the endeavor of the commemorative portrait galleries. For example, in 1816 Philadelphian Joseph Delaplaine began publishing his wide-ranging *Repository of the Lives and Portraits of Distinguished American Characters* in order to stimulate "honorable emulation" and "create new heroes" among his contemporaries.[11] Although the books would never quite fulfill their advanced billing, Delaplaine's original idea was to arrange portraits by categories, some of which were expected (statesmen and divines) and others, unexpected (physicians and "mechanics"). The artists James Longacre and James Herring's acclaimed four-volume *National Portrait Gallery of Distinguished Americans* (1833) followed Delaplaine's organization and further broadened its categories of eminence to encompass statesmen, military leaders, clergy, poets, artists, authors, and inventors. After that, published "galleries" proliferated, and notably included William H. Brown's *Portrait Gallery of Distinguished American Citizens* (1845), Charles Lester Edwards's *The Gallery of Illustrious Americans* (1850), Abner Jones's *Illustrated American Biography* (1853), Evert A. Duyckinck and Alonzo Chappel's two-volume *National Portrait Gallery of Eminent Americans: Including Orators, Statesmen, Naval and Military Heroes,*

Jurists, Authors, etc. (1862), and Benson Lossing's three books: *Biographic Sketches of the Signers* (1848), *Our Countrymen* (1855), and *Eminent Americans* (1857).[12]

Merchants and businessmen, however, were rarely showcased in these early galleries and compendiums of worthies.[13] And when men such as Henry Laurens, Nicholas Biddle, and Stephen Girard appeared, it was only insofar as they stood for their contributions to public life, for business in the era of Peale, Longacre, and Herring was not thought to be an *exemplum virtutis*. Thomas Jefferson went so far as to say that merchants "are least virtuous, and possess the least of the *amor patriae*."[14] But this logic began to crack after mid-century when lithography and photography, which were easier, faster, and cheaper than engraving, were used by new entrepreneurs to promote populist galleries and publish self-serving books profiling physicians, musicians, athletes, and bankers who did not fit the traditional model of the public man tending to his moral duties.[15] Moreover, publishers at mid-century began to acknowledge the growing popular belief that the very definition of male success had expanded from the classical notion of selfless civic-mindedness to now include personal success and the accumulation of wealth.

Arguably, the gallery of alternative heroes reached its zenith in New York when the photographer Mathew Brady started in the 1840s to assemble his daguerreotypes into a Hall of Fame on Broadway, opposite Grace Church.[16] An article written in the *New York Times* in 1860, just as the Chamber of Commerce inaugurated its own collection, described Brady's now renamed National Portrait Gallery in vivid language. Avoiding the words "eminent," "exemplary," and "heroic," which would have been inaccurate, the *Times* called it "a very Valhalla of celebrities, ranging over two continents, and through all ranks of human activity. . . . In this deep-tinted luxurious room are gathered the senators and the sentimentalists, the bankers and the poets, the lawyers and the divines of the state and of the nation."[17] In effect, Brady had liberalized the idea of the *Ruhmeshalle* (hall of renown) by extending its mandate from political leaders, such as Daniel Webster, to include professionals, industrialists, manufacturers, inventors, actors, and those who had acquired celebrity, like Atlantic cable promoter Cyrus Field (figure 80), even going so far as to include machine boss Simon Cameron, who certainly did not possess all the moral virtues required of a traditional "worthy."[18]

With the definition of a hero having been democratized by Brady, specific occupations were emboldened by mid-century to publish customized "galleries" of their own men. For example, John Livingston not only limited his illustrated *Eminent American Lawyers* (1853) to one occupation, but had it published by lawyers and for lawyers, who constituted its only plausible market. Perhaps the nadir of these self-serving projects was reached in the postbellum "mug" book, wherein individuals could simply pay a fee to be included in a biographical history.[19]

The first instance in which businessmen were featured in a biographical project came in 1856 when Freeman Hunt, a well-known publisher of a business

trade journal, wrote his two-volume *Lives of American Merchants*, illustrated with portrait engravings of Amos Lawrence, John Jacob Astor, James Gore King (figure 81), and others. Hunt's book paralleled the New York Chamber of Commerce's early efforts to build a gallery of biographical pictures, and, moreover, it publicly articulated the first rationale for treating businessmen as eminent. In a preface justifying his project, Hunt explained: "We have lives of the Poets and the Painters; lives of Heroes, Philosophers, and Statesmen; lives of Chief-Justices and Chancellors." But now, he added, we have businessmen "whose wealth has equaled that of princes, whose interests have become a chief concern of statesmen, and have involved the issues of peace and war." Hunt went on to list the mental attributes that linked merchants to traditional heroes: "vast comprehensiveness with a most minute grasp of details," a "force of mind and will [that] in other situations would have commanded armies and ruled states," and an ability to apply "ingenious instruments and marvelous discoveries in aid of their enterprises," which now cover "continents with railroads and oceans with steamships." Hunt wished for his book the same goal that the Chamber wished for its gallery, that it contribute to the conduct of "business life," that it be "the Plutarch's Lives of Trade."[20]

Hunt's book and Brady's gallery opened up the ideological possibilities for the gallery of renown, and they were joined by the New York Chamber of Commerce, which made its own cultural argument for declaring its members "worthies" and for gathering hundreds of them into a temple of their own in the Financial District. The Chamber would even go so far as to invert the traditional formula for a gallery of renown by sprinkling among its portraits of businessmen a few of the nation's presidents, some Civil War generals, a judge, a poet, and an artist. Presidents Grover Cleveland (figure 82) and Chester Arthur were logical inclusions. (Arthur had been the chief of Roscoe Conkling's notorious Custom House machine in New York, and Cleveland was a former governor who stood against graft and for laissez-faire business policies.) But others—such as George Washington, Abraham Lincoln, Admiral David Farragut, General Ulysses S. Grant, General William Sherman, General Winfield Scott, General Philip Sheridan, the poet William Cullen Bryant, and Samuel F. B. Morse (depicted as an artist, not an inventor [figure 83])—were made heroic equivalents to the Chamber's men of commerce, each for being a "success" in his own "trade," broadly defined.

But even taking into account the populist precedent of Brady's gallery, there are persuasive reasons for thinking the Chamber's visual hagiography of American businessmen a strategic, even an audacious, and at the very least a timely move for the institution. The Chamber launched its gallery in earnest at the end of the Civil War, which was an auspicious moment in American business history because the war had been won in part by the North's industrial colossus. The North's victory was capitalism's victory, and as a result business and businessmen were held in newfound esteem in the 1860s, not only accepted

but also celebrated for their accomplishments. As if sensing the cultural shift, the Chamber unveiled a forceful new identity for itself at the end of the war. Previously, it had been a trade organization, its membership weighted toward shipowners absorbed in international trade. Politically and institutionally, it had been relatively inert, not yet involved deeply in public issues, city politics, or urban problems. It had not attempted to direct its members toward unified standards of ethical practice, nor attempted to balance its membership with manufacturers.

But after the Civil War the Chamber invigorated itself. It plunged into reform politics by proposing and funding the "Committee of 70," which empowered "Swallowtail" Democrats to bring down William Marcy Tweed's corrupt Tammany Hall, which controlled the city.[21] It barred from its membership shady commodity manipulators such as Jay Gould and Jim Fisk, who in 1869 entered a successful scheme to corner the gold market, leading to the worst financial panic of the century. It implicitly passed judgment on speculation in general, which from a commercial point of view separated profit from production. At the same time, it was becoming successful at attracting industrialists of impeccable reputation, such as Peter Cooper, who was not only a leading manufacturer, but also a civic leader admired as a political reformer and philanthropist. And it also

FIGURE 80
Mathew Brady Studio, *Cyrus Field*, 1858. Salted paper print, 17⅝ × 14¹⁄₁₆ in. (National Portrait Gallery, Smithsonian Institution, Washington, D.C.)

FIGURE 81
James Gore King. Engraving. (From Freeman Hunt, *Lives of American Merchants* [New York: Derby and Jackson, 1856])

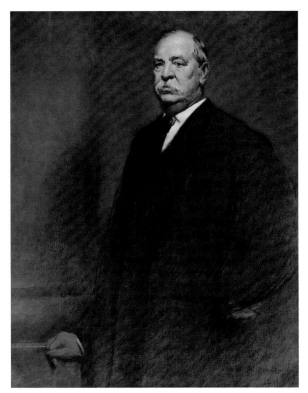

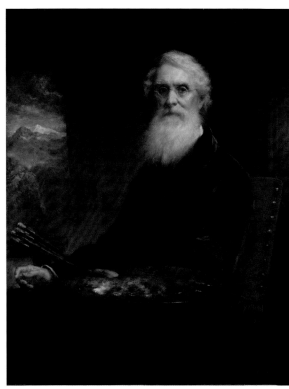

FIGURE 82
John White Alexander, *Grover Cleveland*,
1911. Oil on canvas, 50 × 40 in.
(Credit Suisse, New York)

FIGURE 83
Daniel Huntington, *Samuel F. B. Morse*,
1900. Oil on canvas, 50¼ × 40½ in.
(New York State Museum, Albany)

began its gallery project, which acknowledged professional success, acted as an idealized mirror of self-worth, confirmed and celebrated the new influence of businessmen in American culture, served as an instrument of professional bonding within the business community, and provided future men of business with visual models of emulation. From a complicit, business point of view, it can be said that the Chamber's gallery project was congratulating and lionizing the ascendant capitalist in American culture.

From a dissenting point of view, however, the gallery project might also be understood as defending and promoting the aspiring industrial moguls of the period. Although the late nineteenth-century's biggest magazines—*Munsey's*, *McClure's*, *Cosmopolitan*, and *The Century*—published innumerable complimentary stories of businessmen for an adoring audience of tens of millions of readers looking to discover the keys to success, intellectuals for the most part were skeptical of or even hostile to businessmen. In postbellum America, a new negative business stereotype was being constructed around the monopolistic titans of industry and finance who were disdained as "robber barons." The Chamber itself was never under attack (indeed, it was widely perceived by the *New York Times* and other critical journals as possessing compassion and morality), but caricaturists aimed their barbs at some of the most prominent industrialists

in the Chamber's membership, turning them into poxed thieves, one-eyed brigands, and devouring leviathans. A chromolithograph in *Puck*, for example (figure 84), shows a group of well-dressed capitalists, including the Chamber's William H. Vanderbilt and Cyrus W. Field, bidding on chained workers at a public sale run by an auctioneer who looks like Uncle Sam.[22]

In addition to caustic caricaturists, distinguished writers created in their fiction reprehensible business characters who were hopelessly stupid, crass, crooked, and dangerous.[23] At the turn of the century, Frank Norris constructed Curtis Jadwin as a cold-hearted speculator who ruthlessly corners the wheat market in *The Pit* (1902). In 1901, novelist Charles Keeler Lush wrote in *The Autocrats* the tale of a piratical businessman who uses bribery and outright blackmail to improve the prices of his stock holdings. In *The Financier* (1912), Theodore Dreiser's Frank Cowperwood is a commodities wheeler-dealer who discovers, while manipulating his wife and mistresses, the pleasures of force and fraud, and takes delight in every crooked money deal he cuts with corrupt politicians. And in *A Hazard of New Fortune* (1890), William Dean Howells makes Jacob Dryfoos into a monumentally deficient and imperious millionaire.

FIGURE 84
Bernhard Gillam, *The Slave Market of Today*. Chromolithograph. (From *Puck*, January 2, 1884; Chicago Historical Society)

THE SLAVE-MARKET OF TO-DAY.
"Going—going—lower—lower!"

Even the ever-optimistic Walt Whitman was forced to observe in 1871 that "the depravity of the business classes of our country is not less than has been supposed, but infinitely greater."[24] Over and over in these literary productions, the theme was not just the exposé of the underhanded business deal, but an indictment of the morally defective businessmen who were capable of such dishonest acts, both personal and public.

Almost all of the fictional businessmen appearing in American literature, however, were based on the public reputations of a few titans, only some of whom were in the Chamber's membership (among them J. Pierpont Morgan, John D. Rockefeller, Andrew Carnegie, "Commodore" Vanderbilt, William H. Vanderbilt, Cornelius Vanderbilt II, John Jacob Astor II, James J. Hill, and Collis P. Huntington). To be sure, most of the men pictured in the Chamber's gallery were of a different business and ethical sort. Indeed, some had spotless reputations and might be considered "worthies" in the old sense that Charles Willson Peale imagined. William F. Havemeyer, for example, was a mogul of New York's booming sugar trade, but at the same time he crusaded against the corruption of the Tweed Ring by running in the mayoral election of 1872. In an era rife with political patronage and scandal, Havemeyer ran a clean, independent, and reform-minded campaign. Morris Jesup was another example (figure 85). A banker, he quit the business in 1884 and devoted the last twenty years of his life to dozens of philanthropic institutions in the city, including the Five Points House of Industry, the New York Mission and Tract Society, the American Museum of Natural History, the Metropolitan Museum of Art, and the YMCA.

Nonetheless, the attacks on the dozen or so titans created a reputation problem that had the potential to affect all the Chamber's men, for in fact the titans were not always above disreputable conduct, despite their many philanthropic gifts. For example, Collis P. Huntington, president of the Southern Pacific Railroad, rationalized his habit of using bribery to have his way, once declaring, "If you have to pay money to have the right thing done, it is only just and fair to do it. . . . If a man has the power to do great evil and won't do right unless he is bribed to do it, I think the time spent will be gained when it is a man's duty to go up and bribe the judge."[25] Morgan and Rockefeller built monopolies for themselves, at one point each owning, respectively, more than half of the steel and oil industries. Carnegie, though a tremendous philanthropist, was also a factory despot who exploited immigrant labor. And in an era of immense class differences, Rockefeller imagined work to be a Darwinian game of competition and the survival of the fittest, and once declared narcissistically that God had given him his wealth.[26]

From the viewpoint of business critics, it might seem that the Chamber's hall of renown represented a sharp veering away from Peale's or Delaplaine's or Longacre's old notion of honoring what anthropologists call "Great Men." Besides

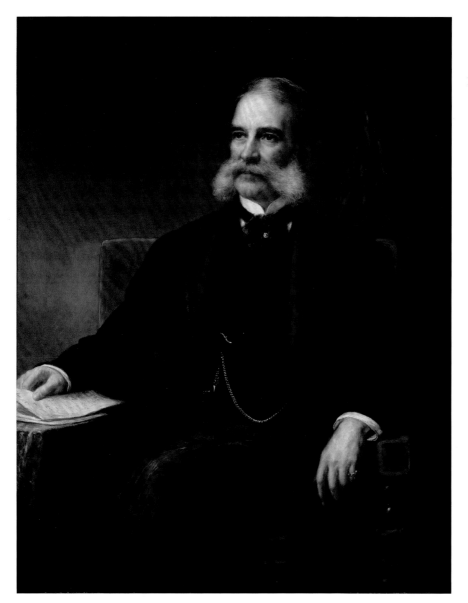

FIGURE 85
Daniel Huntington, *Morris K. Jesup*,
1896. Oil on canvas, 50¼ × 40 in.
(New York State Museum, Albany;
photo Gavin Ashworth)

the obvious difference that monetary success had become the sine qua non for a businessman's inclusion in the Chamber's gallery, whereas civic or moral or intellectual accomplishment had been the primary criteria for inclusion in Peale's Philadelphia Museum, the Chamber's art project was also unabashedly self-congratulatory. In the eighteenth century, Peale had acted, in effect, as an outside "juror" of civic exceptionalism, but the Chamber's gallery, like the collections of private colleges and other professional societies, was exclusively serving the ends of the parent institution and its members. Peale, Delaplaine, and other early cataloguers of virtue had been attempting to identify Americans who had a reputation for being "Great" in the eighteenth-century sense that they were thought to be motivated by the characteristics of morality, virtue, and disinterestedness, and their ability to act on behalf of others—to improve the common wealth—was thought to spring from their freedom from the vicissitudes of money-making, which perforce dictated self-interest and not public interest.[27] Although we now know that George Washington and Thomas Jefferson, who appeared in every early gallery of heroes, were themselves profit-minded landowners who used slave labor, they also had public reputations for leading the nation out of crisis, doing much of their work symbolically or intellectually, operating on the principle of noblesse oblige, occupying public office based on merit, using moral suasion instead of coercion, basing their actions on widespread ideological consensus, and situating themselves at the sacred center of collective values.

The Marquis de Lafayette, for example, was justifiably honored as a "Great Man" during his farewell tour of America in 1825 and 1826. When Samuel F. B. Morse, the artist who had been awarded the prestigious commission to paint Lafayette for New York City, met the general in Washington, he had to confess to being awestruck and overcome by "feelings [that] were almost too powerful." His description of his audience with Lafayette is a classic example of what characterizes a "Great Man":

> This is the man now before me, the very man, thought I, who suffered in the dungeon of Olmutz, the very man who took the oaths of the new constitution for so many millions, while the eyes of thousands were fixed upon him; . . . The very man who spent his youth, his fortune, and his time, to bring about (under Providence) our happy Revolution; the friend and companion of Washington, terror of tyrants, the firm and consistent supporter of liberty, the man whose beloved name has rung from one end of the continent to the other, whom all flock to see, whom all delight to honor. This is the man, the very identical man.[28]

Compared with Lafayette or any other traditionally designated hero, the business leaders enshrined in the Chamber's gallery were definitionally not

"Great" because they were known chiefly for their success in business and only secondarily for good works. As such, their lives ran counter to the value system attributed to the eighteenth-century model. But the Chamber nevertheless enshrined them in a "Great Man" format, which was not only an audacious twist on an artistic convention, but also an acknowledgment that the idolized man in late-nineteenth-century America had now become a model of success and self-interest, and was no longer a paragon of virtue and disinterestedness. Although the idea for the Chamber's portrait gallery may have derived ultimately from the enterprises of Peale and his followers, the true purpose of the collection and its monumental installation, critically observed, was to promote "Big Men," not "Great Men," to glory.[29]

"Big Men," as an anthropologically defined type, are those who are interested in power and who openly use their material possessions to multiply social relations, in the semblance of a gift. One salient aspect of a "Big Man" is that he may show "an ostensible interest in the general welfare," but this would always be grafted onto "a more profound measure of self-interested cunning and economic calculation. . . . His every public action is designed to make a competitive and invidious comparison with others, to show a standing above the masses that is the product of his own personal manufacture."[30] In the modern American version of the "Big Man," much of his performed generosity—whether to the YMCA or the collections of the Metropolitan Museum or the gift of a portrait to the Chamber of Commerce—might be seen as forms of what social theorist Pierre Bourdieu calls "conspicuous distribution." That is, these were the socially rewarded ways in which a "Big Man" could convert the money made from banking or steel into renown-building.[31]

In that critical light, even the generous gifts from the Chamber's best men, such as Jesup and Havemeyer, could be interpreted as the *personal* exercise of power, contingent on the acquisition and application of money and position, and ultimately those gifts were yoked to self-enhancement. However great one's largesse, gift-giving almost always postdated a person's capitalist ascent and, moreover, never threatened it. (Recall, by way of contrast, Morse remarking that Lafayette, motivated by core values and ideological conviction, sacrificed *everything* for what he thought was right.) The gifts of a "Big Man" "are in no way disinterested," wrote Marcel Mauss in 1925 in a classic anthropological study of gift-giving. For to give, in such a view of late-nineteenth-century power, "is to show one's superiority, to show that one is something more and higher," to indicate, in other words, that unlike the "Great Man," the "Big Man" wishes to flag hierarchy by means of gifts.[32]

Precisely because they were entrepreneurs first and foremost, the Chamber's men were not definitionally "Great," nor would they have qualified for enshrinement in Peale's or Delaplaine's era. But in the very different society of the Gilded Age, businessmen could qualify themselves for enshrinement precisely because

they *were* entrepreneurs first and foremost. For the Chamber, a self-referential gallery of portraits had less to do with the ancient idea of honoring worthies than with the new bourgeois effort of occupations concerned about their reputations and wishing to use portraiture to project or stabilize a coherent new image.[33] In that regard, the Chamber was following a strategy that had begun in the eighteenth century when British physicians hired acclaimed portraitists, such as Joshua Reynolds, to fashion them into men of letters or science as part of an effort to overcome the common stereotype of doctors as experimenters or butchers.[34] It was the same logic that inspired portrait-collecting at many other American professional institutions, such as New York Hospital, the Hospital of the University of Pennsylvania, Columbia Presbyterian Hospital, and the New York Mercantile Society. As a rebuttal to the negative image of the "robber baron" and other critical tropes that dogged the reputation of some businessmen, the Chamber filled its gallery with hundreds of images of thoughtful, polite, conventional, even noble men who present a stable collective identity for the conformist—rather than transgressive—status aspirations of an ascendant professional group. It can be said that the Chamber's portrait strategy actually amounted to the conferring of "greatness" on its members, who were already in possession of "bigness." The Chamber's secretary, George Wilson, made a similar pitch for greatness when he proclaimed, without qualification, that the persons depicted in the gallery "show those types of enterprise and judgment which have raised the character of the New-York merchant to its high standard, and carried their fame to the uttermost ends of the earth."[35]

To be sure, it can be argued that all galleries of famous people, including Peale's, were actively conferring greatness. However, the Chamber's biographical idealizations—visual euphemizations, really—were meant to have purchase primarily on the Chamber's own members, and not visitors. Here—and nowhere else—a big businessman could bond with his peers in representation by sharing a collective rhetoric of greatness. He could look at the gallery walls and feel a part of a network of power and influence, and come to believe, as many outside the Chamber did also, that he mattered as much as great American presidents, generals, and clergy had a half-century earlier. Publishing tycoon and business admirer Frank Munsey accurately captured that spirit of self-congratulatory euphoria when he wrote in 1892: "The time was when the soldier, the poet, the orator, the jurist, the sculptor, the painter were almost alone endowed with genius. That was before the day of the financier. In this country of ours . . . genius asserts itself in the financier and becomes most forceful and most dramatic. The most dramatic spot on this earth today is Wall Street."[36]

In one significant way, the Chamber of Commerce's project even exceeded those of all previous professions in the crusade for self-legitimization and self-congratulation. For unlike the portraits of physicians, lawyers, churchmen, and academics, which tended to be acquired haphazardly and then scattered into

small private collections or hung in the offices and corridors of institutions, the Chamber's collection was self-consciously managed and then grandiloquently displayed at its headquarters in the geographic heart of the occupation. The Chamber's monumental Great Hall stood out as the first and most spectacular pantheon of a profession in the nation's history.

Typology

Though there is the anomalous sight of merchant Pelatiah Perit sitting between a stack of money and a view of a freighter loading up in New York Harbor (see figure 29), or railroad entrepreneur James Gore King beside a clock held up by Atlas, over which is suspended a map of the world (figure 86), the typology of mastery and power is uncommon in the Chamber's collection. Instead, the pictures concentrate, for the most part, on confidence, grace, intelligence, character, respectability, sincerity, individuality, some minor business activity, and rarely any personal life. They deemphasize the specific attributes and behaviors associated with running a business or making money or even conspicuously giving it away, and instead encourage viewers to focus on the generalized look of high character. These men are to be understood above all as gentlemen. For example, both merchant Josiah Orne Low (figure 87) and banker Samuel Babcock sit face-forward and remove spectacles with their right hands in order to address the viewer with solemn earnestness. New York Stock Exchange president J. Edward Simmons (figure 88), leather trader Jackson S. Schultz (see figure 151), real-estate magnate Amos Eno, and Equitable president Henry B. Hyde stand like classical orators. Some, such as railroad financier John S. Kennedy (figure 89) and Equitable president Thomas I. Parkinson, handle letters and papers.

A significant number hold or are engrossed in books or prints. For example, Charles Loring Elliott represented Chamber president James De Peyster Ogden as a man of letters who tips his open book to the viewer while being watched over by a statue of William Shakespeare (figure 90). For a portrait of Henry DeRham, Munich-trained Albert Abendschein based his picture on a photograph of the aging importer avidly studying an illustrated book. Daniel Huntington made something of a subspecialty of the student-businessman. He painted antiquarian and property owner James Lenox holding an open book illustrated with scenes from the life of Christ (see figure 22). He portrayed Jonathan Sturges not as a wholesale grocer or promoter of the Illinois Central, but as a connoisseur poring over a book illustrated with a print of the *Supper at Emmaus* (figure 91). And repeating the iconography, Huntington showed copper tycoon William E. Dodge II holding a sheaf of etchings, the one on top being Rembrandt's *Supper at Emmaus* (see figure 116).

FIGURE 86
Thomas P. Rossiter, *James Gore King*,
1865. Oil on canvas, 40 × 32 in.
(Richard H. Jenrette Collection)

FIGURE 87
Henry Stanley Todd, *Josiah Orne Low*,
1899. Oil on canvas, 48 × 41 in.
(Currently unlocated; photo Chamber
of Commerce Collection, New York
State Museum, Albany)

FIGURE 88
Thomas Waterman Wood,
J. Edward Simmons, 1903.
Oil on canvas, 46 × 32 in.
(Credit Suisse, New York; photo
Chamber of Commerce Collection,
New York State Museum, Albany)

FIGURE 89
Seymour J. Guy, *John S. Kennedy*,
1903. Oil on canvas, 42½ × 34½ in.
(New York State Museum, Albany;
photo Gavin Ashworth)

FIGURE 90
Charles Loring Elliott, *James De Peyster Ogden*, 1855. Oil on canvas, 36 × 29 in. (Credit Suisse, New York)

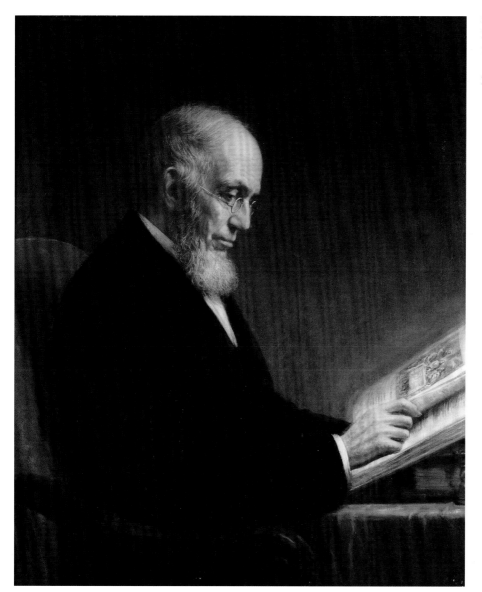

FIGURE 91
Daniel Huntington, *Jonathan Sturges*,
1889. Oil on canvas, 38 × 32 in.
(New York State Museum, Albany;
photo Gavin Ashworth)

The majority of pictures show even less. Mostly bust-length portraits, they depict men emotionally uninflected and with few or no objects, even when the person portrayed was known to have led a high-achieving or flamboyant life. Eastman Johnson's Rembrandtesque *William H. Vanderbilt*, a gift to the Chamber from his son Cornelius, is one of the best examples (figure 92). The eldest son of the patriarch, Commodore, he lived an opulent life as the richest man in America. His "Triple Palace" at 640 Fifth Avenue filled an entire city block (figure 93). Six hundred men worked day and night for a year and a half on its construction. Sixty sculptors were imported from Europe to work on its decoration. Herter Brothers laid out the whole interior. John LaFarge designed the stained glass. A full-size gilt-bronze casting of Ghiberti's *Gates of Paradise* led to the private rooms. An entrance arch covered in Limoges enamels, framed by gold and inlaid with mother-of-pearl, led to the drawing room, which had walls covered in embroidered red velvet decorated with butterflies of cut crystal. The *New York Times* declared, "In size, in elegance, in costliness there is no house like it."[37] In fact, it was so oppressively opulent that the *Times* later added, "[T]he gustatory sense is sometimes cloyed by overtasting. One longs to find out if there is not one single room where there might be found some repose."[38] This was the habitat of an archetypal "Big Man."

Yet Johnson's picture is of a plain man in a simple setting, looking and behaving unremarkably and, except for a gold watch chain, not outfitted in the manner to which he was accustomed. The same asceticizing discourse occurs dozens of times among the Chamber's portraits. William Merritt Chase's *Charles Lewis Tiffany*, for example, looks ahead simply, the only embellishment being Chase's signature. Yet this was New York's master of opulence, the founder of Tiffany and Company, which in the postbellum years specialized in japonismé silver and gaudy diamond and enameled jewelry. In a similar way, Thomas P. Rossiter's *James Brown* (figure 94) could have been mistaken for a clergyman, and Mary Foote's nuanced *John Crosby Brown* (figure 95) looks weakly out from behind his spectacles. These are the simplest of portraits, yet these men were the force behind Brown Brothers, which was New York's leading commercial-banking house, famous for arranging the reorganization and merger of America's largest railroads. Each of these men was an arch-individualist, but when it came to being enshrined, they assented to being placid replicas of one another.

The related images of "the simple man" and "the man of letters" derived from the same Gilded Age cultural mythology that was known as the log-cabin myth or the rags-to-riches story. Businessmen of the period wrapped themselves in stories of humble origins and self-learning, which in the late nineteenth century was seen as a key component of the American ideology of success. Success writers such as Horatio Alger regularly devoted a portion of their novels to the moment of epiphany when a poor, young, but ambitious boy learns to read and write. For example, in the penultimate chapter of Alger's *Ragged*

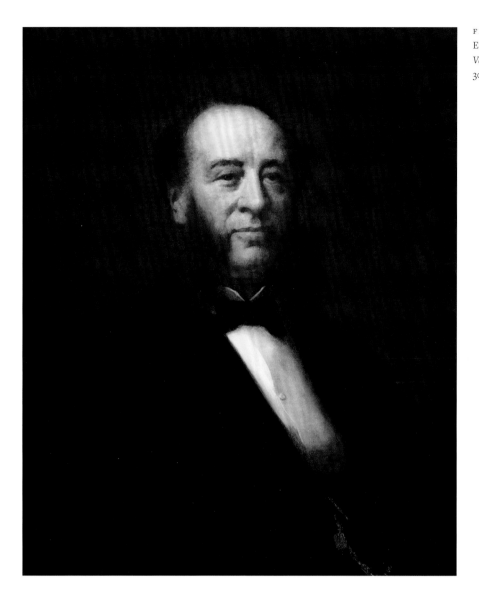

FIGURE 92
Eastman Johnson, *William H. Vanderbilt*, 1887. Oil on canvas, 30 × 25 in. (Credit Suisse, New York)

FIGURE 93
"The Triple Palace (William K.
Vanderbilt Home)" (1879–81;
Richard Morris Hunt, architect).
(Photo Museum of
the City of New York)

Dick (1868), the ascending hero writes his first letter after months of study, and it becomes the symbol of "the great progress he had made."[39] In other venues also, from Charles C. B. Seymour's *Self-Made Men* (1858) to didactic guidebooks such as William Makepeace Thayer's *Onward to Fame and Fortune* (1897) and biographies such as James Parton's *Captains of Industry* (1884) and Andrew Carnegie's *The Gospel of Wealth* (1900), the persistent theme was that a man could be his own agent of success, whatever his origins, and that "education, education, education," as Carnegie put it, was the key.[40] Although hands-on training was thought to be important, it was self-study that made the businessman sharp. "You see," Carnegie added, "the businessman of this day has to read, yes, and study, and go to the roots of many things, that he may avoid the pitfalls that surround business upon every side."[41]

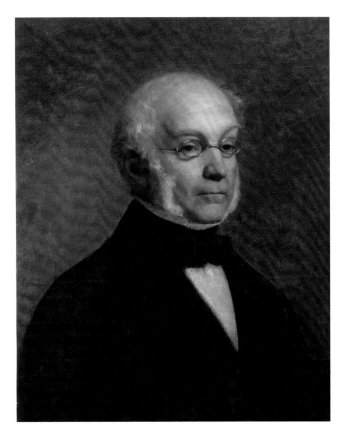

The log-cabin thesis of humble origins and self-training found some authentic corroboration in the true rags-to-riches lives of some of the Chamber's men—Collis P. Huntington, Luman Reed, Charles Leupp, Cornelius Vanderbilt, John D. Rockefeller, James J. Hill, and Carnegie himself. But it was not true of many, including Ogden, DeRham, Sturges, Lenox, and Dodge, who are depicted in deep study in their portraits. Despite their advanced age, it is as if the value of study, learned early in life, continues to be a font of good character and marker of success. Although this is not necessarily untrue of these men, it should be understood as a representational strategy that served to guide viewers away from the context of business and to provide sitters with a graceful way of acquiring an attractive biographical aura in an era that valorized the self-made man.

Those businessmen who are depicted in completely unadorned, simple, bust-length portraits, such as Johnson's of Vanderbilt, Enoch Wood Perry's of William F. Havemeyer, a copy after Henry Peters Gray's portrait of George T. Hope (figure 96), and many other Chamber pictures, participate in the same humble discourse. As Robert Cushman wrote at mid-century in *Elements of Success*, "The things which are really essential for a successful life are not

FIGURE 94
Thomas P. Rossiter, *James Brown*, 1856. Oil on canvas, 24 × 20 in. (Credit Suisse, New York)

FIGURE 95
Mary Foote, *John Crosby Brown*, 1914. Oil on canvas, 29 × 23 in. (Credit Suisse, New York)

circumstances, but qualities; not the things which surround a man, but the things which are in him."[42] In assembling its collection through commissions and gifts, the Chamber seems to have endorsed that theory, which was manifest in the elimination of objects and environments and in the concentration on facial character as the true measure of "worth." As countless writers, from Henry Ward Beecher to Theodore Roosevelt, insisted, success in business was the by-product of success in character; personal qualities were thought to be more essential than managerial skills in the path toward riches.

That theory was wickedly debunked in 1899 by Thorstein Veblen in *The Theory of the Leisure Class*, in which he saw success in America taking the outward signs of "conspicuous consumption" and "conspicuous leisure," both amply epitomized by William Vanderbilt's mansion. Nonetheless, the persistent rhetoric—not behavior—of success in that era, most evident in the Chamber's portraits, was of self-restraint and asceticism. Benjamin Franklin had been the first to propose, in his essay "The Way to Wealth" (1736), that "Industry, Frugality, and Prudence" were the virtues needed for success.[43] And in the Gilded Age, that list of ascetic virtues—which were encountered everywhere, from corner newsstands selling self-help books to grammar schools indoctrinating students

with *McGuffey's Reader*—lengthened to include self-reliance, orderliness, perseverance, and initiative.[44] Max Weber, writing *The Protestant Ethic and the Spirit of Capitalism* in 1904, at the apex of laissez-faire capitalism, attempted to explain that alliance between values of restraint and values of profit in the form of a grand theory. He identified asceticism as not only a key attribute in the calculus of success, but its precondition. Self-renunciation, privation, and saving, which had once been Calvinist values, were now the necessary secularized instruments of character in the making of the modern capitalist. The "valuation of restless, continuous, systematic work in a worldly calling, as the highest means of asceticism," wrote Weber, "must have been the most powerful conceivable lever for the expansion of that attitude toward life which we have here called the spirit of capitalism."[45]

Along the same cultural lines, the unadorned, ascetic look of so many of the Chamber's wealthy men might thus be called a Protestant aesthetic, in which the look of restraint and simplicity is linked, oddly, to aggressive entrepreneurship. Although William H. Vanderbilt and others privately led ostentatious lives, the portraits in the Chamber's gallery of official representations invoke a Puritan ideal of sober simplicity not seen in American painting since the seventeenth century in Calvinist New England. Even the German Jews, when the time came to give a portrait to the Chamber, conformed to the Protestant aesthetic. Although investment bankers Jacob H. Schiff (figure 97), Felix Warburg, Otto Kahn, and Joseph, Jesse, and Isaac Seligman; retailers Benjamin Altman and Isidor Straus; and publisher Arthur Ochs lived their personal lives within Jewish culture, including marriage, language, clubs, education, charities, and Temple Emmanu-El, at the same time they all assimilated selectively into the Protestant public culture of New York. "We are all Americans," declared Schiff.[46] And part of that included the occasion of having their official portraits painted for the Chamber of Commerce, wherein they all agreed to put aside their otherness and accept preestablished visual conventions. For example, Alphonse Jongers's portrait of Straus (figure 98), the founder of Macy's, is virtually identical to Fedor Encke's portrait of J. Pierpont Morgan (figure 99). This move toward representational congruency with the Protestant elite was part of the enactment of the immigrant version of the rags-to-riches story. Another example is the story of Joseph Seligman, who began work as an assistant in a small retail store in Mauch Chunk, Pennsylvania, after his emigration from Germany. He went on to New York to become a rival to Morgan, had his son tutored by Horatio Alger, and, as part of his intended assimilation, had his portrait painted to look visually undifferentiated from all the Protestant members of the Chamber. A portrait might be seen, in this discourse, as an ultimate badge of membership in the circle of powerful businessmen.

But, in fact, that membership was limited, even for the approved "Seligman-type" Jews, as they were called.[47] The tacit "code of exclusion" was brought to

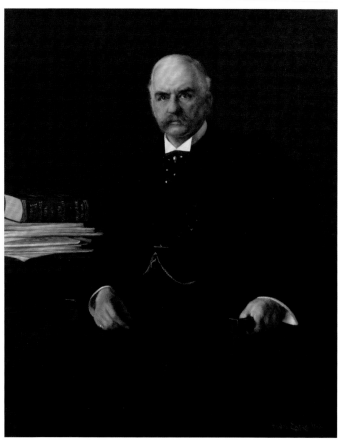

FIGURE 98
Alphonse Jongers, *Isidor Straus*, 1914.
Oil on canvas, 50 × 40 in.
(New York State Museum, Albany;
photo Gavin Ashworth)

FIGURE 99
Fedor Encke, *John Pierpont Morgan*,
1903. Oil on canvas, 50 × 40 in.
(Credit Suisse, New York)

fictional life in Edith Wharton's *The House of Mirth* (1905) in the character of Simon Rosedale, who had to be reckoned with in the business world, but found it impossible to crack the edifice of polite society.[48] Although Protestant New Yorkers acknowledged the conspicuous financial prowess of the German Jews (who were welcome at the Chamber of Commerce), they made harsh distinctions between commercial acceptance and social acceptance. Especially in the last two decades of the nineteenth century, powerful men such as Seligman and Bernard Baruch were rejected by clubs, hotels, and private schools. Nonetheless, a portrait symbolized to the German Jews—and to the Protestant Chamber, too—their rightful membership among the financial gods. And it also indicated the unshakable cultural authority of the "Protestant aesthetic," which caused these "uptown" Jews to camouflage ethnic markers for the sake of membership in the Chamber and to embrace a denatured business identity, while performing their Jewishness elsewhere.[49]

Clearly, there were other typological routes that the Chamber's portraits could have taken besides the ascetic. The "Gospel of Wealth" was one. In essence, it was the theory, associated with Carnegie, that capitalism and indi-

vidual fortune were necessarily yoked to philanthropy. "Individualism will continue," Carnegie predicted, "but the millionaire will be but a trustee for the poor."[50] Although the deadly conflicts between labor and capital in the last quarter of the nineteenth century would seem to nullify the plutocracy's conceit that they were essentially beneficent, the Gospel of Wealth came to have an intense hold on the business imagination, inspiring many titans to donate tens of millions of dollars to libraries, schools, museums, charities, and even pension funds. But the gospel of giving seems to have had no life as a visual trope in the Chamber, as no one is shown doing good, helping out, organizing charities, or overseeing the condition of the "Other Half," as Jacob Riis called the poor in 1890.

"Charismatic Grandeur" was the other missing typology in the Chamber. In the pages of the popular magazines of the era, there was the repeated formulation of the businessman as a charismatic figure made up of equal parts force and "personal magnetism." He was imagined to be a Napoleon, someone who had mastery over others, his environment, and even, as one flattering drawing of J. Pierpont Morgan proposed, the solar system. As one commentator wrote in 1903, "There is not a railway king of the present day, not a single self-made man who has risen from the ranks to become chief in the vast movement of capital and labor, who will not recognize in Napoleon traits of his own character, the same unflagging purpose, tireless persistence, silent plotting, pitiless rush to victory."[51] *Cosmopolitan* described one railroad mogul as "the founder of a financial dynasty, lord of the destinies of a great army of men who are fighting for him and his courtiers—the stockholders—fighting to make him ever more powerful."[52] And *McClure's* claimed that the railroad titans of America "would have been in England, Germany, or France, prime ministers, leaders of parties, makers of states, governors of empires."[53]

In the language of drunken excess, publishers at the end of the century told their middle-class audiences that male heroism was being cultivated in business, not politics.[54] In Richard Gilder's *Century*, one could read serious entreaties to businessmen to shake the hold of politicians and save American government, while *Munsey's* specialized in such flashy illustrated articles as "The Reign of the Business Man" and tributes to the railroads as "the greatest secular organizations of the world."[55] Insuperable power and "inflexible will," derived from wealth, were the businessman's mythic attributes.[56] *Munsey's*, as if writing about a Greek god, described Collis P. Huntington as "one of the great men of our times. He is inherently great. Nature cast him in a big mold. He . . . has left his impress upon the history of our national development."[57] And *Cosmopolitan* claimed that Morgan "works not merely for money but for the sense of power."[58] He was represented as a demi-god of "towering ability," the "plumed knight of finance."[59]

This mythic superman is precisely what Edward Steichen captured in his 1903 portrait of J. Pierpont Morgan (figure 100). High in the frame, head

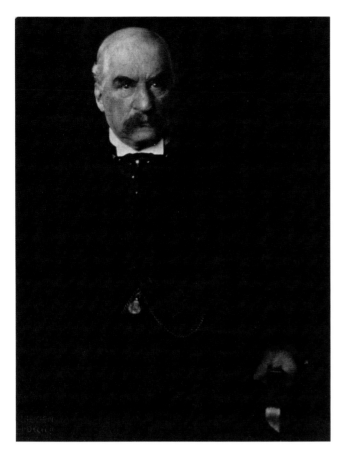

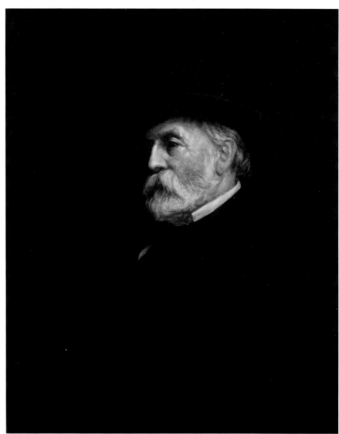

FIGURE 100
Edward Steichen, *J. Pierpont Morgan*,
1903. Photogravure, 8¼ × 6¼ in.
(The Museum of Modern Art, New
York. Gift of A. Conger Goodyear)

FIGURE 101
Francis Lathrop, *Collis P. Huntington*,
1890. Oil on canvas, 40 × 32 in.
(Credit Suisse, New York)

leaping from darkness, body a stately bulk, eyes flaring in murderous gaze, and left hand grasping a dagger-like chair arm, he is the epitome of animal vitality and preternatural power. Certainly, he came close to living up to that image in reality. As head of J. P. Morgan and Company, he controlled, through stock and positions on corporate boards, 30 percent of American railroads and 70 percent of the steel industry.[60] But in the same year that Steichen shot his renowned photograph, German-born Fedor Encke based his painted portrait of Morgan (see figure 99) for the Chamber on a second, more pedestrian photograph by Steichen. This official image, given to the Chamber by Morgan himself, keeps the facial shadows much brighter than the first photograph, shortens the jaw and nose, and adds contextualizing papers and book. The Chamber's *Morgan* sharply deviates from the other, Jupiterian, almost demonic image of Morgan, and substitutes for the idol of power the image of the responsible, respectable, simple, hard-working man.

For the most part, the Chamber's portraits—whether Encke's bureaucratic-looking *Morgan*, Thomas Waterman Wood's flatly descriptive *Andrew Carnegie*,

or Francis Lathrop's Whitmanesque *Collis P. Huntington* (figure 101), shown with tired, poignant eyes averted in reverie—possess none of that Napoleonic charisma, none of what has been called the "magnification of personality" in that era.[61] The Chamber's anti-charismatic images indicate a rejection or suspicion of the Napoleonic metaphor, and a corresponding embrace of the cult of outward modesty and respectability. Yet these men *were* the charismatic leaders of America. Writing about economic actions and political authority in 1904, Max Weber theorized that the charismatic leader inspires admirers, followers, and disciples and exercises domination as if it were a state of grace. Also, the charismatic leader, set apart from "the ordinary person" and "treated as endowed with supernatural, superhuman, or at least specifically exceptional powers or qualities," was further associated with cultures in upheaval, anomie, strain, and insecurity.[62]

Certainly America's turn-of-the-century business leaders were in Weber's charismatic mold. Millions of admirers read of their lives and followed their "philosophy." And certainly the United States was in a state of revolutionary change, in large part attributable to charismatic leaders who arguably held more power than the president or Congress and who had engineered, in both deliberate and inadvertent ways, the irreversible transformation of America, from a rural, agrarian society to a modern industrial state. But in the conservative realm of official Chamber portraiture was a corresponding and inversely proportionate need for businessmen to be perceived as traditional men, not supernatural forces.[63] Although Americans in the late nineteenth century felt deeply the convulsive effects resulting from radical changes in the industrial, labor, technological, political, and military sectors—all the consequence of big businessmen and their emergent corporations—the Chamber's men understandably would not wish to see themselves represented as key agents of that euphoric, yet alarming revolution, even though they were.[64] Just the opposite. In the Chamber of Commerce, they shrouded themselves entirely in the aesthetics of stability, sameness, continuity, and tradition to the degree that a portrait of 1869, such as that of insurance magnate Richard Lathers (figure 102), looks to have been cast from the same mold as John Singleton Copley's portrait of 1769 of the merchant Nicholas Boylston (figure 103), as if they were linked by a timeless brotherhood of business. Although the financial lives of the Gilded Age titans were built on risk, their portraits never take risks.

Instead, most of the Chamber's portraits convey the image of what Weber called "traditional" authority, which, he proposed, was gerontocratic, carried out under the influence of custom and habit, and comprehended as naturalized.[65] Instead of looking imperial or beneficent or revolutionary, these men seem little changed from the businessmen of the past. The Chamber clearly was interested in limiting its iconographic reach to hygienic images of the "respectable professional man," which it accomplished by displaying images mostly

FIGURE 102
Daniel Huntington, *Richard Lathers*,
1869. Oil on canvas, 50 × 40 in.
(Credit Suisse, New York)

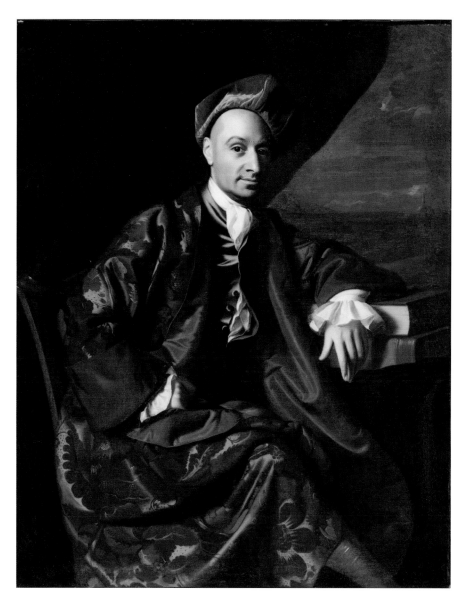

FIGURE 103

John Singleton Copley, *Nicholas Boylston*, 1769. Oil on canvas, 50⅛ × 40 in. (Bequest of David P. Kimball. Courtesy, Museum of Fine Arts, Boston)

divested of references to business, production, bureaucracies, staffs, buildings, largesse, public service, power, profligacy, or near-religious devotion. That in itself was political, of course. But the Chamber carried out its polemic transparently, and, visually at least, it had the effect of removing the men of the Chamber from the semblance of actual power, both bureaucratic and charismatic.

Artists

In achieving such a complex of political goals for its portraits, the Chamber and its members gravitated predictably toward select "house" artists who could enforce proper iconographic management over the images. As might be expected, they turned to Eastman Johnson, who painted twelve portraits; to Thomas Waterman Wood, who painted twenty-five; and especially to Daniel Huntington, who painted forty-three. Huntington was the perfect Chamber artist, having made a distinguished career of fulfilling commissions for portraits of leading citizens, especially clergy, academics, and doctors, along with prominent businessmen. *Scribner's Magazine* accurately captured his significance in 1871: "A list of eminent Americans, their wives and daughters, painted by Mr. Huntington during the past ten years, would cover at least an entire page of this magazine. . . . His portraits are to be found in the homes of our wealthy metropolitans, in our colleges, and in the State and national collections."[66] Since part of the project of the Chamber's collecting had to do with creating a new collective image of respectability for the expanding managerial elite of the city, Huntington's recognized ability to make Americans look "eminent" was an impeccable credential.

Moreover, Huntington was familiar to the Chamber's membership, and in some ways he was like them. He was president of the National Academy of Design for twenty-one of the years between 1862 and 1890, and in that office was himself a sort of chief executive officer of the New York art world, in particular known as someone who stood for the institutionalization and centralization of art in the city. His upright reputation as a model Victorian was appealing, too; he was a devout Episcopalian, and as an artist he often gravitated to moralizing subjects, such as *A Lesson in Charity* and *Philosophy and Christian Art*.[67] Finally, Huntington was a club man, a president and founder of the Century, a vice president and founder of the Metropolitan Museum of Art, and deeply connected to the male professional communities of New York. All this was crucial, given the ethnic homogeneity of the city's elite communities (90 percent of the leading businessmen in America were Protestant), for it meant that the pious and conservative Huntington knew how to speak fluently in the visual language of what one historian called "social gentility and Anglo-Saxon exclusivity."[68]

Huntington's unmatched ability to fashion the kind of desirable image that appealed to the Chamber is evident in his stunning *Richard Lathers* (see figure 102), a gift of the family. It predictably contains no business or commercial accoutrements, no references to his family and personal life, and only oblique clues to his occupation. Huntington presents Lathers, a chief executive officer of the Great Western Marine Insurance Company, almost emblematically as the man of good character. He sits elegantly in a plush red armchair near an open window with a view toward a tall ship navigating a rocky shoal on choppy seas beneath storm clouds. Facing the viewer with an expression both genteel and yet gravely concerned, he reaches his left arm across his torso and points toward the storm-tossed boat. Behind him to the right is a bas relief of a pelican piercing its breast in order to feed a child with its own blood, a Eucharistic expression of charity, sacrifice, and protection.

Huntington's representational strategy in the portrait had nothing to do with how well Lathers actually managed his business or his money, nor did it even associate Lathers with an official corporate enterprise. But the picture does say a lot about Lathers's paternalistic concern for humanity. A viewer cannot help but to imagine the dangers of ocean travel, the unpredictability of life, the suddenness of loss, and the comparative security that Lathers achieved in his own life. Although there is an embedded message on financial risk and the benefits of a good insurance policy, it is subsumed by the more overt drama of the good Lathers watching over his fellow man. Like the many other pictures by Huntington in the Chamber, his portrait of Lathers was aimed at conveying the proper image of the man of responsible, reasonable, and honorable character.

Understandably, none of the three hundred portraits in the collection is by Thomas Eakins, who obtained numerous commissions for portraits of late-nineteenth-century Philadelphia businessmen for hanging in corporate offices: Asbury W. Lee, Richard Wood, Edward S. Buckley, Edward A. Schmidt, William B. Kurtz, Frank St. John, John B. Gest (figure 104), and Robert C. Ogden. The Chamber may have overlooked him first and foremost because he was an artist associated with Philadelphia. But his work also presented an aesthetic challenge that was unacceptable to almost every institution. Most of the businessmen whom Eakins painted in Philadelphia wished that he had never painted their image. Lee gave the artist $200 to take his portrait back. Buckley destroyed his so that his descendants would never think that he ever resembled such a thing. From the businessmen's point of view, Eakins was ungenerous, even cruel. For example, in his portrait of the eighty-one-year-old Gest, former president of the Fidelity Trust Company in Philadelphia, Eakins mercilessly captured a faraway stare that veers toward vacancy and emphasized the clasped hands, which, as Lloyd Goodrich accurately pointed out, seem arranged to look as though the right one holds the left "as if to keep it from escaping."[69]

FIGURE 104

Thomas Eakins, *John B. Gest*, 1905.
Oil on canvas, 40 × 30 in.
(The Museum of Fine Arts,
Houston; Museum purchase)

A naturalist representational philosophy, such as Eakins's, was clearly not in the interest of the Chamber and its members, nor, for that matter, of bourgeois society at large, which was seeking precisely the opposite effect. To be sure, the Chamber owned portraits of its aged members, some of whom were painted in a format similar to Eakins's of Gest and Ogden, but as might be expected, the images are never so vulnerable or brutal. For instance, Jared B. Flagg's 1891 portrait of eighty-three-year-old James S. T. Stranahan (figure 105), a railroad tycoon and park planner, conveys the signs of old age, but does not flaunt them. Flagg worked toward generous pictorial solutions that direct attention to Stranahan's enduring capacities, such as his direct and alert address to the viewer and his gently clasped hands that convey a sense of calm wisdom. This aversion to Eakins or any artist like him was similar to the problem the National Portrait Gallery in London had with George Frederick Watts's portraits of eminent British men. Watts, like Eakins, felt that a portrait ought to tell of the "storms and vicissitudes" experienced in the sitter's life.[70] And that vital baring of unresolved emotions, further, ought to take form with rough paint surfaces, indefinite edges, and weary, self-absorbed expressions that show the complexity of affect through the toll it takes on the body.

The Chamber of Commerce wished to avoid collecting—and its members wished to avoid giving—such portraits because when an artist probed the inner person, the outer biography that encompassed the man's public achievements was obscured. The Chamber embraced Huntington, Johnson, Wood, and other "house" artists precisely because their portraits *never* provided intimate access to the otherwise guarded individual. By avoiding interiority and adhering to conservative portrait templates, the artists could more effectively abstract the Chamber's men into public icons, conveying neither storms nor vicissitudes, but status and respectability instead. A portrait in the Chamber was the equivalent to an official biography, in which intimate expression was avoided and replaced by visual effects that were quantifiable and assayable, that were consonant with money, privilege, and power. And the irony of this was that at the zenith of swashbuckling American capitalism, the enduring image of status and respectability was held at a higher premium than transient images of charisma and power. As a result, the paint surfaces of most Chamber portraits, whomever the artist, are smooth or only moderately inflected, as if to emphasize the seamlessness of the presentation and the wholeness of the person. Instead of attempting to probe the ellipses and ambiguities of businessmen who truly had complex lives, the Chamber's pictures claimed the opposite—that these portraits are sufficient disclosures that announce that a person counted, that he was a visible man in the culture of business and civic affairs, and that that is all that really mattered.

Installation

The ideological imperatives behind the Chamber's collection—not only to honor, but also to define the American businessman—led to surprisingly modest forms of visual etiquette exemplified by the portrait iconography of "the simple man" and "the man of letters." Moreover, in fulfilling its idea of creating a pantheon of capitalist heroes, the Chamber concentrated on individuals, with the one exception of Daniel Huntington's *Atlantic Cable Projectors*. But when the time came in 1902 to move all those individual portraits into the Great Hall on Liberty Street (figure 106), the Chamber hung them in a thick group installation that collectively communicated an imperial presence to be reckoned with. Taken together, the Chamber's portraits no longer expressed simplicity and modesty, but conjured up power, solidity, impenetrability, and dynastic succession.

Certainly, the Great Hall could always be experienced hagiographically, as a galaxy of individuals packed tight. Viewers could not be prevented from seeing the pictures, despite the aesthetic consensus of image types, as a congress of isolated singulars, both linked and separated by individual wooden frames. But for one stepping back and viewing those same individuals as a whole, the Great Hall projected the meta-impression of being a family of professional fathers and brothers, the overall architecture of the display taking on the distinct look of a kinship, with all its suggestions of affinity, loyalty, obligation, and propagation. The large "ancestral" portrait of Cadwallader Colden, the eighteenth-century New York agent for the Chamber's royal charter (see figure 1), always occupied the central position on the east wall, below which, on a dais, was positioned the chair and podium of the Chamber's current president (figure 107). Flanking Colden were smaller portraits arranged in vertical tiers. Whatever the particular arrangement and density of the flanking pictures, which changed from time to time, they always had the look of being the "descendants" of Colden, giving the Great Hall a sense of both history and destiny.

Being entirely male, the portrait "family," moreover, was a parthenogenic mythology, but with a twist, looking as if colonial forefathers begat more men, without the agency of women. And because the men were massed imperially together, arranged in successive rows, and dressed formally, they appeared like a phalanx of soldiers of business. Although none of the men were shown expressing masculinity in stereotypical acts of performative prowess, which, after all, would have conveyed an undesired message for anyone aspiring to be "Great," the impenetrability of the portrait armada spoke emblematically and prescriptively to the question of what a successful professional man should look like in late-nineteenth-century America. Whereas traditional male identity had once been located in the roles of provider, protector, and patriarch, in the postbellum era it shifted into those of moneymaker and successful entrepreneur. The rogue hunters in Gilded Age New York now were its financiers, railroad men, and publishers.[71]

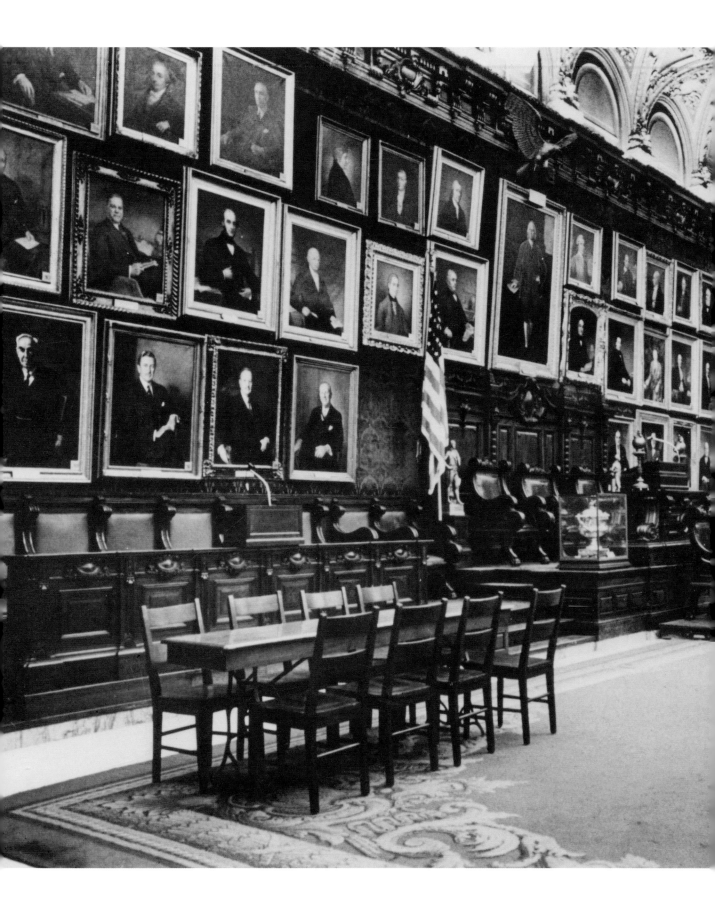

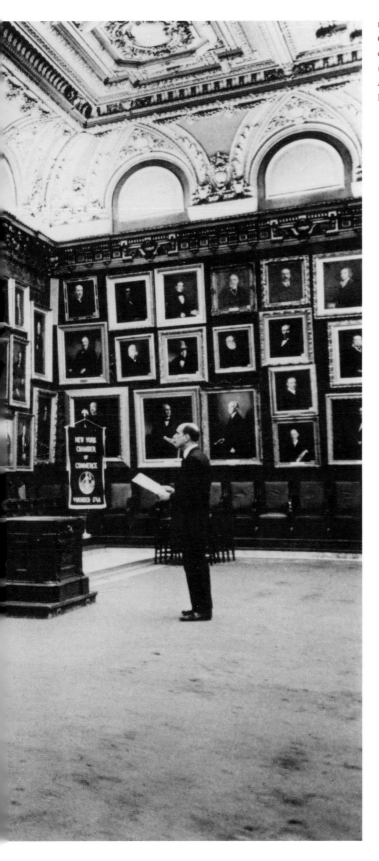

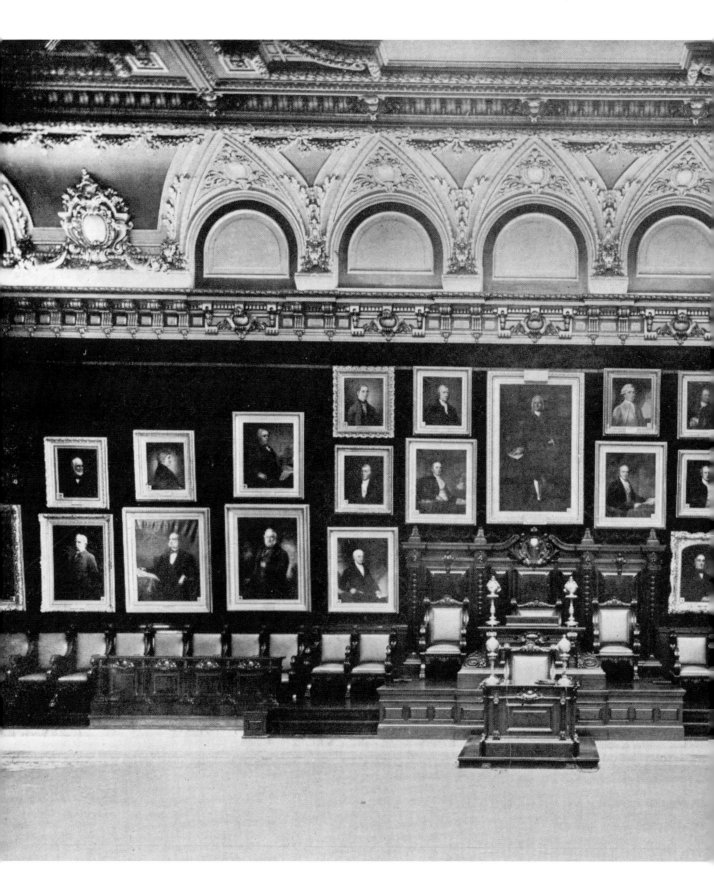

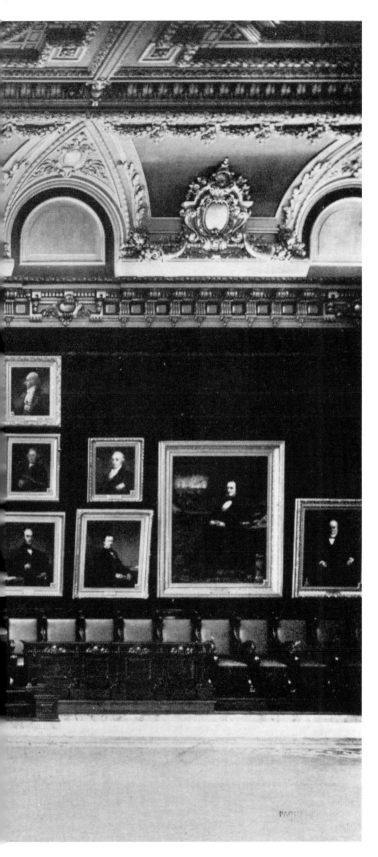

FIGURE 107
Great Hall, with dais. (From *Catalogue
of Portraits in the Chamber of Commerce
of the State of New York, 1768–1924*
[New York: Chamber of Commerce of
the State of New York, 1924])

For the Great Hall to amount to an ersatz business family, the perception of individual identities had to yield in some degree to an overarching visual network that conveyed the fiction of a unified male community over history, its fraternal members positioned shoulder to shoulder.[72] Although the pictures may have begun life with the goal of identifying and hailing famous capitalists individually, the collective of portraits, seen whole and in situ, was the aesthetic correlative to the modern corporation in the sense that both were structured so as to remove a person from singular liability, whether fiduciary or visual, and then bundle him into a unified entity. This process of unification is treated by social theorist Georg Simmel, who analyzed the movement from individual identities to group identity in the essay "The Web of Group-Affiliations" (1922). He described the migration of previously disconnected individuals from "heterogeneous groups" (rural, urban, Protestant, Jewish) toward associations of "homogeneous members" (the Chamber being one example).[73] Newly "related" by a "similarity of talents, inclinations, activities, and so on," these men, who might have been strangers or foes outside the affiliation, willingly and temporarily bracket off other cultural differences in order to form "a group whose cohesion was based on purpose."[74] Thus "the merchant joins other merchants in a group which has a great number of common interests: legislation on issues of economic policy, the social prestige of business, representation of business-interests, joint action as over against the general public in order to maintain certain prices, and many others."[75] Simmel's idea of a web of affiliation speaks accurately to the culture of the Chamber as well as to the aesthetics of the Chamber's gallery. That is, looking at the gallery in 1902, there is an undeniable sense that these are individuals *assembled* into an artificial society, a manufactured superstructure open to being expanded, contracted, and reconfigured by house fiat. Disconnected individuals could be folded into a "family" of like images as long as each portrait was entirely mute on the subject of the individual's nonbusiness life, as if all diversity had been checked at the Chamber's front doors. The portraits—and the institution—could cohere into a group because most signs of individuation were repressed and then replaced by the narrow typological templates discussed previously, creating fictive kin.

Yet for all the pictured solidarity, few of these men would have actually wished to mingle or to export their in-Chamber alliances to what Simmel called "every nook and cranny" of their "natural relationships." Their affiliation was collapsible, as men came only occasionally to the Chamber for a specific purpose and then disassembled, moving back to other, more constant and entrenched social structures.[76] Some of these men, especially those owning railroads, were actually in mortal conflict with one another, vying for markets, stocks, shipping routes, track rights, and patents. Commodore Vanderbilt, for example, considered his railroad rival and fellow Chamber member James J. Hill to be a dangerous threat to his New York Central empire. Meanwhile, Jacob Schiff battled

Chamber colleague J. Pierpont Morgan in advancing Edward H. Harriman's hostile bid to take over Hill's Northern Pacific Railway. As Simmel concisely put the conflictual dimension of voluntary societies: "[E]ach merchant is in competition with many others. To enter this occupation creates for him at one and the same time associations and isolation, equalization and particularization. He pursues his interests by means of the most bitter competition with those with whom he must often unite closely for the sake of common interests."[77]

Simmel's theory on the tension between individual interests and group interests suggests the dense politicking that must have percolated behind the scenes of the Chamber of Commerce. It also suggests the degree to which the impressive solidarity of images displayed in the Chamber's gallery was a façade on which all identities, however complex and conflicted they may have been on the street, now flattened out, in Simmel's words, to "concern the world of commerce as such and make it appear to others as a unified group."[78] Although the pictures in the gallery promised professional congruity and mutual order, the real-life logic of competitive individualism modified the possible pleasures of fraternal exchange. Which is to say, the competitiveness of businessmen with one another was temporarily interrupted on the walls of the Chamber for the sake of a common purpose and replaced by the aggregate image of a placid network, a family tree, a professional genealogy. If a pan-business brotherhood existed as an ideal or a goal of the Chamber of Commerce, it was most manifest in the pictorial unity on the Chamber's walls, and not necessarily on Wall Street. In the headquarters of American capitalism, of all places, the discourse of professional and personal rivalry, in which many of the businessmen reveled, was converted into the quiet visual economy of prestige and honor. This complex process of artful self-domestication, the end product of which is the artificial family created on the walls of the Great Hall, represents the stake each man had in being "shareholders" in the common goal of improving not just the economic capital, but also the symbolic capital of New York's businessmen. However individualistic or idiosyncratic a Morgan or a Carnegie might have been, in the realm of the gallery their images conform to and share in the official visual norms of the Chamber group, which in turn provides them with a share of the institution's collective symbolic value.[79]

At the turn of the twentieth century, it was common for professional men to meet willingly with one another in a variety of fraternal societies, clubs, orders, and groups in which collective action was organized through secondary social bonds.[80] For the New York Chamber of Commerce, it was particularly important that its gallery specifically contribute to the businessmen's sense of themselves, that it express the collective mission of the Chamber, that it create and consolidate social ties, and that through shared imagery it promote particular values, identities, and implicit models of professional conduct. The

gallery articulated, as well as any material artifact could, the sense that the Chamber was a brotherhood of voluntary mutual assistance. The great age of industrial and financial capitalism in New York had produced a city of divergent cultures—and thus divergent individuals—no longer cohered by a singular set of authoritative social values, but instead fractured into an endless array of articulated subgroups. The captains of industry themselves often were not acquainted with one another, were in cutthroat competition with one another, or were isolated from one another behind layers of corporate management. Although industrialism and urban society had made individuals anonymous and social relations mechanistic, the portrait gallery, paradoxically, both celebrated corporate capitalism and counteracted its effects. Here, the makers of American capitalism could be recognized as a community. In that way, the Chamber's Great Hall, with all its monumental imagistic power, was a special urban island where members of a dominant male class could mingle in representation and in the unconflicted brotherhood of portraiture bid allegiance to a single overarching value—the triumph of commerce in New York.

Notes

The author appreciates the wise counsel, thoughtful remarks, and kind words offered at various stages of the preparation of this essay by Daniel Czitrom, Neil Harris, Carrie Rebora Barratt, Valentijn Byvanck, Marianne Doezema, Elliot Bostwick Davis, Karl Kusserow, and Debbora Battaglia. I thank the Metropolitan Museum of Art and the Department of American Paintings and Sculpture for awarding me a J. Clawson Mills Fellowship, which allowed me to work uninterrupted on this essay.

1. *Tribute of the Chamber of Commerce of New York to the Memory of Abiel Abbot Low, President, 1863–1867* (New York: Press of the Chamber of Commerce, 1893), 20.

2. Randolph Starn, "Reinventing Heroes in Renaissance Italy," in *Art and History: Images and Their Meaning*, ed. Robert I. Rotberg and Theodore K. Rabb (Cambridge: Cambridge University Press, 1988), 67–84; Andrew Martindale, *Heroes, Ancestors, Relatives, and the Birth of the Portrait* (The Hague: SDU, 1988); Christine Joost-Gaugier, "Castagno's Humanistic Program at Lenaia and Its Possible Inventor," *Zeitschrift für Kunstgeschichte* 45, no. 3 (1982): 274–282.

3. Marcia Pointon discusses this in *Hanging the Head: Portraiture and Social Formation in Eighteenth-Century England* (New Haven, Conn.: Yale University Press, 1993), 53–78.

4. Paul Barlow, "Facing the Past and Present: The National Portrait Gallery and the Search for 'Authentic' Portraiture," in *Portraiture: Facing the Subject*, ed. Joanna Woodall (Manchester: Manchester University Press, 1997), 219–238; Pointon, *Hanging the Head*, 227–244.

5. Cotton Mather, *Magnalia Christi Americana; or, The Ecclesiastical History of New England* (1702; repr., Cambridge, Mass.: Harvard University Press, 1977).

6. In the British tradition of biographical promotion, Peter Pelham took public enshrinement into the consumer sphere by selling mezzotints of the portrait of Shirley, as well as of Smibert's companion portrait of William Pepperell, another of the heroes of Louisbourg. For public galleries, see Richard H. Saunders and Ellen G. Miles, *American Colonial Portraits, 1700–1776* (Washington, D.C.: Smithsonian Institution Press, 1987), 21, 53–58. For an archival account, see Pierre Du Simitière, "Paintings in Boston New England" (1767), Du Simitière Papers, Library Company, Philadelphia. See also Ellen G. Miles, "Portraits of the Heroes of Louisbourg, 1745–1751," *American Art Journal* 15 (1983): 48–66.

7. One of Peale's "worthy personages," his portrait of Daniel Tompkins of 1819, ended up in the collection of the Chamber of Commerce.

8. For Peale's Philadelphia Museum, see Roger Stein, "Charles Willson Peale's Expressive Design," *Prospects* 6 (1981): 139–185; Susan Stewart, "Death and Life, in That Order, in the Works of Charles Willson Peale," in *The Cultures of Collecting*, ed. John Elsner and Roger Cardinal (Cambridge, Mass.: Harvard University Press, 1994), 204–223; and the excellent dissertation of Brandon Brame Fortune, "Portraits of Virtue and Genius: Pantheons of Worthies and Public Portraiture in the Early American Republic, 1780–1820" (Ph.D. diss., University of North Carolina, 1987).

9. Max Weber, *The Protestant Ethic and the Spirit of Capitalism* (1904–1905), trans. Talcott Parsons (New York: Scribner, 1930).

10. Edith Holzer and Harold Holzer, "Portraits in City Hall, New York," in *Portrait Painting in America: The Nineteenth Century*, ed. Ellen Miles (New York: Universe, 1977), 15–24.

11. Joseph Delaplaine, *Delaplaine's Repository of the Lives and Portraits of Distinguished American Characters* (Philadelphia: Joseph Delaplaine, 1816), 1:vi. For discussions of illustrated biographies in America, see Gordon M. Marshall, "The Golden Age of Illustrated Biographies," in *American Portrait Prints*, ed. Wendy Wick Reaves (Charlottesville: University of Virginia Press, 1984), 29–82; Robert G. Stewart, *A Nineteenth-Century Gallery of Distinguished Americans* (Washington, D.C.: Smithsonian Institution Press, 1969); and Barbara J. Mitnick and David Meschutt, *The Portraits and History Paintings of Alonzo Chappel* (Chadds Ford, Penn.: Brandywine River Museum, 1992).

12. In 1890, the Chamber of Commerce itself would publish its *Portrait Gallery*, which contains lengthy laudatory biographies meant to be absorbed in context with the corresponding paintings that hung in the Chamber's rooms.

13. This was also the case in the periodical literature at the time. Before 1820, as Theodore P. Greene summarized it, "business in itself did not rank as a sufficient testing ground for the hero" (*America's Heroes: The Changing Models of Success in American Magazines* [New York: Oxford University Press, 1970], 56). Yet this had changed by the 1850s.

14. *The Writings of Thomas Jefferson*, ed. Paul L. Ford (New York: Putnam, 1892–1899), 4:143.

15. Fortune discusses the idea of moral duties in "Portraits of Virtue and Genius," 94–97.

16. Mary Panzer, *Mathew Brady and the Image of History* (Washington, D.C.: Smithsonian Institution Press, 1997).

17. *New York Times*, October 6, 1860.

18. Pointon discusses some of the distinctions between a worthy, who is a source of moral inspiration, and a celebrity, who may be morally flawed, in *Hanging the Head*, 229.

19. Archibald Hanna Jr., "Every Man His Own Biographer," *Proceedings of the American Antiquarian Society* 80, pt. 2 (1970): 280–298. For an amusing account, see Oscar Lewis, "Mug Books," *The Colophon* 17 (1934).

20. Freeman Hunt, *Lives of the American Merchants* (New York: Derby and Jackson, 1856), 1: iii. As some testimony to the success of projects such as the Chamber's gallery, it was commonplace by the end of the nineteenth century to see businessmen in compendiums of renown. For example, William C. King had sections on "Great Railroad Men" and "Great Merchants" mixed in with sections on "Eminent Preachers" and "Prominent Inventors" in *Portraits and Principles of the World's Greatest Men and Women* (Springfield, Mass.: King, Richardson, 1894).

21. For an overview of the relationship between businessmen and politics, see David C. Hammack, *Power and Society: Greater New York at the Turn of the Century* (New York: Russell Sage Foundation, 1982), 130–157.

22. The negative image of the American businessman is thoroughly elaborated in Louis Galambos, *The Public Image of Big Business in America, 1880–1940* (Baltimore: Johns Hopkins University Press, 1975); and Sigmund Diamond, *The Reputation of the American Businessman* (Cambridge, Mass.: Harvard University Press, 1955). I am following some aspects of the critical position proposed by Matthew Josephson, *The Robber Barons: The Great American Capitalists, 1861–1901* (New York: Harcourt, Brace, 1934).

23. Walter Benn Michaels, *The Gold Standard and the Logic of Naturalism* (Berkeley: University of California Press, 1987); Henry Nash Smith, "The Search for a Capitalist Hero," in *The Business Establishment*, ed. Earl F. Cheit (New York: Wiley, 1964), 77–112; Emily Stipes Watts, *The Businessman in American Literature* (Athens: University of Georgia Press, 1982); Walter Fuller Taylor, *The Economic Novel in America* (Chapel Hill: University of North Carolina Press, 1942).

24. Walt Whitman, *Democratic Vistas* (1871; repr., New York: Liberal Arts Press, 1949), 10.

25. Quoted in Richard Hofstadter, *The American Political Tradition and the Men Who Made It* (New York: Vintage Books, 1948), 165.

26. This theme comes up repeatedly in Ron Chernow, *Titan: The Life of John D. Rockefeller, Sr.* (New York: Random House, 1998).

27. David H. Solkin, "Great Pictures or Great Men? Reynolds, Male Portraiture, and the Power of Art," *Oxford Art Journal* 9, no. 2 (1986): 42–49; J. G. A. Pocock, *The*

Machiavellian Moment: Florentine Political Thought and the Atlantic Republican Tradition (Princeton, N.J.: Princeton University Press, 1975); Benjamin H. Lehman, *Carlyle's Theory of the Hero: Its Sources, Development, History, and Influence on Carlyle's Work. A Study of a Nineteenth Century Idea* (Durham, N.C.: Duke University Press, 1928); Thomas Carlyle, *On Heroes, Hero-Worship, and the Heroic in History* (1840; repr., New York: Oxford University Press, 1974); Dixon Wecter, *The Hero in America: A Chronicle of Hero-Worship* (New York: Scribner, 1941).

28. *Samuel F. B. Morse: His Letters and Journals*, ed. Edward Lind Morse (Boston: Houghton Mifflin, 1914), 1:268–270.

29. I am borrowing and adapting some of the language of cultural anthropology. See Marshall Sahlins, "Poor Man, Rich Man, Big-Man, Chief: Political Types in Melanesia and Polynesia," *Comparative Studies in Society and History* 5, no. 2 (1963): 285–303; Maurice Godelier, *The Making of Great Men: Male Domination and Power Among the New Guinea Baruya* (Cambridge: Cambridge University Press, 1986); and Maurice Godelier and Marilyn Stathern, *Big Men and Great Men: Personifications of Power in Melanesia* (Cambridge: Cambridge University Press, 1991).

30. Sahlins, "Poor Man," 292.

31. Pierre Bourdieu, *Outline of a Theory of Practice*, trans. Richard Nice (Cambridge: Cambridge University Press, 1977), 192.

32. Marcel Mauss, *The Gift: Forms and Functions of Exchange in Archaic Societies* (1925), trans. Ian Cunnison (New York: Norton, 1967), 72. Social theorist Thorstein Veblen called philanthropy a form of "predatory temperament" (*The Theory of the Leisure Class: An Economic Study of Institutions* [1899; repr., New York: Signet, 1953], 155).

33. Richard Sennett points out that public life was changing anyway, as men in all walks of life evacuated the idea of *res publica* and moved toward forms of personality and celebrity in the nineteenth century, in *The Fall of Public Man* (New York: Knopf, 1977).

34. Ludmilla Jordanova, *Defining Features: Scientific and Medical Portraits, 1660–2000* (London: Reaktion Books, 2000), and "Medical Men, 1780–1820," in Woodall, *Portraiture*, 101–115. See also Renate Burgess, *Portraits of Doctors and Scientists in the Wellcome Institute of the History of Medicine* (London: Wellcome Institute, 1973).

35. George Wilson, ed., *Portrait Gallery of the Chamber of Commerce of the State of New York* (New York: Press of the Chamber of Commerce, 1890), vi.

36. "Stephen V. White," *Munsey's Magazine*, April 1892, 15.

37. *New York Times*, August 25, 1881.

38. *New York Times*, March 6, 1882.

39. Horatio Alger Jr., *Ragged Dick; or, Street Life in New York with the Boot Blacks* (1868; repr., New York: Signet, 1990), 174.

40. Andrew Carnegie, *Triumphant Democracy* (New York: Scribner, 1886), 101. The literature on this subject is large, but its outlines are presented by Irvin G. Wyllie, *The Self-Made Man: The Myth of Rags to Riches* (New Brunswick, N.J.: Rutgers University Press, 1954). See also John G. Cawelti, *Apostles of the Self-Made Man* (Chicago:

University of Chicago Press, 1965); Richard M. Huber, *The American Idea of Success* (New York: McGraw-Hill, 1971); and Judy Hilkey, *Character Is Capital: Success Manuals and Manhood in Gilded Age America* (Chapel Hill: University of North Carolina Press, 1997).

41. Andrew Carnegie, *The Empire of Business* (New York: Harper, 1902), 8.

42. Robert Woodward Cushman, *Elements of Success* (Washington, D.C.: Waters, 1848), 10.

43. Benjamin Franklin, "The Way to Wealth," in *The Writings of Benjamin Franklin*, ed. Albert Henry Smyth (New York: Macmillan, 1905), 3:417–418.

44. Wyllie, *Self-Made Man*, 34–54.

45. Weber, *Protestant Ethic*, 172.

46. Quoted in Barry E. Supple, "A Business Elite: German-Jewish Financiers in Nineteenth-Century New York," *Business History Review* 31, no. 1 (1957): 167.

47. Moses Rischin, *The Promised City: New York Jews, 1870–1914* (Cambridge, Mass.: Harvard University Press, 1977), 263.

48. Moses Rischin, *The American Gospel of Success: Individualism and Beyond* (Chicago: Quadrangle Books, 1965), 14; Christian Riegel, "Rosedale and Anti-Semitism in *The House of Mirth*," *Studies in American Fiction* 20, no. 2 (1992): 219–224.

49. See Richard Brilliant's brief but important essay, "Portraits as Silent Claimants: Jewish Class Aspirations and Representational Strategies in Colonial and Federal America," in *Facing the New World: Jewish Portraits in Colonial and Federal America* (New York: Jewish Museum, 1997), 1–8.

50. Andrew Carnegie, "Wealth," *North American Review* 148, no. 391 (1889): 664.

51. Quoted in C. Vann Woodward, *Tom Watson, Agrarian Rebel* (New York: Macmillan, 1938), 340.

52. *Cosmopolitan*, January 1903, 340.

53. *McClure's Magazine*, February 1894, 263.

54. Greene calculated that 16 percent of all biographies from 1894 to 1903 were about businessmen, ahead of the categories of foreign rulers, American politicians, military leaders, scientists and inventors, clergy, educators, and judges, in *America's Heroes*, 153.

55. Greene, *America's Heroes*, 78, 105; *Munsey's Magazine*, June 1896, 383.

56. Greene, *America's Heroes*, 112.

57. *Munsey's Magazine*, August 1893, 422.

58. *Cosmopolitan*, January 1903, 340.

59. "There Isn't Money Enough in the World To-Day to Do the World's Work," *Munsey's Magazine*, May 1908, 216.

60. Morgan is perhaps the most fascinating personality among the financial elite, the one with the most potential for picture making. To fathom his aura at the turn of the century, see Ron Chernow's superb *The Death of the Banker: The Decline and Fall of the Great Financial Dynasties and the Triumph of the Small Investor* (New York:

Vintage Books, 1997), and *The House of Morgan: An American Banking Dynasty and the Rise of Modern Finance* (New York: Atlantic Monthly Press, 1990).

61. Philip Fisher, "Appearing and Disappearing in Public: Social Space in Late-Nineteenth-Century Literature and Culture," in *Reconstructing American Literary History*, ed. Sacvan Bercovitch (Cambridge, Mass.: Harvard University Press, 1986), 174.

62. Max Weber, *Economy and Society: An Outline of Interpretive Sociology* (1922), ed. Guenther Roth and Claus Wittich, trans. Ephraim Fischoff (New York: Bedminster Press, 1968), 1:241. See also Max Weber, *On Charisma and Institution Building*, ed. S. N. Eisenstadt (Chicago: University of Chicago Press, 1968).

63. John Higham alludes to this in "The Reorientation of American Culture in the 1890s," in *The Origins of Modern Consciousness*, ed. John Weiss (Detroit: Wayne State University Press, 1965), 74–102.

64. For an excellent study of the cultural revolution brought about by big business, see Galambos, *Public Image of Big Business*.

65. Weber, *Economy and Society*, 1:226–241.

66. D. O. C. Townley, "Living American Artists," *Scribner's Magazine*, May 1871, 47.

67. *A Lesson in Charity* is in the collection of the Wadsworth Atheneum in Hartford, Connecticut, and *Philosophy and Christian Art* is in the collection of the Los Angeles County Museum of Art.

68. William Miller, "American Historians and the Business Elite," *Journal of Economic History* 9, no. 2 (1949): 203; Wendy Greenhouse, "Daniel Huntington and the Ideal of Christian Art," *Winterthur Portfolio* 31, nos. 2–3 (1996): 103–140.

69. Lloyd Goodrich, *Thomas Eakins* (Cambridge, Mass.: Harvard University Press, 1982), 2:232.

70. Mary S. Fraser-Tytler Watts, *George Frederick Watts* (London: Macmillan, 1912), 1:35.

71. Peter Gabriel Filene, *Him/Her/Self: Sex Roles in Modern America* (New York: Harcourt Brace Jovanovich, 1975); E. Anthony Rotundo, *American Manhood: Transformations in Masculinity from the Revolution to the Modern Era* (New York: Basic Books, 1993).

72. For a discussion of masculinity and fraternal civic action, see Dana D. Nelson, *National Manhood: Capitalist Citizenship and the Imagined Fraternity of White Men* (Durham, N.C.: Duke University Press, 1998).

73. Georg Simmel, *Conflict & The Web of Group-Affiliations* (1922), trans. Kurt H. Wolff and Reinhard Bendix (Glencoe, Ill.: Free Press, 1955), 128, 140–143.

74. Simmel, *Conflict*, 129.

75. Simmel, *Conflict*, 155.

76. Anthropologist Mary Douglas would call this a "weak-grid, strong-group" society in which external boundaries are maintained against outsiders, but internally it is minimally structured, allowing individuals freedom to exercise their own sense of personal responsibility. See Mary Douglas, *In the Active Voice* (London: Routledge and Kegan Paul, 1982), 183–254. See also Mary Douglas and Baron Isherwood, *The World of Goods* (New York: Basic Books, 1979), 38–43. In the future, there may be

interpretive lessons to be applied to portrait installations from network theory, as posited by sociologists. See David Knoke, *Political Networks: The Structural Perspective* (Cambridge: Cambridge University Press, 1990); David Knoke and James R. Wood, *Organized for Action: Commitment in Voluntary Associations* (New Brunswick, N.J.: Rutgers University Press, 1981); and Mark S. Mizruchi, *The American Corporate Network, 1904–1974* (Beverly Hills, Calif.: Sage, 1982).

77. Simmel, *Conflict*, 155.

78. Simmel, *Conflict*, 155.

79. I am following Bourdieu, *Outline*, 192–194.

80. Eric J. Hosbawm, "Fraternity," *New Society*, November 27, 1975, 470–473; Anthony Oberschall, *Social Conflict and Social Movements* (Englewood Cliffs, N.J.: Prentice-Hall, 1973), 110–122.

EXERCISING POWER

The New York Chamber of Commerce and the Community of Interest

ELIZABETH BLACKMAR

For the 205 years of its independent existence, the New York Chamber of Commerce prided itself on having been the first and most powerful business association in the United States. Founded by merchants in the colonial port, by the end of the nineteenth century the Chamber was bringing together leaders of commerce, finance, industry, and real estate, giving them a means of speaking with a single voice while serving both formally and informally as an arbiter of conflicts within business ranks. If its primary goal was to look after its own "community of interest," a phrase coined during one of many legislative investigations into the affairs of New York businessmen, the Chamber's main achievement was to enhance the collective reputation of its members by linking commerce and civilization, enterprise and civic leadership.[1] The portraits of officers in the Great Hall projected and honored the power accumulated and the services rendered by these men. Still, uses of this collective power changed as enterprise evolved from family firms to corporations; as the city grew, national markets consolidated, and international markets expanded; and as both national and local governments developed policies that prompted business leaders to redefine their own understanding of the proper relation between public and private interests. When the Chamber expired after two centuries, a voluntary association no longer sufficed to represent the collective power of New York's business elite.

Merchants in a Revolutionary Era

In April 1768, twenty New York merchants met at Fraunces Tavern to form a mercantile society "for promoting and encouraging commerce, supporting industry, adjusting disputes relative to trade and navigation, and procuring

such laws as may be found necessary for the benefit of trade in general."[2] There were few precedents for a voluntary association of this kind. Groups of European merchants had come together in syndicates, joint-stock companies, and trade associations to pursue specific investments, and vestiges of medieval merchant guilds survived as fraternal associations. But in the age of monarchy and mercantilism, national governments regulated both commerce and commercial organizations in European cities.[3] Nor did merchants in Philadelphia, the largest colonial port, feel the need to form a trade association.[4] But then again, it probably was competition from Philadelphians that pushed the New York merchants to organize themselves.

In 1768, as the port of New York climbed out of the depression that followed the Seven Years' War, merchants chafed under imperial trade regulations aimed at making the American colonies help pay for that conflict. Three years earlier, two hundred New York merchants had led a successful boycott of English imports to pressure Parliament to rescind the Stamp Act (1765). In March 1768, merchants held another flurry of meetings to organize a nonimportation movement to challenge new duties imposed by the Townshend Act (1767), coordinating this political protest with shippers in Boston and Philadelphia. The same spring, the Chamber of Commerce was founded as an apolitical mercantile society, concerned less with challenging imperial trade policies than with managing the port's commercial affairs.[5]

Although many of the same merchants joined both movements, the men of the Chamber met monthly to address such issues as the standard of weights, valuation of currency—particularly the paper money of other colonies—and inspection of flour, meat, and timber in order to preserve New York's reputation as a supplier of quality produce. Equally important, the Chamber appointed committees to arbitrate disputes among merchants, including fights over salvage fees and liability for damaged cargo.[6] Still, the very ambiguity of boundaries between political and commercial activities in the mercantile world of the late eighteenth century may explain how the Chamber of Commerce secured a royal charter at the very moment that its merchants were aggressively contesting royal prerogatives.

Although their boycotts helped launch a revolutionary movement, New York's elite merchants saw themselves as the voices of reason in a sea of discontent. In 1765, when artisans and laborers had joined the radical Sons of Liberty to denounce the Stamp Act and block its implementation, Mayor John Cruger, who three years later became the Chamber's first president, negotiated with the royal lieutenant governor, Cadwallader Colden, to turn the hated stamps over to city officials.[7] (An angry crowd had already destroyed the home of a British army officer and burned Colden in effigy, using his carriages for firewood.) Throughout his nearly fifty years of service to the Crown, Colden had tried to enforce imperial policies even when he judged mercantilist trade restrictions

unwise.[8] Although he had made many enemies among New York's leading merchants, as the colonies' Whig and radical leaders became more outspoken, Colden understood that merchants were crucial allies for the Crown. The desire to keep them loyal doubtless spurred his grant in 1770 of a royal charter of incorporation for the Chamber of Commerce despite the nonimportation movement.[9] The summer after the Chamber received its charter (and a committee gratefully assured Colden that they were "zealous in our Support of Government"), New York merchants enraged their compatriots in Boston and Philadelphia by abandoning the boycott.[10]

The incorporation of the Chamber of Commerce represented a crucial, almost metaphysical, development for its subsequent history; for even when the organization ceased to hold meetings, the charter sustained its existence. The charter recognized the Chamber as "one Body Corporate and Politik in Deed, Fact, and Name," "capable in the law" of entering into all manner of economic transactions. Only three other New York institutions held charters that granted such powers: the municipal corporation, Trinity Church (the established Anglican church), and Kings (later Columbia) College. Aside from the chartered monopolies of the British East India Company and the Royal African Society, eighteenth-century corporations were not business institutions; rather, the Crown delegated authority to a corporate "body politic" in exchange for the performance of public services—in this instance, the promotion of commerce and industry. Precisely because public-service corporations allowed a large group of individuals to transact business together, they provided a model of association that fifty years later would be taken up by merchants and entrepreneurs for the purpose of private enterprise.[11]

The one hundred or so members of the Chamber of Commerce in the late colonial period included some of the wealthiest citizens of the port. Some shared family as well as economic ties to Crown officials or the great Hudson Valley landlords. Other members were provision merchants, who made their fortunes exporting flour and timber and importing sugar, rum, and molasses from the Caribbean or wine from Madeira. Or they were dry-goods merchants, who imported cloth, tea, metals, and china from England.[12] New York's merchants had prospered not only through legitimate commerce but by smuggling and privateering—that is, plundering enemy and neutral commercial vessels during the Seven Years' War. (Indeed, "it is notorious that the Genius of no people was ever more peculiar or conspicuous than that of the Americans for Privateering," a 1782 letter from the Chamber's merchants observed.)[13]

Because shipping was such a risky enterprise, it fostered both collaboration and the diversification of investments. The leading mercantile houses were organized as partnerships, often with family members.[14] In the early 1770s, the most successful merchants held assets in ships and cargoes that might be worth as much as £10,000 in an era when an estate of £1,000 represented comfortable

independence. Importers and exporters also invested surplus capital in land, in loans to other New Yorkers, or in insuring one another's ships and cargoes. In an era before commercial banks, merchants operated their own counting houses and developed and managed extensive networks of long- and short-term credit. This early alliance of commerce and finance defined the Chamber's community of interest and set its agenda for the next century.[15]

In seeking to stabilize the conditions of commerce, the Chamber's merchants sought to fix the prices of their own services as well as the price of flour and money. Standard commission rates for services that ranged from outfitting a ship to exchanging currency implicitly established guidelines for arbitration awards. Yet from the earliest meetings, conflicts arose that could not be easily resolved according to a single corporate interest. Passage of a resolution setting the exchange rate for New Jersey's paper currency, for example, prompted more than a dozen members to resign.[16] The merchants also faced dissent from outside their ranks. As Revolutionary fervor disrupted the customs of social deference, merchants found themselves arguing with artisans in the ad hoc political committee that enforced the nonimportation agreements and elected representatives to the Continental Congress. New York's merchants, unlike those of Philadelphia, initially retained the upper hand in the struggle for leadership, but debates sometimes turned into brawls, as happened in 1779 when the Chamber's vice president, Elias Debrosses, tried to disband a gathering of the Sons of Liberty.[17]

When the movement for political independence broke into war, merchants' own ranks divided. Half the Chambers members—including most of its officers—remained loyal to the Crown, another quarter declared themselves neutral, and the rest left the city to join the patriot cause.[18] From 1776 to 1783, during the British occupation of New York City, the Chamber's loyalist core effectively governed the port's civilian affairs. With independence, more than twenty thousand loyalists left New York State, including five former Chamber presidents whose estates had been confiscated by the new republican legislature in 1779.

The American Revolution marked the starkest division in the organization's history. By the late 1780s, however, Parliament had compensated loyalists for their property, the New York legislature had reaffirmed the Chamber's charter, a number of loyalist merchants returned, and the portrait of Cadwallader Colden, commissioned in 1772 as a gesture of appreciation for the Chamber's charter and in this sense perhaps a token of servility to the Crown, instead became a totem of the association's distinguished history.

The Treaty of Paris called for the repayment of all debts that predated the Revolution, and that burden, alongside unstable currency and the jurisdictional uncertainties associated with the Articles of Confederation, encumbered commerce in the 1780s. Through the decade, the Chamber directed its collective strength to the project of nation building, especially endorsing the Constitu-

tion, which placed commerce and currency under the protection of a national government rather than competing state assemblies. Indeed, commerce was the primary object of federal governance. In this respect, it is fitting that the portrait acknowledging Cadwallader Colden (see figure 1) as the imperial authorizer was matched by a painted tribute to Alexander Hamilton (see figure 2), marking the transition from British mercantilism to American federalism.

The early history of the Chamber of Commerce provides several keynotes for the institution's later history. The sense that commerce had its own imperatives and—even more important—that it required the expertise of those engaged in similar pursuits to arbitrate differences in a timely and consistent manner set merchants apart from the city and made them accountable primarily to one another. Shopkeepers and artisans took their contract disputes to local courts. But the Chamber's members regarded arbitration as a way to keep the numerous quarrels of their joint ventures from disrupting commerce: the results of arbitrations were delivered quickly and were final. In modern economic terms, the merchants had devised a collective strategy for reducing transaction costs within their own sector. In addition to arbitration, the Chamber established and refined merchants' habits of self-governance through committees that investigated and reported back to the membership on specific issues that troubled the waters of commerce, from piracy to yellow fever epidemics.

The Chamber also established merchants as rulers of the port's economic affairs, especially the daily operations of the harbor and wharves. Shipbuilders, coopers, printers, dockworkers, mariners, boarding housekeepers—perhaps one-quarter of the port's households—directly served and depended on commerce. With merchants' numbers and financial interests dwarfing those of the crafts or professions, the Chamber of Commerce asserted that promoting private interests served the public good. Such a claim could not be matched by other associations—for example, journeymen shoemakers or tailors—whose own "combinations" in nascent trade unions were deemed by English common law to be conspiracies in restraint of trade.[19] The Chamber's classical motto, enshrined on its seal, *non nobis nati solum* (not born for ourselves alone) implied a larger altruism, though it might also have simply recognized that no merchant could act alone and succeed.

Merchants' claims to public authority did not go unchallenged, however. When members of the Chamber endorsed John Jay's treaty with England in 1794, they faced a jeering crowd of sailors, dockworkers, and journeymen outraged by this concession to the British Crown at the expense of the revolutionary movement in France.[20] The merchants won the battle over the Jay Treaty, and in the 1790s European wars brought a surge of prosperity to them and their clients. But the popular crowds in effect won the war when Jeffersonians captured the White House in 1800. Far from having the power to establish national policy, the city's merchants found themselves cast ashore first by Thomas

Jefferson's 1807 embargo to protest English impressments of American sailors and then by "Mr. Madison's War" in 1812 to defend neutral Americans' right to trade with fighting European nations. In the face of recession, the Chamber ceased meeting for nearly a decade.

Merchant Entrepreneurs and Family Capitalism

In 1817, with the promotion of commerce as its sustaining goal, merchants called the Chamber back into regular assembly and immediately endorsed proposals to build both the Erie Canal and a new Merchants' Exchange.[21] The Chamber's nineteenth-century historian, John A. Stevens Jr., credited John Pintard, the first compensated secretary, with revitalizing the institution. The son of an early Chamber member and once a merchant himself, Pintard had lost his fortune in the 1790s and gone to debtors' prison after serving as surety for speculator William Duer's bad debts. Thereafter, Pintard worked as a cashier for a marine insurance company and became a tireless booster for such new organizations as the New-York Historical Society, the American Bible Society, and the city's first savings bank, considered a philanthropic institution. He told his daughter Eliza that he had agreed to become the Chamber's secretary only out of personal loyalty to the patrician merchants William Bayard and Robert Lenox, whose successive terms as president ran from 1819 to 1840. For ten years, Pintard saw to it that the organization convened and had a public presence—most dramatically realized in the Merchants' Exchange Building, opened in 1827 (see figure 11). Still, Pintard remained rather bitter about his "paltry" compensation for organizing the merchants, a mere $100, he told Eliza, for duties "which are at times very oppressive."[22] Pintard represented a new factor in the institution's history: as much as the members themselves, hired secretaries fashioned the Chamber's culture and even its policies.

At the same time that John Pintard established the Chamber's new routines, he represented the last ties to the organization's patrician past. In 1862, Pelatiah Perit, who served as Chamber president from 1855 to 1862, drew an intimidating picture of the old guard of "royal" merchants—Archibald Gracie, William Bayard, Herman LeRoy, Benjamin Minturn, John Murray, Matthew Clarkson—and the aura they cast around themselves: "Men who in that day held a prominence which, at present time, is not accorded to those in the same position. There was some remnant of aristocracy at that time, which has since become obliterated. I remember well the profound respect which the junior merchants of those days paid to these eminent men."[23] The gentlemen merchants of Perit's memory adhered to the values of a hierarchical society; they extended patronage, and they expected deference to their power and prestige.

By the 1830s, a new generation of merchant princes—the great majority from Connecticut and Massachusetts—were capitalizing on the agricultural wealth of the nation, especially its cotton and wheat, while introducing a more pious and benevolent style for the city's power elite.

With the economic boom that followed the opening of the Erie Canal, Yankee merchants formed an inner circle at the Merchants' Exchange and the Chamber of Commerce. Between 1845 and 1875, all but one of the Chamber's presidents hailed from New England.[24] They came to power at the moment of New York port's greatest expansion; by 1860, the port controlled more than half the nation's combined imports and exports.[25] Most of the Yankee merchants made their money in international commerce and solidified both those fortunes and their local social standing through advantageous marriages, often to Knickerbocker daughters. They went on to invest their wealth not only in real estate but also in banks, insurance companies, and railroads, most of which, indeed, they helped organize. Here, then, was the transition from merchant to industrial capital, most often by way of finance.

Although more than 400 mercantile houses engaged in foreign commerce by 1840 (with another 918 commission firms serving local and interior trade), the Chamber had fewer than 200 members, comprising only the most successful "merchants on the seven seas." Leading merchant houses, often family firms with from two to six partners and twice as many clerks, generally identified with specialized commodities and markets. The Griswolds and Lows concentrated on the China trade; Jonathan Goodhue (with his silent partner Perit) and the firm of Phelps Dodge imported metal from England and exported cotton. The house of Howland and Aspinwall, the city's largest company with as many as eighteen ships, developed a Pacific trade and then captured the Latin American market (and later built railroads across Panama). Moses Taylor, who started out as a clerk for the Howlands, dominated the Cuban sugar trade.[26] The great shipping houses were also embedded in a chain of credit networks that reached from the great banking establishments of London to their own inner circles.[27] The Brown brothers, originally from Baltimore; the Morgans and Peabodys, from Connecticut and Massachusetts; and the Dodges and Jameses all had family members strategically settled in more than one city and country, thereby working multiple terminals of the import–export business and early investment banking.[28]

The Chamber of Commerce was one of a network of institutions through which these leading merchants organized their affairs. The heads of firms assembled daily at the Merchants' Exchange and informally negotiated deals and shared information. The Chamber's monthly or bi-monthly meetings built on this habit of assembly and provided a setting in which to formulate collective policies for managing the harbor (for example, hiring the pilots), lobbying government officials, or corresponding with mercantile bodies in other leading

ports. A century later, members of the Chamber would describe their organization as following a democratic "town meeting" procedure and contrast it to a "corporate committee model" of decision making found in later businessmen's lobbying organizations. Yet the Chamber itself adopted a committee system that closely resembled the ways antebellum boards of directors oversaw banks, insurance companies, and railroads in the generation before salaried managers took over.[29]

However much merchants believed in the invisible hand of the market, they never fully embraced a laissez-faire theory of government. Rather, the Chamber became a forum in which merchants helped refashion British mercantilism into an American system. In the early nineteenth century, an era of piracy and war on the high seas, commerce literally required protections, and New York merchants readily accepted tariffs to sustain the federal government on which their larger enterprise depended. Only when manufacturers proposed higher tariffs to protect domestic industry did New York merchants balk, but even then, some merchants came to view the internal improvements of canals and roads, which opened domestic markets, as an acceptable quid pro quo, while others had begun to invest in iron foundries and textile mills, which benefited from tariffs.[30] On the most divisive question of the era—slavery—New York merchants, whose own fortunes rested so squarely on the cotton trade, advocated compromise; only in the 1850s did some Whig members begin to rally to the anti-slavery banner.

Merchants also looked to the federal government to resolve conflicts in state laws. The Chamber repeatedly endorsed strong national bankruptcy laws, a matter that members regarded from the perspective of both creditors and debtors. When a popular merchant raconteur asked Nathaniel Griswold how many merchants had prospered among all those he knew over the course of fifty years, he replied, "The average who have succeeded have been about seven in the hundred. All the rest, ninety-three in the hundred of untold thousands have been bankrupts."[31]

Although they professed great humility at the risks of international shipping, as New York's leading merchants expanded their community of interest, they saw in the Chamber of Commerce an association of wealthy men who had succeeded because they were reliable and circumspect. "The model merchant," an 1884 banquet toast proclaimed, "He gives as good as he gets; he pays as he goes; and he keeps his book by the Golden Rule."[32] Many of the most successful merchant entrepreneurs, whether acting as individuals or in family partnerships, conducted their business and personal affairs conservatively. They hedged their bets against wars, weather, and weak markets by owning and insuring shares of ships and cargoes, keeping many ships afloat at a time, and maintaining personal balances of trade that could withstand sudden turns. A man's reputation for soundness was forged and repeatedly tested by the recurring downturns

that punctuated commerce, whether wartime disruptions of Continental markets or declines in the price of cotton or in the supply of species or the demand for opium.

Caution and close calculation also marked financial entrepreneurship. For fifty years, speakers at Chamber banquets singled out Moses Taylor as exemplary: "It was a sober head that wore Moses Taylor's crown."[33] Taylor, the sugar importer who was said to pay more in tariffs in 1855 than any merchant other than the dry-goods magnate A. T. Stewart, refused to purchase on credit. He invested his vast mercantile profits in City Bank and then ran it on the principle of "ready money," thereby keeping it afloat during the panics of 1857 and 1873. Yet however cautious in his day-to-day financial operations, Taylor also boldly moved capital into new enterprises. Using City Bank as a personal clearinghouse, he invested in utilities (Manhattan Gas Light Company), railroads, coal, iron, and ultimately the firm that became Bethlehem Steel. As the controlling stockholder, he sat on the boards of directors and actively managed a half-dozen companies by the 1860s.[34]

Taylor, whose own start had surely been eased by his father's standing as John Jacob Astor's most trusted agent, adhered to conventions of nineteenth-century family capitalism when his clerk, Percy Pyne, became a partner and married Taylor's daughter. The consummate bourgeois, Taylor's only flaw in the eyes of his contemporaries was his single-minded devotion to making money. At the time of his death in 1882, with an estate worth more than $50 million, his only significant charitable contribution was $270,000 to establish a hospital for railroad and ironworkers in Scranton, Pennsylvania.[35] Still, and despite his erratic membership, the Chamber of Commerce readily claimed Taylor as one of its own, in effect enhancing his civic identity in exchange for the right to bask in the reflected glory of his remarkable business career. Thus Taylor was honored in Daniel Huntington's painting *The Atlantic Cable Projectors* (see figure 164) as well as by an individual portrait (see figure 56).

Exceptional in his own success, Moses Taylor sought out merchants like himself as he organized and invested in the financial institutions and heavy industries that transformed the American economy in the mid-nineteenth century and with it the Chamber of Commerce. Indeed, far from embodying unbridled individualism, the Chamber's most prominent members developed a talent for association that was essential for securing capital for new ventures. And as he looked for merchants of like attitude to build an investment group for his projects, Taylor readily found William E. Dodge.[36]

President of the Chamber of Commerce from 1868 to 1875, Dodge was more aggressive than Taylor in his philanthropic work and thus was regarded by his peers as the city's representative merchant prince.[37] (A statue erected by the Chamber to honor him still stands in Bryant Park.) Born in 1805, Dodge was the son of a Hartford merchant who pursued numerous enterprises before retiring

in 1827 to write pacifist religious tracts. At age eighteen, Dodge began clerking in a wholesale establishment; five years later, he took over his father's business in partnership with the son of another Connecticut merchant. In 1828, he married Melissa Phelps, whose father, Anson Phelps, had gone from being a Hartford saddle maker to commanding New York's metal trade. Dodge became a partner in Phelps's metal-importing and cotton-exporting firm, along with two other sons-in-law. By 1869, the firm was capitalized at $4 million with shares divided among eight family partners. As early as 1835, Dodge began to invest in the lumber business in Pennsylvania, an enterprise he turned over to his sons in 1863. While Phelps moved the firm into brass and copper manufacturing in Ansonia, Connecticut, Dodge developed its mining interests in Minnesota and Michigan. He backed the New York and Erie Railroad and became a director for twelve years. He resigned in 1857 to protest the railroad's violation of the Sabbath, a pattern that recurred with railroads in New Jersey and, after the Civil War, in Texas and Georgia. (His biographer notes that Dodge always seemed to pull out on moral grounds just before the enterprise collapsed financially.) His joint investment with Moses Taylor in the Lackawanna Iron and Coal Company led to the development of the Delaware, Lackawanna, and Western Railroad, which did not operate on Sunday, as well as to the acquisition of extensive coalfields. In the 1870s, the family firm of Phelps Dodge moved into copper mining in the New Mexico Territory. It remained one of the nation's largest mining companies through the twentieth century.

The rise of Phelps Dodge into a leading national corporation illustrates how merchants fueled the industrial expansion of the American economy. But despite his participation in this process, Dodge prided himself on his indifference to money except as it could be put to benevolent use. Like his father-in-law, Dodge was a patron of the American Bible Society, the YMCA, and Christian missions, as well as of the Chamber of Commerce. In 1868, President Ulysses S. Grant tapped him for the Indian Peace Commission, which advocated the reservation system as an alternative to military suppression. Dodge saw himself as adhering to a code of conduct established by his father's generation. Addressing an audience of young men at the Mercantile Library Association in 1879, he urged a "return to the high-minded and steady habits so general fifty years ago; unless industrious, persevering attention to regular business, with moderate annual gains, shall take the place of the more recent notion of making haste to be rich and running the risks of enormous credits, with a view of jumping into fortune at once, our city can never attain a position and reputation indispensable to permanent prosperity."[38]

Given that New York's merchant capitalism was family capitalism, a sentimental invocation of the trope of fathers and sons became part of the culture of the Chamber of Commerce, which paid tribute to the continuity within firms and especially to filial respect. In 1863, Pelatiah Perit stressed the Chamber's

value in maintaining a "continuous or connecting link between the present race of merchants and those of the past and those who are to follow."[39] Older merchants established paternal relations with young men even if they were not related or in the same firm; Perit's own successor as president, Abiel Abbot Low, celebrated Perit as a mentor who brought him along in the Chamber as well as in commerce.[40] When Low himself endowed a fund to commission portraits, he reinforced the rhetorical custom of speakers enumerating great merchants of an earlier generation and thus helped organize and illustrate a collective institutional memory. As the sons and sons-in-laws of the Yankee merchant entrepreneurs began taking over their banks, railroads, and civic organizations, the portraits recapitulated the patrilineal transmission of power. The fathers in this story, models of probity who had made their own way, now watched over the conduct of sons and grandsons from the walls.

Engagements in Public Affairs

Pelatiah Perit, Abiel Abbot Low, and William Dodge formed the cohort of Yankee merchants who directed the institutional consolidation of the Chamber of Commerce in the mid-nineteenth century. With revised bylaws no longer restricting membership to merchants, in the 1850s Perit had aggressively recruited new entrepreneurs. In 1858, the Chamber expanded its quarters to include a substantial library, and in 1863 its annual report added a second volume with "reports and statistics of trade and finance" assembled from shipping lists and business journals.[41] The annual reports did more than organize and disseminate economic information. Just as the portraits imparted personality and a sense of familial tradition to the Chamber, the statistical series amplified the "story" of business enterprise in New York by displaying its many different sectors. This collective economic biography, in turn, served as another tool of recruitment: What successful entrepreneur would not want to belong to an organization that in effect took credit for an ever-ascending line of progress and prosperity? By the mid-1870s, with Dodge at its head, and even in the face of the most severe economic depression the country had yet experienced, the organization had between 750 and 800 members, and the arbitration committee was hearing from thirty to forty cases a year.[42]

The Chamber's initial expansion coincided with the deepening crisis over the future of slavery—and, by implication, the cotton trade—in the United States. Officially, the Chamber, like most of the city's merchants, tried to dodge the slavery question and looked for reconciliation after Abraham Lincoln's election. But many Yankee leaders had converted from the Whig to the Republican Party, and with the firing on Fort Sumter, these merchants delivered New York's

wealth and power to the Lincoln administration.[43] Deeply moved by their own display of unqualified patriotism, the merchants never lost track of the relation between war and commerce. In calling for an investigation of the Customs House, where the tariffs that helped finance the war were collected, Low noted that "the prompt aid extended by merchants of this city to the Government at all times entitled them to exemptions from unnecessary burdens and annoyances."[44] The merchants also worried about the war's impact on shipping: at the extreme, the danger posed by southern battleships (Low lost two ships), but, more broadly, the steady erosion of American shipping since the 1850s as steamship lines from Liverpool and Hamburg came to dominate the port.

The Civil War brought the Chamber's members dramatically into city politics as well as national affairs. Although the Chamber was in summer recess at the time of the bloody five-day draft riot in 1863, the protest against the conscription law (which permitted wealthy men to buy their way out of service by paying for a substitute) shook the city to its core. Many of the Chamber's members backed the Citizens Association, which promoted housing and health reforms to assuage the brutal class conflicts exposed by the riots. But others also literally placed their money on the pro-growth coalition of Tammany Democrats, who came into power under the leadership of William Marcy Tweed. Tammany promised jobs on public works to compensate for the economic costs of wartime inflation, claiming that taxes on rising land values would keep the city solvent. By the late 1860s, with the city's real-estate market booming, City Hall was issuing a steady stream of bonds for new streets, sewers, and a courthouse built by Tweed supporters at inflated costs. Many members were all too happy to reap the rewards of the boom until the bankers among them warned that the city would not be able to pay back its debts. In 1870, the Chamber of Commerce in effect dissolved itself into an ad hoc committee of the whole, a group that came to be known as the Committee of Seventy, and for the first— but not the last—time in the city's history, business leaders took control of the city's fiscal affairs.[45]

The ousting of the Tweed Ring became one of the legends of the Chamber's public service, but three years later, Mayor Henry Havemeyer, a sugar refiner who had been put in office as the Chamber's man in 1871, warned of the ongoing "indifference and inertness of the commercial and capitalist classes." Until a "deeper interest in public affairs is manifested by those who have a large stake in this community," he announced at the annual banquet, "nothing but extravagance, dishonesty and corruption will continue to disgrace" government, and public improvements would be treated as spoils. "Popular government," Havemeyer said, "requires the watchful, patient, patriotic self-sacrificing care and guardianship of all citizens; and it is the particular duty of those who gain and appropriate to themselves the largest pecuniary result of our free institutions to fulfill these obligations of citizenship, to watch and work as well as pray

and resolve, without which their own wealth will soon turn into ashes in their grasp." Many a banquet speech that night had elicited genial laughter or rousing applause. These words were met with silence.[46]

Perhaps taking Havemeyer's warning to heart, business leaders did engage in city as well as national politics in the late nineteenth century. Eight out of fourteen mayors elected between 1872 and 1901 were members of the Chamber of Commerce, with civil service and fiscal reform figuring prominently in their programs.[47] In 1894, the Chamber funded the state legislature's Lexow Committee investigation into police corruption and added moral reform to its bipartisan campaign against Tammany Hall. A Presbyterian faction within the Chamber's leadership was especially moved by the fervor of minister Charles Parkhurst, whose City Vigilance League denounced everything from lax enforcement of Sunday closing laws to abusive child labor.[48] Charles S. Smith, president of the Chamber from 1887 to 1894, explained the business interest in moral reform in an article in the *City Vigilant*: "Capital has no sentiment; the question of its location is determined by consideration of gain and security; it fears corruption in government as one fears a highwayman in traveling." Since "government by the people" held sway in large cities, Smith observed, "we must look to moral conduct as the proper preservative force."[49]

Morris Jesup—the Chamber president from 1899 to 1907, a descendent of Connecticut shopkeepers, and a pillar of the Presbyterian church—shared Smith's perspective.[50] Jesup's godfather, Morris Ketchum, had been one of the city's most powerful bankers, and Jesup began his own business career as a clerk in Ketchum's Paterson Locomotive Works before forming his own commission house to supply equipment to railroads. He married Maria Van Antwerp De Witt, and after the Civil War, with his wife's money as well as his own savings, Jesup moved into investment banking, specializing in western railroad securities as well as streetcars. Jesup retired in 1884 at the age of fifty-four to pursue good works, including the presidency, for twenty-three years, of the American Museum of Natural History. He thought of himself, he once said, as a brother to William Dodge II, and, like William Dodge, he thought of the Chamber of Commerce as a civic rather than merely a business association. "I maintain that we have got to do something besides simply caring for the commerce of this City," he told his colleagues. "We must take part, not only as individuals, but collectively as a Chamber, in an unpartisan way, in every reform inaugurated in this City for the protection of life, for the preservation of property, for the maintenance of our liberties. . . . This Chamber is interested, or should be, in all matters bearing on the welfare of the country or the city."[51]

However much the Chamber's leaders felt the need to counter the demoralizing effects of industrial society, civic and moral reform competed for their attention with broader economic concerns. At the top of the agenda stood the organization and administration of transportation to expand the flow of

goods, people, and money. The Chamber's preoccupation with the conditions of the port itself had slackened as the enterprises of members extended far beyond shipping. At the annual banquet in 1874, a toast was proposed—"May the foreign carrying trade in U.S. vessels be speedily restored"—in response to the mortifying information that American ships carried only 25 percent of all imports and exports, as compared with 90 percent fifty years earlier.[52] But in 1877, when President Rutherford B. Hayes expressed his "very great gratification" at meeting "such an assemblage of the business men of the city," he signaled the Chamber's new collective identity.[53] Although some members continued to pursue the import/export trade, "merchants" had also become bankers, industrialists, and brokers—men who pursued "business enterprise."

Whether as merchants or as financiers, the Chamber's members individually and collectively worried about the railroads. The war years had launched the investment of $1.5 billion in a system that went from 31,000 miles of track to 75,000 miles in less than a decade. As the railroads drew investment capital from European bankers as well as American merchants, their expansion spurred heavy industries and national markets for agricultural produce and manufactured goods. Although the Chamber's bankers and merchants had been promoters and beneficiaries of this expansion, William Dodge blamed "too rapid construction" of the railroads for the financial panic of 1873 and the subsequent depression.[54] The speculative maneuvers of Jay Gould (never a member of the Chamber) and the Crédit Mobilier scandal contradicted longstanding protestations of the integral relation of individual character and commercial success. At the same time, the general strike of railroad workers in 1877 introduced New York's entrepreneurs to class conflict on a national scale.[55]

Over the next thirty years, the regulation of railroads became the Chamber's most divisive issue. In the early 1870s, business leaders like Dodge criticized regulatory laws initiated by the Granger movement (and upheld by the Supreme Court in *Munn v. Illinois* [1877]) and charged that government oversight of rates contributed to economic instability.[56] By the end of the decade, however, a reform faction within the Chamber challenged this classical liberal position and also looked more critically at the business practices of other Chamber members. In 1877, wholesale merchants Francis B. Thurber and Charles S. Smith organized a special meeting of two hundred "leading traders" to air their grievances against railroads that discriminated against New York commerce by charging higher rates to go there than to other ports.[57] Noting that "the revenues collected by the railroads exceed by more than tenfold the entire revenues of the State," the Chamber petitioned the New York Assembly to appoint a committee, headed by A. Barton Hepburn, to investigate the charges against William Vanderbilt's New York Central and Hudson River Railroad and Hugh Jewett's New York Lake Erie and Western Railroad.[58] Thirty years later, Hepburn himself became Chamber president, but it was the association's lawyer, Simon

Sterne, who exposed stock watering, rate discrimination, and huge rebates to Standard Oil, which John D. Rockefeller was rapidly building into a monopoly.

Although the railroads protested that New York had long benefited from trading advantages at the expense of other cities and that they adjusted rates solely to meet their competition, the Hepburn Committee's endorsement of regulation paved the way for the creation of the federal Interstate Commerce Commission in 1887. Meanwhile, the corporate counsel for Vanderbilt's trunk line, Chauncey DePew, a favorite toastmaster at Chamber banquets, shed the usual flattery of his after-dinner speeches when he caustically warned members that their campaign bordered on "communistic." Replying on behalf of the Chamber, Thurber and Smith did not flinch: "We cannot uphold a system of operating public highways which is honey-combed with abuses, and which is controlled absolutely by a few individuals who tax production and commerce at will, and who practically dictate what reward the producer, manufacturer and merchant shall receive for his labor."[59]

The conflict of interest between the major trunk lines and merchants festered within the Chamber. Though many members had made fortunes in railroad investments, they initially sided with the advocates of regulation and elected Charles S. Smith as Chamber president from 1887 to 1894. But when the Populist movement called for the nationalization of the railroads, as well as bimetallism for currency, members looked to other modes of disciplining an enterprise that had racked the nation with labor strife as well as financial panics. Market failure was, of course, one discipline: between 1880 and 1894, as many as five hundred railroad companies went into receivership.[60] Yet the Chamber's campaign for regulation also prompted another, related, form of market discipline. When the Hepburn investigation fanned public hostility against the Vanderbilt family in particular, William H. Vanderbilt sold a large chunk of New York Central stock to J. Pierpont Morgan, thus opening the way, as historian Lee Benson writes, for the "active domination by the financier of large-scale corporate enterprise in general, and railroads in particular."[61]

When the Interstate Commerce Commission proved to be a weak regulatory body, New York dry-goods merchants and jobbers, many of them not sufficiently wealthy or prominent to be invited to join the Chamber of Commerce, organized the Merchants' Association in 1897 to contest once again "discriminatory freight rates."[62] But by that time, the Chamber of Commerce had by and large made its collective peace with the railroads; moreover, in order to maintain peace within its own halls, the Chamber's leadership chose to avoid aggressive confrontations. After all, John D. Rockefeller not only had joined the Chamber in 1889, but had contributed $50,000 toward its new building.[63]

The system of street railways in New York presented a different kind of transportation problem for the city's leading businessmen. By the 1880s, merchants agreed that the privately franchised elevated railways owned and operated

by William C. Whitney and Thomas Fortune Ryan failed dismally in moving people and goods quickly around the city. Although deeply ambivalent about the European model of publicly owned urban transit, in 1888, Abram Hewitt, a Chamber member who two years earlier had defeated both Henry George and Theodore Roosevelt for mayor, called for the public financing of a new transit system. In 1894, the Chamber of Commerce submitted a legislative bill to create a permanent eight-member Rapid Transit Commission; six commissioners were Chamber members, including its president, Alexander Orr, a retired commission merchant who also promoted the creation of Greater New York. Advocating public ownership of the rails and private operation of the trains, the Rapid Transit Commission oversaw the initial financing and construction contracts for New York's first subway.[64]

In 1897, noting the Rapid Transit Commission's success (and overlooking its own collaboration with Tammany-affiliated contractors), Progressive reformer Albert Shaw declared that New Yorkers "are governed in this city today, and governed splendidly, by the New York Chamber of Commerce."[65] Given the social and political turmoil of the 1890s, in another voice this remark might have been ironic. But the promotion of the subway came to represent the Chamber's single boldest act of civic betterment, and in some respects it was possible precisely because business leaders in their private enterprises had rehearsed the form of action. Although railroads had pioneered in establishing professional managers to oversee operations, the Chamber's bankers were used to directing complicated financial transactions. Other Chamber members had served on the numerous bipartisan political commissions—whether to manage parks or to establish railroad rates—that American elites turned to as an alternative to party and electoral politics.[66] The formation of the Rapid Transit Commission was of a piece, then, with business leaders' habits of both economic and political governance at the end of the nineteenth century.

Both the fight to regulate the trunk lines and the quest to provide an alternative to private transit monopolies placed the Chamber in a position of asserting a collective—"public"—interest over and above the private interests of a particular enterprise or sector. But the financial booms and busts that produced three severe depressions in as many decades drew public attention both to the intensity of competition within business ranks and to speculators' lack of accountability. As New York's business leaders found themselves facing attacks from outside as well as inside their own ranks, the work of smoothing over differences was often performed by luminaries, including clergy, brought in to remind the Chamber's banquet-goers of their own virtues.

At the 1884 banquet, the minister R. Herbert Newton, who would later endorse Henry George for mayor, drew analogies between "Old Time Guilds and Modern Commercial Associations." The guilds, Newton said, used arbitration to handle disputes among firms and between masters and workers, and

they also had developed an "industrial partnership" and discovered "profit sharing" as "the solution to the problem of labor and capital." Moreover, the guilds had fostered a "real brotherhood among men," offered assistance to members in need, and "upheld the high ideals of honor." And when a member violated their codes, the guilds "declared him infamous. It was a secular excommunication; a sort of moral boycotting. It was the last punishment meted out to an obdurate offender. [*Applause*]."[67] As historian David C. Hammack has shown, the language of the business guild circulated widely in the mid-1880s, and the romance of the guild surely informed how the city's business leaders regarded their "Great Hall" on Liberty Street when it opened in 1902.[68]

If the guild ideal suggested a model for handling conflicts, it also captured business leaders' efforts to find a way of explaining their public status. In the late 1870s, following the Tweed scandal and the reforms of the Committee of Seventy, several Chamber members participated in a state commission appointed by Governor Samuel Tilden that recommended the restriction of the municipal franchise to property owners, and the Chamber endorsed the proposal.[69] This challenge to democratic precepts failed, but the corporatist notion persisted that propertied citizens held a superior collective claim to govern. Business leaders embraced a new associationalism that they said—disregarding profound asymmetries of power—was no different from the movement of wage earners to organize trade unions to defend their interests. At the same time, the Chamber's leaders gradually converted the older moral and paternalistic rhetoric of duty and guardianship into a new discourse of rational and progressive public service.

By the turn of the twentieth century, officers positioned the Chamber of Commerce as a civic organization that mediated between unrestrained strategies of maximizing private wealth and new demands for protecting the public interest. Not only did the Chamber repeatedly form coalitions with other organizations on behalf of good government or moral reform, but business leaders advocated the conservation of natural resources in the name of efficiency, preservation, and their own passion for the outdoors. As early as 1884, the Chamber helped launch the campaign to set aside a state preserve in the Adirondacks—where a number of members had summer cottages—that would be "forever wild." Over the twentieth century, the Chamber of Commerce also endorsed preserving Niagara Falls, protecting the Croton and Catskills watersheds, and controlling air pollution. The Chamber supported the conservation of cultural as well as natural resources; in the 1920s, the Chamber threw its weight behind saving City Hall, built in 1807, and in the early 1940s, it backed the preservation of Castle Clinton in Battery Park.[70]

Yet even as the Chamber selectively aligned itself with preserving the city's history and the state's natural resources, more and more members came to the organization, as to the city, from other regions and with few family connections. Trained at colleges or new business schools and then advanced through

company ranks, their loyalties increasingly lay with the national corporations that stood at the center of the business elites' community of interest in the twentieth century. Gradually this new business elite remade the Chamber of Commerce in its own image, turning away from the intimate world of merchants and entrepreneurs who had made one another's fortunes and married one another's daughters and toward a business organization that prided itself on the absence of sentimental attachments.

Corporate Officers

Three significant changes redefined the business community at the turn of the twentieth century: the ascendancy of finance capital, the corporate careers of business leaders, and new negotiations over the uses of state power and regulation. The three trends, of course, were closely linked, and they pushed the Chamber's lobbying and its ceremonial life in new directions.

Despite remarkable aggregate economic expansion from 1870 through 1897, volatile business cycles, stagnant productivity, and industrial conflict cut into rates of profit.[71] The practical solution to the profit squeeze of the late nineteenth century was the merger movement, a consolidation of companies between 1897 and 1907 largely organized by investment bankers.[72] Although the merger movement yielded substantial gains for its sponsors, it also introduced new problems of legitimacy, especially as legislative investigations in 1905 and 1911 exposed the insular transactions of finance capital to public scrutiny.

Bankers and insurance executives became increasingly visible in the Chamber of Commerce in part because so many successful merchants moved into finance after making or inheriting their first fortune from commerce. Marine and fire insurance had long attracted merchant capital, but following the Civil War not only did trust companies and commercial banks proliferate, but life insurance developed into a financial juggernaut. In 1859, at the age of twenty-five, Henry B. Hyde created the Equitable Life Insurance Company; after 1868, the company took off when he introduced the "tontine" system, essentially a gambling pool that rewarded only the last survivor. Hyde, who joined the Chamber of Commerce in 1875, was said to have raised the capital to start his company from fellow members of the Fifth Avenue Presbyterian Church. However much he owed to a shrewd tapping of old cultural capital, Hyde represented a new style of Gilded Age entrepreneurship, which depended on building a home office bureaucracy that superintended agencies across the country devoted to aggressive salesmanship. Other insurance companies, particularly New York Life, also accumulated capital by retaining and investing the "surplus" between what the company collected in premiums and what it paid out to beneficiaries.[73]

By 1905, the three largest companies—Mutual, Equitable, and New York Life—had insurance worth $5 billion in force, compared with $150 million in 1865, with company assets averaging $410 million. Prudential and Metropolitan, which had introduced industrial insurance policies for wage workers in the late 1870s, were worth more than $100 million each. These insurance assets, economic historian Douglas North notes, formed "an important part of the capital accumulation financing the expansion and consolidation of transportation and industry," making available "to the expanding capital market in New York . . . the savings of millions of wage and salary earners, representing over $1.7 billion in 1900."[74]

After thirty years of spectacular growth, however, the insurance industry was brought to heel in 1905, when a state senate committee, chaired by William Armstrong and with Charles Evans Hughes acting as its lawyer, held hearings on what were popularly regarded as insurance executives' high-handed investment strategies that came at the expense of policyholders. As a result of the investigation, new laws required the insurance companies to divest their heavy stock holdings in banks and trust companies and barred them from participating in syndicates for bond purchases or other public offerings—the high finance that had been so central to their "drive to corporate power and place," as historian Morton Keller observes.[75]

The Chamber of Commerce regretted the "spirit of sordid commercialism which . . . clouded the judgment of the custodians of large and important trusts."[76] In the aftermath of the Armstrong Committee's exposure of George Perkins's financial sleights of hand at New York Life, Alexander Orr, who had served as Chamber president from 1894 to 1899, was brought in (at the modest salary of $50,000) to restore the company's credibility. Orr retired after eighteen months, as merchant John Claflin reported, "leaving the company absolutely secure, stable in fact, and stable and strong in the minds of the whole community because he had been there during that difficult period."[77] But the Chamber did more than lend sterling reputations to discredited firms. It formed committees—with insurance executives well represented—to weigh proposals for new regulatory legislation.[78] Within the insurance industry itself, executives' "leadership style" shifted from aggressive entrepreneurship to what Keller calls a "reassuring corporate face," intent on performing a quasi-public service.[79] Such a face was familiar within the Chamber of Commerce, and between 1920 and 1972, seven insurance executives served as president.

Despite the scandal of the Armstrong investigation, finance capital and the merger movement brought the Chamber of Commerce triumphantly into a new corporate era. Although a merchant once again became president in 1912, his three predecessors had been bankers.[80] With the membership ceiling set at fifteen hundred (raised to two thousand in 1917), annual reports and banquet speeches celebrated the growth of American wealth. "The influence

of the Chamber is expanding," banker J. Edward Simmons assured members in May 1910. "You do not begin to appreciate, my friends, many of you, what a vast power this body represents."[81] A. Barton Hepburn was even bolder in his assertion: "Commerce is king, and the whole world bows down before its power."[82] Hepburn had gone from being a reform-minded assemblyman to state comptroller of currency to president of Chase Bank in 1904 and president of the Chamber from 1910 to 1912.

Associating itself with the new era, the Chamber also addressed the multifaceted agenda set by Progressive reformers. Thus the Chamber's leadership endorsed the effort of Chicago businessmen and social activists who had organized the National Civic Federation in 1899 to seek new ways to deal with labor militancy, on the one hand, and the specter of business monopoly on the other. At stake was not only a more stable and predictable business climate but credibility with a general public tired of strikes, panics, bribery, and patronage politics. In 1907, the Chamber sent to the Civic Federation's Conference on Trusts and Combinations a blue-ribbon delegation that included Seth Low, former mayor of Greater New York and president of Columbia University; steel magnate Andrew Carnegie; transit tsar August Belmont; druggist William J. Schieffelin; and Cornelius N. Bliss, a merchant-turned-industrialist who had served as Secretary of the Interior under William McKinley and was a staunch backer of the Charity Organization Society of New York.[83]

The Chamber took part in deliberations over other economic reforms. When government investigations disciplined the insurance industry in the first decade of the century, banking was not far behind. In 1911, Congress authorized the Pujo Committee to investigate the "money trust." Famous for bringing J. Pierpont Morgan to the floor of Congress, where he testified that commercial credit was based not on money or property but on character—"before money or anything else. Money cannot buy it"—the Pujo Committee also provided a backdrop for the banking and currency reforms that culminated with the adoption of the Federal Reserve in 1912.[84] For more than a decade, the Chamber closely monitored debates over these reforms, sending delegates to the national bankers' conventions and petitions to Congress.

Economic growth and businessmen's energetic engagement with shaping acceptable regulations and blocking all others contributed to a sense of optimism. But the need to answer critics still shadowed the Chamber's banquets, which moved from Delmonico's to the larger Waldorf-Astoria. In 1912, Senator Elihu Root (once lawyer for the city's transit monopolists) invoked a familiar filiopietism when he expressed his "reverence" for the men who had "made the Chamber of Commerce," including Abiel Abbot Low, "the noble and inspiring presence of the father of your present President," Seth Low. Reverence, however, was not the only sentiment Senator Root shared with the Chamber. "Hundreds of thousands of people, outside the great industrial communities . . .

think of you as a den of thieves," he informed his audience matter-of-factly, "no better than a set of confidence men." It was, of course a "misunderstanding," but one that had to be redressed.[85]

Caught between their own claims of unlimited power and prosperity, on the one hand, and reformers' attacks on monopoly and the exploitation of labor, on the other, the Chamber's members continued to insist on the link between commerce and civilization and to rehearse their own code of ethics in special meetings called to eulogize one after another of the generation that had given the Chamber its influence and stature. Yet paying tribute to Morris K. Jesup, Seth Low stressed his virtues in such a way as to acknowledge the problem of business rogues and tarnished reputations: Jesup had the "finest traits of character that we of the Chamber of Commerce, at least, like to believe are characteristic of the ideal man of business. Upright; with an integrity that we sometimes speak of as old-fashioned . . . well balanced, ready to dare, yet knowing when to stop. The master of his business and not its slave. The master of his money and of himself."[86]

Perhaps the most remarkable moment of retrospection came in 1908 with the death of George Wilson, who had served as the Chamber's secretary since 1868. Sixty-nine when he died, Wilson was said to have been absent from the Chamber's meetings only four times in half a century. But the merchants and bankers barely knew how to eulogize a man who had made their institution rather than making himself. Wilson was "very devoted to the Chamber . . . well-informed, attentive, courteous, discrete . . . so unassuming, so constant, so tactful. . . . The traditions of the body were part of his life." It was Wilson who had written the annual reports and gathered together many of the more than two hundred portraits that now adorned the Chamber's walls. Indeed, said George Seward, "if it be true that a corporation is always the lengthened shadow of a man, this corporation, in some ways, is more a shadow of George Wilson than any other person who has taken part in its activities. And if it be true that a man is always greater than his work, then surely we do well to render to George Wilson recognition of the full stature of his manhood."[87]

The recognition of George Wilson's manhood in conjunction with the Chamber's identity as a corporation is perhaps worth underscoring, for the institution was gradually moving away from the tropes of family capitalism and toward new ways of affirming business virtue and honor in relation to institutional service. The culminating moment of the old order came in 1914, when Seth Low himself was overwhelmed by the sense of his father's presence. Thus he concluded the Chamber's lengthy deliberations over restoring an American merchant marine while war raged in Europe: "[A]s son of my father who fifty years ago was president of this Chamber, and who, in his day, kept the American flag upon the sea when it was dangerous to be there [*applause*], I hope you will pardon me when I say how deeply I rejoice in the action of the Chamber today [*continued applause*]."[88]

But the family tie and the family firm were also losing stature in business circles. Economists and businessmen intent on defending the new corporations argued that older firms were inefficient—indeed, that family ties often interfered with good business judgment.[89] Among leading businessmen in the decade 1910 to 1920, 14 percent had started their own firms, 27 percent had "inherited their high position," and 47 percent had "climbed the bureaucratic ladder," especially in railroads, insurance, commercial banking, and utilities, according to historian William Miller.[90] To be sure, the Chamber's elite membership ensured that independent entrepreneurs and their scions continued to hold pride of place for another decade, and in the 1890s, the great industrialists—John D. Rockefeller, Andrew Carnegie, and the son of the archenemy of the railroad wars, Cornelius Vanderbilt—not only had been recruited to join but were given the honorary office of vice president as well, thereby ensuring that their portraits could be displayed to the Chamber's credit in the business "hall of fame" and their contributions collected for the new building. But alongside the captains of industry stood a new generation of executives who had risen through the firm, and in the aftermath of World War I, they moved into the Chamber's leadership, although not without having cultivated strategic cultural ties.

Alfred Marling, who headed Horace S. Ely's real-estate firm and became Chamber president in 1918, had also belonged to Morris Jesup's church. And the first insurance executive to become a Chamber president (in 1920), Darwin P. Kingsley, headed New York Life, the company whose reputation Alexander Orr had certified in the aftermath of the Armstrong investigation. Kingsley had gotten his start in Colorado by both selling insurance and serving as a state insurance superintendent; he was brought to New York by George Perkins, who, by serving as vice president of New York Life at the same time that he served as J. Pierpont Morgan's "right-hand man," had embodied the conflicts of interest that spurred popular suspicion of the "money trust."

Changes in the Chamber's internal organization mirrored the professionalization of management in national companies. In 1915, Charles T. Gwynne, who had come to the organization as George Wilson's assistant in 1894, took over as secretary and then became "executive vice president" in 1924; until his retirement in 1944, Gwynne conducted a burgeoning correspondence with administrators and secretaries of chambers and trade associations in other cities.[91] An expanded research staff marked another dimension of professionalization that ran from business firms to their lobbying organizations. In 1915, the Chamber appointed John Franklin Cowell as the first executive officer; he had attended Yale College, earned a doctorate in economics, served on the staff of the Industrial Commission of 1900, and been an associate editor of the *Wall Street Journal*.[92] Crowell directed a research staff that wrote the committee reports once produced by merchants or bankers themselves and now distributed to smaller chambers across the nation. At the same time, in 1927, the Chamber ceased pub-

lishing its own compendium annual report, since its reams of statistical data could be obtained from other sources, especially the Department of Commerce.

One small but telling change in the Chamber's organizational culture came with the demise of eulogies, long the occasion for telling life stories that honored the public service of individuals and thus rhetorically mirrored the portraits.[93] The younger generation of leaders had no personal tie to the organization's traditions and recognized the names (and faces) of only the most prominent businessmen staring down at them from the walls. Thus in place of eulogies, in 1916 the Executive Committee introduced the "minute" tribute, a streamlined and homogenized summary of committee service to the Chamber with no personal anecdotes, such as "A sense of keen regret among our members will attest to the loss from our ranks of one who was so helpful as A. Foster Higgins," a merchant who had joined in 1857.[94]

Another subtle inversion of the Chamber's rhetorical conventions accompanied the abandonment of the eulogy. After decades of paying respect to the virtues of the older generation, businessmen now sought to distance themselves from their immediate forebears, whose public reputations had been tarnished by the revelations of Progressive historians and muckraking economists. At the 1925 banquet, President Calvin Coolidge commended the members for being animated by "something far more important than a sordid desire of gain," in implicit contrast to the previous generation, whose "excesses" had prompted reforms. "The present generation of business almost universally through its responsible organizations," Coolidge said, "has shown every disposition to correct its own abuses with as little intervention of the Government as possible."[95] (The new narrative proved equally useful to succeeding cohorts at the Chamber of Commerce, as when a 1938 committee noted that "many of the difficulties of the 1930s may be traced quite directly to the abuses of the earlier decade.")[96]

One of the last of the older generation of activist members to use his own investigative and analytic skills on behalf of reform was banker Isaac Seligman, who as chairman of the Committee on Taxation in 1916 advocated the essential justice and logic of adopting a state as well as a federal income tax, both measures long resisted by the propertied elite. Seligman drew on the scholarship of his nephew Edwin R. A. Seligman, an economist who specialized in the problem of how to pay for the Progressive Era's expansion of government activity at all levels. The "income tax is in harmony with the pronounced tendency of fiscal reform throughout the civilized world," Isaac Seligman advised his colleagues. By contrast, the personal property tax (on stocks, bonds, jewelry, and art) had led to such egregious fraud as to undermine any claim wealthy households might make to civic virtue.[97]

Even as Seligman persuaded some businessmen to accept the necessity of new taxes to pay for beneficial government services, fiscal politics remained a preoccupation of the Chamber through the rest of the century. Indeed,

opposing taxes generally was one of the few positions that transcended the particularities of different enterprises and perhaps helped hold the business coalition together even when specific economic and political interests diverged. Ultimately, fiscal politics also repositioned the New York Chamber of Commerce from a Progressive business organization, willing to back government services and regulations as long as business leaders had a hand in setting up the rules, to a "conservative" organization that resisted all forms of regulatory or social welfare legislation that businessmen feared would increase budget deficits, introduce public competition, or constrict their own autonomy.

World War I marked a turning point for the Chamber, as it did for so many other American cultural institutions. In 1916, Darwin Kingsley, Alfred Marling, and Welding Ring, an export shipper, pushed ardently for military preparedness, even as the Chamber also called for new institutions to build international peace.[98] In place of the sober virtue projected by the nineteenth-century Yankee merchants, the war-era unleashed a militant virtue among businessmen who took as their mission the suppression of "unpatriotic utterances."[99] In the context of war and then the Bolshevik Revolution in Russia, the Chamber could denounce labor radicals without losing the Progressive patina associated with the National Civic Federation. Many members continued to advocate cooperation between management and labor; typically, the Chamber denounced the 1919 Boston police strike and at the same time urged New York officials to give the city's policemen and firemen a preemptive raise.[100]

The Chamber turned away from Progressive reform gradually. In 1918, the Committee on Industrial Problems and Relations recommended that "managers of all large productive enterprises" investigate the "methods of industrial democracy now making progress in both Great Britain and the United States" and urged the "closer association of wage-earners, managers, and capitalists." The resolution was met with applause.[101] Even as members ripped into the 1919 strike wave, they paid lip service to traditional trade unionism as well as to paternalistic tactics—company unions, pension plans, paid vacations—that might preempt organizing drives. ("We are all wage earners, we are all wage payers," Nicholas Murray Butler told the Chamber, echoing the prevailing theme of "industrial partnership.")[102] In 1924, when a committee recommended that the Chamber oppose a federal law banning child labor, members engaged in a vigorous debate before endorsing the committee's conclusion that such a law exceeded the constitutional powers of Congress.[103] Similarly, members divided over whether to support a New York State initiative on slum clearance, with some members fearing "state competition" with private enterprise but the majority endorsing a law that would enable limited-dividend corporations to construct low-income housing.[104]

Perhaps the Chamber's own most significant contribution to the development of the twentieth-century administrative state was the creation of the

American Arbitration Association, organized in 1926 with the assistance of Charles Bernheimer, who had directed the Chamber's arbitration service since 1911 and lobbied hard, alongside the New York Bar Association, first for a state law upholding binding arbitration agreements and then for a similar federal law. Although the Chamber often took sole credit for the custom and the law of arbitration, historians have noted that the specialization of commerce by commodities in the mid-nineteenth century had spurred different trade associations—from the New York Stock Exchange to the cotton and produce exchanges—to adopt their own systems of arbitration. In other words, the Chamber no longer encompassed and represented the specific concerns of the city's many spheres of commerce, although it continued to claim to speak on behalf of a unified community of interest.[105]

Chamber members may have found government regulations less necessary in the 1920s, but they still welcomed government subsidies. The war years—especially the federal government's development of the merchant marine through the Emergency Fleet Corporation, which constructed ships, and the Shipping Board, which oversaw their operation—brought the long-neglected conditions of the port back into the Chamber's field of vision. Four presidents between 1915 and 1928 were closely associated with marine transportation or had been active in civilian war mobilization.[106] Eugenius Outerbridge, head of an import–export firm and Chamber president from 1916 to 1918, joined the Chamber's counsel and lobbyist, Julius Cohen, in fashioning the Port of New York Authority as a new kind of quasi-public agency and became its first head in 1921.[107] The port's revitalization dovetailed with the increasing attention given by banks as well as manufacturers to international markets. The Chamber's Great Hall lent itself to the ceremonial reception of delegations of foreign business leaders and government officials. And when it was not projecting the collective prestige of the city's business leaders to the world, the Chamber's building provided a new downtown lunch club for members, a feature added by Darwin Kingsley, whose buoyant evangelical salesmanship suited the general mood of business boosterism in the 1920s.[108]

Meanwhile, as members of the Chamber of Commerce became more comfortable in its quarters, the Merchants' Association had assumed new powers as the primary lobbying agent for New York's business community. In contrast to the Chamber's individual memberships, the Merchants' Association adopted a more overtly "corporatist" system of company membership, with an executive board and staff making policy decisions. Bankers, hoteliers, lawyers, large retailers, and executives from the oil, automobile, chemical, and electrical industries (which were moving corporate headquarters to New York) expanded the association's ranks beyond the wholesale merchants and jobbers who had founded it in 1897. With more than twice the membership of the Chamber by 1922, the organization's broader base supported scrappier and more sustained lobbying.[109]

Like the New York Chamber of Commerce and the National Civic Federation, the Merchants' Association embraced capitalist paternalism in the 1920s over and above the hard anti-union line of the National Manufacturers Association and the U.S. Chamber of Commerce. But because leaders of the Merchants' Association had more readily moved into support of the New Deal, in 1934 the Roosevelt administration chose it as New York City's representative "chamber of commerce" under the National Industrial Recovery Administration "to advise local industries on the art of association management and the formulation of codes."[110] The Merchant Associations' Committee on Industrial Relations had endorsed section 7a of the National Industrial Relations Act (1933), which recognized labor's right to organize unions to bargain collectively with employers. (The committee included General Electric president Owen Young, who in an influential speech at the Harvard Business School in 1927 had articulated new standards of "corporate responsibility" that "construed managers as modern liberals." Although Young was also a vice president of the Chamber of Commerce, Roosevelt identified his "forward-looking" leadership with the Merchants' Association.)[111]

In Franklin Roosevelt's view, the Merchants' Association's cooperative stance contrasted with the image of entrenched and discredited power associated with banking and Wall Street in the aftermath of the 1929 stock-market crash. In 1933, the Senate Banking and Currency Committee's investigation into Stock Exchange practices exposed some shady deals of investment bankers, Chase Bank's president, Albert Wiggin, among them. Winthrop Aldrich, whose own firm, the Equitable Trust, had merged with Chase in 1930, became the bank's new president; he joined the Chamber in 1930, and in 1936 became its president. Indeed, between 1932 and 1942, five of the Chamber's presidents were bankers. If the Chamber certified a banker's civic standing in exchange for the prestige of his affiliation and leadership, this relationship seems only to have riled President Roosevelt, who identified the New York Chamber of Commerce with the "economic royalists" that he so famously denounced.

In 1935, he made his anger explicit in a letter to Thomas Watson, the president of IBM, the former president of the Merchants' Association, and a supporter of Roosevelt. "It makes me very sad," Roosevelt wrote,

> that because of the actions of a few Associations the country as a whole has it pretty well in mind that businessmen are "agin" every improvement and have been consistently for more than a generation. An actual inspection of the record will show that our own Chamber of Commerce in New York has a one hundred percent record of opposition to things like factory inspection, excessive hours, elimination of child labor, old age pensions, unemployment insurance—year after year, the same old story. Furthermore, in all this time, during my own experience of twenty-five

years in public life, the same Chamber has never initiated and pressed one single item of social betterment.[112]

The Chamber had endorsed reforms other than progressive labor laws in the previous twenty-five years, but Roosevelt's indictment, departing sharply from nearly a century of presidential praise, placed New York's business elite on the defensive. They fought back by calling for greater fiscal restraint in the federal government and by taking up public relations.

In a sense, all the Chamber's rituals, from banquets to monthly meetings covered by the press, had been exercises in public relations—public performances of civic virtue and authority. But business use of public relations to counter public criticism had taken off in a new and self-conscious way after Ivy Lee orchestrated the Rockefeller family's response to the congressional investigation of the 1914 Ludlow mining massacre. When in 1915 the Chamber created the new staff position of executive director, the bylaws specified his responsibility for handling public relations. In a perhaps typical procedure, in 1924, the executive director arranged a private meeting of the region's leading financial editors to give them inside information on the Port Authority.[113] Further, the Chamber of Commerce publicized itself by permitting radio broadcast of banquet speeches, most notably that of President Coolidge in 1925, and even by publishing a tourist guide. Yet the public-relations work of the late New Deal took on a different kind of project, that of aggressively persuading the public that the New Deal itself was too hard on business and that only private enterprise, not public works, could bring economic recovery.

Looking back from the mid-1960s, a public-relations adviser suggested that the Chamber of Commerce may never have recovered from the demoralization of the Depression, which had reduced its membership and left a permanent "inferiority complex."[114] Yet other forces besides the Depression altered the Chamber's standing. Although finance continued to drive the economy, leaders of the nation's fastest-growing industries—oil, automobiles, electrical products, chemicals—organized a new kind of association in 1933, the Business Council, to maintain a presence in Washington, D.C., and to negotiate with an ever more powerful federal government. Composed of the chief executive officers of from thirty to fifty national corporations, and supported by a research staff, the Business Council believed that selectivity enhanced its efficiency and influence. Its members took a hands-on approach to lobbying public officials and shaping policy during the late New Deal and World War II. Some of the executives of the Business Council—Standard Oil's Walter Teague, General Electric's Gerald Swope, Chase Bank's Winthrop Aldrich—were also members of the New York Chamber of Commerce. But others—the chief executive officers of DuPont, U.S. Steel, Eastman Kodak, and Sears, Roebuck—found their community of interest only at the national level.[115]

Thomas Watson of IBM, who had joined the New York Chamber of Commerce in 1918, gave voice to a larger shift in the ideology and practice of business association in the aftermath of the Depression, a shift that laid the seeds first for the merger of the Chamber of Commerce with the Commerce and Industry Association (as the Merchants' Association was renamed in 1941) and then, ultimately, for the institution's demise. Watson had little patience with either ideological warfare or the ceremonies that affirmed business leaders' special sense of community. Rather, he embraced the realism of pluralist interest-group politics. Thus in 1938, he outlined for the board of directors of the Merchants' Association his understanding of the purpose of a business association. "There appears less and less disposition on the part of businessmen to support business organizations as a civic or public duty," he noted, "and more and more insistence on some direct returns in the way of service before support can be given. The question therefore arises whether it is possible to develop a business organization which as a pressure group (in a confidential memorandum there need be no fear of this word) can be as effective as other groups with no better endowment of thought, brains, or intelligence."[116]

By the mid-1960s, the Chamber had embraced this mission as well. "The entire Chamber staff and all members have but one task to perform: to communicate the views of the New York Business community to other businessmen, to other civic-business groups, to public officials and legislators, and to the general public. Our ultimate objects are to influence these publics and to stimulate actions beneficial to business and to the community at large," wrote its public-relations adviser.[117]

The "Power Elite" and the Decline of the Chamber of Commerce

Thomas Watson's memorandum reveals a change in businessmen's disposition that shaped the history of the Chamber of Commerce after 1945. World War II brought business out of the Depression, and in its aftermath executives found themselves in ambiguous relation to government power. On the one hand, government stood squarely behind policies that served business needs, and federal subsidies or direct spending on highways, housing, and higher education (and, even more so, federal military contracts) continued to spur economic growth. On the other hand, an expanded welfare state meant that businesses, like individuals, paid more taxes. Moreover, business operated on a playing field defined by New Deal rules, from fair employment standards to the separation of investment and commercial banking. In this context, New York's business lobbying organizations—both the Chamber of Commerce and the Commerce and Industry Association—took as their primary goal defending business interests

against what they perceived to be the countervailing power of government officials and organized labor.

The Chamber's first step was rebuilding its membership and staff, both of which had been significantly reduced during the Depression and the war. But just as World War I had marked the end of rituals and rhetoric associated with the nineteenth-century bourgeois, so World War II sounded the death knell of a particular style of business and civic boosterism. In 1945, Peter Grimm, then chair of the Chamber's Executive Committee and president from 1946 to 1948, laid out a program aimed at revitalizing the organization. Grimm was a real-estate executive active in the New Deal and was well known for his arbitration skills in negotiations between property owners and tenants over rent control in New York City. As a symbolic statement of a new beginning, he led a fund-raising campaign to pay off the mortgage on the Chamber's building and raise money for renovations and maintenance.[118] At his urging, the Chamber joined the Commerce and Industry Association in establishing the Empire State Chamber of Commerce in Albany, with a full-time lobbyist for the state legislature. And the Chamber weighed in with Congress to oppose increased income taxes and, in 1947, to support the Taft-Hartley Act (1947), which reduced the power of trade unions and purged the labor movement of radical leaders and organizers. Grimm also pushed for a stronger public-relations program and expanded research staff to inform members and lobbyists alike of the Chamber's stands on new economic legislation.

Despite the accent on modernization, in some respects it was business as usual when Chamber secretary B. Colwell Davis was promoted to executive director, and Charles T. Gwynne's son, John Gwynne, became secretary. But the symptoms of weariness with its own history were also everywhere to be seen in the late 1940s and early 1950s, and even the staff seems to have worn out, with two female secretaries who had been with the Chamber since 1915 and 1919 both suffering from some form of mental collapse and retiring in the early 1950s.[119] Although monthly meetings in the Great Hall, attended by anywhere from 150 to 300 members, continued to read and approve committee reports, the main attractions were featured speakers rather than policy deliberations. In 1947, the Executive Committee rejected the proposal of Tom Watson and others to merge with the Commerce and Industry Association. But the Chamber's leaders themselves had less and less time or energy to perform the distinctive rituals of community building. Portraits of the Chamber's presidents continued to go up on the walls, but officers seldom invoked their predecessors. And in 1951, the Executive Committee decided that "so many public dinner demands are made on the Chamber members today that it does not seem desirable to continue to hold annual dinners."[120]

The Chamber followed the lead of the Commerce and Industry Association and adopted a new system of corporate membership, whereby a company could pay an officer's dues. Membership thus might signify a man's company status as

much as his personal achievement within the business community. The Executive Committee also changed the bylaws to permit lawyers to join and become officers. Still, some traditions held. In 1949, when Julius Cohen suggested that the Chamber admit women, the proposal was tabled.[121]

The New York Chamber of Commerce perhaps maintained the prestige that came with age, but more and more of its "services" had been taken over by either the Commerce and Industry Association, which had a much larger staff that lobbied more aggressively, or by specialized trade associations, which closely followed legislation that affected members' immediate interests. In Washington, the Business Council and its offspring, the Committee for Economic Development, founded in 1942, used the selective membership of CEOs to represent and defend the interests of "big business." Lobbying was also handled by internal company staffs and by the top executives themselves, who could add a personal touch at the highest levels of power.[122]

Still, in addition to fiscal politics at all levels of government, the Chamber sustained two fields of engagement, one ideological and the other pragmatic. Although in the early 1950s, strains of the Cold War could be heard in speakers' addresses ("Air Power: Key to Survival" or "Free Men in a Frightened World"), the organization's stronger ideological commitment was toward the promotion of international free trade ("Economic Nationalism: A World Wide Menace"). When a flurry of intense debate erupted over the Chamber's endorsement of the goals of the Conference on General Agreement of Tariffs and Trade (GATT) in 1955 and 1956, Bronson Trevor, among others, argued that lower tariffs "would put Americans out of work, so let's assess the damage we plan to advocate." Such reservations were quickly set aside, with the dominant sentiment expressed by Charles E. Bingham: "We are businessmen; we are traders . . . we do believe in a philosophy of the expansion of trade, and in free trade and in less rather than in greater restriction."[123] In the early 1960s, the Chamber welcomed the construction of the World Trade Center and celebrated the federal court decision that, after nearly a century of controversy, permitted railroad rates to New York City to be reduced to the level charged to other ports, thus reanimating the Port Authority of New York and New Jersey as a gateway to international commerce.[124]

The other arena of the Chamber's enduring engagement was the condition of New York City, and here the leadership saw troubling signs by the late 1950s, as more and more firms left the city for the suburbs along with a significant number of middle-class households, which had not only paid taxes but supplied the city's clerical labor force. Companies were also moving their Manhattan headquarters from downtown to midtown, geographically fragmenting the business community. At the same time, city government was growing, with new agencies to administer expanded social welfare programs. Businessmen believed that city spending had become a major problem, since the accompanying increase in taxes, they argued, further discouraged firms from staying put. In this context,

the Chamber not only supported the watchdog activities of the Citizen's Budget Commission, but also issued elaborate reports on the city's fiscal health, warning, by the early 1960s, of the "Coming Crisis" in New York City finances.[125]

Because businessmen left the city with their companies, between 1954 and 1964 the Chamber's resident membership dropped from 1,700 to 1,450. (The Commerce and Industry Association saw a similar decline of roughly 15 percent in its corporate memberships.) The Chamber tried to cover the loss in dues by increasing the number of corporate memberships.[126] As officers felt the organization to be stagnating in the 1950s, they hired Jack Steinberg of the public-relations firm Cunningham and Walsh to stir up interest; by the mid-1960s, Steinberg and research director Gus Tregell were worried that the Chamber was losing the active support of its membership and its ability to "follow through" on a course of action. When a new executive vice president was hired in 1963, they proposed that the Chamber focus its agenda around three or four key issues and then reinforce its public authority by calling attention to committee reports, speakers, and lobbying efforts that addressed those issues.[127]

The presidents of the Chamber of Commerce in the 1960s included chief executive officers of American Express, Chase Manhattan Bank, Chemical Bank, New York Telephone, and Metropolitan Life as well as Met Life's corporate counsel and a lawyer from Sterling and Shearson. These executives represented the "power elite" analyzed by sociologist C. Wright Mills in his 1956 book of that name—the products of corporate consolidations, businessmen who could "move from one company's policy and interests to those of the industry" and then "from the industrial point of interest and outlook to the interest and outlook of the class of all big corporate property as a whole."[128] They oversaw billion-dollar business operations of companies that had upward of fifteen thousand employees.

These executives also worked in the one local sector—called FIRE (finance, insurance, and real estate)—that was growing, even as New York's manufacturing and retail declined. They encountered head-on the contradictions of a changing city. Banks, like stores, needed customers, many of whom were leaving town. To get around regulations that restricted the opening of branches in the suburbs, the city's commercial banks underwent a merger wave in the 1950s and 1960s.[129] But the expansion of back-office operations in the city also meant that banks, like insurance companies and utilities, needed thousands of new clerical workers, prompting a growing concern with "manpower training," education, and affordable housing within the city. This self-interest placed business executives, even of national corporations, in the central arena of local politics.

In 1962, George Champion became president of the Chamber. Born in Illinois, he graduated from Dartmouth in 1926. Champion was working at the Equitable Trust Company when it merged with Chase Bank in 1930. He moved up through the ranks, becoming head of the U.S. Department in 1953, from which

position he managed Chase's merger with the Manhattan Bank in 1955. Two years later, Champion became the bank's president, and in 1961 he became chief executive officer in a joint tenure with David Rockefeller.[130] Champion was proud of his professional and public service, and when he assumed the presidency of the Chamber, he saw himself bringing the institution into the "action" era. Business interests were organizationally fragmented, he believed, just at a time when business had to be able to speak out strongly in a unified voice. One solution was to consolidate forces through merger.

The break in continuity that came with the retirement of B. Colwell Davis in 1963, after twenty years of service as executive director, seemed to offer a strategic moment to reconfigure the organization in its entirety. When members resisted an initial proposed merger with the Commerce and Industry Association, Champion followed a procedure adopted by virtually every bank in the city in the 1960s and hired management consultants to study the "systems" of the Chamber and the association and evaluate the prospects for a merger. Needless to say, McKinsey and Company, which three years later would famously seek to reorganize City Bank (having earlier been brought in to look at Chase Manhattan), endorsed the merger.[131]

The management consultants sketched a clear portrait of New York business executives' expectations for their association:

> The new organization would have the nucleus of a strong research capability to dig deeply into basic issues and produce analyses and recommend programs that could provide the foundation for action on such basic problems as unemployment, municipal management of fiscal affairs, and the metropolitan area development. And while leading a broad attack on problems such as these, it would also be able to fight the never ending battles in the legislatures, courts, and public hearing rooms, and to remain closely attuned to current political developments and—most important of all— to the voting public. By combining these strengths of the Chamber and the Association, the new organization should be able to serve business more effectively than either of them separately.[132]

According to some executives, the Chamber alone was "handicapped by an undue love of tradition and is far less vital than it could be," as the New York manager of Lockheed Aircraft Corporation expressed it, and thus "falls far short of approaching the dynamic kind of civic-guidance, business assistance, business development job that is crying out to be done in this city."[133]

Champion and his fellow members of the Executive Committee knew that the Chamber's staff (who numbered nineteen in contrast to the Commerce and Industry Association's eighty) continued to have reservations about a merger. What Champion had not anticipated was the recalcitrance, even sentimentality, of

members. With denunciations of the Executive Committee's high-handed tactics on behalf of merger, opponents blocked the required two-thirds majority by eight votes in the fall of 1964. Advocates charged that it was the perk of the Schrafft's-operated lunchroom rather than the organization's venerable history that motivated the opponents. Still, the Chamber had long prided itself on decision making by consensus in its plenary town meetings, and many found the *Wall Street Journal* and the *New York Times* coverage of the contretemps embarrassing.[134]

Champion's indignant friends quickly wrote to assure him that the rejection was not meant as a personal humiliation. And, as it turned out, Champion got the last word in 1979 when, in his capacity as the head of the Economic Development Council, he oversaw the closing of not only the lunchroom but the entire Chamber building. The Chamber of Commerce, which merged with the Commerce and Industry Association in 1973, and then affiliated with the Economic Development Council, moved uptown to 200 Madison Avenue, where it was subsumed within the New York City Partnership, established as a business forum of leading executives by David Rockefeller in 1979.[135]

The Chamber of Commerce's last autonomous decade had been painful. In 1965, officers hired Peter P. Grey, a public-relations expert from American Express, to orchestrate a celebration of the organization's bicentennial.[136] Grey, who graduated from Harvard College, saw promotional value in the Chamber's history. In 1967, he brought a cousin of Queen Elizabeth II to the Great Hall to commemorate the issuing of the royal charter, and in 1968, he organized public tours of that imposing space and staged a ceremony with the officers in historic costumes.[137] In his lively "informal history" of the institution, Grey returned to the tradition of linking portraits to life stories of business leaders; tellingly, he singled out the magnates—Carnegie, Morgan, Rockefeller, Schiff—whether or not they had been active in the Chamber's affairs. But in 1968, respect for the past as either legend or precedent was hard to come by in the United States. Grey succeeded in generating publicity—the U.S. Chamber of Commerce devoted an issue of its monthly periodical to the bicentennial—but the celebration appears to have been less inspiring to many businessmen than the "Welcome Home" luncheons that the Chamber sponsored for the New York Yankees in the spring of 1967 and 1968.[138]

As the abbreviated annual reports continued to insist that the Chamber was committed to "action," its leaders moved the organization away from member participation and toward "modern management techniques" aimed at "assuring close working relationships with other leading business and civic organizations." Once again, the retirement of a research director who had been at the Chamber for twenty years, and its secretary, who had served the institution for thirty-three years, facilitated a redefinition of the organization's goals—and even the tone of its self-portrait. The new executive director moved to New York from Ohio to take the job. The past seemed less and less usable, and the

1970 annual report hailed a "growing quality membership" and highlighted a new "contemporary framework designed to intensify the involvement of New York business in the total process of the city."[139]

While continuing to campaign for fiscal retrenchment, businessmen wrestled with other political and cultural tensions of the era. For example, the Chamber launched a program on "drug abuse in business" (just as it had targeted alcoholism in the 1950s). For the first time in the organization's history, officers became self-conscious about the composition of its membership, discovering that it had only one black member, an insurance executive in North Carolina who never attended meetings. In 1970, worried about antiwar demonstrations and bombing incidents on Wall Street, the Chamber hired a guard and restricted public access to the Great Hall.[140] (Noting that "there is a wide divergence of opinion of members of the Chamber as to what action the Government should take," the Executive Committee also resolved that the association "should not attempt to express an official position on the war in Southeast Asia.")[141]

The most pressing concern of business leaders was the deteriorating national as well as local economy and the accompanying social conflicts. Inflation, spurred by the war in Vietnam, ate into corporate profits. Labor militancy, felt strongly in the city due to a series of strikes by public employees, as well as ongoing civil rights and antiwar protests, put business leaders on the defensive and eroded the optimism with which they had hailed sustained economic growth. In 1968, at a program jointly sponsored with the Urban League on training a new workforce, executives from AT&T, General Electric, and Chase Manhattan shared their experiences with employing the "hard core."[142] The theme was brilliantly revisited in the movie *Trading Places* (1983), in which comedian Eddie Murphy played a savvy Philadelphia beggar, with crucial scenes shot in the Chamber's building.

Even the Chamber's endowment portfolio turned sour. With its leaders intent on expanding programs, the institution operated with a deficit and experimented with new ways to raise funds, including renting its building and taking government grants for manpower-training programs. The greatest problem, the Chamber's leaders told themselves, was the lack of a strong unified "voice of business" to counter the voices in the streets. In the late 1960s, the Chamber participated in a steering committee of leaders of business organizations convened by George Champion, now head of the Economic Development Council, to develop strategies for addressing the stormy business climate and, especially, local fiscal affairs.

In what was to become a widely publicized keynote of a new era (indeed, an era designated "a changing world" by the Chamber's public-relations group, which made the phrase the theme of the year's monthly speeches), in 1967 Gilbert Fitzhugh, president of Metropolitan Life and in 1972 the last president of the independent New York Chamber of Commerce, spoke on "Business–

Government Relationships in a Changing World." Announcing that it was time for business to throw off the "hair shirt," Fitzhugh warned that government had become a "growth industry," rushing in to fill any void, and he called on businessmen to become more actively involved in the community, showing government officials how "they can do their jobs better" by adopting the private sector's models for systems analysis and cost-effectiveness studies. Moreover, Fitzhugh said, executives affiliated with the Economic Development Council had already committed themselves to "improv[ing] the business climate of the city and help[ing] solve some of the numerous problems facing the larger metropolis—problems such as transportation, housing, jobs for minorities."[143]

Still informed by the corporate liberalism of the Great Society, Fitzhugh's speech nonetheless provided an early blueprint for an ideology that would evolve into calls for public–private partnerships and privatization in the aftermath of the fiscal crisis. In 1974, the city's business leaders took a leaf out of the Chamber's own history and restaged the "capital strike" with which the Committee of Seventy had brought down the Tweed Ring a century before.[144] But even as the fiscal crisis permitted business leaders to reclaim authority and power in city affairs, the Chamber of Commerce had itself become little more than a "voice" speaking through press releases without a body of active members.

By 1972, when the Chamber's leaders once again took up the merger with the Commerce and Industry Association, few members had a strong stake in preserving the institution's traditional identity. Even the lunchroom had lost patronage. Once the merger was effected, the difficulty of turning the Chamber's "guild hall" into a viable office building for an expanded staff became evident. Officers and staff of the newly named Chamber of Commerce and Industry, itself now affiliated with the Economic Development Council, wrestled for five years with coordinating their work from two locations, while maintaining the Chamber's building on Liberty Street. By 1979, they were ready to accept defeat. In the larger scheme of things, the use of business resources to develop job-training programs or nonprofit housing for a city that faced widening disparities of wealth and reduced government resources seemed more important than hanging on to a relic of New York's entrepreneurial past.[145]

In 1924, Jere Tamblyn, secretary of the Chamber, had answered a query from an executive secretary of a chamber of commerce in Pennsylvania on the advantages of the organization having its own building. "It adds to the prestige and self-respect of the organization, and it lends it dignity and permanency," Tamblyn wrote, echoing the words of Abiel Abbot Low a century earlier. "Commerce should do something in its own honor to perpetuate its history. A permanent home for a Chamber of Commerce, where its records are kept and portraits of its outstanding merchants are accumulated, serves to hand down to posterity a means of visualizing the activities of its predecessors."[146]

In 2002, despite the charter granting it immortality, the Chamber of Commerce and Industry merged into the New York City Partnership and disappeared from history.[147] Spokesmen for business executives continue to lobby lawmakers, sponsor civic projects, and negotiate with public officials, but the world of commerce has expanded well beyond the reach of a community of interest that can convene town meetings in its own chamber.

NOTES

1. Vincent Carosso, *Investment Banking in America: A History* (Cambridge, Mass.: Harvard University Press, 1970), 139.

2. John Austin Stevens Jr., *Colonial Records of the New York Chamber of Commerce, 1768–1784, with Historical and Biographical Sketches* (1867; repr., New York: Lenox Hill, 1971), 3–4.

3. Joseph Bucklin Bishop, *A Chronicle of One Hundred & Fifty Years: The Chamber of Commerce of the State of New York, 1768–1918* (New York: Scribner, 1918), 1–2. For a useful discussion of the French corporation of merchants, see Carolyn Sargentson, *Merchants and Luxury Markets: The Marchands-Merciers of Eighteenth-Century Paris* (London: Victoria and Albert Museum, 1996), 7–17. Chambers of commerce were established in Charleston in 1773 and New Haven in 1794, as well as in Jersey, England (1769), Dublin (1783), Glasgow (1783), Leeds (1785), Edinburgh (1785), Manchester (1794), and Belfast (1796), according to Chamber of Commerce of the State of New York, *List of Chambers of Commerce in the United States in All Cities of 5000 and Over* (New York, 1960), 2. According to John Austin Stevens Jr., in the eighteenth century, "commerce" was "held to be the exchange of products with foreign countries" and "trade" meant the "interchange among our States": membership was largely confined "to those who owned ships, with occasional exceptions in favor of those to whom cargoes were consigned" (*Thirty-Fifth Annual Report of the Chamber of Commerce of the State of New York* [1892–1893] [New York: Press of the Chamber of Commerce, 1893], 130 [hereafter, 35 AR (1892–1893), etc.]).

4. Thomas Doerflinger, *A Vigorous Spirit of Enterprise: Merchants and Economic Development in Revolutionary Philadelphia* (Chapel Hill: University of North Carolina Press, 1986), 19.

5. Virginia Harrington, *The New York Merchant on the Eve of the Revolution* (New York: Columbia University Press, 1975), 75. See also Arthur M. Schlesinger, *The Colonial Merchants and the American Revolution* (1917; repr., New York: Facsimile Library, 1939), 262–263, 272–274.

6. Stevens, *Colonial Records*, 8–9, 29, 36, 43–44, 47, 50, 108, and passim.

7. Gary Nash, *The Urban Crucible: Social Change, Political Consciousness, and the Origins of the American Revolution* (Cambridge, Mass.: Harvard University Press, 1979), 301–302.

8. Alice Mapelsden Keys, *Cadwallader Colden: A Representative Eighteenth Century Official* (1906; repr., New York: AMS Press, 1967), 295–299; Harrington, *New York Merchant*, 262–263, 272–274.

9. Stevens, *Colonial Records*, 88. Another significant concession in the spring of 1770 allowed New York to issue paper currency, a move that had been banned by the Currency Act (1764), which in turn had fueled the merchants' protests. See Schlesinger, *Colonial Merchants*, 224.

10. Stevens, *Colonial Records*, 88. For the response of merchants in other ports, see Schlessinger, *Colonial Merchants*, 220–230.

11. The charter can be found in Bishop, *Chronicle of One Hundred & Fifty Years*, 233–241. For context, see Joseph S. Davis, *Essays in the Earlier History of American Corporations*, vol. 2, *Eighteenth Century Business Corporations in the United States* (Cambridge, Mass.: Harvard University Press, 1917); and Ronald E. Seavoy, *The Origins of the American Business Corporation, 1784–1855* (Westport, Conn.: Greenwood Press, 1982). Although it held less property than the municipal corporation, the Chamber can be viewed as no less a governing institution under the royal charter; for the limited "public" scope of the municipal corporation, see Hendrick Hartog, *Public Property and Private Power: The Corporation of the City of New York in American Law, 1730–1870* (Ithaca, N.Y.: Cornell University Press, 1983), 11–68. Harrington notes that Colden also granted a royal charter with limited powers to New York Hospital, in *New York Merchant*, 50.

12. For biographical sketches of officers and members before 1784, see Stevens, *Colonial Records*, 1–172. For discussions of how colonial merchants organized their trade, see Cathy Matson, *Merchants and Empire: Trading in Colonial New York* (Baltimore: Johns Hopkins University Press, 1998), pt. 2; and Doerflinger, *Vigorous Spirit of Enterprise*, esp. chap. 2.

13. Stevens, *Colonial Records*, 282, 368n. See also Harrington, *New York Merchant*, 303–308.

14. Harrington finds that "61 members of the Chamber of Commerce carried on their business in association with one another, and 43 were independent" (*New York Merchant*, 50).

15. Harrington, *New York Merchant*, 126, 164; Matson, *Merchants and Empire*, 149–164.

16. Stevens, *Colonial Records*, 43, 151–153, 185–187. Although the connection is obscure, most of the merchants who protested the rule on New Jersey currency also became patriots, whereas advocates of limiting New Jersey money remained loyalists.

17. Schlesinger, *Colonial Merchants*, 218–221; Nash, *Urban Crucible*, 332, 364, 366, 368–371.

18. Edward Countryman, "The Uses of Capital in Revolutionary America: The Case of the New York Loyalist Merchants," *William and Mary Quarterly* 49, no. 1 (1992): 7–8.

19. Sean Wilentz, *Chants Democratic: New York City and the Rise of the American Working Class, 1788–1850* (New York: Oxford University Press, 1984), 48–53, 56–60.

20. Alfred Young, "Mechanics and the Jeffersonians: New York, 1789–1801," *Labor History* 5 (1964): 225–246.

21. Robert Greenhaugh Albion, *The Rise of New York Port, 1815–1860* (New York: Scribner, 1939), 13–14. Albion attributes the ascendancy of New York after 1817 to the scheduling of regular Black Ball ocean liners between Liverpool and New York, the state legislature's authorization of the Erie Canal, and the regulation of the auction system, which attracted more buyers to the city.

22. *Letters from John Pintard to His Daughter, Eliza Noel Pintard Davidson, 1816–1833*, ed. Dorothy Barack (New York: New-York Historical Society, 1941), 2:310; on the Chamber's activities in this period, see 1:320; 2:58, 114, 316. Stevens notes that early secretaries received £20 to defray clerical expenses, in *Colonial Records*, 327.

23. 6 AR (1863–1864), 35. Shortly thereafter, Charles King eulogized Perit himself by noting that he was a "peer of royal merchants of other days—the LeRoys, Bayards, Gracies, Lenoxes, Stevens, Griswolds, the Wrights, the Thompsons, the Fishers, the Fosters, the Girards" (78). Perit's sentiments were also echoed by Walter Barrett (pseudonym of Joseph Alfred Scoville), describing the "great house" of LeRoy, Bayard, and Company: "All its partners to this time had been kings, princes and dukes among the merchants. Socially no families stood higher; commercially, none stood so high" (*The Old Merchants of New York City* [New York: Knox, 1885], 2:172).

24. The Yankee presidents were James G. King, Moses H. Grinnell, Pelatiah Perit, Abiel Abbot Low, and William E. Dodge. See Albion, *Rise of New York Port*, 250, and, on the Yankee presence more generally, 235–259. In 1892, Low was eulogized as the "last of the great merchants of New York . . . the race of Goodhues, the Griswolds, the Howlands, the Grinnells, whose ships were on every sea and whose honored names passed untarnished through the vicissitudes and calamities of half a century" (35 AR [1892–1893], xviii). Unless otherwise noted, all biographical information on officers is from *Catalogue of Portraits in the Chamber of Commerce of the State of New York, 1768–1924* (New York: Chamber of Commerce of the State of New York, 1924); and *Supplement to the Catalogue of Portraits in the Chamber of Commerce of the State of New York* (New York: Chamber of Commerce of the State of New York, 1941).

25. Albion, *Rise of New York Port*, 266.

26. Albion, *Rise of New York Port*, 244–247. On Howland and Aspinwall, see Daniel Hodas, *The Business Career of Moses Taylor* (New York: New York University Press, 1975), 4–7; and Barrett, *Old Merchants of New York City*, 1:302–307.

27. Albion sketches the history of New Englanders' banking houses in New York—including the private banking house of Prime, Ward, and King; the Morgans; and Stephen Whitney—in *Rise of New York Port*, 249–250. On the Brown brothers, see John A. Kouwenhoven, *Partners in Banking: A Historical Portrait of a Great Private Bank, Brown Brothers Harriman & Co., 1818–1968* (New York: Doubleday, 1968), with Walker Evans's photographs of the firm's offices. See also Ron Chernow, *The House of Morgan: An American Banking Dynasty and the Rise of Modern Finance* (New York: Simon and Schuster, 1991), 3–94.

28. Albion, *Rise of New York Port*, 236–237.

29. In a 1960 pamphlet, the Chamber typically described this "town meeting plan," in contrast to a "federal plan" introduced by the London Chamber of Commerce

(featuring delegates from different trades) and a "corporation plan" with a board of managers (*List of Chambers of Commerce*, 2, 58). On the antebellum management of business, see Alfred Chandler Jr., *The Visible Hand: The Managerial Revolution in American Business* (Cambridge, Mass.: Harvard University Press, 1977), chap. 2. Albion notes that the chief function of the Chamber in this era remained arbitration, in *New York Port*, 265.

30. Bishop, *Chronicle of One Hundred & Fifty Years*, 53, 55, 62, 63. Although the Chamber formally opposed Henry Clay's proposal for protective tariffs in the 1820s, by the 1840s members divided evenly over tariffs and most approved of government support for building infrastructure, be it harbor improvements or the Croton Waterworks.

31. Quoted in Barrett, *Old Merchants of New York City*, 1:317.

32. 27 AR (1884–1885), 55.

33. 27 AR (1884–1885), 55–56.

34. Moses Beach, *The Wealthiest Citizens of New York* (New York: Sun Press, 1855); Harold van B. Cleveland and Thomas F. Huertas, *Citibank, 1812–1970* (Cambridge, Mass.: Harvard University Press, 1985), 5–31; Hodas, *Business Career of Moses Taylor*.

35. Hodas, *Business Career of Moses Taylor*, 198, 280.

36. Hodas, *Business Career of Moses Taylor*, 86–87, 99–101, 104–106, 148–150.

37. All biographical information is from Richard Lowitt, *A Merchant Prince of the Nineteenth Century: William E. Dodge* (New York: Columbia University Press, 1954).

38. Quoted in Lowitt, *Merchant Prince*, 351.

39. 6 AR (1863–1864), 35.

40. 6 AR (1863–1864), 38.

41. 6 AR (1863–1864). J. Smith Holmans, secretary of the Chamber between 1859 and 1862 and editor of *Bankers Magazine*, initiated the annual report. See 16 AR (1874–1875), xx. John Austin Stevens Jr., secretary from 1863 to 1868, organized the second volume. Stevens, the son of a founding member, also annotated and published the colonial minutes.

42. 17 AR (1874–1875), 144, iii–xv.

43. Sven Beckert, *The Monied Metropolis: New York City and the Consolidation of the American Bourgeoisie, 1850–1896* (New York: Cambridge University Press, 2001), 116–126.

44. 6 AR (1863–1864), 54.

45. Iver Bernstein, *The New York City Draft Riots: Their Significance for American Society and Politics in the Age of the Civil War* (New York: Oxford University Press, 1990), 206–209; Martin Shefter, *Political Crisis/Fiscal Crisis: The Collapse and Revival of New York City* (New York: Basic Books, 1987); Seymour J. Mandelbaum, *Boss Tweed's New York* (New York: Wiley, 1965), 77–85.

46. 17 AR (1874–1875), 17–18.

47. David C. Hammack, *Power and Society: Greater New York at the Turn of the Century* (New York: Columbia University Press, 1987), 335n.42.

48. For Parkhurst and city politics, see Hammack, *Power and Society*, 144, 147–152. Parkhurst was minister of the Madison Square Presbyterian Church. Chamber

presidents William E. Dodge, Morris Jesup, and Alfred Marling were active in the Church of the Covenant, which merged with the Brick Presbyterian Church in 1894. See Shepherd Knapp, *A History of the Brick Presbyterian Church in the City of New York* (New York: Trustees of the Brick Presbyterian Church, 1909). It is perhaps important to underscore the ecumenicalism of the Chamber of Commerce. In the 1880s, fashionable resorts for the first time began to exclude wealthy German Jews as customers, but the Chamber's leadership included members of the Seligman, Schiff, and Straus families, who were no less worried about lax public morals than the Presbyterian clique, though they did not mind Sunday entertainments. See also Hammack, *Power and Society*, 101–103.

49. Charles S. Smith, in *City Vigilant* 1, no. 3 (1894).

50. All biographical information is from William A. Brown, *Morris Ketchum Jesup: A Character Sketch* (New York: Scribner, 1910). See also Glenn Porter and Harold C. Livesay, *Merchants and Manufacturers: Studies in the Changing Structure of Nineteenth-Century Manufacturing* (Baltimore: Johns Hopkins University Press, 1971), 103–104.

51. 37 AR (1894–1895), 97–98.

52. 17 AR (1874–1875), 33.

53. 20 AR (1877–1878), 8.

54. 17 AR (1874–1875), 9.

55. On bourgeois New Yorkers' response to the labor movement, see Beckert, *Monied Metropolis*, 273–288.

56. Lowitt, *Merchant Prince*, 308–311.

57. 20 AR (1877–1878), xiv–xv, 121, 160.

58. Lee Benson, *Merchants, Farmers, and Railroads: Railroad Regulation and New York Politics, 1850–1887* (Cambridge, Mass.: Harvard University Press, 1955), 78–79, 115–132. Smith and Thurber had organized the New York Board of Trade and Transportation to defend the particular interests of the city's dry-goods merchants, but concluded that they needed the greater clout of the Chamber of Commerce. For a sharp analysis of the mistaken assumptions of the Chamber's view of railroad regulation, see Albro Martin, "The Troubled Subject of Railroad Regulation in the Gilded Age—A Reappraisal," *Journal of American History* 61, no. 2 (1974): 339–371.

59. 22 AR (1879–1880), 11–19, 63–67, 98–118, quote on 108. For the subsequent battle and move to the federal arena, see 23 AR (1880–1881), 52–55, 80–87, 110–111, 115–121; and 24 AR (1881–1882), 45–47, 102–104, with Chauncey DePew's conciliatory banquet address on 16.

60. Albro Martin, "Railroads and Equity Receivership: An Essay on Institutional Change," *Journal of Economic History* 34, no. 3 (1974): 685–709, figures on 688.

61. Benson, *Merchants, Farmers, and Railroads*, 141.

62. Arnold J. Bornfriend, "The Business Group in the Metropolis: The Commerce and Industry Association of New York" (Ph.D. diss., Columbia University, 1967), 11–17, 21–48. Although many members of the Chamber of Commerce also participated in

the Merchants' Association, the wholesale merchants went much further than the Chamber in recognizing the divided interest of business and calling for the public regulation of utilities as well as transportation.

63. *CXXXII Anniversary of the Founding of the New-York Chamber of Commerce, April 5th, 1900* (New York: Press of the Chamber of Commerce, 1900), 20. J. Pierpont Morgan also contributed $50,000, while Andrew Carnegie and Cornelius Vanderbilt each donated $25,000. In contrast to these four, most of the other large donors had been active in the Chamber's affairs.

64. Hammack, *Power and Society*, 245–253, 255.

65. Quoted in Hammack, *Power and Society*, 13.

66. Daniel Rodgers contrasts the American penchant for nonpartisan administrative commissions with the European preference for state regulation, in *Atlantic Crossing: Social Politics in a Progressive Age* (Cambridge, Mass.: Harvard University Press, 1998), 150–151, 155–156.

67. 27 AR (1884–1885), 62–73, quotes on 65, 66, 68.

68. Hammack, *Power and Society*, 15–17.

69. 19 AR (1876–1877), 96–101.

70. See, for example, 27 AR (1884–1885), 16 (appointment of a Special Committee on the Preservation of the Adirondack Forests); 35 AR (1892–1893), 155–156 (Croton watershed); 56 AR (1913–1914), 83, 133–144 (history of Chamber's conservation stands and report on federal conference); 57 AR (1914–1915), 207–210 (Adirondacks); 59 AR (1916–1917), 258–264 (support for creation of a National Board of Water Conservation); 59 AR (1916–1917), 112–113 (support for purchase of additional state park land); on the Battery, *Monthly Bulletin* [of the New York Chamber of Commerce], April 1941, 399–400; and Executive Committee Minutes 8:83 (March 25, 1947), New York Chamber of Commerce Archives, Columbia University Rare Book and Manuscript Library [hereafter, NYCC Archives]. On businessmen and conservation, see Samuel Hays, *Conservation and the Gospel of Efficiency: The Progressive Conservation Movement* (Cambridge, Mass.: Harvard University Press, 1959); on business and historic preservation, see Randall Mason, "Memory Infrastructure: Preservation, 'Improvement,' and Landscape in New York City, 1898–1925" (Ph.D. diss., Columbia University, 1999).

71. James Livingston, "Social Analysis of Economic History and Theory: Conjectures on Late Nineteenth-Century American Development," *American Historical Review* 92, no. 1 (1987): 69–95.

72. Chandler, *Visible Hand*, 331–344; Carosso, *Investment Banking*, 44–47.

73. Douglas North, "Capital Accumulation in Life Insurance Between the Civil War and the Investigation of 1905," in *Men in Business: Essays in the History of Entrepreneurship*, ed. William Miller (Cambridge, Mass.: Harvard University Press, 1952), 238–253. On Hydes's use of cultural connections, see Elisha Douglass, *The Coming of Age of American Business: Three Centuries of Enterprise, 1600–1900* (Chapel Hill: University of North Carolina Press, 1971), 302.

74. North, "Capital Accumulation," 239.

75. Morton Keller, *The Life Insurance Enterprise, 1885–1910: A Study in the Limits of Corporate Power* (Cambridge, Mass.: Harvard University Press, 1963), 282–283.

76. 48 AR (1905–1906), 107.

77. 57 AR (1914–1915), 56.

78. 57 AR (1914–1915), 175–176.

79. Keller, *Life Insurance Enterprise*, 291. Keller also notes that in a 1959 sampling, insurance men were "the best educated, most active in community affairs—and the lowest paid" of executives, and that C. Wright Mills had largely overlooked them in his book *The Power Elite*.

80. 54 AR (1911–1912), xxxvi.

81. 53 AR (1910–1911), 21.

82. 53 AR (1910–1911), 57.

83. 50 AR (1907–1908), 24.

84. Carosso, *Investment Banking*, 110–155, quote on 150. On banking reforms that the Chamber embraced, see James Livingston, *Origins of the Federal Reserve System: Money, Class, and Corporate Capitalism, 1890–1913* (Ithaca, N.Y.: Cornell University Press, 1986), 157–166. In 1900, the Chamber presented a gold medal to Hugh Hanna, head of the Indianapolis Monetary Convention, to express appreciation for his leadership in saving the gold standard. See *CXXXXXII Anniversary of Founding*, 53–56.

85. 55 AR (1912–1913), 101, 105.

86. 50 AR (1907–1908), 92.

87. 51 AR (1908–1909), 27–28. Only 110 of the Chamber's 1,500 members and 2 former presidents attended the memorial meeting.

88. 52 AR (1909–1910), 199. For the full intense debate over the Shipping Board and merchant marine, see 157–177, 179–199.

89. Kimberly Phillips-Fein, "Free Markets, Potential Competition, and Investors' Rights: The Merger Movement and Late Nineteenth-Century Economic Thought" (manuscript, in possession of author), 35.

90. William Miller, "The Business Elite: Careers of Top Executives in the Early Twentieth Century," in Miller, *Men in Business*, 286–305, 328–337.

91. The reorganization began in 1915. See 58 AR (1915–1916), 78–80; and 67 AR (1924–1925), 36–37. Jere Tamblyn became secretary when Gwynne was promoted to executive vice president.

92. 58 AR (1915–1916), 78.

93. 57 AR (1914–1915), 35. A. Barton Hepburn made the correspondence between eulogies and portraits explicit in his 1914 memorial to Alexander Orr.

94. 59 AR (1916–1917), 154.

95. 68 AR (1925–1926), 109–110.

96. *Monthly Bulletin*, April 1938, 60.

97. 58 AR (1915–1916), 120–121, 123, 136.

98. On preparedness, see, for example, 58 AR (1915–1916), 106–113, 209–222 (with addresses by Joseph Choate and General Leonard Wood), 238–256; and 59 AR (1916–1917), 204–211.

99. Senator Robert La Follette and socialist Morris Hillquit are singled out in 60 AR (1917–1918), 137–138.

100. On the 1919 strike wave, see the speech and enthusiastic reception of Sherman Rodgers at the annual banquet, in 62 AR (1919–1920), 116–124; on the police strike, see 107–108. On raising policemen and firemen's wages, see Police Commissioner R. E. Aweigh to Charles T. Gwynne, October 16, 1919; and on longshoremen's strike, see Alfred Marling to John F. Hylan, October 16, 1919, both in Executive Committee Correspondence, 1919, NYCC Archives. The Executive Committee also telegraphed its support to President Wilson for his position on the coal strike, which it regarded as "a fundamental attack which is wrong both morally and legally upon the Rights of society and the welfare of our country" (October 28, 1919, Executive Committee Correspondence).

101. 60 AR (1917–1918), 119–134, quote on 123.

102. 61 AR (1918–1919), 107–108, 115.

103. 67 AR (1924–1925), 119–131.

104. 68 AR (1925–1926), 238–254.

105. For an assessment of the Chamber's declining influence, see Bruce L. Benson, "An Exploration of the Impact of Modern Arbitration Statutes on the Development of Arbitration in the United States," *Journal of Law, Economics, and Organization* 11, no. 2 (1995): 479–501; and William C. Jones, "Three Centuries of Commercial Arbitration in New York: A Brief Survey," *Washington University Law Quarterly* 1956, no. 2 (1956): 193–221.

106. In addition to Outerbridge, Lenor Loree, a railroad executive, supervised troop movements during the war; J. Barstow Smull, who got his start as a steamship broker, served on the Shipping Board and was president of the Emergency Fleet Corporation; and Irving Bush headed the Bush Terminal warehouses in Brooklyn and served as executive officer of the War Port Board of New York.

107. Jameson Doig, *Empire on the Hudson: Entrepreneurial Vision and Political Power at the Port of New York Authority* (New York: Columbia University Press, 2001), 17–18, 30–46, 68–69, 95–96.

108. John A. Garraty, *Right-Hand Man: The Life of George W. Perkins* (New York: Harper, 1960), 57–58; Keller, *Life Insurance Enterprise*, 268–269.

109. Bornfriend, "Business Group in the Metropolis," 75. In 1922, the Merchants' Association had 5,900 members; membership peaked at 7,800 at the decade's end.

110. Bornfriend, "Business Group in the Metropolis," 157.

111. Allan Kaufman and Lawrence Zacharias, "From Trust to Contract: The Legal Language of Managerial Ideology, 1920–1980," *Business History Review* 66, no. 3 (1992): 527.

112. Quoted in Bornfriend, "Business Group in the Metropolis," 168n.

113. "Suggested Draft of Letter to Financial and other newspaper writers"; and "Meeting of Financial Editors," February 18, 1924, both in miscellaneous papers, NYCC Archives.

114. "The Chamber's Public Relation Program," draft memo, in Jack Steinberg to Peter Gray [*sic*], November 23, 1965, NYCC Archives.

115. William Marx Wolff, "Peak Business Associations in National Politics: The Business Council and the Committee for Economic Development" (Ph.D. diss., Tufts University, 1978).

116. Quoted in Bornfriend, "Business Group in the Metropolis," 102–103. The classic account of business ideology in this period is Francis X. Sutton, *The American Business Creed* (Cambridge, Mass.: Harvard University Press, 1956).

117. "Chamber's Public Relation Program."

118. *Monthly Bulletin*, March 1946, 329. For the postwar agenda, see Executive Committee Minutes, June 22, 1945, with Grimm's five-point program to make the Chamber a "more effective voice of business," NYCC Archives. For Grimm's reputation, see Jared Day, *Urban Castles: Tenement Housing and Landlord Activism in New York City, 1890–1943* (New York: Columbia University Press, 1999), 187.

119. Memorandum, B. C. Davis Jr. to Mr. Hamill and Mr. Coppers, March 25, 1952; John Gwynne to Charles Merritt, November 14, 1957; and Margaret Clarey to B. Colwell Davis, November 10, 1957, all in NYCC Archives.

120. Executive Committee Minutes, April 25, 1951, NYCC Archives.

121. Executive Committee Minutes, November 23, 1949, NYCC Archives.

122. Wolff, "Peak Business Associations in National Politics."

123. *Monthly Bulletin*, March 1955, 237–238, 240; April 1956, 517–535.

124. Thomas E. Dewey, "The Port of New York—Back in the Union and Back in Business," *Monthly Bulletin*, December 1963, 239–250; Doig, *Empire on the Hudson*, 282–284.

125. New York Chamber of Commerce Committee on Taxation, "The Coming Crisis in New York City Finances," December 1960, NYCC Archives. See also "New York City Finance: A Ten-Year Review," *Monthly Bulletin*, December 1963, 260–270.

126. McKinsey & Company, "An Examination of the Feasibility of the Proposed Merger of the Chamber of Commerce of the State of New York and the Commerce and Industry Association, Inc.," August 1964, 4–5, NYCC Archives.

127. Jack Steinberg to Mark Richardson, September 16 and 25, 1963; November 17, 1964; and Jack Steinberg to Peter Gray [*sic*], November 23, 1965, all in NYCC Archives. In 1955, the Chamber introduced a "newsletter for members"; in 1964, it discontinued the *Monthly Bulletin* and adopted a "synopsis of action taken" at the regular meetings and a separately printed copy of the speaker's address. See John T. Gwynne to "Fellow Executives" of "Other Chambers in the United States," January 17, 1964, NYCC Archives.

128. C. Wright Mills, *The Power Elite* (New York: Oxford University Press, 1956), 121.

129. For a valuable discussion of New York banking in the 1950s and 1960s, see Cleveland and Huertas, *Citibank*, chaps. 12–14; on the mergers, see 239–251.

130. John Donald Wilson, *The Chase: Chase Manhattan Bank, N.A., 1954–1985* (Boston: Harvard Business School Press, 1986), 36, 51, 117. James Grant draws on an oral history to illuminate Champion's philosophy of banking, in *Money of the Mind: Borrowing and Lending in America from the Civil War to Michael Milken* (New York: Farrar, Straus and Giroux, 1992), 324–326, 330–332.

131. McKinsey, "Examination of the Proposed Merger"; Wilson, *The Chase*, 197; Cleveland and Huertas, *Citibank*, 279–286.

132. McKinsey, "Examination of the Proposed Merger," 2, 6.

133. Richard L. Bean to Walter F. Pease, October 23, 1964, NYCC Archives.

134. See, for example, "New York Chamber's Ballots Being Counted in Fight over Merger," *Wall Street Journal*, September 30, 1964; and Leonard Sloane, "Chamber Miffed by Merger Talk," *New York Times*, March 13, 1965. See also Walter Pease to Members of the New York Chamber of Commerce, March 18, 1965; and "For the Information of Members of the New York Chamber of Commerce, March 23, 1965," both in NYCC Archives.

135. The relationship between the New York City Partnership and the New York Chamber of Commerce and Industry is not easily traced, but in 1982, stationery placed "New York Chamber of Commerce and Industry" at the top of the page and "Associated with the New York City Partnership" in smaller typeface at the bottom; David Rockefeller was listed as chairman. In 1984, the letterhead read "New York Chamber of Commerce and Industry, an Affiliate of the New York City Partnership, Inc.," again with David Rockefeller listed as chairman. The New York City Partnership, Inc., formed the New York City Partnership Foundation in 1983, with which the Chamber of Commerce and Industry and the Economic Development Council were "affiliated organizations." See "Notes to Financial Settlement of New York City Partnership Foundation," December 31, 1985, NYCC Archives.

136. Press release, May 11, 1965, NYCC Archives.

137. AR (1967), 10; Peter P. Grey, *The First Two Centuries . . . : An Informal History of the New York Chamber of Commerce* (New York: New York Chamber of Commerce, 1968); press release, January 2, 1968, all in NYCC Archives.

138. AR (1967), 9; Wilbur Martin, "How Men of Commerce Made New York," *Nation's Business*, April 1968, 58–64.

139. "Action, 1970," AR (1970). See also "New York Chamber of Commerce Action Program for the 1970s," May 20, 1970, NYCC Archives.

140. Thomas Stainback to Robert Stromberg, June 26, 1970; Thomas Stainback to G. Wallace Bates, July 16, 1970; memorandum, Jack Cushman to Chamber Staff, October 13, 1975, all in NYCC Archives.

141. Executive Committee Minutes, May 25, 1970, NYCC Archives.

142. "New Careers in Private Industry: Papers Presented at a Conference Under the Auspices of the Urban League of Greater New York and the New York Chamber of Commerce, July 10, 1968," NYCC Archives. In response to the civil rights movement, the Chamber advocated "non-legal voluntary solutions" ("Racial Tensions in New York State," *Monthly Bulletin*, July 1963, 271–309).

143. Gilbert W. Fitzhugh, "Business–Government Relationships in a Changing World," December 7, 1967, NYCC Archives. For further elaboration of the new business agenda, see David Vogel, *Fluctuating Fortunes: The Political Power of Business in America* (New York: Basic Books, 1989).

144. Joshua Freeman, *Working-Class New York: Life and Labor Since World War II* (New York: New Press, 2000), chap. 15.

145. On the final denouement, see Oscar Dunn, "Review of the New York Chamber of Commerce and Industry Office Location Issue: Status Report," July 11, 1977; Thomas F. Creamer to George Champion and Oscar Dunn, December 10, 1977; Donald E. Moore to Oscar Dunn, April 5, 1978; George Champion to Board of Directors, May 2, 1978; Tom Creamer to George Champion, August 9, 1978; George Champion to Richard Shinn, August 17, 1978; and Oscar Dunn to Richard Shinn, August 25, 1978, all in NYCC Archives.

146. Jere Tamblyn to Carl Fissell, July 12, 1924, NYCC Archives. That the letter was filed in a box labeled "1968, 1969, 1970" suggests efforts to consider the significance of the building in relation to the institution.

147. For an account of the new model of business association, see that of an early head of the New York City Partnership, Frank J. Macchiarola, "Managing Partnerships: A CEO's Perspective," *Proceedings of the Academy of Political Science* 36, no. 2 (1986): 127–136.

PORTRAITS IN THE GREAT HALL

The Chamber's "Voice" on Liberty Street

DANIEL BLUESTONE

For over a century, the New York Chamber of Commerce portraits conveyed to members and visitors reassuring images of rootedness, stability, wealth, and culture in a commercial economy increasingly characterized by speed, national and international networks of finance and trade, and impersonal corporate dealing. The portraits constituted a key element of institutional and personal self-presentation. In 1902, the Chamber's new Liberty Street building—part portrait gallery, part meeting hall and library, part civic embellishment—powerfully reinforced the portrait collection's ideological, economic, and cultural meaning. Adopting the French Renaissance style, New York architect James B. Baker (1864–1918) provided the Chamber with a monumental presence in New York City's landscape (figure 108). This essay explores the form and meaning of the Chamber's building and its relationship to the portrait collection. The building itself provides an important physical and conceptual venue for scrutinizing the portraits.

Transience and impermanence characterized the Chamber's first 130 years, during which it never had its own building. In the eighteenth and early nineteenth centuries, the Chamber met in a series of taverns and coffeehouses, where dining and drinking provided a congenial complement to mercantile business. Since at least the 1860s, portraits of merchants and well-known people associated with the Chamber had lined the meeting room walls. As the number of members and portraits expanded, so did the Chamber's space. After the Merchants' Exchange burned, in 1835 (see figure 14), the Chamber moved to the directors' room in the Merchants' Bank, at 42 Wall Street. In 1858, it leased rooms in the Underwriters' Building, at 63 William Street. Here the Chamber had approximately 1,200 square feet (figure 109). In 1884, the group rented 3,500 square feet in rooms on the fourth floor of the Mutual Life Insurance Company's modern, fireproof building on the east side of Nassau Street,

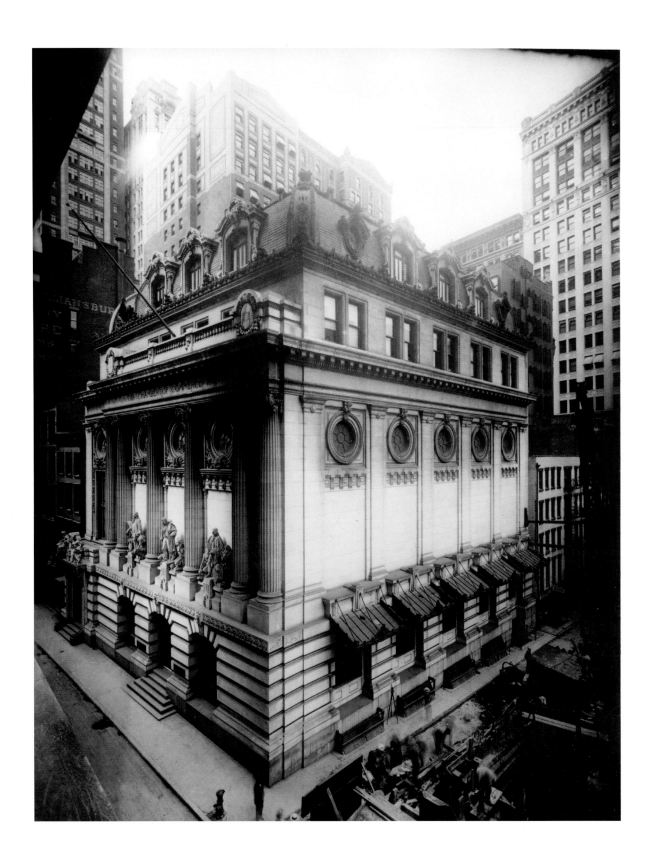

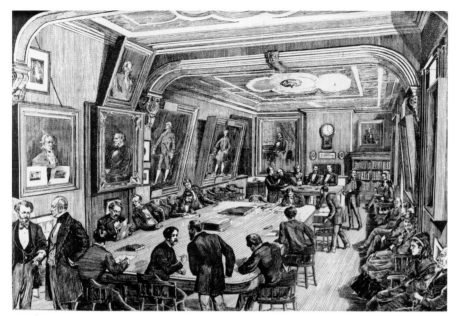

between Cedar and Liberty. The new rooms were "large and commodious, elegantly finished in mahogany, of which the desks and chairs [we]re also constructed, and the general effect [wa]s very rich and pleasing"; portraits lining the walls created part of the effect (figure 110).[1]

Despite its wanderings, the Chamber historically stood at the center of New York's financial district. When the Chamber sought a building site in 1900, it limited its search to the eight blocks bounded by Wall and William Streets, Maiden Lane, and Broadway.[2] Over the previous seventy-five years, the Chamber had stood either on these blocks or, in one case, facing them. Despite such geographical stability, people lamented the Chamber's lack of its own building. In 1858, Columbia College president Charles King surveyed the ninety-year history of the Chamber and called the institution "homeless—dependent upon accidental accommodations." King proposed a new building with a library, gallery of pictures, museum, meeting rooms, and offices, "furnishing to Commerce, what it has not, a place where its voice can be heard." Similarly, in 1865, President Abiel Abbot Low insisted that the "influence" of the Chamber would be "enlarged" with a permanent home. And in 1894, Chamber president Alexander E. Orr declared that "the permanency of our organization would be made more secure, and our influence very much strengthened if our official acts went out from a dignified and well equipped building." Orr argued for a building not only on the basis of institutional and civic image, but also "on behalf of those portrait memories we own and so highly prize, . . . those silent witnesses who are continually testifying to the energy, the enterprise, and the honorable record of the Chamber." The architectural "voice" of the Chamber in the broader urban and architectural landscape merits some elaboration; it rested on the perceptions of Chamber officials of a link between architecture, portraiture, and "influence."[3]

As the Chamber stayed rooted in its neighborhood, the surrounding blocks consolidated their identity as the city's financial center. They also underwent a profound architectural and urban transformation. In the 1870s, developers started replacing three-, four-, and five-story buildings with skyscrapers that doubled, tripled, and even quintupled the height of the existing streetscape. Skyscrapers sharpened the images of nineteenth-century commerce. Contemporary commentators recognized in them a strong metaphor for the new scale, complexity, and dominant power of business enterprise.[4] Skyscrapers personified commerce through their simple act of multiplication; they took the space of a single lot and used modern technology to multiply it many times over, in the air, and in so doing multiplied rents. Whereas church steeples and civic cupolas had once dominated New York's skyline, representing the city's religious and public life, it was business and skyscrapers that drew the eye and attention of city residents and visitors after the 1860s.[5]

In the 1890s, members of the Chamber had only to look out of their fourth-floor meeting room windows in the Mutual Life Building to see commerce dras-

tically changing the form and scale of the financial district. In 1884, when the Chamber took space in the building, four- and five-story structures predominated on the block immediately across the street—the block bounded by Nassau, Liberty, Broadway, and Cedar. This pattern persisted into the mid-1890s, and then, within five years, two-thirds of the block was demolished and rebuilt. First, in 1895 and 1896, at the southwest corner of Nassau and Liberty, the fifteen-story Syndicate Building, designed by Lamb & Rich, was constructed. The nineteen-story National Bank of Commerce, designed by James B. Baker, went up adjacent to the Syndicate Building and filled the southern half of the Nassau Street block facing the Mutual Life Building. Tripling and quadrupling the height of the existing streetscape, the Syndicate and Bank of Commerce blocked the sky and afternoon sun from the Chamber's meeting rooms. Finally, in 1900 and 1901, the American Exchange Bank, designed by Clinton & Russell, rose sixteen stories on the northeast corner of Broadway and Cedar Street (figure 111). At the same time that these buildings were built just west of the Chamber's rooms, the twelve-story John Wolfe Building (figure 112) rose a block east of the Mutual Life Building. Henry J. Hardenbergh designed it in a whimsical

FIGURE 111
Cedar Street between Nassau Street and Broadway, with the American Exchange Bank (*left*) and the National Bank of Commerce (*right*), ca. 1912–15. (Collection of the New-York Historical Society)

FIGURE 112
Wolfe Building (completed 1895; Henry J. Hardenbergh, architect), southeast corner of Maiden Lane and William Street, ca. 1910. (Collection of the New-York Historical Society)

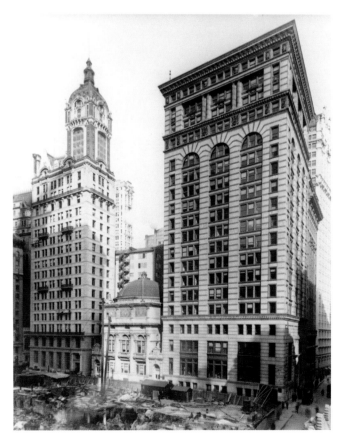

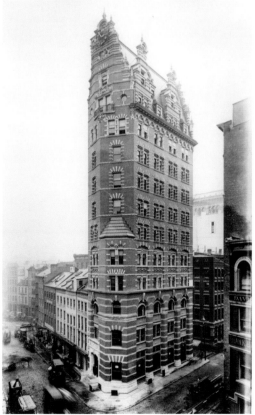

Dutch Renaissance style, rooted partly in the vernacular of colonial New York, but, as in the case of the Bank of Commerce, these historicist elements did little to disguise commerce's transformation of the financial district and the broader images of the city.[6]

Facing Nassau Street between Liberty and Cedar, the Mutual Life Building had itself reflected the broader architectural transformation of Lower Manhattan. The building rose on the site of a former church that the federal government had purchased for use as a post office in 1860. In 1882, the Chamber considered buying the land with Mutual Life and splitting the site for two separate buildings. When Chamber members balked at constructing a building, Mutual Life bought the property. The company then commissioned architect Charles W. Clinton to design a building that was to serve as both a headquarters for Mutual Life and a profitable investment of company assets in income-producing office space (figures 113 and 114). When completed in 1884, the building's eight stories, its banks of elevators, and its expansive floors represented one of New York's notable "hives of business." It accommodated hundreds of white-collar workers. When the Chamber became one of the early tenants, the Mutual Life president insisted that the $6,000 a year rental was "extremely low"; he stated that the company was "moved by public spirited motives as well as by the credit of having so eminently desirable a tenant."[7] The building contributed to the changing scale of business in the neighborhood. It also captured something of the growing intensity of land development: Mutual Life purchased additional properties on the block and made an eight-story addition in 1884, followed by two fifteen-story additions completed in 1892 and 1904.[8]

The Chamber could easily have adopted the skyscraper form when building its own "home." The form personified commerce, it stood at the center of modern urban monumentality, and many members of the Chamber recognized its economic and expressive possibilities. Two members of the Chamber's initial seven-man building committee served as directors of the National Bank of Commerce, which had just completed the nineteen-story building across the street from the Chamber's meeting rooms. J. Pierpont Morgan, one of the largest subscribers to the Chamber's building fund, was the National Bank's vice president. Moreover, James B. Baker, the architect commissioned to design the Chamber's Liberty Street building, had designed the National Bank's building. Many more members of the Chamber had developed, designed, or occupied modern skyscrapers. Indeed, the Chamber debated whether it should build its own skyscraper on its expensive financial district land and use the rental income to cover operating expenses. This was a good hardheaded business proposition. Even if members viewed the Chamber as a civic institution rather than as a commercial entity, they could find plenty of cases where skyscrapers supported broader institutional missions. In the early 1890s, Burnham & Root's Masonic Temple, in Chicago, was the tallest building in the world. A

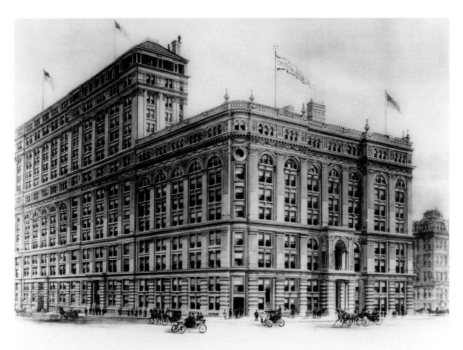

FIGURE 113

Mutual Life Insurance Company
Building (completed 1884; Charles W.
Clinton and Clinton & Russell,
architects [later additions visible]),
Nassau Street between Liberty and
Cedar Streets. (Collection of the
New-York Historical Society)

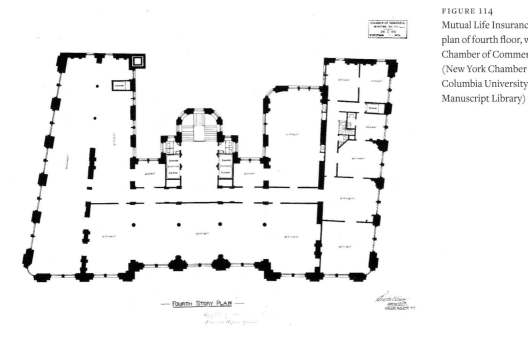

—FOURTH STORY PLAN—

FIGURE 114

Mutual Life Insurance Company Building,
plan of fourth floor, with meeting room of the
Chamber of Commerce in the central section.
(New York Chamber of Commerce Archives,
Columbia University Rare Book and
Manuscript Library)

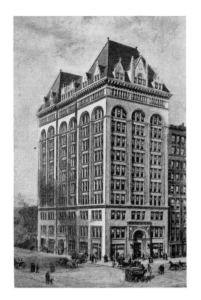

FIGURE 115
Presbyterian Building (1894; James B.
Baker and Thomas Rowe, architects).
(From *Harper's Weekly*, July 28, 1894)

Masonic lodge occupied the top floors, above commercial offices and stores. The Women's Christian Temperance Union occupied a Chicago skyscraper designed by Burnham & Root in 1890 to 1892. In New York, several religious and charitable associations had built skyscrapers to reduce their rents and gather income to support their work. In 1894, for example, James B. Baker and Thomas Rowe designed the twelve-story Presbyterian Building at Fifth Avenue and Twentieth Street (figure 115).[9]

Some people took strong exception to the Chamber's consideration of plans to add to the city's skyscraper landscape. When the editors of the *New York Times* heard of the proposed Chamber of Commerce skyscraper, they quickly editorialized against its "letting lodgings, so to speak, in order to save or diminish its own rent," which could easily "swamp" the institution in the "investment." The *Times* continued,

> There is, in fact, a distinct lack of dignity about [skeleton] construction itself for any purposes but those of bare utility. And things have already come to such a pass that, so far from height being a sign of distinction of the purpose of an edifice, lowness is rather such a sign, and . . . distinguishes an institution from a merely money-making enterprise. . . . [W]e are quite clear that it would consult its own dignity and embellishment of the city if it decided to put up a building strictly for its own use, in which any rentable apartments that might occur should be both really and obviously incidental to the chief purpose of the structure.[10]

It was thus suggested that, on some of the most expensive land in New York, the Chamber of Commerce should show that it did not have to squeeze rents out of its property.

When the Chamber ultimately chose to build a five-story monumental building rather than a commercial skyscraper, it gestured toward the members' perception of themselves as cultured individuals who could bestow, in grand acts of philanthropy, beauty on the city. In a sense, the Chamber's decision to forgo the skyscraper form involved an implicit critique of commercial logic, an assumption of a higher set of aesthetic and moral values than those that customarily prevailed in the market world of the Chamber's members. Nevertheless, some commercial calculus went into such a decision. The architectural statement that the mercantile community did not have to maximize rents suggested the presence of surplus capital accumulation that could, in turn, more easily attract new investment and population to New York. In reviewing the Chamber's design, the *Architectural Record* reported that the Chamber, with fairly modest space requirements, had sought a building that would "avoid insignificance" and that could "easily impress the popular imagination. . . . It must indicate plainly the financial exuberance of its most important members, and of their native or chosen city."[11] Moreover, in choosing low-rise over high-

rise construction, in building a Great Hall for its portraits and meetings, and in adopting classical forms and a design with a highly ornamented interior and exterior, the Chamber significantly appropriated civic architectural form. The deployment of civic architecture in the midst of skyscrapers backed the Chamber's sense of its mission as an organization that ferreted out municipal corruption, promoted efficient government, engaged in charitable causes, and wisely arbitrated disputes between its members.

By declining to pursue the opportunity to construct a skyscraper and collect rent, the Chamber moved toward a building project that closely paralleled the ideals and purposes of its portrait collection. The sitters in the portraits seem very much aloof from the pursuits that made them the subject of Chamber portraiture. Some portraits caught the merchants looking up from their desks and business papers, but the majority of sitters strike a more contemplative pose, detached from the business of mercantile dealing and money making. With clothes and surroundings that suggest established wealth, the sitters often appear to transcend their own commercial and mercantile work. Daniel Huntington's *William E. Dodge II*, for example, has Dodge, a vice president of the Chamber during the 1890s, at home looking up from an illustrated folio; his window opens to a panoramic view of the Hudson River Palisades (figure 116). The portrait's perfect image of stability and rootedness seems to go against the grain of popular images of the rapidity and turbulence of modern business. In choosing not to build a skyscraper in an area where skyscrapers were going up on all sides, the Chamber settled on the architectural equivalent of the commercial transcendence apparent in Dodge's portrait.

Conceiving of the Chamber's building project as a monument rather than as a commercial building shaped the project's $1 million fund-raising methods. In 1894, the building campaign gathered momentum when Alexander Orr became president of the Chamber and formed a new building committee, which he chaired. The building fund subscription took the form of a bond fund that would make quarterly payments of interest and principal to individual subscribers. However, subscribers understood from the start that many members were treating their subscriptions as contributions to the Chamber. In fact, Orr often cast the building project in terms of charitable philanthropy. He argued that the Chamber had always educated its members "into a system of princely giving towards maintaining works of philanthropy and charity, in founding universities of learning and libraries, in cultivating the arts and sciences, and all else that pertains to the elevation, refinement and happiness of a great community." Orr regarded the contributions to the building fund as a "gift to the city" and as an application of the old proverb that charity begins at home. As J. Pierpont Morgan, John D. Rockefeller, and Morris K. Jesup subscribed $50,000 each and Cornelius Vanderbilt, Andrew Carnegie, William E. Dodge II, and others each gave $25,000 to the building fund, their subscriptions conformed to the patterns of wealthy philanthropic giving. The monumental civic, as opposed

FIGURE 116

Daniel Huntington, *William E. Dodge II*,
1896. Oil on canvas, 50 × 40 in.
(Currently unlocated; photo Chamber
of Commerce Collection, New York
State Museum, Albany)

to commercial, character of the proposed building eased this link. Here Dodge could contribute to the building campaign as an act commensurate with the cultivated pursuits captured in Huntington's portrait. In fact, Dodge's mother made a $10,000 contribution in memory of her husband, a former Chamber president. The construction of a skyscraper for the Chamber would, perhaps, not have required the same sort of charitable support, nor is it likely that it could have elicited the "generous" and "heroic measures" that helped complete the $1 million building fund.[12]

The Chamber selected an architect for the building in a decidedly unconventional manner. In January 1901, the building committee called a meeting of leading architects from the city who were also members of the Chamber. Eleven architects attended. Many of them had made their reputations by designing skyscrapers, including Charles Clinton, Robert Robertson, George B. Post, J. Cleveland Cady, and James B. Baker. The committee asked for the architects' advice on how it should select an architect. Although the architects outlined possible plans for a competition, they were almost unanimous in their hopes to avoid one. Architect Robert W. Gibson insisted that a competition led architects to bend their professional and ethical standards to present "a showy design and a showy rendering" for a building that was not likely to fit the budget. The architects argued that competitions wasted time and money and did not always produce responsible solutions. Rejecting a twenty-four-hour competition plan, as resulting in only the sketchiest of designs, James Baker said, "If you are going to make a twenty-four hour competition, I would suggest, as far as my own name is concerned, writing it on a piece of paper and dropping it in a hat."[13] The building committee decided to simply appoint an architect from among those who attended the meeting. The members voted, and only Baker, Robertson, Gibson, Clinton, and James B. Lord received votes. When the committee deadlocked on two ballots (with Baker, Gibson, and Lord each receiving two votes), Orr directed the Chamber secretary to place the three names "in a hat from which the Secretary was instructed to draw one. The Secretary then drew the name of James B. Baker."[14]

Upon hearing of his appointment, Baker wrote to the Chamber of his "appreciation of the honor" and his "earnest desire" to design a building "worthy of the Chamber, the Committee, and myself."[15] In 1901, a "worthy" building could take on any number of forms or styles. In considering the Chamber's final French Renaissance form, it is important to understand what made Baker's design seem an appropriate aesthetic and architectural response to the commission. When the building committee appointed Baker, it had a rough idea of the sort of building it wanted. It planned to replace what the *Times* had called "commodious" accommodations with monumental ones. The Chamber would move from its 3,500 square feet of space in the Mutual Life Building to nearly 25,000 square feet of space in the new building. Opulence and grandeur would characterize the interior and exterior spaces. The committee sought a

four-story building; the first story would be 22 feet high and would accommodate a banking room, as demanded by the seller of the Liberty Street property. It planned for a 14-foot second story with a library and reading room, a third floor for offices and committee rooms, and then a fourth floor with a "great auditorium." The committee anticipated that the new building would reach 110 feet from the sidewalk to the "top of the dome." This image of the "dome" suggests that the committee had an architectural vision of the building beyond a schematic sense of the program. On January 31, 1901, the committee met with James Baker. The basic elements of the plan remained in place; however, the location of the auditorium and the library were switched, so that the auditorium occupied the second floor, easily accessible by a grand staircase. After the preliminary discussions, Baker went to work; he completed the basic design in six weeks, and the building committee approved the plans on March 27, 1901.[16]

James Baker's Chamber of Commerce design incorporated the exuberant sculptural elements and opulent materials and forms of late-nineteenth-century modern French Renaissance and Beaux-Arts architecture in New York. Architects used the style in monumental civic and institutional buildings as well as in the sumptuous homes of many of the city's wealthiest residents. Rooted in French architectural education at the École des Beaux-Arts and in American appropriations of European classicism and Parisian urbanism, these designs stylistically commanded center stage in turn-of-the-century New York. Personifying the style, historian David Lowe writes: "It was the Beaux Arts that found New York a city of sooty brownstone and left it one of bright marble, furnished it with palaces and galleries, caravansaries and public monuments. It was the Beaux Arts style that made New York dare to be extravagant and also to be beautiful."[17]

Adopting an ornate French style—with Ionic columns, a deeply rusticated base, heavily sculpted dormers, and a swelling mansard roof—James Baker designed the Chamber in a manner that was both familiar and popular with the membership. French-style buildings dotted the urban landscape of mansions, clubs, galleries, and civic institutions. Indeed, the architectural similarities between the Chamber and Carrère & Hastings's H. T. Sloane house at 9 East Seventy-second Street, completed in 1894, are striking (figure 117). Sloane, a rug manufacturer and Chamber member, provided the enormous hand-tufted Berlin rug for the Great Hall. In the 1890s, his house was a center of New York society life.[18] The Chamber shared with the Sloane house a four-bay rusticated ground story, with three identical arched openings and a grand entrance set to the left side; both also included colossal Ionic columns, a heavy dentil cornice, a balustrade, and dormers projecting from a mansard roof. In addition, Warren & Wetmore's New York Yacht Club building, located on West Forty-fourth Street, had striking formal similarities with Baker's design for the Chamber (figure 118). The clubhouse had opened with great fanfare just three days before Baker's appointment as the Chamber's architect. The Yacht

Club's colossal columns, sumptuous entrance, dentil molding, balustrades, and dormers—all characteristic of the French style—were elements found in Baker's later design.[19] Like the Sloane house, there were direct personal links between the Chamber and the Yacht Club. The Chamber, and its building committee, were full of Yacht Club members, and J. Pierpont Morgan stood as one of the leading contributors to both the Yacht Club and the Chamber building funds.

The necessity of providing a unified first-floor banking room determined the placement of the Chamber's main entrance off to one side of the façade. Baker's design emphasized the Chamber's entrance by projecting an entrance pavilion forward from the main façade of the building. In contrast, the entrance to the bank, the only commercial part of the building, received a much more restrained

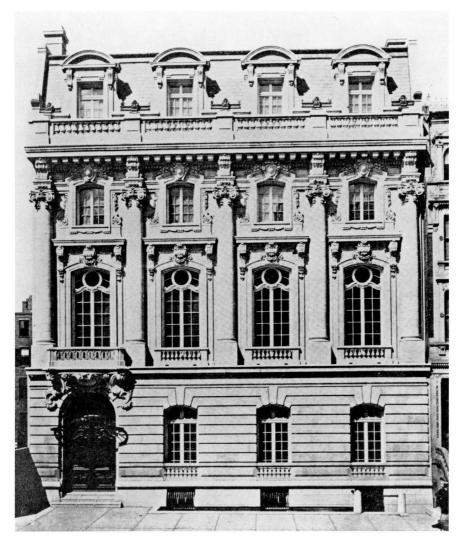

FIGURE 117
H. T. Sloane House (completed 1894; Carrère & Hastings, architect). (From *Architectural Record*, January 1910)

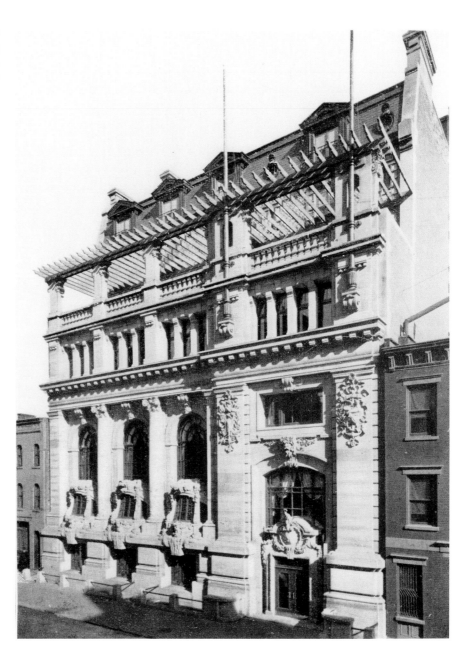

treatment, with little to distinguish it from the window openings on either side (figure 119). The six Ionic columns that cross the Chamber's façade above the rusticated first floor effectively mark the most significant and monumental part of the building's interior—the Great Hall, where meetings took place and where most of the portrait collection was exhibited. Measuring 60 feet by 90 feet, by 30 feet high, the Great Hall—with its mahogany wainscot and seats, paneled and gilded ceiling, and great central skylight—easily claimed its place among New York's most extraordinary interior spaces (figures 120 and 121). To better accommodate the Chamber's collection, Baker designed a continuous lower wall for the Great Hall, unbroken by windows. In this way, the building took on something of the character of contemporary museum galleries, with their long unfenestrated façades (figure 122). Baker's Liberty Street façade suggested the gallery-like space of the Great Hall, even though in actuality this elevation directly enclosed a large coatroom and not the Great Hall (figure 123). The treatment of the front elevation was consistent with that of the side elevation, where the exterior wall did indeed enclose the Great Hall. The unfenestrated wall of the Great Hall required that the room and portraits be illuminated in another way. Along the side façade, the round windows, with their lavish terra-cotta frames, introduced light directly into the upper level of the Hall. The Great Hall also received light obliquely from the three round windows in the front façade, but most of the room's natural light came from a skylight, measuring 18 feet by 31 feet, located at the base of the building's central light court.

The disposition of major architectural elements in Baker's design emphasized the location of the Great Hall and the Chamber's portrait collection in the middle stories of the building. The balustrade over the main cornice masked the floor of offices and committee rooms above the Hall. The setback of this floor and the library floor above from the front plane of the building also enhanced the monumental exterior treatment of the Hall. The elaborately developed sculptural program complemented the Ionic columns and the ornate moldings to further distinguish the building's middle section. The three sculptural groups featuring Alexander Hamilton, Dewitt Clinton, and John Jay filled the main niches between the columns and softened the blank wall surfaces of the main elevation (see figure 119). In an effort to find sculptors to execute this work, and on the advice of painter C. Y. Turner and designer Charles Rollinson Lamb, Baker interviewed sculptors Karl Bitter, Philip Martiny, Daniel Chester French, and Herbert Adams. He concluded that Adams was "both too expensive and too busy" and advised the Chamber to commission French for the central statue of Clinton and Martiny for the figures of Hamilton and Jay. Bitter executed the allegorical figures that topped the main entrance.[20] The sculptures did not fare well in the New York weather and began crumbling after only a few years. By the mid-1920s, portions of the marble statues had turned to sand, and other parts had broken off and fallen onto the street. The statues

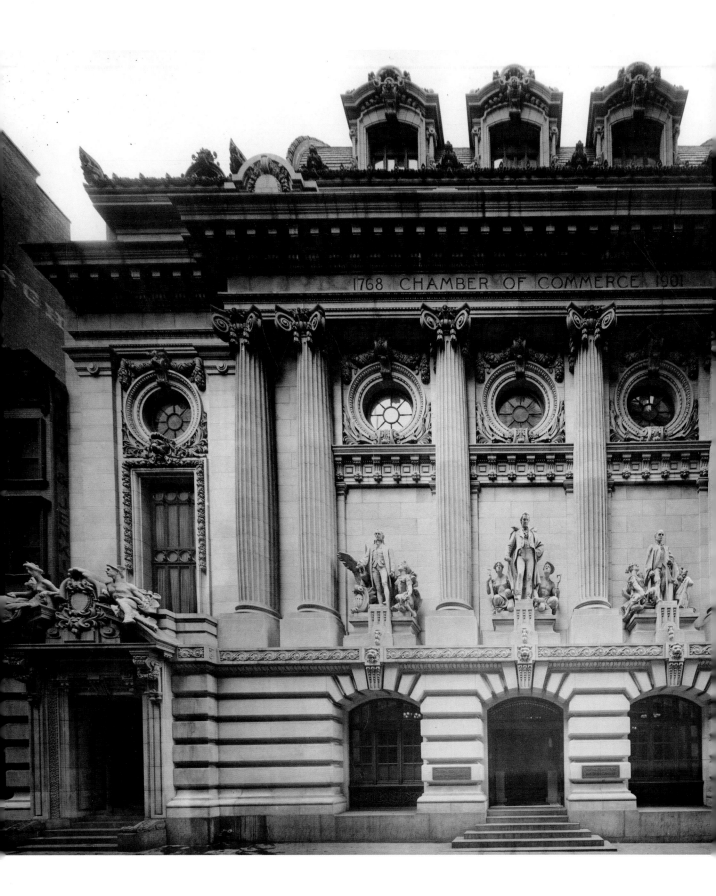

FIGURE 119
New York Chamber of Commerce
Building, ca. 1910. (Photo Pach
Brothers; New York Chamber of
Commerce Archives, Columbia
University Rare Book and Manuscript
Library)

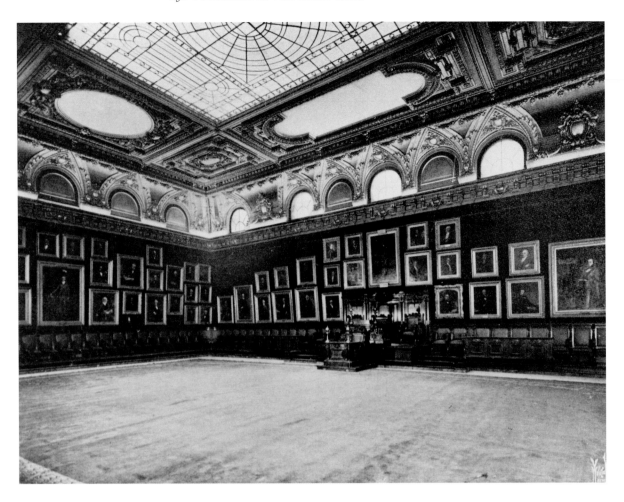

FIGURE 120
Great Hall, New York Chamber of
Commerce Building, looking northeast.
(Photo Wurts Brothers Company;
from *Architectural Record*, January 1903)

were removed and destroyed in 1926.[21] Beyond the natural elements, Bitter's sculptures had to weather the criticism of members. In 1903, several Chamber members objected to the seeming inelegance of Bitter's allegorical figures. They proposed their immediate removal, but Baker defended the work, getting support from leading architects, and the sculptures remained in place. In fact, the sculptural program fit the pattern of many turn-of-the-century court, library, custom house, and other public buildings, further underscoring the design's basic civic gesture.[22]

In March 1901, the building committee retained William R. Ware, an architect and a professor at Columbia University, to review Baker's recently completed design. Ware made numerous minor suggestions that aimed, among other things, at "obviat[ing] the character of heaviness" in the upper part of the building. He, for example, suggested reducing the size of sculptural groups planned for the top of the building (figure 124). In the final plan, these sculptures were eliminated. Overall, Ware pronounced himself quite impressed with the design:

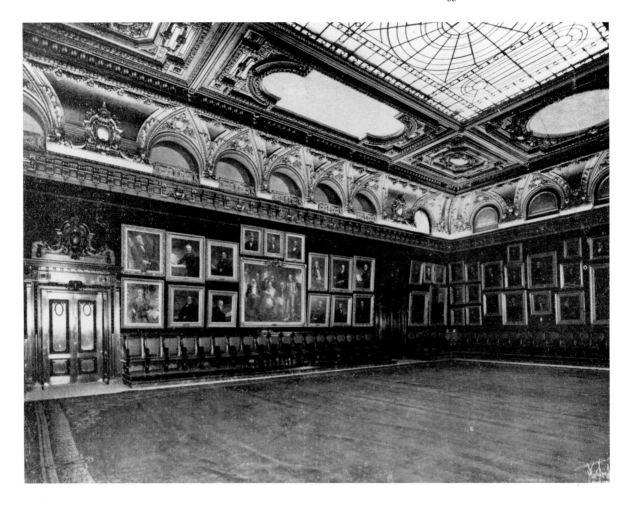

FIGURE 121
Great Hall, New York Chamber of
Commerce Building, looking northwest.
(Photo Wurts Brothers Company;
from *Architectural Record*, January 1903)

The general scheme . . . could, it seems to me, hardly be improved. . . . The committee have designs eminently suited to their purpose, dignified and monumental in character, as they should be, and while conspicuously free from eccentricities and caprice, so well accommodated to the special requirements of the case as to possess a marked individuality. The building promises to look like a Chamber of Commerce and not like a Bank, Clearing House, Stock Exchange or Office Building.[23]

The committee took heart from Ware's report, making only slight modifications to the design. Baker estimated that the building would cost $695,675.

Attending to the advice of Ware and the committee, Baker finalized his monumental design. The building would include a grand processional sequence that commenced when visitors crossed the main threshold. They would enter an elevator lobby on axis with the Great Stairway, richly decorated in colored marble and mosaics. An 18-foot-wide stair, lined at the level of the second floor

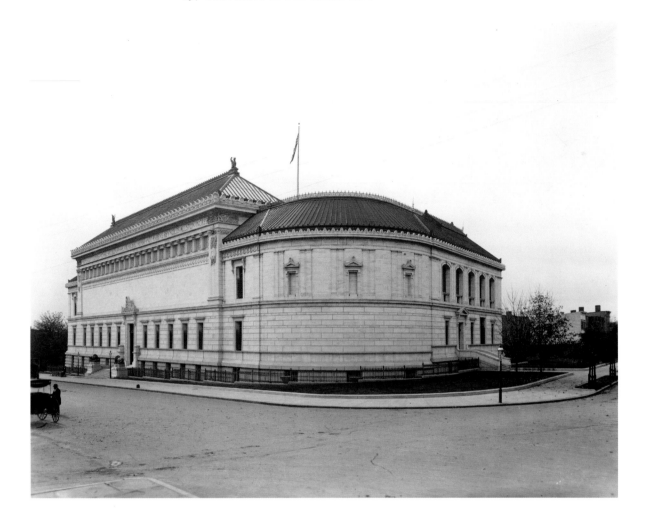

with marble columns and topped by a gilded, barrel-vaulted ceiling, provided access to the Great Hall (figure 125). Ornate tablets along the stair provided space for carving the names of Chamber officers, past, present, and future. The ascent along the stair would introduce and memorialize in stone many people whose portraits lined the walls of the Great Hall. The Great Stairway architecturally orchestrated the arrival at the Hall, where portraits filled all four walls, like a gallery, hung in multiple tiers. The effect of the room was exceptional; however, like the Chamber's exterior, the design was not without precedent. Again, Warren & Wetmore's New York Yacht Club, opened in the weeks before Baker sketched the broad outlines of his Chamber plan, provides one of the closest models. In the Yacht Club, a monumental stair ascended to the main interior space: a two-story, sky-lit assembly room. The collection displayed in

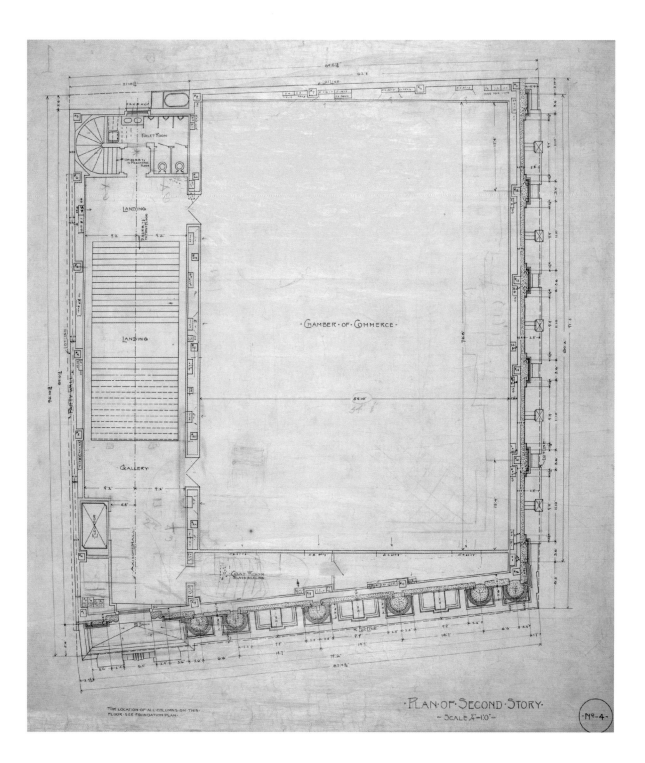

CHAMBER·OF·COMMERCE

LANDING

LANDING

GALLERY

TOILET·ROOM

COAT·ROOM

·PLAN·OF·SECOND·STORY·
·SCALE ⅛"=1'0"·

·Nº·4·

FOR LOCATION OF ALL COLUMNS ON THIS
FLOOR SEE FOUNDATION PLAN.

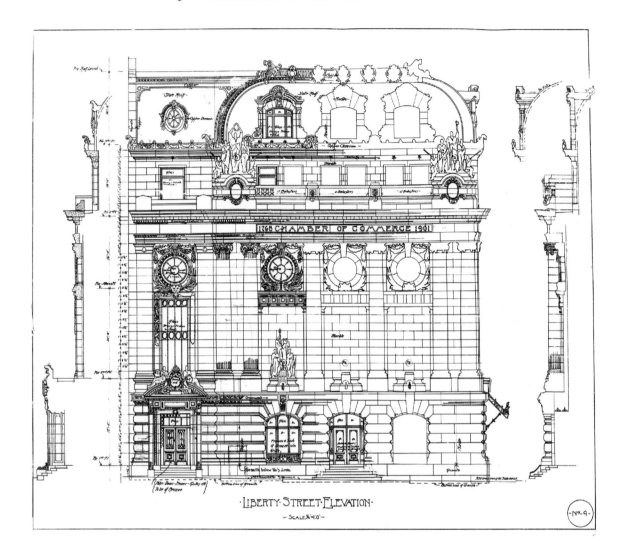

FIGURE 124
New York Chamber of Commerce
Building, early elevation
design with unexecuted sculptural
groups at top. (New York
Chamber of Commerce Archives,
Columbia University Rare Book
and Manuscript Library)

the Yacht Club's main room was composed not of members' portraits, but of the Club's huge collection of boat models (figure 126). The many Chamber members who also belonged to the Yacht Club must have felt in familiar surrounds as they moved back and forth between the Chamber and the Yacht Club.

Numerous features of the Chamber had architectural affinities with other New York clubs. Baker was a member of the Century Club, which occupied a building designed by McKim, Mead & White in 1891 (figures 127 and 128). The building included the impressive double-cube space of the library and art gallery; the two-story height and inward orientation of the grand space resembled that of the Great Hall. The Chamber's mahogany and oak tables and chairs, overstuffed divans and easy chairs, wicker and bentwood lounges, and Chenille and Kermanshah rugs constituted a decor very much like that of an exclusive private club.[24]

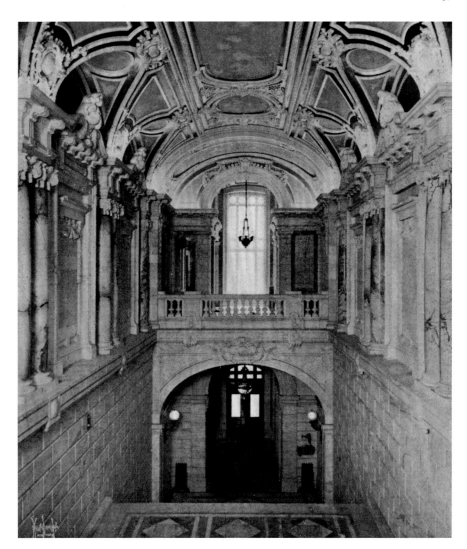

FIGURE 125
Great Stairway, connecting the street
entrance with the Great Hall, New
York Chamber of Commerce Building.
(Photo Wurts Brothers Company;
from *Architectural Record*, January 1903)

The need for continuous uninterrupted walls in the Great Hall gave the room a quality of seclusion. Indeed, the Great Hall's cloistered character, in concert with the raised dais and ornate mahogany desk and seats for the Chamber's officers, along with the member seats, ranged around the walls, followed the established architectural tradition of Masonic lodges (figure 129). Masonic temples and lodges often built meeting rooms that had no window openings in the lower walls and included surrounding passageways and other buffer zones to ensure privacy for the members and their ceremonies (figure 130). In the Chamber design, the requirements of hanging the portrait collection, rather than a demand for privacy, produced an interior quite characteristic of Masonic lodges.[25]

The Chamber's portrait collection sprawled beyond the Great Hall into offices, committee rooms, the library, and the corridors and stairs. In those

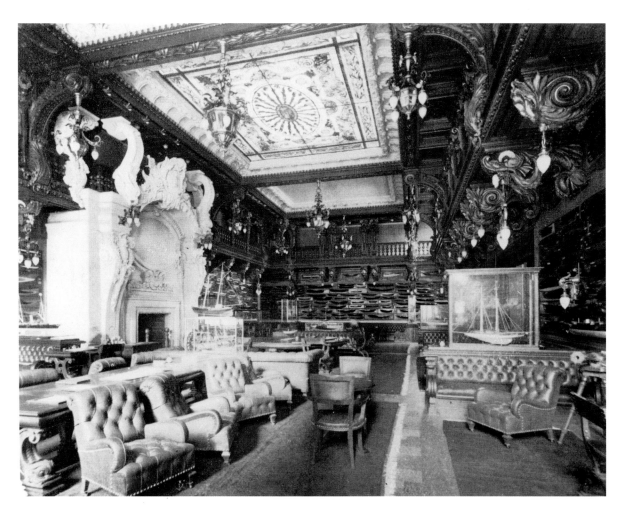

FIGURE 126
Model Room, New York Yacht Club
(1900–1901; Warren & Wetmore,
architect). (From *Architectural
Record*, April 1901)

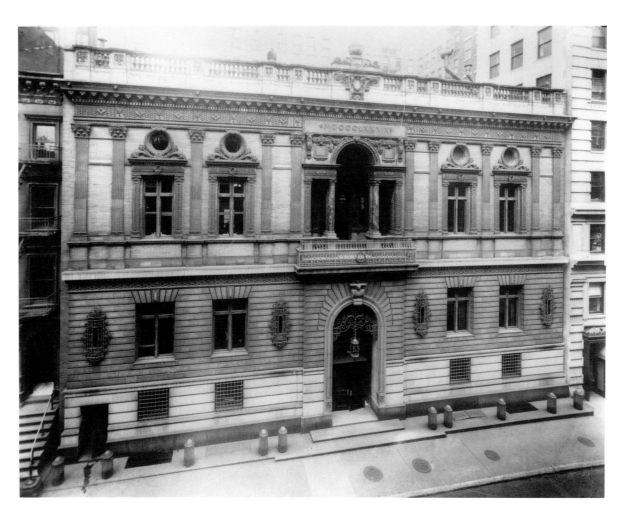

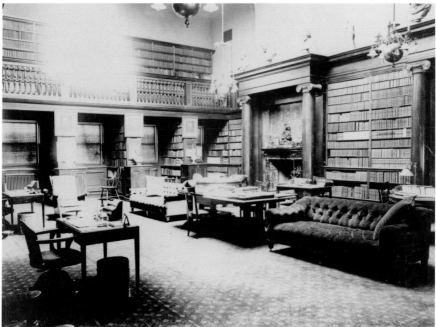

FIGURE 129

Grand Lodge of Massachusetts
(ca. 1900; Charles H. Dunbar,
architect), architectural rendering
of the interior. (National Heritage
Museum, Lexington, Massachusetts,
gift of Ann M. Dowrick; photo
David Bohl)

FIGURE 130

Francesco Bartolozzi and James Fittler
(after Giovanni Battista Cipriani and
Paul Sandby), English Masonic hall,
ca. 1784. Frontispiece engraving.
(From James Anderson, *Constitutions of the
Ancient Fraternity of Free and Accepted Masons*
[London: Society of Free Masons, 1784];
National Heritage Museum, Lexington,
Massachusetts, gift of the Zipp estate;
photo David Bohl)

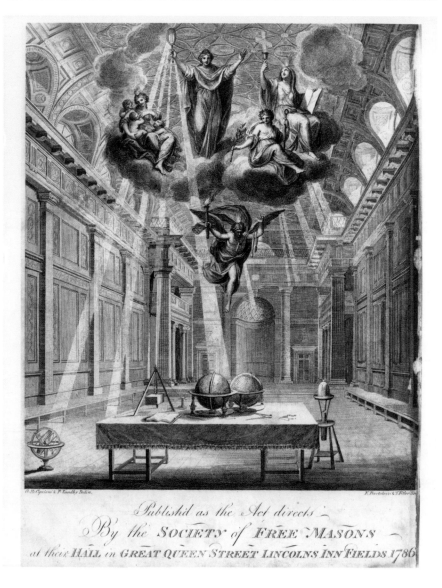

spaces, the nature of Chamber business contrasted with that of the Great Hall; the techniques for exhibiting the portraits were similarly varied. The stairs and hallways connecting the Great Hall with the floors above were considerably simpler, related, according to one architectural critic, more to the "domestic life of the institution than to its public function."[26] In the rooms and spaces above the Great Hall, the portraits were exhibited individually rather than in the portrait tiers of the Great Hall. Socially, these offices and meeting rooms were dominated by individual Chamber officers and committee chairs, and the portraits buttressed this reality, encouraging attention to single images. In contrast to the office, meeting room, and corridor venues (figures 131–133), the Great Hall was given over to collective expressions both in the assembly of members and in the exhibition of portraits. Thus the different portrait exhibition styles recapitulated and reinforced the different social use of the Chamber's interior spaces.

When the Chamber set out to build on Liberty Street, it hoped that building monumentally would increase its "influence" and further project its "voice" in public affairs. The Chamber's dedication ceremonies, which took place on November 11, 1902, confirmed its sense of itself as an institution of great economic power and civic import. President Theodore Roosevelt dedicated the building in the company of former president Grover Cleveland, Secretary of War Elihu Root, the ambassadors of England and France, and the chairman of the London Chamber of Commerce. By all accounts, the pomp and circumstance were extraordinary. Dignitaries gathered in the Chamber's old rooms in the Mutual Life Building and formed a procession that moved up the street and around the corner to the new building. Episcopal bishop Henry C. Potter opened the dedication ceremony with prayer. Chamber president Morris K. Jesup made a speech of welcome, and Grover Cleveland delivered a major oration. A luncheon followed, and an evening banquet was held at the Waldorf-Astoria. In the dedication and banquet speeches, officials laid out both flattering and critical images of commerce; the Chamber and its new monument seemed to confirm benign conceptions of business. This is precisely what the Chamber hoped to convey architecturally and in its extensive display of portraits. Grover Cleveland spoke about commerce's "civilizing influence" and potential for peacefully forging national greatness and international community. He insisted that there was evidence that commerce had established a standard of honest dealing that was "curbing man's besetting sin of selfishness and greed"; he concluded that commerce's mission could not be fulfilled by directing effort toward "gaining more business advantage." In short, people involved in commerce had to live lives that drew on but transcended mere business; again, this image of good works and refinement guided the Chamber's construction of a monument to house art and itself.[27]

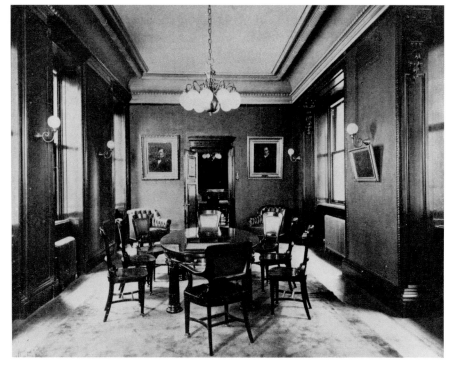

FIGURE 133
Third-floor hallway and stairs,
lined with portraits, New York
Chamber of Commerce Building.
(Photo Wurts Brothers Company;
from *Architectural Record*, January 1903)

President Roosevelt echoed Cleveland's themes, using more pointed words. He declared, "There is no need of my preaching to this gathering [about] the need of combining efficiency with upright dealing, for as an American and as a citizen of New York I am proud to feel that the name of your organization carries with it a guarantee of both." He exhorted the gathering to attend to the need for equitable and peaceful labor relations. Roosevelt took up the mixed reputation of business, but located the Chamber among the virtuous:

> There are very different kinds of success. There is the success that brings with it the seared souls—the success which is achieved by wolfish greed and vulpine cunning . . . then there is the other kind of success—the success which comes as the reward of keen insight, of sagacity, of resolution, of address, combined with unflinching rectitude of behavior public and private. The first kind of success may, in a sense—and a poor sense at that—benefit the individual, but it is always and necessarily a curse to the community. . . . Throughout its history the Chamber of Commerce has stood for this second and higher kind of success. It is therefore fitting that I should come on here as the Chief Executive of the Nation to wish you well in your new home.

Images of decorum and stability coursed through the building project and the portrait collection; they seemed expressions of "sanity and common sense," hedges against the "reckless gambling" that Roosevelt saw accompanying commercial prosperity.[28]

Many comments on the Chamber's new building incorporated the rhetoric of dedication speakers; although at the turn of the twentieth century skyscrapers were sometimes praised for their dynamic and impressive revelation of technical ingenuity, commentaries contrasted the Chamber's monumental architectural forms with the surrounding skyscrapers, which reflected what Roosevelt might have characterized as "wolfish greed." Many observers were struck by the fact that the organized representative of commerce had engaged in an expensive and seemingly uncommercial civic gesture. The *Journal of Commerce and Commercial Bulletin* reported, "It is in no sense a 'skyscraper,' nor is it in any sense designed to be a producer of revenue in the nature of rentals." The *Architectural Record* declared that the low building "contrasts curiously with its towering neighbors, and is distinguished at once from the merely business buildings by its sumptuous character, its costly materials, and the obvious freedom from ordinary business limitations." The dedication speakers and early reviewers of the Chamber's building consistently viewed the building as a model for the devotion of business success to higher ends.[29] The *News Press* of Poughkeepsie, New York, reported that the building provided a "strange contrast" to the area's "dingy skyscrapers,"

built where "every inch of available space" was utilized. A decade earlier, according to the *News Press*, such a project would have been unthinkable, but

> within the last few years art and architecture have made great advances, and business men have arisen above the sordid lines of barter and recognize that something more is due to the growing sentimentality and refinement of the people than tall and dreary rows of buildings, erected with the sole view to the rentals they will earn. The Chamber of Commerce resembles more than anything else such a temple as the ancient Greeks erected in gratitude for favors bestowed upon them by their gods. And it might be rightly called a temple—a temple reared as a tribute to the genius of commerce, . . . the best that is offered to us in the ethics of business.[30]

Despite the high praise that greeted the building, in both the 1910s and the early 1920s the Chamber changed its circulation and secondary spaces in significant ways. In 1912, the Chamber responded to the "many complaints from older members" about the steep climb to the Library by installing a second elevator.[31] The addition required raising the roof over the entrance bay to accommodate new mechanical equipment. Such changes were dwarfed by the alterations done in 1921, when the Chamber spent nearly $350,000 on interior remodeling. The project aimed to correct a major flaw in the building's circulation plan: members who used the Great Stairway had to pass through the Great Hall in order to reach the coatroom. If they wanted to avoid walking through the Great Hall, they had to ride overcrowded elevators and fight the "congestion." The building managers viewed the "very little used" Great Stairway as "impracticable while very beautiful." Moreover, people objected to the "narrow and more or less dangerous" staircase leading from the Great Hall level to the floors above. Also, members felt cramped in the library's makeshift accommodations for luncheons.[32]

Architects Helmle & Corbett redesigned the Chamber in fundamental ways. Most important, they drastically altered the Great Stairway. By narrowing the stair, they provided a passageway along the western wall of the building, permitting members to go from the landing outside the Great Hall forward to the coatroom without passing through the Great Hall. The architects assured Chamber members that "the effect of the staircase" would be "no less satisfactory" than the original stair. When the work was completed, the earlier grand ornamental forms and materials had given way to much simpler forms, ones perhaps more in harmony with the nascent lines of 1920s modern design (figure 134). Seeking more interior space, the Chamber also filled in the central light shaft on the top two floors of the building. Thus natural light no longer filtered into the top of the Great Hall to illuminate the portrait collection; instead, artificial lights were installed above the skylight. The library floor was

FIGURE 134
New York Chamber of Commerce
Building, remodeled interior of
fourth floor (1921; Helmle & Corbett,
interior design). (From *American
Architect*, March 15, 1922)

expanded into the light shaft and converted into a lunchroom. A new rooftop penthouse accommodated the library. Members saw the modernization as thoroughly desirable; however, they also felt bound to point out that the Great Hall was left "untouched." In the 1920s, the Chamber still felt very much bound by its monumental architectural identity.[33] Here, in the Great Hall, the Chamber maintained images of permanence while changing other parts of the building.

Despite redesigns, the Chamber continued to show great enthusiasm for the building as a vital part of the organization's image and history. In 1924, an official of the Northeast Philadelphia Chamber of Commerce wrote to the New York Chamber inquiring about the propriety of constructing its own building. In response, a Chamber official enumerated the advantages of having a building to attract the admiration of members, visitors, and distinguished public officials and businessmen:

> It adds to the prestige and self-respect of the organization, and it lends it dignity and permanency. . . . No institution has been able to command to a large extent the sympathy and support of mankind without having a home of its own. . . . A permanent home for a Chamber of Commerce, where its records are kept and portraits of its outstanding merchants are accumulated, serves to hand down to posterity a means of visualizing the activities of its predecessors. An appropriate Chamber of Commerce building takes its place . . . in the civic development of the community, and the adornment of the city.[34]

Buttressing the notion of the Chamber as being central to New York's public life, the Chamber frequently granted permission for civic associations to use the Great Hall. Organizations including the American Economics Association, American Historical Society, New York Academy of Political Science, Interstate Commerce Commission, YMCA, International Police Federation, Harding Memorial Association, American Board of Applied Christianity, Committee on Preservation of the Palisades, Tri-State Anti-Pollution Commission, Citizens' Reconstruction Organization, American Bar Association, and Investment Bankers Association all met at various times in the Great Hall during its first decades.

Increasingly after World War II, the Chamber turned to a professional staff to analyze and develop strategies for New York's economy. The membership still viewed the Chamber's building and its portraits with great fondness. In 1963, when the Chamber considered merging with the Commerce and Industry Association of New York, Chamber officials found that members feared that the merger might threaten the use of the Great Hall and the monthly luncheon meetings. Supporters of the merger went out of their way to celebrate the beauty of the Great Hall and its monthly meetings, "one of the most cherished

traditions of the Chamber." Although the increased membership that a merger would bring would tax the capacity of the Great Hall, Chamber officials adopted the optimistic stance that a merger would increase the use of the Great Hall rather than lead to its abandonment. One study of the merger concluded that the "handsome building at 65 Liberty Street not only carries practical and sentimental value as a part of the Chamber tradition, it also carries—together with its contents—considerable value on the balance sheet."[35] Despite assurances about the continued use of the Chamber building, the membership rejected the proposed merger. The reverence of the membership and of New Yorkers more generally for the Liberty Street building was underscored in 1966 when it became one of the early structures designated as a New York City landmark by the newly constituted Landmarks Preservation Commission. The commission felt that the building's "bold design" and "fine materials and detail" contributed to the "elegance of the city."[36] In 1968, the Chamber celebrated its bicentennial and decided to open the Great Hall on successive Fridays for informal public tours.

Not all members of the Chamber appreciated the Great Hall. In fact, for those who sought in the organization a more vital agent for economic development, the building and its portraits offered symbols not of stability and rootedness, integrity and honesty, but rather of the ponderous weight of tradition. In the wake of the defeat of the Chamber's merger with the Commerce and Industry Association, one relatively new member offered his somewhat negative portrait of the Chamber:

> [M]y impression is that in its present form, despite the highly commendable work which is done on a few major problems, the New York Chamber is, over all, handicapped by an undue love of tradition and is far less vital than it could be because there is too little opportunity for individual members to be doers rather than listeners and aye-voters. . . . The Chamber falls far short of approaching the dynamic kind of civic guidance, business assistance, business-development job that is crying out to be done in this city.[37]

The people most caught up in the effort to modernize the Chamber and its work simply did not live in the same business world or speak the same language as the people who had built the Liberty Street building. They approached the affairs of the Chamber with the same profit-maximizing sensibility that characterized their business and corporate lives. They saw little value in transcending business pursuits as they framed Chamber issues. The notion of merging the Chamber with allied business organizations was itself part of a broader economic ideal that placed a premium on efficient business management. In 1973, the Chamber did merge with the Commerce and Industry Association. Also in the 1970s, collaborations with the Economic Development Council of New York

City and the New York City Partnership led to additional merger discussions that placed the Liberty Street building's future in question.

The bankruptcy of New York City in 1975 created something of a crisis for the Chamber and New York's business community. It tarnished the city's financial reputation and raised doubts about the viability of New York as a place to live and work. The fiscal crisis provided the backdrop against which George Champion, chair of the board of directors of the Economic Development Council, aggressively promoted a merger with the Chamber. Champion hoped to bring the two organizations under a single roof in a Midtown Manhattan office building. In 1978, Champion argued,

> The crisis still exists and we have not generated public awareness of the problems. A constituency for good government by the majority in the private sector is an essential ingredient for any continuity of a healthy economic atmosphere. Fragmentation of effort due to the vast number of agencies, programs and committees weakens the voice of the majority. . . . Quite obviously, if we are not quite able to completely co-ordinate our programs of EDC/Chamber, there is little reason for others to join in a unified effort.[38]

The merger discussions thus reinvoked the effectiveness of institutional "voice," but now this had to do with organizational charts rather than with architecture and portraiture. The council and the Chamber considered consolidating their operations in the Liberty Street building, but "key people," in need of offices, would be called on to make "sacrifices" in their customary accommodations.[39]

For its part, the Chamber worried that a relocation to Midtown Manhattan might result in losing members who were attached to the Chamber's building in Lower Manhattan and its programs. Members also worried that the move would threaten "historic continuity," give the impression of the Chamber "giving up" on downtown redevelopment, and involve the "loss of prestigious history." The Chamber's support for downtown redevelopment, of course, had a distinct aesthetic dimension. The future of the downtown redevelopment that the Chamber wished to support seemed best expressed not by turn-of-the-century French Renaissance–style landmarks, but by the forms of international modernism. This architecture received notable local expression in Skidmore, Owings & Merrill's 1960 design for the sleek, 813-foot high, sixty-story, glass and aluminum tower of David Rockefeller's Chase Manhattan Bank (figure 135). The Chase tower rose on the site of the Mutual Life Building, where the Chamber had occupied rooms from 1884 to 1902. In 1967, Skidmore, Owings & Merrill's modern fifty-two-story Marine Midland Bank was built across the street from the Chamber; this was the same site that James Baker had helped transform to high-rise with his nineteen-story National Bank of Commerce. Clearly, the Chamber's Ionic colonnade and other traditional forms had lost their grip

on the imagination of New York architects and their clients. The Chamber and the Economic Development Council prepared reports treating the Liberty Street building not as a repository of institutional history and memory but as a piece of real estate that could be compared with Midtown buildings in terms of dollars per square foot.[40]

For a few years, the Chamber sought both a merger and to hold onto its building. It considered establishing a not-for-profit educational foundation to use and manage the building while eliminating $77,000 in city real-estate taxes. This arrangement would maintain the Great Hall for special meetings and for the display of the portrait collection; the lunchroom would stay open to members—and, at the same time, the Chamber would enjoy the efficiencies and benefits of merging with the council.[41] In the end, the pressure to join with other business organizations, to develop an institutional "voice" beyond architecture, led to a merger in 1979 with the Economic Development Council and with David Rockefeller's New York City Partnership, an organization chartered to promote economic development, housing, worker education, and a host of social service programs. In the context of modern architecture, and modern economic problems, this institutional "voice" had little use for the architectural "voice" on Liberty Street. In November 1980, the Chamber moved out of its "permanent home" and into a conventional thirty-story office building at 200 Madison Avenue, designed in 1926 by Warren & Wetmore. In 1900, people had objected when the Chamber briefly considered constructing such an office building to accommodate itself. Now, nobody protested the move as a lapse of institutional dignity. The ideology of business and civic life had changed substantially since 1900. The Chamber soon set about the business of selling its portraits and its building. After early efforts fell through, the Chamber sold the Liberty Street building to the International Commercial Bank of China in 1989. The Chamber's architecture had in every sense shared with its portraits the materialization and the dematerialization of the Chamber's voice and identity in the broader physical and cultural landscape of New York City.[42]

Notes

1. "Merchants in Their New Rooms," *New York Times*, May 2, 1884.
2. Chamber of Commerce of the State of New York, "Minutes of the Board of Trustees of the Real Estate, 1900–1936," November 26, 1900, New York Chamber of Commerce Archives, Columbia University Rare Book and Manuscript Library, New York [hereafter, NYCC Archives].
3. King, quoted in *Proceedings of the Chamber of Commerce of the State of New York, at the Opening of Their New Rooms, June 10, 1858* (New York: Douglas, 1858), 5, 7; Low,

quoted in *Eighth Annual Report of the Chamber of Commerce of the State of New York* (1865–1866) (New York: Amerman, 1866), 8 [hereafter, 8 AR (1865–1866), etc.]; Orr, quoted in "Report of Chamber of Commerce Executive Committee," 1912, NYCC Archives, and in 40 AR (1897–1898), 33–34.

4. On images of the skyscraper, see Daniel Bluestone, *Constructing Chicago* (New Haven, Conn.: Yale University Press, 1991), 104–151.

5. For contemporary responses to New York's changing skyline, see Montgomery Schuyler, "The Skyline of New York, 1881–1897," *Harper's Weekly*, March 20, 1897, 295; "Two Views of New York," *Harper's Weekly*, August 11, 1894, 756–759; Royal Cortissoz, "Landmarks of Manhattan," *Scribner's Magazine*, November 1895, 531–544; Jesse Lynch Williams, "The Walk Up-Town," *Scribner's Magazine*, January 1900, 44–59; and "Great Office Buildings of New York," *Scientific American*, July 7, 1894, 8.

6. Sarah Bradford Landau and Carl W. Condit, *Rise of the New York Skyscraper* (New Haven, Conn.: Yale University Press, 1996), 257–258.

7. Richard A. McCurdy to Alexander E. Orr, December 31, 1902, in "Minutes of Board of Trustees of Real Estate," NYCC Archives.

8. Landau and Condit, *Rise of the New York Skyscraper*, 298–299.

9. "The Presbyterian Building," *Harper's Weekly*, July 28, 1894, 710–711. See also Bluestone, *Constructing Chicago*, 104–151.

10. Editorial, *New York Times*, February 18, 1900.

11. A. C. David, "New York's Great Commercial Institution," *Architectural Record*, January 1903, 61.

12. *CXXXII Anniversary of the Founding of the New-York Chamber of Commerce, April 5th, 1900* (New York: Press of the Chamber of Commerce, 1900), 17–21.

13. "Minutes of Board of Trustees of Real Estate," January 23, 1901, NYCC Archives. Also, at this meeting George B. Post recounted for the committee a recent experience in which a client had asked him to compete against McKim, Mead & White and Carrère & Hastings for the commission to design a building. The architects were asked to meet to work out the grounds for a competition. Instead, they decided that the client should simply appoint an architect, and to aid the process they drew lots and reported that Carrère & Hastings had won the competition.

14. "Minutes of Board of Trustees of Real Estate," January 23, 1901.

15. James B. Baker to George Nelson, January 24, 1901, NYCC Archives.

16. "Minutes of Board of Trustees of Real Estate," January 23 and 31, 1901; February 7 and 11, 1901; March 18 and 27, 1901, all in NYCC Archives.

17. David Garrard Lowe, *Beaux Arts New York* (New York: Watson-Guptill, 1998), 17. See also Mardges Bacon, *Ernest Flagg: Beaux-Arts Architect and Urban Reformer* (Cambridge, Mass.: MIT Press, 1986), 17–74; and Robert A. M. Stern, Gregory Gilmartin, and John Montague Massengale, *New York, 1900* (New York: Rizzoli, 1983), 325–334.

18. "Mrs. Henry Sloane's Dance," *New York Times*, January 12, 1897; "Sloanes to Separate," *New York Times*, December 22, 1898.

19. John Parkinson Jr., *The History of the New York Yacht Club* (New York: New York Yacht Club, 1975), 1:176–184.

20. James B. Baker to Morris K. Jesup, July 20, 1901, NYCC Archives.

21. The Chamber approached the Jesup, Dodge, and Kennedy families, who had paid for the original commissions, and asked them whether they wanted to contribute to a $70,000 fund to replace the statues. When the answer turned out to be no, the Chamber had Piccirilli Brothers, the original contractors, remove and destroy the statues. See "Minutes of Board of Trustees of Real Estate," September 27, 1926, NYCC Archives; and *Chamber of Commerce of the State of New York Bulletin*, October 1926, 35, and March 1927, 10–11.

22. Michele H. Bogart, *Public Sculpture and the Civic Ideal in New York City, 1890–1930* (Chicago: University of Chicago Press, 1989).

23. William R. Ware to Morris K. Jesup, April 4, 1901, NYCC Archives.

24. Continental Appraisal Company, "Appraised Valuation of the Furnishings of the Chamber of Commerce of the State of New York, 65 Liberty St., New York," December 15, 1926, NYCC Archives.

25. John D. Hamilton, *Material Culture of the American Freemasons* (Hanover, N.H.: University Press of New England, 1994); C. Lance Brockman, *Theatre of the Fraternity: Staging the Ritual Space of the Scottish Rite of Freemasonry, 1896–1924* (Minneapolis: University of Minnesota Press, 1996).

26. David, "New York's Great Commercial Institution," 65.

27. George Wilson, ed., *Opening of the Building of the Chamber of Commerce of the State of New York and Banquet in Honor of the Guests Who Attended the Dedicatory Ceremonies, November 11, 1902, Together with a Brief History of the Chamber from 1768–1902* (New York: Press of the Chamber of Commerce, 1902), 4.

28. Transcript, in "President Roosevelt at Chamber Banquet," *New York Times*, November 12, 1902.

29. *Journal of Commerce and Commercial Bulletin*, November 10, 1902; David, "New York's Great Commercial Institution," 61. See also "New Home of Chamber of Commerce," *New York Times*, September 28, 1902.

30. Frederick Boyd Stevenson, "Belong to History: The Doings of the New York Chamber of Commerce," *News Press*, December 6, 1902.

31. Cecil F. Shallcross to Sereno S. Pratt, April 19, 1912, NYCC Archives.

32. "Proposed Alteration to Chamber's Building," 64 AR (1920–1921), 22–24.

33. "Proposed Alteration to Chamber's Building."

34. Jere Tamblyn to Carl Fissell, July 12, 1924, NYCC Archives.

35. McKinsey & Company to Special Committee on Merger, August 28, 1964, NYCC Archives.

36. Landmarks Preservation Commission, Calendar Item 1, LP-0053, January 18, 1966, NYCC Archives.

37. Richard L. Bean to Walter F. Pease, October 23, 1964, NYCC Archives.

38. George Champion to Members of the Operations Committee, August 17, 1978, NYCC Archives.

39. A. J. Scolaro to Chester L. Fisher Jr., February 13, 1975, NYCC Archives.

40. See, for example, Oscar Dunn, "Review of New York Chamber of Commerce and Industry Office Location Issue: Status Report," July 11, 1977, NYCC Archives.

41. The Chamber also considered making a gift of the building to Pace University or to the city of New York.

42. "For Business Group, Art Is a Moving Problem," *New York Times*, June 9, 1982; "New Owner for a 1902 Landmark," *New York Times*, April 23, 1989.

"THE WHOLE LUSTRE OF GOLD"

Framing and Displaying Power at the Chamber of Commerce

DAVID L. BARQUIST

Frames played an integral role in the presentation of the Chamber of Commerce portrait collection. Protecting the individual works, the frames endowed portraits with the status of art and sitters with dignity. In addition, some frames were designed to highlight specific paintings as images worthy of special attention. As a group, the frames created a larger frame for the collection and its interpretation. Their styles provided the collection with the aura of history, and the organization with grounding and legitimacy. The Chamber duly adopted hangings for the collection that reinforced these relationships and historical associations.

During the era when the Chamber portrait collection was principally formed, frames were viewed as an important component of the portraits, validating them as finished works of art. A manual for framers and art dealers declared in 1876: "It is the picture and the frame, taken as a whole, that is to form the ornament to the walls of your home. Apart, they are of no value for this purpose; together, they form a work of ART, the real elegance of which depends quite as much upon the frame as upon the picture." In 1893, regarding a portrait of John James Audubon that was executed but never donated to the Chamber, artist Thomas Waterman Wood was anxious that the donor, Morris K. Jesup (see figure 156), not view the painting before it was framed: "As soon as the Audubon frame arrives at my Studio, the portrait will be ready for the inspection of Mr. Jessup [sic]." Photographs and paintings of American artists from this period show them in their studios with unfinished works that have already been framed, the implication being that the frame was necessary before the finishing touches could be made to the painting.[1]

There are three principal categories of frames in the Chamber's collection. First and fewest in number are frames patterned after prototypes used on public or royal portraits. Second are early-nineteenth-century frames on portraits

FIGURE 136 (*facing page*)
John Trumbull, *Alexander Hamilton*,
1792. Oil on canvas, 86 × 58 in.
(Credit Suisse, New York)

painted originally for domestic contexts that were acquired by the Chamber a generation or more after they were created. The third and largest group are frames that postdate 1860, some on paintings originally made for the sitters and donated to the Chamber later, others on portraits painted for presentation.

The Chamber itself commissioned relatively few portraits early on, relying as much on donations from members and their families. Certain important paintings were given frames that underscored the public character of the images. The two earliest portraits in the collection, Matthew Pratt's *Cadwallader Colden* (1772 [see figure 1]) and John Trumbull's *Alexander Hamilton* (1792 [figure 136]), were acquired and displayed to connect the Chamber explicitly with political figures who shared its mercantile concerns. *Colden* and *Hamilton* now have very similar Grecian frames that probably date from the first quarter of the nineteenth century. Their design, particularly the large rectangular tablets at top and bottom, reinforced the identification of these full-length, Grand Manner portraits as public rather than private images. By providing space for large-scale inscriptions, the frames identified the portraits as worthy of textual commentary.[2] In this detail as well as their overall design, these two frames are closely related to a group of frames made for portraits painted by Trumbull, Thomas Sully, and John Vanderlyn for the Governor's Room of New York City Hall between 1805 and 1822 (figure 137). The Governor's Room frames, executed

FIGURE 137
Charles Burton, *Governor's Room,
City Hall*, ca. 1830. Watercolor,
$2^{11}\!/_{16}$ × $3\frac{1}{2}$ in. (Collection of the
New-York Historical Society)

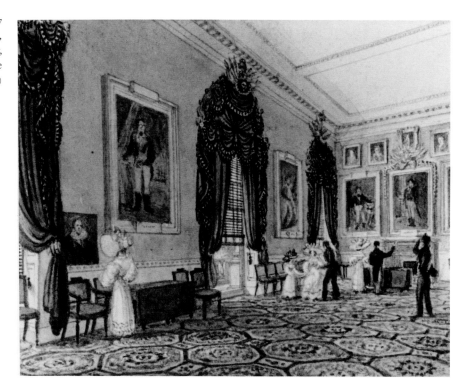

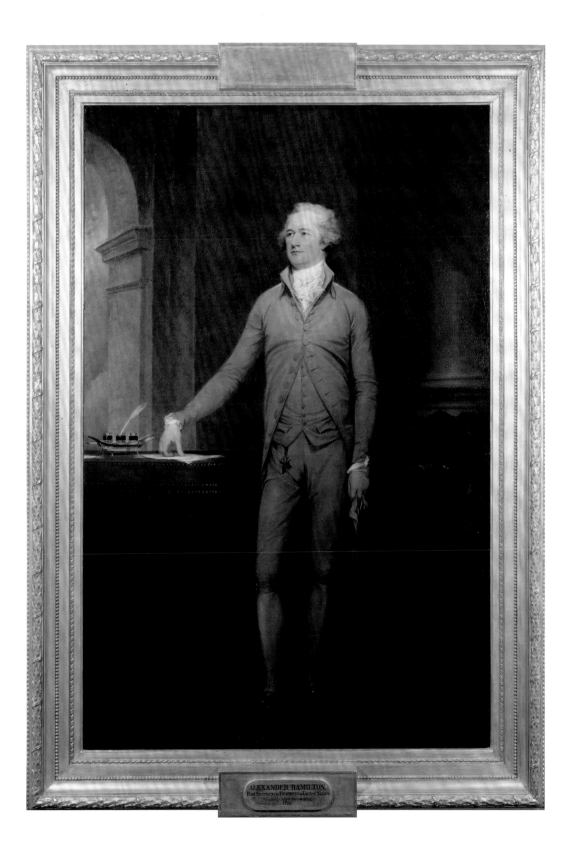

ALEXANDER HAMILTON,
First Secretary of the Treasury of the United States
1792

over at least seventeen years, adhere to a single model for public display. The Chamber's intent in selecting frames similar to those at City Hall may have been to underscore Colden's and Hamilton's status as political figures equal to those whose portraits hung in City Hall. Moreover, Trumbull's *Hamilton* was exhibited for a time there: the *New-York Daily Advertiser* of July 4, 1792, reported that the newly completed portrait "has been . . . for the present, placed in City Hall." Its next recorded location was the Tontine Coffee House in 1817, by which time it may have been framed to match other City Hall portraits.[3]

Another frame designed to signify the public character of the painting was provided for Daniel Huntington's commission, *The Atlantic Cable Projectors* (1895–96). The frame's design is derived from eighteenth-century trophy (known in French as *fronton*) frames with coats of arms placed above the top member. Such frames traditionally were used on royal or aristocratic family portraits to underscore the family's continuity through generations as well as to legitimize its claim to power. In a departure from earlier prototypes, the Chamber's coat of arms framed by a laurel wreath was placed within the cove molding rather than above the top of the frame, perhaps to accommodate this large picture to the crowded conditions of display at the Chamber (figures 138 and 139).[4]

The frame for *The Atlantic Cable Projectors* also reflected a self-referential, historicist agenda. Its plain-cove pattern as well as the corner scallop shells (figure 140) are direct references to Grecian frames of around 1830, such as that on *Henry Wyckoff* (figure 141). Remnants of the very Atlantic cable the picture commemorates were used to create a twist molding on the frame's outside edge that would normally have been executed in wood on a neoclassical frame. These visual references to late-eighteenth- and early-nineteenth-century models may have been intended to situate this scene depicted by Huntington within the historical context of the formative years of the United States rather than the more recent past.[5]

Antebellum Frame Styles: Ancient Greece and Modern France

Most of the pre-1860 portraits in the Chamber's collection were acquired by the group after that date. Originally commissioned for the homes of the sitters or their families, these portraits came to the Chamber in frames that had been chosen for domestic rather than quasi-public spaces. Hence they reflected the two dominant styles, Grecian and French, of antebellum American interiors.[6]

The Grecian style, today more commonly called Greek Revival, was a later phase of neoclassicism that had begun in England and France in the early 1760s. By the second decade of the nineteenth century, American architecture and decorative arts in this style were typified by references to Greek and Roman

FIGURE 139
Frame of *The Atlantic Cable Projectors*,
detail showing the Chamber of
Commerce coat of arms.

FIGURE 140
Frame of *The Atlantic Cable Projectors*,
detail showing a corner.

prototypes, large-scale forms, sculptural ornament, and a relatively austere sensibility. Frames in the Grecian style were composed of moldings taken from classical architecture, most prominently the cove, or cavetto, molding. Ornament tended to be limited to stylized shell or foliage forms placed in the corners and was derived from ancient monuments as well as metalwork or ceramics. A superlative example of a Grecian frame is found on John Wesley Jarvis's *Henry Wyckoff* (see figure 141). The visual and textural complexity of this frame suggests that it was made about twenty years later than the portrait. The carved wood corner ornaments extend over the outside edges of the corners, adding curvilinear elements to the rectangular form. Sand was applied on the flat molding outside the cove, adjacent to the sight edge, and in the corner shells,

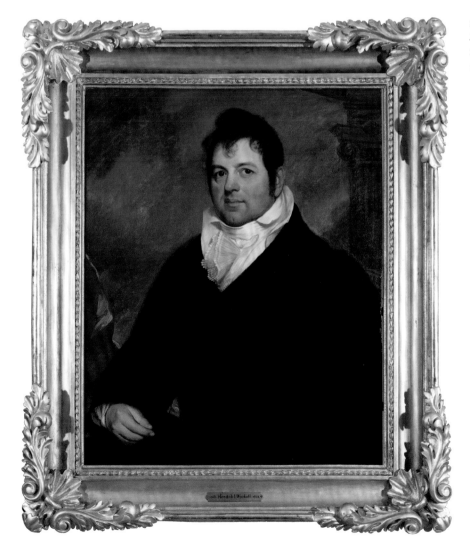

FIGURE 141
John Wesley Jarvis, *Henry I. Wyckoff*, 1809. Oil on canvas, 33 × 27 in. (Credit Suisse, New York)

creating not only textural variety but also areas of "dead" (matte) gilding to contrast to the burnished moldings.[7]

The rival style to Grecian in the United States during the second quarter of the nineteenth century was variously known as Modern French or Louis Quatorze. Andrew Jackson Downing observed in 1850: "There is, at the present moment, almost a mania in the cities for expensive French furniture and decorations." Although many of the craftsmen working in this style in New York were French émigrés, it was equally popular in England, where French-inspired frames were associated with the artist Sir Thomas Lawrence; the term "Lawrence frames" was used then and now to describe English frames based on models from the Louis XIV, Régence, and Louis XV periods. Early examples

FIGURE 142
Harrison Plummer, *Samuel Marsh*, n.d.
Oil on canvas, 30 × 25 in.
(New York State Museum, Albany)

FIGURE 143
George A. Baker, *Abiel Abbot Low*, 1864.
Oil on canvas, 42 × 34 in.
(Credit Suisse, New York)

FIGURE 144
Henry Inman, *Charles King*, 1843.
Oil on canvas, 30 × 25 in.
(Credit Suisse, New York)

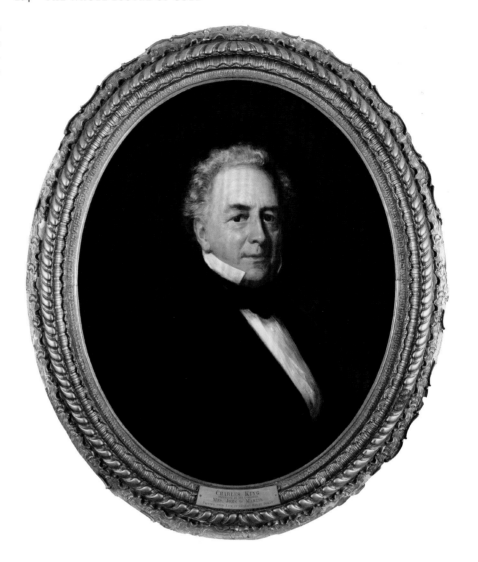

of Modern French frames in the Chamber's collection are found on Asher B. Durand's *Luman Reed* (1835), Henry Inman's *DeWitt Clinton* (1843), and Harrison Plummer's *Samuel Marsh* (undated, but probably from the 1840s [figure 142]). Their design is an accurate reproduction of a Louis XV frame, much closer to eighteenth-century prototypes than to contemporary Modern French tables or chairs that loosely incorporated cabriole legs and naturalistic ornament into their designs.[8]

The ornament on these frames was made from compo, a mixture of calcium carbonate, rosin, and glue that could be cast in molds and easily applied to wooden substrates. A form of compo known as *pastiglia* had been used on frames during the Italian Renaissance, and the delicate effects made possible through casting compo led to its revival in the neoclassical period, during the

FIGURE 145
Charles Loring Elliott, *James De Peyster Ogden*, 1855. Oil on canvas, 36 × 29 in. (Credit Suisse, New York)

later eighteenth and early nineteenth centuries. On neoclassical frames like Trumbull's *Hamilton* and Jarvis's *Wyckoff* (see figures 136 and 141), compo was used only for the repeating ornamental moldings, whereas larger corner elements or other details were executed in carved wood. By the mid-nineteenth century, however, the surfaces of many frames were entirely ornamented with compo. Its elastic qualities were ideal for achieving the naturalistic effects that were an important aspect of the rococo style. On the frame for George Baker's *Abiel Abbot Low* (figure 143), the plasticity of damp compo was exploited to drape the flowers and foliage realistically around and into the corners and centers. The frame's cavetto moldings are ornamented further with organic, vermicular patterns that were created by applying sand with a stencil prior to gilding.

Two superlative, less slavish interpretations of Louis XV models are found on Henry Inman's *Charles King* (figure 144) and Charles Loring Elliott's *James De Peyster Ogden* (figure 145). The oval frame on *King* is labeled by its maker, the New York firm Williams, Stevens, and Williams, and was made between 1854 and 1858, some ten years after the painting was executed. This dramatic frame, with the compo applied like frosting to the wood substrate, is created from a series of *rocaille* and gadroon moldings in a highly original combination. The contemporary frame on *Ogden* is likewise executed entirely in compo, achieving the sculptural quality of Louis XV originals through the use of a different material. The arched top mitigates the painting's rectilinearity, as do the corner and center devices extending across the frame to the sight edge. Like that of the *Wyckoff* frame, the surface of the *Ogden* frame is enlivened by contrasting areas of matte and burnished gilding.[9]

Later Nineteenth-Century Frame Styles: Historical Eclecticism

The frames on portraits painted after 1860, when the Chamber began collecting in earnest, raise many questions about their selection. It seems clear from documentary evidence that the organization, particularly its long-time secretary, George Wilson, exerted considerable authority over the selection of frame designs of donated portraits. In 1886, Congressman William Walter Phelps notified Wilson that his father's portrait, *John J. Phelps* by Henry Ulke, was ready to ship to "the address of the framer you suggest. . . . [I] will remind you of your promise to see him & order such a frame & inscription as you think becoming." For the *Phelps* frame, Wilson chose a Louis XIV pattern from Dawson and Company of New York. Similarly, seven years later, Thomas Waterman Wood entrusted Wilson with ordering the frame for his portrait *John James Audubon*.[10]

For other paintings by Wood, who executed twenty-five of the portraits in the collection, it is less clear whether he or the Chamber was choosing the frames. Two portraits by Wood from 1890, *Comfort Sands* and *John Caswell*, have identical Louis XIV frames; the former was commissioned by the Chamber, and the latter was donated by Charles Smith. The same situation occurred in 1903, when Wood's portraits *J. Edward Simmons* and *Admiral David G. Farragut* were framed by Dennis Dinan in the same, likewise French-inspired, pattern. This consistent use of French frames suggests that Wood favored them for his portraits and that the artist himself was a motivating force in their selection.

In other instances, the donors took control. Regarding Eastman Johnson's *Amos F. Eno*, Wilson was informed in November 1899, "It has not yet been

framed, and there has been some discussion by the family as to the kind of frame that would be suitable." In contrast to those on Wood's paintings, the frames on Johnson's portraits for the Chamber exhibit a wide range of styles: Italian baroque on *Francis Skiddy* (1887), a Rough Deals frame on *William H. Fogg* (1887), Dutch ripple molding on *David Dows* (1891), fluted cove on *James M. Constable* (1902), and Louis XV on *Alfred van Santvoord* (1902). This diversity suggests, at least in these instances, that the donors of the portraits rather than the artist or the Chamber controlled the choice of frames.[11] As these examples indicate, frames chosen for Chamber portraits painted after 1860 were made in myriad styles, reflecting the wide-ranging eclecticism in contemporary decorative arts. Still, the overwhelming majority of frames on Chamber portraits were reproductions of historical models, most notably from the eighteenth century. Although modified to suit changes in fashion, the basic types were quite apparent and intended to be recognized as references to tradition. Certain styles were more popular than others, and the Grecian and French Revival styles that had dominated antebellum frames continued to be the most popular alternatives. Examples of both are found from virtually every decade into the twentieth century.

The single most popular frame on Chamber portraits during these years was a Grecian pattern with a fluted cove. It was a reproduction, albeit in compo rather than carved wood, of a neoclassical English and French model of the 1770s and 1780s. Its classical origins undoubtedly appealed to the artists patronized by the Chamber sitters, although it is not clear that these historical associations were a significant factor in its popularity. One bill of sale in 1905 referred to it simply as "six-inch fluted." American artists who had trained in Europe, such as Daniel Huntington, may also have favored this frame because of its widespread adoption for paintings featured in such public exhibitions as the annual Paris Salon.[12]

The style of the fluted cove frame underwent subtle changes over time. Frames on portraits of past presidents that the Chamber commissioned in the mid-1860s, such as Henry Peters Gray's 1867 copy of John Singleton Copley's *Henry White*, had fluted coves with tightly spaced, narrow fluting and delicate subsidiary compo moldings and corner ornaments (figure 146). These subtle qualities contrast with the fluted cove frames made after 1880. As seen on Denis Dinan's frame for Daniel Huntington's *Cornelius Vanderbilt* (figure 147), the standard version of this later period features a high-relief outer molding, usually of laurel leaves; broad, stylized acanthus-leaf corners; and an overall effect more sculptural than delicate. Twelve additional portraits by Huntington from between 1880 and 1905 have frames of this type, as well as at least thirteen portraits by ten artists.[13]

Other frames for Chamber portraits executed after 1875 were derived from Italian and French Renaissance models. The "bunched leaf" frame on Eastman

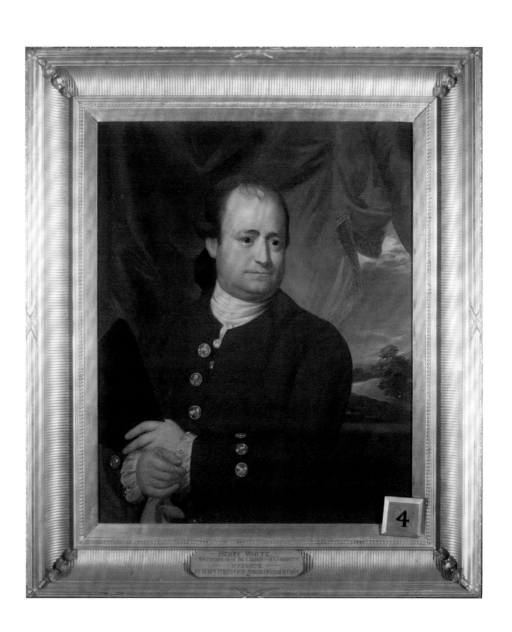

HENRY WHITE
4th President N.Y. Chamber of Commerce
1772 to 1773
By Henry Pelham (Copley Brother, Original & Only)

4

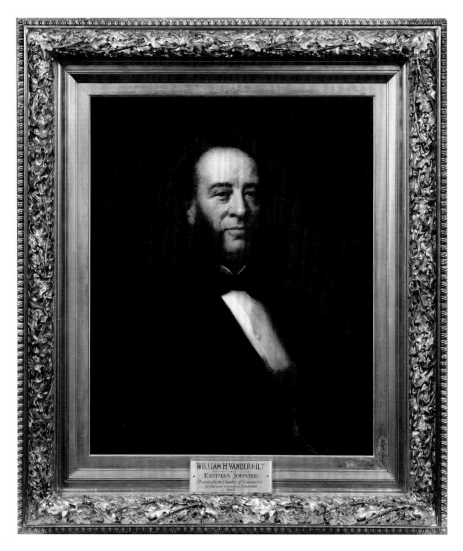

Johnson's *William H. Vanderbilt* (figure 148) imitated Italian and French patterns from the late sixteenth century, with torus moldings covered by tightly spaced leaves and vines. Another Renaissance model was the "reverse pattern" frame of the later sixteenth century, on which the usual recession of moldings inward to the picture plane was reversed, with the moldings instead projecting outward toward the center. A frame of this type was adopted for the Chamber's *Levi Morton*, painted by George Hughes (figure 149). Huntington's *James Stokes* (figure 150) had a rectilinear frame copied from Tuscan and Sienese *cassetta* (little box) prototypes of the late fifteenth and early sixteenth centuries, a model that Thomas Eakins chose around 1885 for his painting *Swimming* (also known as *The Swimming Hole*).[14]

These frames were relatively close copies of Renaissance frames, produced using compo in place of carved wood. The frame on Eastman Johnson's *Jackson*

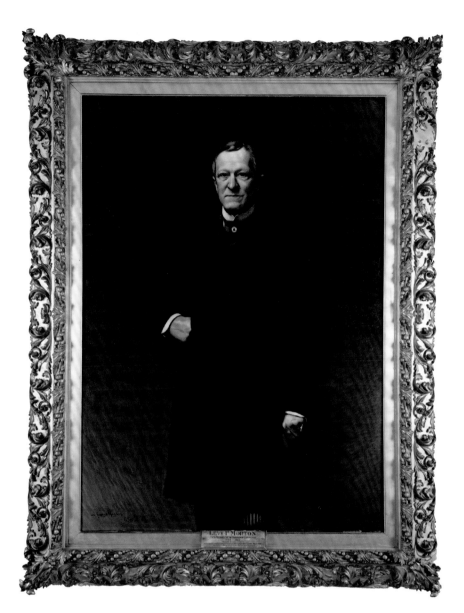

FIGURE 149
George Hughes (after Leon
Bonnat), *Levi Morton*, 1896.
Oil on canvas, 56 × 41 in.
(Credit Suisse, New York)

FIGURE 150
Daniel Huntington, *James Stokes*, 1884.
Oil on canvas, 34 × 27 in.
(New York State Museum, Albany)

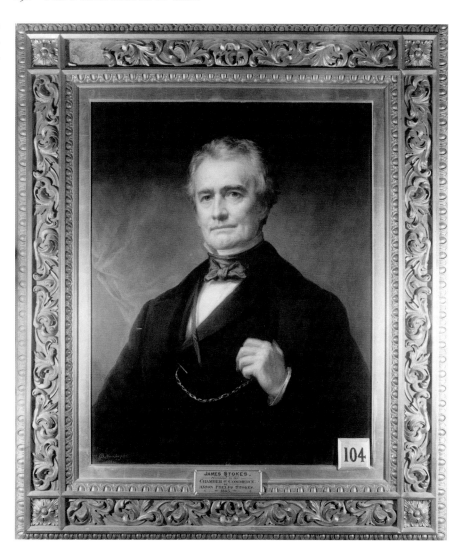

Schultz (figure 151), labeled by Thomas A. Wilmurt's Sons of New York, was a more eclectic response to Renaissance prototypes. The outer molding of the "bunched leaf" pattern encloses flats decorated with low-relief patterns derived from Islamic ornament, which was very popular in the last quarter of the nineteenth century. This low-relief ornament was executed using roller dies to create continuous strips of patterned compo ornament. Unlike cast compo, which was usually produced from molds of 12 inches or less in length, patterns created with roller dies could be executed in strips of compo of any length, thereby eliminating the need for breaks in the pattern.[15]

In the last decades of the nineteenth century, frames influenced by the Arts and Crafts movement began to appear on Chamber portraits. The easily replicated forms of compo ornament had come under attack from design reformers

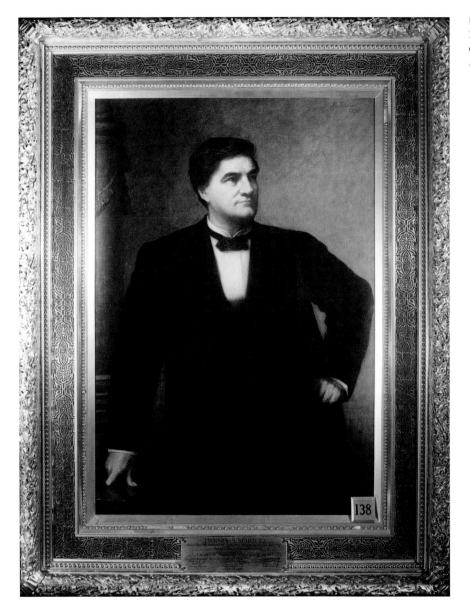

FIGURE 151
Eastman Johnson, *Jackson Schultz*, 1896.
Oil on canvas, 51¾ × 35¼ in.
(New York State Museum, Albany)

FIGURE 152

Unidentified artist (after Henry Peters
Gray, 1870), *George T. Hope*, n.d.
Oil on canvas, 34 × 27¼ in.
(New York State Museum, Albany;
photo Gavin Ashworth)

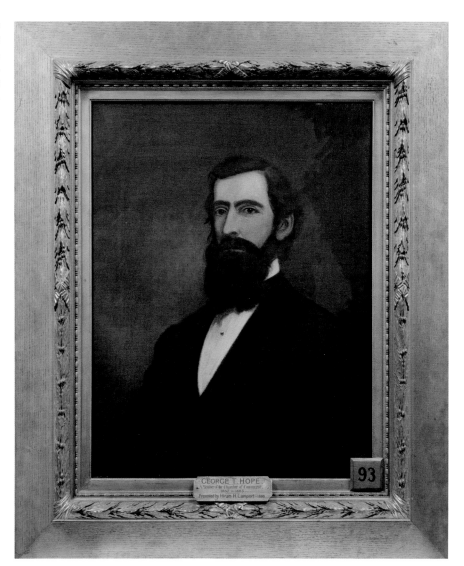

appalled by the deleterious effects of mechanical production on traditional handicrafts. Charles Eastlake formulated the seminal condemnation of compo frames in his influential book *Hints on Household Taste* (1868): "In place of carving, the wood is overlaid with a species of composition molded into wretched forms, which pass for ornament as soon as they are gilded. These are so brittle that, instead of protecting the picture, they have to be handled more carefully than the glass itself. . . . Instead of confining attention to the picture, this sort of frame distracts the eye by its fussiness." One way in which framemakers responded to such critiques was to eliminate or limit the amount of compo on the frame, thereby exposing the wood. An anonymous replica after Henry Peters Gray's *George T. Hope* (figure 152), presented to the Chamber in 1886, has a frame with gold leaf that was applied directly to its flat, quarter-sawn oak members, highlighting the grain of the wood. This technique, and the raised compo ornament around the sight edge, are features of the so-called Watts frame, named for the British painter George Frederick Watts. Originating in frames designed by painters Dante Gabriel Rossetti and Ford Maddox Brown in the 1850s, frames of this type were adopted by Watts in the following decade, and by the 1880s it was one of the most popular patterns in Great Britain. The *Hope* frame differs from the classic Watts design in its naturalistic and three-dimensional ribbon-and-laurel ornament, which is unlike the stylized, low-relief foliage found on British frames. It also lacks the outer border usually present on Watts frames.[16]

This tentative replication of the Watts pattern seems representative of the Chamber's preference for more traditional styles. Nevertheless, aspects of the Arts and Crafts aesthetic can be detected in certain Chamber frames from the twentieth century. Most notably, some framers emphasized the wood of the frame by carving or incising ornament rather than applying compo. Narrower and shallower moldings are also found on many frames of the early twentieth century, in response to critiques such as that of Edith Wharton and Ogden Codman, in *The Decoration of Houses* (1897), of the inevitable "large oil-painting in a ponderous frame."[17] The frame made by Frank H. Hamlin of D. B. Butler and Company of New York for Herman von Herkomer's *Joseph H. Choate* (figure 153) exhibits these narrow moldings, characterized by shallow depth and low-relief, partially incised carving. A 1905 frame by one of the leading Arts and Crafts framers, Herman Dudley Murphy of the Carrig-Rohane Shop of Boston, was selected for John White Alexander's *Chester A. Arthur* (figure 154). Renaissance *cassetta* frames influenced its rectilinear format, but the flat, stylized interpretations of classical laurel and bead-and-reel moldings are Murphy's original design. Alexander may have had a hand in choosing this frame, since it is in harmony with his treatment of the portrait as a two-dimensional work of art rather than a three-dimensional illusion.

FIGURE 153
Herman von Herkomer,
Joseph H. Choate, 1904.
Oil on canvas, 56¼ × 46¼ in.
(New York State Museum, Albany;
photo Gavin Ashworth)

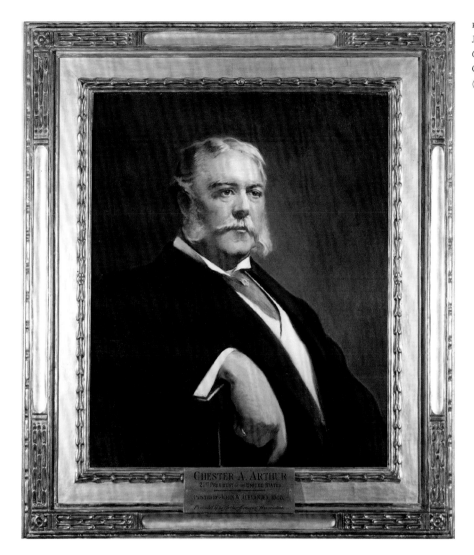

FIGURE 154
John White Alexander,
Chester A. Arthur, 1907.
Oil on canvas, 30 × 25 in.
(Credit Suisse, New York)

FIGURE 155
Alphonse Jongers, *Isidor Straus*, 1914.
Oil on canvas, 50 × 40 in.
(New York State Museum, Albany)

Frames in historical patterns on the Chamber portraits executed after about 1905 represented a smaller range of models, often in abstracted or simplified versions. Although Grecian frames remained popular, no fluted cove frames were made for any portraits dated later than 1905. The classic styles of Louis XIV, Régence, and Louis XV retained their appeal into the 1920s. The Chamber ordered a Régence-style frame for Louis Betts's *Charles L. Bernheimer* from Knoedler and Company as late as 1925. Art dealer Roland Knoedler was on the Chamber's portrait committee, so he may have influenced the choice of style. Like many of the reproduction frames made after 1905, such as the nearly identical one on Alphonse Jongers's *Isidor Straus* (figure 155), the Knoedler frame concentrated on the general effect of the design rather than attempting

to imitate the detail or quality of workmanship found on eighteenth-century models.[18]

Preference for Historicism

The Chamber's preference for frame styles of the past reflected the primacy of historicism in nineteenth-century architecture and interior furnishings. Between 1875 and 1900, when the Chamber's portrait collection experienced its greatest growth, prominent residences such as Richard Morris Hunt's French Renaissance château for William K. Vanderbilt (completed in 1882) established the mania for homes in the historical styles that Hunt and other architects had studied at the École des Beaux-Arts in Paris. The academic training of most American artists and architects stressed the adaptation of historic models to contemporary requirements, rather than the genesis of original styles.[19]

Implicit in this devotion to styles of the past was the belief in their superiority to anything that could be created in the present. As one manual for framers observed in 1906: "The old and well known heavy patterns are and will be used with more or less frequency. Indeed, certain designs are of such character and sterling merit that they cannot be improved." This re-creation of an aesthetically superior historical past was regarded as particularly beneficial for Americans, who lacked the original models. One source announced in 1883: "When an American gentleman introduces into his home the forms and colors that constitute the charm of art-treasures in the museums of the Old World, he walks on sure ground, and allies himself with the elevating and refining instrumentalities of the age. . . . But it is not likely that a multitude of the vagaries of modern decorative art are other than short lived." Moreover, this enlightenment through historicism had national as well as personal benefits. By designing buildings in historical styles, American architects—and their clients—aligned themselves with the great traditions of European civilization.[20]

The failure of many American architects and designers to respond artistically to the technological and social changes generated by industrialization may have had causes other than lack of cultural self-confidence. Writing in the late 1890s, Thorstein Veblen famously interpreted the "conspicuous consumption" of rare and costly commodities—such as historical or historicizing artworks, although he did not cite this example—as a strategy for reaffirming or acquiring prestige. Perhaps more germane to the Chamber and its members, many of whom had fostered American industrialization, is T. J. Jackson Lears's more recent interpretation of the obsession with the past as "antimodernism." By surrounding itself with premodern styles and emblems of authority, the upper

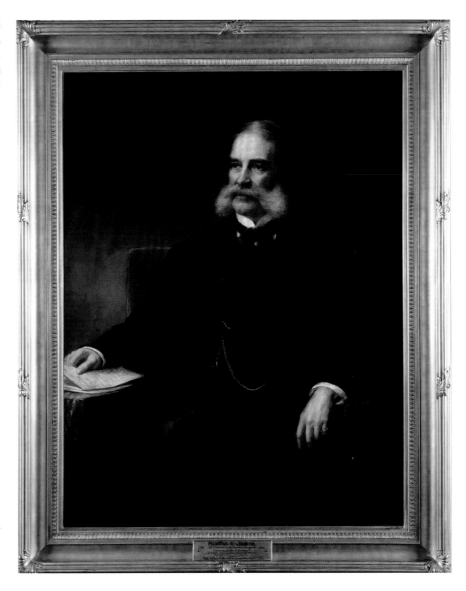

FIGURE 156

Daniel Huntington, *Morris K. Jesup*,
1896. Oil on canvas, 50¼ × 40 in.
(New York State Museum, Albany;
photo Gavin Ashworth)

class could acquire a historically grounded identity separate from that of other Americans, even as its members ushered in changes that brought the nation ever farther from the past they revered.[21]

Some historical styles appear to have possessed a particular appeal for American patrons. The ongoing popularity of the Modern French style can be interpreted as a strategy of using the styles and trappings of the absolutist ancien régime to legitimize a society that since its inception had rested on the consent of the people rather than divine right. Similarly, the appeal of Renaissance-style frames was grounded in associations with that era, deemed the precursor to the last quarter of the nineteenth century, when the tremendous wealth that accompanied industrialization generated new patronage of artists and collecting of art. In several cases, the identification of Chamber members with the Renaissance was explicit, and the frames chosen for their portraits reinforced the connection. The frame for William H. Vanderbilt's portrait was in a Renaissance style (see figure 148), in keeping with a book celebrating the completion of his Fifth Avenue house, which described its style as "Italian Renaissance . . . the edifice would not look out of place among the palazzi put up in Northern Italy" and further noted that it "comes at the right moment, prompt and opportune, when wealth is first consenting to act the Medicean part in America, to patronize the inventions, to create the arts, and to originate a form of civilization." Thomas Waterman Wood's portrait of Andrew Carnegie (1892) was similarly placed in a Renaissance frame, referencing Carnegie's Fifth Avenue mansion, which imitated Genoese palaces of the sixteenth century.[22]

America's colonial and later past was an equally compelling source for styles, reinforcing traditional Anglo-American values in the face of waves of immigration from eastern and southern Europe. A plain-cove frame, labeled by D. B. Butler and Company of New York and found on Daniel Huntington's *Morris K. Jesup* (figure 156), is explicitly related to neoclassical frames produced here during the first quarter of the nineteenth century, which similarly feature prominent, reeded outside edges and an absence of corner ornaments. Perhaps this particular style was considered appropriate for the sitter's strong antiquarian interests. Jesup ultimately bequeathed to the Chamber a Gilbert Stuart *George Washington* and the two monumental silver urns of 1824 by Thomas Fletcher and Sidney Gardiner that had belonged to DeWitt Clinton (seen flanking the president's desk in figure 160).[23]

Display

To some extent, there was a reciprocal relationship between the selection of frames for the Chamber's portraits and the way in which the portraits were

displayed. The steady popularity of frames with cove moldings from the 1860s onward undoubtedly was due at least in part to their simple rectilinearity, which greatly facilitated the dense hangings favored in the later nineteenth and early twentieth centuries. A similar preference for rectangular frames prevailed at the Royal Academy in London. The fact that the Chamber seems to have specifically selected this frame for many of its own portrait commissions suggests that this type of grouping was desired. The popularity of the fluted-cove frame followed in the tradition of simple, rectilinear frames used for the large painting collections in the picture galleries of princely European palaces, which had been started in the early seventeenth century.[24]

Images have been preserved of the Chamber's rooms in both the Underwriters' Building on William Street (occupied between 1858 and 1884 [figure 157]) and the Mutual Life Building on Nassau Street (rented by the group from 1884 to 1902 [figure 158]). In both places, the hanging was governed by the limitations of the available wall space. Portraits were arranged in close proximity, covering almost all of the wall between the chair rail and the ceiling. Smaller portraits were hung above the larger canvases. As the collection expanded, creative solutions had to be found for positioning new portraits. The author of an article in the *New York Times* noted in 1897, "With the pictures the walls of the rooms are covered, and many others stand about on easels, the wall space not being sufficient to accommodate them all."[25] A view of the meeting room published in 1901 shows additional portraits hanging somewhat precariously on a free-standing pier in the middle of the room (figure 159).

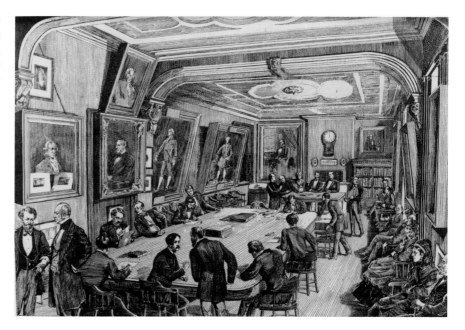

FIGURE 157
"Chamber of Commerce Meeting Room, Underwriters' Building, William Street." (From *New York Daily Graphic*, November 11, 1874)

FIGURE 158
"Interior of the New York Chamber of Commerce." (From *New York Times*, January 24, 1897)

FIGURE 159
Meeting room of the Chamber of Commerce in the Mutual Life Insurance Company Building, Nassau Street. (From *Munsey's Magazine*, October 1901)

In both the William Street and the Nassau Street locations, the arrangement was governed to some extent by the size of the portraits. However, certain categories of individuals occupied specific positions: portraits of early presidents were placed on the wall behind the president's seat or desk (at Nassau Street, portraits of past presidents were to an extent joined by those of other individuals), and *The Atlantic Cable Projectors* held the place of honor opposite the president's desk (see figure 158). At Nassau Street, the prime fireplace wall of the Committee Room featured portraits of political figures (*Cadwallader Colden* and honorary members *John Sherman*, *John D. Jones*, and *Enoch Fancher*) in the most prominent locations. Particularly by the end of the Chamber's occupancy, the portraits intruded into so much of the space of the Nassau Street rooms that they must have created a very immediate presence of departed members that paralleled the current meetings.

The Great Hall of the Chamber's 1902 building on Liberty Street was designed for the specific purpose of displaying a large number of the Chamber's portraits (figures 160–162). Each of its windowless walls was hung following the same pattern: a full-length portrait in the center, with larger three-quarter-lengths flanking it on the lowest register and the far ends, and smaller portraits filling in the remaining space. This design used larger portraits to anchor the arrangement, with the visual emphasis decidedly on the wall's lowest register, thereby avoiding the "top-heavy" appearance that framing guides cautioned against. Unlike most painting collections exhibited in private homes or public galleries, however, the Chamber's portraits did not offer much variety in size and shape, so the more complex patterns of shapes achieved elsewhere were not possible. The Chamber also departed from convention by consistently placing the larger portraits on the lower register of the wall, whereas such picture galleries as those of Chamber members Charles S. Smith, A. T. Stewart, and William H. Vanderbilt tended to do the opposite, displaying the larger pictures above the smaller, apparently prioritizing the legibility of more diminutively scaled compositions over the weighty appearance such arrangements produced (figure 163).[26]

As in earlier locations, the Chamber's portraits in the Great Hall were hung together in very close proximity, usually covering most of the available wall space up to the cornice. Although such a practice might seem a pragmatic solution to the group's own needs, a majority of public and private installations of the period 1875 to 1900 did the same. Contemporary art critics and authors of domestic advice literature condemned both the density of the presentation and the practice of hanging some pictures above eye level. "No picture ought to be hung higher than the height of the average human eye," wrote Laura C. Holloway in 1888. And writing later, in 1902, Edith Wharton and Ogden Codman observed: "It is . . . important to avoid hanging pictures or prints too close to each other. Not only do the colors clash, but the different designs of the frames,

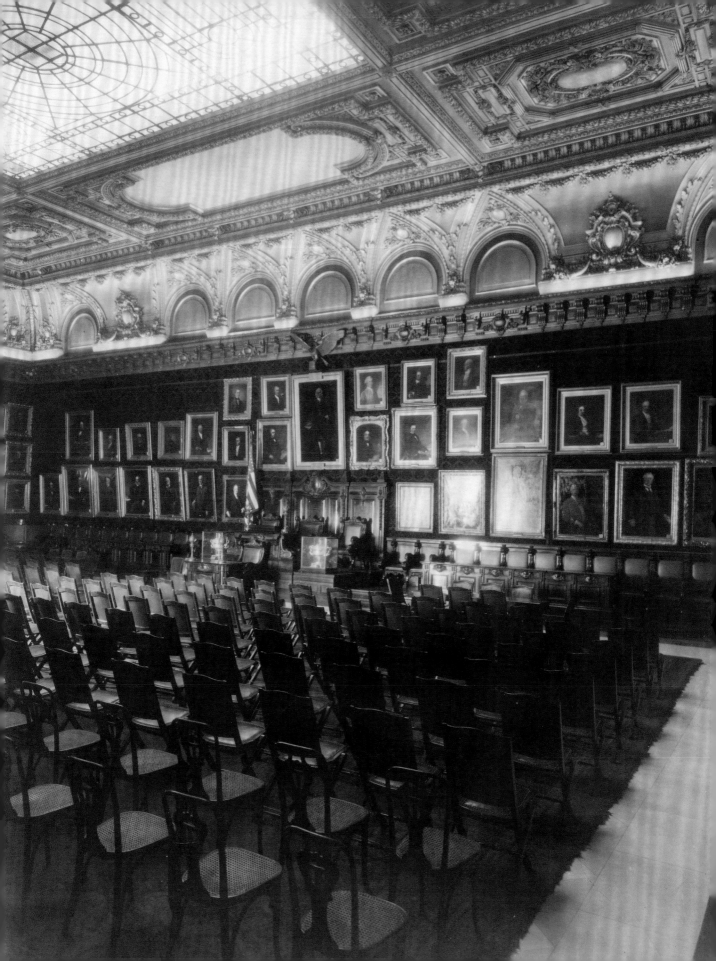

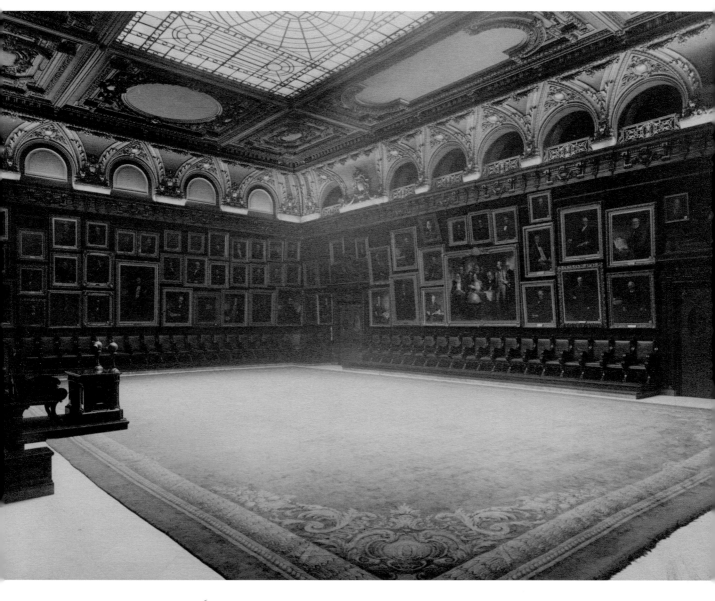

FIGURE 161
Great Hall, south and west walls, New
York Chamber of Commerce Building.
(New York Chamber of Commerce
Archives, Columbia University Rare
Book and Manuscript Library)

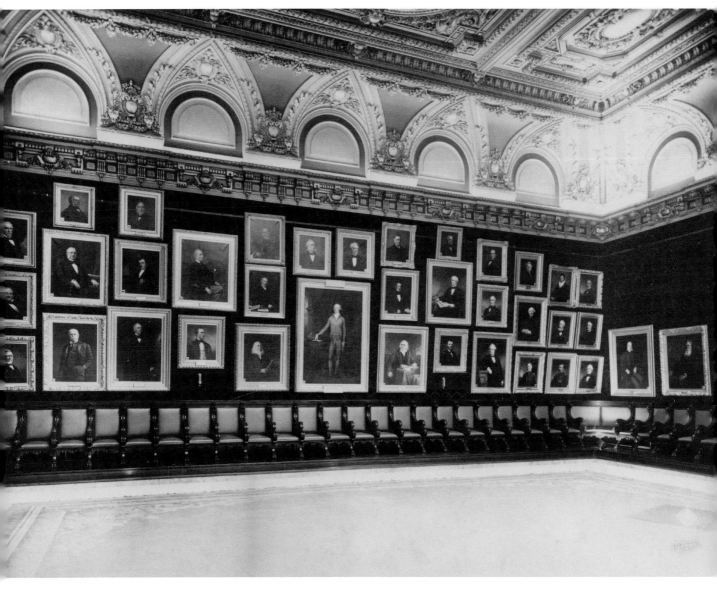

FIGURE 162
Great Hall, north wall, New York
Chamber of Commerce Building.
(New York Chamber of Commerce
Archives, Columbia University Rare
Book and Manuscript Library)

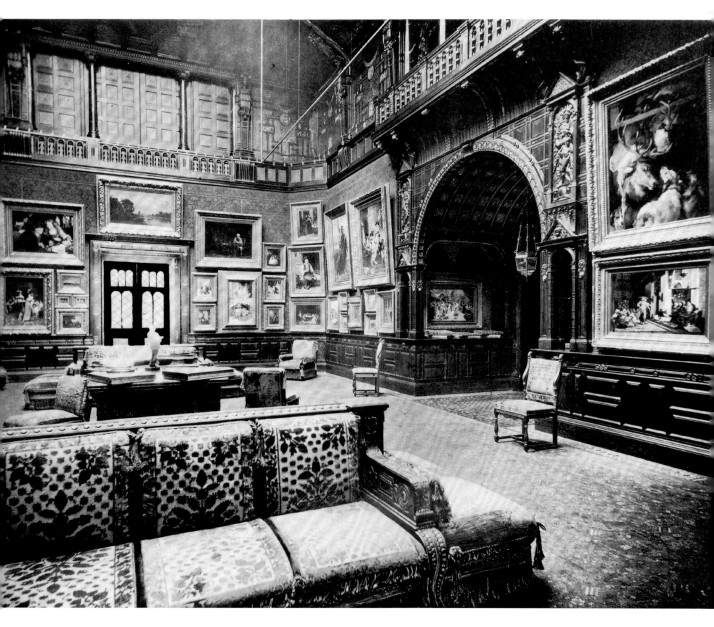

FIGURE 163
Picture gallery of William H.
Vanderbilt, New York. (From
G. W. Sheldon, *Artistic Houses*
[New York: Appleton, 1883–1884])

some of which may be heavy, with deeply recessed moldings, while others are flat and carved in low relief, produce an equally discordant impression."[27]

Because the Chamber's portraits were not viewed primarily as an art collection, however, their hanging was reflective of other agendas. The arrangement of portraits in the Great Hall in particular comprised a series of deliberate groupings of categories. Although there unquestionably had been political ramifications to the size of specific portraits and their positions on the walls at William and Nassau Streets, these were never as legible until the creation of the Great Hall. There, the east wall (see figure 160), in front of which the president's desk was situated, was reserved exclusively for images of past presidents, with the exception of the centrally placed, full-length portrait of Cadwallader Colden, who as lieutenant governor of New York Colony had approved the Chamber's original charter. On the west wall (see figure 161), facing the presidential portraits in the same arrangement as at Nassau Street, was *The Atlantic Cable Projectors*. It was flanked by portraits of vice presidents, appropriately opposite the images of the Chamber presidents. On this wall, the formal device of placing the largest portraits at the bottom permitted the vice-presidential portraits to occupy the lowest, hence most visible and prestigious, register, whereas all but two of the smaller images above them were of regular or honorary members.

The north and south walls originally had at their centers full-length portraits of secretaries of the Treasury (*Alexander Hamilton* and *John Sherman*, respectively), but flanking them were somewhat different selections of individuals. The north wall (see figure 162) emphasized national political and military figures: *Albert A. Gallatin*, another Secretary of the Treasury, to *Hamilton*'s immediate right, and the Civil War heroes *David Farragut*, *Philip Sheridan*, *William T. Sherman*, and *Ulysses S. Grant* all hung in the place of honor on the bottom register, even though these four portraits were smaller, bust-length images. The south wall (see figure 161) featured groups of paintings that emphasized important dynastic relationships in New York business: portraits of patriarchs and scions of the Astor, Brown, Vanderbilt, Schwab, and Seligman families, many of them in matching frames to reinforce the sitters' relationships.

The visual association of portraits of Chamber members with political, military, and other distinguished citizens followed a long tradition in Anglo-American institutions. The best studied of these are the arrangements of family portraits in British country houses, which endeavored to underscore dynastic continuity as well as the political alliances to which the family owed their wealth or power. Lesser known but more significant as a prototype for the Chamber collection are British civic collections of portraits, such as those at the Livery Companies of the City of London, which similarly mixed portraits of masters, wardens, and members of these mercantile associations with images

of monarchs and other national figures, visually reinforcing the ideology that the corporate body derived its authority from the monarchy.[28]

In the United States, and specifically in New York, similar portrait collections were assembled both privately and institutionally for the related purposes of creating a historical pedigree for a newly established nation. The most significant model for the Chamber's portraits was the collection assembled by the city of New York, first intended for Federal Hall and subsequently expanded in the 1811 City Hall, where images of New York politicians were grouped with national military heroes such as the Marquis de Lafayette from the Revolutionary War, Stephen Decatur and Oliver Perry from the War of 1812, and, later, George McClellan from the Civil War. As noted earlier, the Chamber's *Hamilton* portrait was displayed with this collection for a time in the early nineteenth century, and the portraits that the Chamber commissioned of military heroes from the Civil War may have been a specific response to similar portraits commissioned at that time for City Hall. Moreover, the somewhat idiosyncratic hangings adopted by the Chamber closely followed those in the Governor's Room at City Hall, in which the bust-length portraits were consistently placed above the full-length images throughout the nineteenth century (see figure 137). The deliberate and prominent inclusion of these portraits as part of City Hall's permanent architecture must have been intended to impress visitors with the city's distinguished role in American history. On another level, however, the portraits also communicate a certain anxiety about the historical legitimacy of democratic government, as opposed to the long tradition of monarchies.[29]

The Chamber's portrait collection, particularly as installed in the Great Hall in 1902, seems likewise to have reflected an anxiety about its history. By self-consciously situating its members within the company of national figures, the Chamber created its own historical context, which in turn legitimized the organization. T. J. Jackson Lears commented on the popularity of genealogy and its establishment of links to the early American past, noting that it provided the upper class with "emblems of unity and exclusiveness." Moreover, the presence of so many disparate frame styles, particularly so many with specific historical associations, may have been intended to provide a metaphorical, overarching historical "frame" for the portraits. Although the majority of the Chamber's sitters looked relatively similar, and the paintings themselves were, by and large, executed over the course of only a century or so, the different frame styles conjured a much larger historical context for the collection—indeed, if the styles were read literally, across many historical epochs. The fact that the Chamber never adopted a strictly uniform frame for even those portraits it commissioned, or discarded frames such as that on *James De Peyster Ogden* (see figure 145) that were visually dissimilar to the majority, reinforces this supposition. A similar strategy was adopted by the architect Isaac Scott for the

Chicago home of John and Frances Glessner, in which a variety of frame designs were deliberately created for one commission.[30]

Gilded Frames for a Gilded Age

Despite their myriad styles, one characteristic united nearly all the frames assembled in the Great Hall: their entire surface was covered with gold leaf. There were several reasons for the Chamber's preference for gilded frames. From the seventeenth century onward, there was near-unanimous agreement among artists and connoisseurs that gilded frames provided the best complement to the variety of colors in a painting. As the design reformer Charles Locke Eastlake observed in 1868, "Gilding on a picture-frame is not only justifiable by way of ornament, but is much to be recommended as a foil or neutral ground for enhancing the value of color." British artists as varied as Joshua Reynolds, J. M. W. Turner, and Thomas Lawrence stated their preference for gilded frames, particularly for public display, and in 1847 the Royal Academy established the regulation that "None but gold frames can be admitted" to its annual exhibitions, a rule that remained in effect until 1920. Although neither the National Academy of Design in New York nor the Pennsylvania Academy of the Fine Arts in Philadelphia apparently adopted the same regulation, Americans during the last quarter of the nineteenth century wholeheartedly accepted this premise. "An oil painting, chromo, or colored engraving looks best with gilding about it, and the brighter and more ornamental the frame, so far as consistent with the surroundings, the better," wrote the authors of one popular advice book, *Household Elegancies* (1877). Thirty years later, the 1906 framer's manual observed: "It is the opinion of almost all dealers in art, that oil paintings require gold frames.... Nothing used for framing, generally speaking, will have such a happy effect upon the varied tones and effects of light and shade and color as gold."[31]

The preference for gilded frames in nineteenth-century America went beyond aesthetic concerns, however, and drew on subtle metaphorical strategies. Gold, a scarce metal that does not oxidize in contact with the atmosphere, has served almost every human culture to which it has been available as both an indicator and a metaphor of the highest worth and of permanence. Gilded frames reinforced the preciousness and significance of the paintings they surrounded. As the framer's manual informed its readers: "In framing an oil painting you have under consideration the highest expression of the original in art, and ... the end sought is the proper setting of a gem.... It is eminently proper to connect articles of great value with something that expresses the same quality." Gilded frames, moreover, marked a line of demarcation between

the everyday world and the elevated realm of art. An 1876 publication by an art store declared, "It is a sort of boundary, separating the work of art within from the matter-of-fact world without." Henry James used this idea for a passage in his novel *The Ambassadors* (1903), describing the "oblong gilt frame" that enclosed and set apart the ideal world of a painting that the novel's protagonist, Lewis Strether, was unable to acquire.[32]

During the antebellum period, most writers interpreted gilding as imparting the qualities of gold—permanence and intrinsic worth—to whatever object it had been applied. In 1840, Edgar Allan Poe noted in a description of paintings in an interior, "Their [the frames'] profuse gilding gives them the whole lustre of gold." By the last quarter of the nineteenth century, however, a negative reaction had set in among some critics to what was perceived as an indiscriminate use of gilding to mask shoddy construction and poor materials, specifically compo. Instead of partaking of the "whole lustre of gold," gilded compo was interpreted as inherently dishonest. Eastlake spoke of "a gilt frame, or, to speak more correctly, a wooden frame plastered over with composition to imitate carving of a most extravagant kind, and then gilded—a bad style of work, even if the design were tolerable." American advice literature took up Eastlake's objections, and by 1909 one book reported an end of gilding's popularity: "Heavy and elaborate moldings with intricate designs made of putty and covered with gold paint . . . are much less seen than formerly."[33]

Implicit in this critique of gilded frames as meretricious productions was the idea that their use could also be suspect. Gilded frames could be interpreted as not simply reinforcing but actually conferring status and significance on paintings and, by extension, on the subjects of those paintings as well. In 1891, the critic William Lewis Fraser wrote:

> [T]he painter's understanding of the advantage to be gained by a good frame is perhaps, after all, more the artist's love for the symphonic tone of the gold than anything else. The dealer, however, understands not only this value, but also the effect to be produced on the expectant purchaser by the twists and curves of the carving, the play of light and shade of the gilding, and the general effect of a mass of suggested costliness as implied by so much gold, even when that gold is but a cobweb surface on plaster. . . . Here is a gorgeous dress. Surely a thing which is worthy of so much costly decking out . . . must have great value in itself.[34]

If gilding could be used to cover compo and make it look like carved wood, perhaps it followed that a gilded frame could be used to elevate an undistinguished painting (or the subject of that painting) into the realm of art. Henry James offered a subtle depiction of such a situation in *The American* (1877), when Monsieur Nioche delivers to Christopher Newman the copy of a Madonna

in the Louvre: "It had been endued with a layer of varnish an inch thick, and its frame, of an elaborate pattern, was at least a foot wide. It glittered and twinkled in the morning light, and looked, to Newman's eyes, wonderfully splendid and precious." The frame in this story costs half as much as the painting—an absurdly overpriced daub by Nioche's coquettish and immoral daughter—and thus becomes part of the attempt to fleece Newman.[35]

Gilded wood could also be interpreted as inappropriate to American life. Andrew Jackson Downing had cautioned in 1850, "Persons of good taste should not indulge in . . . extraordinary display of gilding, mirrors, and decoration" because of their association with "the palaces of royalty or the nobility, as abroad." In *The Potiphar Papers* (1854), George Curtis observed, "The fever of display has consumed comfort. . . . We could well spare a little gilt upon the walls, for more cleanliness upon the public table." It may also have been considered inappropriate for masculine environments such as the Chamber. At the Seventh Regiment Armory in New York, for example, the portraits of distinguished military veterans in the Board of Officers Room, which was redecorated by Herter Brothers during 1879 and 1880, were given simple frames of dark wood.[36]

Despite these critiques, the sitters and artists of the Chamber's portraits never wavered in their preference for gilded compo frames. In part, this may have had to do with the nature of the formal, semi-public display in the Chamber's Great Hall, where gilded frames were seen as more appropriate than they would be in domestic settings. A description of the drawing room in Henry Wadsworth Longfellow's home noted: "The picture is set in a massive burnished frame, and the effect would be oppressive in another room, but is in admirable harmony with this state apartment."[37] Moreover, the preference for gilded compo frames was part of the aesthetic conservatism of the portrait collection in general. Critiques of framing practices such as those followed by the Chamber came primarily from design reformers like Eastlake or aesthetes like James, rather than from the Royal Academy or other mainstream institutions. The Chamber's use of gilded fames could also be interpreted as a deliberate attempt to endow the painted images—themselves idealized representations that masked the subjects' less attractive features—with the "whole lustre of gold." Surrounding portraits of men of commerce, many of whom worked in banking or finance, gold frames not only enhanced these sober images but endowed them with a metaphorical frame of their real worth.

Although conservative, the Chamber's appreciation for gilded frames in historical styles survived as a tradition long after such frames had disappeared under the force of modernist critiques. This preference insulated the Chamber's collection from the more drastic solutions of removal and replacement undertaken in many museums and other collections in the early twentieth century. Recent studies of American and European frames have begun to reevaluate the achievements of the later nineteenth century, and some art museums have

begun to seek period frames for their now inappropriately reframed paintings. The Chamber's portrait collection is a fortunate exception to this cycle, and allows a richer understanding of the important role played by these historically styled, gilded frames in the presentation of individual and collective identities.

NOTES

1. Averts Cutler, *Hints on Art Matters* (New Haven, Conn.: Cutler's Fine Art Store, 1876), 23; Thomas W. Wood to George Wilson, April 19, 1883, New York Chamber of Commerce Collection Curatorial Files, New York State Museum, Albany [hereafter, NYCC Curatorial Files]. For the images of American artists, see Annette Blaugrund, "On the Framing of Pictures," in *The Gilded Edge: The Art of the Frame*, ed. Eli Wilner (San Francisco: Chronicle Books, 2000), 18–22.

2. For a discussion of this type of frame, see W. H. Bailey, *Defining Edges: A New Look at Picture Frames* (New York: Abrams, 2002), 59–61.

3. For the New York City Hall portraits, see *Autobiography, Reminiscences, and Letters by John Trumbull from 1756 to 1841* (New York, 1841), 245; Edith Gaines, "Portraits in New York's City Hall," *Antiques* 80 (1961): 346–349; and Edith Holzer and Harold Holzer, "Portraits in City Hall, New York," *Antiques* 110 (1976): 1030–1039. A 1983 photograph of the Governor's Room, showing the portraits in situ, is reproduced in Mary Beth Betts, *The Governor's Room, City Hall, New York* (New York: Art Commission of the City of New York, 1983), fig. 11.

4. Paul Mitchell and Lynn Roberts, *Frameworks: Form, Function, and Ornament in European Portrait Frames* (London: Paul Mitchell, 1996), 302–312; Shearer West, "Framing Hegemony: Economics, Luxury, and Family Continuity in the Country House Portrait," in *The Rhetoric of the Frame: Essays on the Boundaries of the Artwork*, ed. Paul Duro (New York: Cambridge University Press, 1996), 72; Paul Mitchell and Lynn Roberts, "Frame," in *Dictionary of Art* (New York: Grove Press, 1996), 11:372.

5. The incorporation of the cable may explain why this frame was ordered through Tiffany & Company rather than from a professional framer, as Chamber member Charles L. Tiffany had purchased 20 miles of unused cable from fellow member and Atlantic cable promoter Cyrus Field in 1858, selling much of it as souvenirs. See Charles H. Carpenter Jr. and Mary Grace Carpenter, *Tiffany Silver* (New York: Dodd, Mead, 1978), 14–15.

6. Andrew Jackson Downing, *The Architecture of Country Houses* (New York: Appleton, 1850), 412–413.

7. Other frames of this type in the Chamber collection include those on Gilbert Stuart, *George Washington* (1798), Rembrandt Peale, *Robert Ainslie* (ca. 1835), and *Thomas Dunham* (1842), by an unidentified artist.

8. Downing, *Country Houses*, 410–411. See also Catherine Hoover Voorsanger, "'Gorgeous Articles of Furniture': Cabinetmaking in the Empire City," in *Art and the Empire City: New York, 1825–1861*, ed. Catherine Hoover Voorsanger and John K. Howat (New York: Metropolitan Museum of Art, 2000), 305. For Lawrence frames, see Jacob Simon, *The Art of the Picture Frame: Artists, Patrons, and the Framing of Portraits in Britain* (London: National Portrait Gallery, 1996), 69–70. Simon distinguishes the term "Lawrence frame" from "Swept," or Louis XV–style, frame. Other sources, though, traditionally have used the former term to describe the latter—such as Ralph Edwards, *The Shorter Dictionary of English Furniture* (London: Country Life, 1964), 417–418. For Louis XV frames, see Mitchell and Roberts, *Frameworks*, pls. 155, 157–160.

9. Information on Williams, Stevens, and Williams can be found in Betty Ring, "Check List of Looking-Glass and Frame Makers and Merchants Known by Their Labels," *Antiques* 119 (1981): 1195. A more conservative oval frame in the rococo style is found on John Wollaston's *Elizabeth Willing Powel* (1758–59), reframed between 1850 and 1858 by Charles N. Robinson and Son of Philadelphia (Yale University Art Gallery, New Haven, Conn. [illustrated in David L. Barquist, "'Well Made from English Patterns': Richardson Silver for the Powel Family," *Yale University Art Gallery Bulletin*, 1993, 80]). Information on Charles N. Robinson and Son is found in Ring, "Check List," 1191.

10. William W. Phelps to George Wilson, January 20, 1886; correspondence between Thomas Waterman Wood and George Wilson, March 26 and 28, 1893; April 19, 1893, all in NYCC Curatorial Files.

11. James W. Pinchot to George Wilson, November 24, 1899, NYCC Curatorial Files. Rough Deals frames originated in England and were made of roughly hewn timber (known as rough deals), finished in imitation of gold leaf for decorative effect. For a discussion of the roles of artists and patrons in choosing frames during this period, see Annette Blaugrund, *The Tenth Street Studio Building: Artist-Entrepreneurs from the Hudson River School to the American Impressionists* (Southampton, N.Y.: Parrish Art Museum, 1997), 94–96.

12. For eighteenth-century models, see *Le cadre et le bois doré à travers les siècles* (Paris: Galerie Georges Bac, 1991), 100; and Gervase Jackson-Stops, "English Picture Frames and Their Makers," *Antiques* 133 (1988): 241, pl. VII. A Florentine mirror frame of around 1550 with similar fluted and pearl moldings is illustrated in Wilhelm von Bode, *Italian Renaissance Furniture*, trans. Mary E. Herrick (New York: Helburn, 1921), pl. 37, fig. 73. For the 1905 bill, see Dennis Dinan to the Chamber of Commerce, New York, January 27, 1905, NYCC Curatorial Files. For the later use of this frame in Europe, see Eli Wilner and Mervyn Kaufman, *American Antique Frames: Identification and Price Guide* (New York: Avon Books, 1995), 62. A contemporary French frame in this style is original to James Tissot's *Baron Aimé Seillière* (1866) (Kunsthalle, Karlsruhe, Germany [illustrated in Mitchell and Roberts,

Frameworks, pl. 231]). This style of frame was also adopted in New York during the later nineteenth century by the Century Association as the standard frame for paintings in its collection.

13. The portraits by Daniel Huntington are the original frame for *John Sherman* (1880), which was cut down after 1924; *Eugene Kelly* (1895); *William E. Dodge II* and *John D. Jones* (both 1896); *Junius Morgan*, *John Roach*, and *George Peabody* (all 1898); *Carl Schurz* and *Albert Gallatin* (both 1899); *Cornelius Vanderbilt II*, *Samuel F. B. Morse*, and *William Cullen Bryant* (all 1900); and *Hugh Wallace* (1905). Portraits by other artists with the same style frame include Julian Scott's *Preserved Fish* (1886); Eastman Johnson's *Thomas Coddington* (1886) and *James Constable* (1902); Jared Flagg's *Cornelius Vanderbilt* (1887) and *Frederick Winston* (1891); Morgan Rhees's *Jeremiah Robinson* (1888); Thomas Waterman Wood's *Jacob Lorillard* (1892), *John Dix* (1899), and *William H. Webb* (1900); Joel Allen's *Theophylact Bache* (1900); and Joseph R. DeCamp's *Daniel Fuller Appleton* (1905). Two earlier pictures also have fluted cove frames of this period: Charles Willson Peale's *Daniel Tompkins* (1820), presented and presumably reframed in 1892, and Thomas Hicks's *Pelatiah Perit* (1864), cut out and reframed in 1915.

14. For "bunched leaf" frames, see F. G. Conzen and G. Dietrich, *Bilderrahmen: Stil, Verwendung, Material* (Munich: Keyser, 1983), fig. 45; *Le cadre et le bois doré*, 44–51; Timothy G. Newbury, George Bisacca, and Laurence B. Kanter, *Italian Renaissance Frames* (New York: Metropolitan Museum of Art, 1990), cat. no. 66; and Mitchell and Roberts, *Frameworks*, 131–142. For reverse pattern frames, see Newbury, Bisacca, and Kanter, *Italian Renaissance Frames*, 96–97, fig. 76; and Nicholas Penny, *Frames* (London: National Gallery, 1997), 37. For *cassetta* frames, see Giulio Ferrari, *Il legno e la mobilia nell'arte italiana* (Milan: Ulrico Hoepli, n.d.), pl. 72; Newbery, Bisacca, and Kanter, *Italian Renaissance Frames*, 24–25, 92, cat. no. 69; and Mitchell and Roberts, *Frameworks*, 45–47. For the original frame on Eakins's *Swimming*, see Claire M. Barry, "*Swimming* by Thomas Eakins: Its Construction, Condition, and Restoration," in *Thomas Eakins and the Swimming Picture*, ed. Doreen Bolger and Sarah Cash (Fort Worth: Amon Carter Museum, 1996), 111–112, pl. 3.

15. For technological change in the frame industry, see Wilner and Kaufman, *American Antique Frames*, 96, color pl. 4.

16. Charles Locke Eastlake, *Hints on Household Taste in Furniture, Upholstery, and Other Details*, 4th ed. (1878; repr., New York: Dover, 1969), 193; Simon, *Art of the Picture Frame*, 46, 73–77, 106.

17. Edith Wharton and Ogden Codman Jr., *The Decoration of Houses* (1902; repr., New York: Norton, 1978), 45.

18. The "frame & plate glass" for the portrait of Bernheimer were purchased by the Chamber from Knoedler and Company on April 28, 1925 (check no. 96, Check Stub Ledger, NYCC Curatorial Files).

19. For the Vanderbilt house, see Paul R. Baker, *Richard Morris Hunt* (Cambridge, Mass.: MIT Press, 1980), 274–287. For academic training, see Richard W. Long-

streth, "Academic Eclecticism in American Architecture," *Winterthur Portfolio* 17 (1982): 55–82.

20. *The Picture Frame and Art Shop: Being a Collection of Hints on Buying, Selling, and Handling Pictures, Frames, Mouldings, and Picture Goods, Together with Practical Recipes for Use in the Frame Shop* (Chicago: Ford, 1906), 119–120; *Artistic Houses: Being a Series of Interior Views of a Number of the Most Beautiful and Celebrated Homes in the United States* (1883; repr., New York: Blom, 1971), 32. For the use of historical styles to situate Americans in European tradition, see Richard Guy Wilson, "Challenge and Response: Americans and the Architecture of the 1889 Exposition," in *Paris, 1889: American Artists at the Universal Exposition*, ed. Annette Blaugrund (Philadelphia: Pennsylvania Academy of the Fine Arts, 1989), 108.

21. Thorstein Veblen, *The Theory of the Leisure Class: An Economic Study of Institutions* (1899; repr., New York: Modern Library, 1931), 74–76; T. J. Jackson Lears, *No Place of Grace: Antimodernism and the Transformation of American Culture, 1880–1920* (New York: Pantheon Books, 1981), 187–188.

22. For the popularity of ancien régime styles, see Simon, *Art of the Picture Frame*, 69; Mitchell and Roberts, *Frameworks*, 348–351, pl. 273; and Jean-Marie Moulin, Kathryn B. Hiesinger, and Joseph Rishel, *The Second Empire, 1852–1870: Art in France Under Napoleon III* (Philadelphia: Philadelphia Museum of Art, 1978), esp. 74–76. For parallels to the Renaissance, see Richard Guy Wilson, Dianne H. Pilgrim, and Richard N. Murray, *The American Renaissance, 1876–1917* (New York: Brooklyn Museum, 1979), 11–12. For the Vanderbilt house, see Edward Strahan [Earl Shinn], *Mr. Vanderbilt's House and Collection* (Philadelphia: Barrie, 1883–1884), 1:4, vi.

23. One of the urns is illustrated and described in David B. Warren, Katherine S. Howe, and Michael K. Brown, *Marks of Achievement: Four Centuries of American Presentation Silver* (Houston: Museum of Fine Arts, 1987), 90–91.

24. For the Royal Academy, see Simon, *Art of the Picture Frame*, 20. For European palaces, see Mitchell and Roberts, *Frameworks*, 90–93, 262–269; and Penny, *Frames*, 39–40, 44–45.

25. "The Chamber of Commerce," *New York Times*, Magazine Supplement, January 24, 1897, 11.

26. For the Smith, Stewart, and Vanderbilt picture galleries, see Arnold Lewis, James Turner, and Steven McQuillin, *The Opulent Interiors of the Gilded Age: All 203 Photographs from "Artistic Houses"* (New York: Dover, 1987), figs. 7, 8, 51, 119, 120.

27. Laura C. Holloway, *The Hearthstone; or, Life at Home* (Chicago: Miller, 1888), 236; Wharton and Codman, *Decoration of Houses*, 45.

28. On the hanging of portraits in country houses, see Francis Russell, "The Hanging and Display of Pictures, 1700–1850," in *The Fashioning and Functioning of the British Country House*, ed. Gervase Jackson-Stops, Gordon J. Schochet, Lena Cowen Orlin, and Elisabeth Blair MacDougall, Studies in the History of Art, vol. 25 (Washington, D.C.: National Gallery of Art, 1989), 133–153; and Marcia Pointon, *Hanging the Head: Portraiture and Social Formation in Eighteenth-Century England* (New Haven, Conn.:

Yale University Press, 1993), 13–24. For civic collections, see Pointon, *Hanging the Head*, 24–27; and G. W. Whiteman, *Halls and Treasures of the City Companies* (London: Ward Lock, 1970).

29. Portraits at City Hall are illustrated in Holzer and Holzer, "City Hall," figs. 4, 5, 11, pl. VI.

30. Lears, *No Place of Grace*, 188. For the Glessner house, see Mary Alice Molloy, "Making a Home What It Is: The Frances and John Glessner Collection of Steel Engravings," *Nineteenth Century* 18 (1998): figs. 4–7; and David A. Hanks, *Isaac E. Scott: Reform Furniture in Chicago, John Jacob Glessner House* (Chicago: Chicago School of Architecture Foundation, 1974), 23.

31. Eastlake, *Hints on Household Taste*, 193. For British artists' framing preferences, see Simon, *Art of the Picture Frame*, 16–17, 20, 79; for the Royal Academy, see Jane Bayard, *Works of Splendor and Imagination: The Exhibition Watercolor, 1770–1870* (New Haven, Conn.: Yale Center for British Art, 1981), 27–31. Mrs. C. S. Jones and Henry T. Williams, *Household Elegancies: Suggestions in Household Art and Tasteful Home Decorating*, 5th ed. (New York: Williams, 1877), 100; *Picture Frame and Art Shop*, 119.

32. For gold as a metaphor of worth, see C. H. V. Sutherland, *Gold: Its Beauty, Power, and Allure*, 3rd ed. (London: Thames and Hudson, 1969), esp. 11–21; Patricia A. Raynor, "'Good as Gold' at Postal Museum," *The Grapevine*, November 1998, 5–10; and *Picture Frame and Art Shop*, 119. For gilded frames as a boundary, see Cutler, *Hints on Art Matters*, 22; and Henry James, *The Ambassadors*, ed. S. P. Rosenbaum, 2nd ed. (New York: Norton, 1994), 303–304; for similar metaphors in James, see Viola Hopkins Winner, *Henry James and the Visual Arts* (Charlottesville: University Press of Virginia, 1970), 70–77.

33. Edgar Allan Poe, "The Philosophy of Furniture," *Burton's Gentleman's Magazine and American Monthly Review*, May 1840, 245; Eastlake, *Hints on Household Taste*, 184; Sidney Morse, *Household Discoveries: An Encyclopaedia of Practical Recipes and Processes* (New York: Success Company, 1909), 55.

34. William Lewis Fraser, "Exhibition of Artists' Scraps and Sketches," *Century Illustrated Monthly Magazine*, May 1891, 96.

35. Henry James, *The American* (New York: New American Library, 1963), 43–44.

36. Downing, *Country Houses*, 411; George W. Curtis, *The Potiphar Papers* (New York: Putnam, 1854), 37–38. For an illustration of the Board of Officers Room, see Katherine S. Howe, Alice Cooney Frelinghuysen, and Catherine Hoover Voorsanger, *Herter Brothers: Furniture and Interiors for a Gilded Age* (Houston: Museum of Fine Arts, 1994), fig. 74.

37. Richard Henry Stoddard et al., *Poets' Homes: Pen and Pencil Sketches of American Poets and Their Homes* (Boston: Lothrop, 1877), 10.

MEMORY, METAPHOR, AND MEANING
IN DANIEL HUNTINGTON'S
ATLANTIC CABLE PROJECTORS

KARL KUSSEROW

One day in the autumn of 1866, Cyrus W. Field, flush with the final success of his twelve-year crusade to lay the first transatlantic telegraph cable, traveled the few blocks from his mansion on Gramercy Park to the Fifteenth Street studio of Daniel Huntington, president of the National Academy of Design and New York society's leading portraitist. Field had a commission in mind, a commemorative group portrait depicting the meeting a dozen years before at which the company that financed the cable was formed. He consulted with the artist, and the two returned to Field's home, where the meeting had taken place. A message was sent summoning Peter Cooper, also present at that initial gathering, who posed with Field in his dining room amid charts and a globe arranged to evoke the original scene, while Huntington made preparatory sketches. Plans for the portrait were discussed among surviving members of the company—transportation entrepreneur Marshall O. Roberts approved the idea, but others objected to the self-congratulatory painting and the proposal was dropped.

Nearly twenty-six years later, in the spring of 1892, an ailing Field called on Huntington again, in the course of conversation expressing his regret about the abandoned portrait project. Soon after Field's death later that year, the artist—perhaps with an eye toward renewing an important and potentially lucrative commission—related the conversation to his friend George Wilson, longtime secretary of the Chamber of Commerce and chiefly responsible for its portrait collection, to which by then Huntington had already contributed more than twenty portraits. As a result, at the October 1892 meeting of the Chamber, a resolution was adopted directing its Executive Committee "to suggest to the Chamber some plan by which an appropriate and lasting memorial to Mr. Field's great work may be procured"; in April of the following year, the Executive Committee reported back that "they recommend that arrangement be made with Mr. Daniel

Huntington, the artist, to execute a work of this character, to be displayed on the walls of the Chamber." Huntington was offered the princely sum of $10,000 (more than $250,000 in today's dollars) to execute the painting, which was presented with great fanfare at a widely reported special meeting of the Chamber in May 1895. So it was that, nearly thirty years after first proposed, and more than forty years after the event depicted, *The Atlantic Cable Projectors* (figure 164) was unveiled, billed as the accurate, life-size rendition of a long ago meeting at which the artist was not present and with which its new patron had nothing to do.[1]

The Chamber's reasons for taking over the commission seem clear enough: for decades, the Atlantic cable—fundamentally a business enterprise—was regarded as of colossal significance, analogous in the twentieth century to the first moonwalk but with far greater implications for daily life, and the years-long drama of its materialization was one of the nineteenth century's greatest spectacles (figure 165). As initial failure and tantalizing brief success culminated in ultimate realization in August 1866, there followed celebrations "such as the world has never before witnessed" and an enormous outpouring of praise for Field and his associates. Extensive, often wildly hyperbolic press coverage lionized Field, in particular, as a hero of historic proportions, and his venture was likened to the Crusades and the discovery of America. Moreover, as an American-led enterprise, the cable's success was the nation's success, which tapped directly into a long-standing affiliation between technology and American progress and identity. In such a climate, the Chamber's desire to link itself to the cable project can in part be seen as an attempt to insinuate its own stature, a function the portrait collection had long served and one similarly suggested by the group's earlier claiming of Field by making him an honorary member.[2]

The Painting

The Chamber's associative strategy in this instance appears to have worked, for it was not only the cable project at large that attracted widespread interest. Decades later, *The Atlantic Cable Projectors*, the largest painting produced in the long career of the country's leading establishment artist (Huntington was nearly eighty by the time he completed it), was a picture to be reckoned with. Huntington's portrayal of the cable project's conception and the Chamber's role as patron garnered successive articles in the *New York Times*, the second of them a lengthy, illustrated account occupying the prime position on the front page of the second section.[3]

Indeed, the attention accorded the painting was by any measure extraordinary. Despite its avowedly *retardataire*, even retrograde appearance, it received pride of place at the National Academy of Design's annual of 1897 (figure 166),

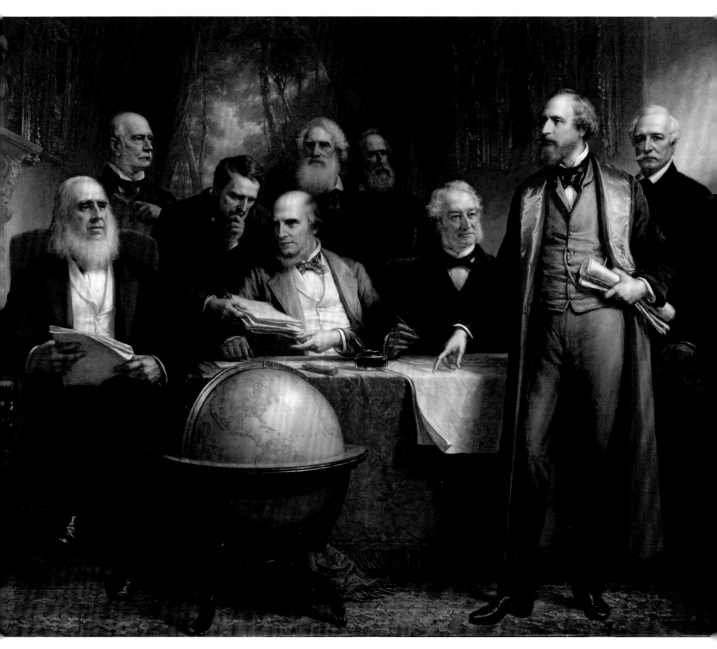

FIGURE 164
Daniel Huntington, *The Atlantic Cable Projectors*, 1895. Oil on canvas, 87 × 108¼ in. Seated (*left to right*): Peter Cooper, Marshall O. Roberts, and Moses Taylor; standing (*left to right*): David Dudley Field, Chandler White, Samuel F. B. Morse, Daniel Huntington, Cyrus Field, and Wilson G. Hunt. (New York State Museum, Albany)

FIGURE 166
Frontispiece of *Illustrated Catalogue,
72nd Annual Exhibition*, 1897 (National
Academy of Design, New York)

an anachronistic placement that caused the *Times* critic to demur, "[S]ome of the poorest canvases occupy the most conspicuous places. There is a historical value to Daniel Huntington's large photographic group of the first promoters of the Atlantic cable. . . . From the art standpoint, however, it should have occupied a less prominent place." Even so, beyond the evolving tastes of the art world, the *Projectors* subsequently appeared on the cover of magazines, was reproduced for sale as a large folio photograph (18 by 22¼ inches), and even inspired the production of Cable Cabinet cigars (figure 167). The Chamber in particular, which already had two hundred portraits, deemed the painting special, publishing a lavish hardbound catalogue at the time of the unveiling and esteeming the grand-scale canvas to be "the masterpiece of our art collection." Just why this was the case—how the picture overcame its aesthetic inertia to resonate powerfully within and beyond the Chamber of Commerce—is the subject of this essay.[4]

The painting shows the partners gathered around Field's dining-room table and engaged in planning for the project, a segment of the original cable—as marketed by Tiffany and others following the project's initial success (figure 168)—anachronistically but conspicuously placed at the center of the image. Field stands distinctively separate from the group at near right, balanced compositionally opposite by the seated Peter Cooper. The others, from left to

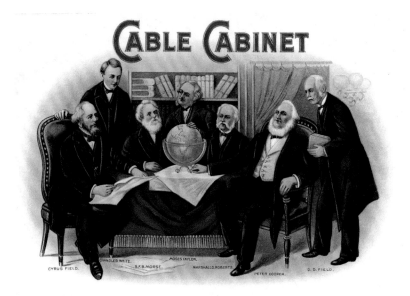

CABLE CABINET

CYRUS FIELD. CHANDLER WHITE. S. F. B. MORSE. MARSHALL O. ROBERTS. MOSES TAYLOR. PETER COOPER. D. D. FIELD.

TIFFANY & CO.,
No. 550 Broadway, New-York,
announce that they have secured the entire balance of the
ATLANTIC TELEGRAPH SUBMARINE CABLE,
now on board the
U. S. STEAM FRIGATE NIAGARA.

In order to place it within the reach of all classes, and that every family in the United States may possess a specimen of this wonderful mechanical curiosity they propose to cut the cable into pieces of four inches in length, and mount them neatly with brass ferules.

Each piece will be accompanied with a copy-righted *fac simile* certificate of

CYRUS W. FIELD, ESQ.,
that it is cut from the genuine cable. Twenty miles of it have been actually submerged and taken up from the bottom of the ocean. This will be first sold in precisely the condition in which the great cable now lies in the bed of the Atlantic.

Orders will be received from dealers and others for not less than 100 pieces at a time, at $25 per hundred. Retail price, 50 cents each.

Each order must be accompanied by the money, in funds current in New York, as it will not be possible to open accounts. A register will be kept of the orders as they are received, which will be filled in turn, without favor or partiality.

A large portion of the specimens will be ready, it is expected, for delivery within a week.

NEW-YORK, Aug. 21, 1858.

FIGURE 167
Cable Cabinet cigar box label, ca. 1895. (Atlantic-cable.com)

FIGURE 168
Tiffany & Company advertisement. (From *New York Times*, August 21, 1858; Atlantic-cable.com)

right, are David Dudley Field, Cyrus's brother and the group's legal adviser; Chandler White, an investor who died in 1856 and was replaced by Wilson G. Hunt, the marginal figure at far right; Marshall O. Roberts, seated behind the globe; telegraph inventor Samuel F. B. Morse, at center behind Roberts; Huntington himself with sketch pad in hand, farther back; and, seated in front of him, financier Moses Taylor. At upper left, a bust of Benjamin Franklin, muse of American invention, regards the group from the mantle.[5]

By including himself in the painting, and in other ways, too, Huntington has taken enormous liberties in a depiction purported to be historically correct. Although presented by both artist and patron as an image of reconstructive accuracy, the *Projectors* is anything but. In addition to Huntington's actual absence from the meeting, the extended lapses in time between that event in 1854, the initial commission and preparatory sketches of 1866, and the painting's ultimate completion in 1895 caused both the selective process of memory and broader forces of cultural change to transmute the image into a historical fiction of both intended and unintended meaning. Operating on numerous levels of signification, the painting encodes metaphors of communication, appropriately, but also rhetorical references to iconic American images, changing conceptions of masculinity and masculine virtue, expressions of Americans' complicated mother–child relationship with England, and anxieties about the vanquishment of the American wilderness through the agency of technology. The work itself can further be seen as both a symbolic pictorial summa of late-nineteenth-century epistemology and a metaphoric recapitulation of its patron.

In each of these ways, the *Projectors* engages themes relevant to the Chamber and the specific times during which the commission evolved, either by adopting positions resonant with the particular interests of the institution and its members, or by manifesting a preoccupation with the wider issues that broadly absorbed them and their peers. Revealing how the painting invokes matters of importance to its patron's constituents and in some cases directly advances their ideological positions helps to explain the extraordinary significance the painting had for the group and its milieu.

Communication Metaphors

Befitting an image concerned with communication, Huntington's picture incorporates representations of various means of transmitting knowledge and thought. In addition to the figure of Morse himself as literally the éminence grise embodiment of telegraphy, these include the artistic, symbolized by Huntington in the act of sketching; the literary, denoted by the book held by David Dudley Field; the printed, figured by the maps and papers; the written, represented by Taylor with pen in hand; the act of reading, implicit in Cooper's pose; and the interpersonal, signified by White and Roberts passing the sheaf of papers between them. This last symbol of communication—the most direct in being the only one that illustrates the actual process of sending and receiving—occurs just above the piece of cable, a synecdochic representation of the Atlantic cable, thus suggesting the role and function of the larger cable project (figure 169). Moreover, the piece of foreshortened cable is positioned so as to visually imply its movement back into the fictive space of the painting, where it supplants the papers and bridges the distance between White's and Roberts's hands, linking them together in yet another communicative act while intimating telegraphy's displacement of the older, more conventional method of communication. The cable segment further indicates the role of its referent through its relationship to the immediately adjacent objects, the globe and the inkwell, all linked in addition to their proximity by the gold highlights they share. The concatenation of the three—inkwell filled with dark blue aqueous fluid, globe oriented and highlighted to display the cable's actual route, and cable fragment positioned as if in displaced approximation of that route—suggests in symbolic, miniaturized terms the telegraphic joining of the continents enacted in reality by those in the painting.

Complementing these subtexts of communication and linkage are passages in the painting where a metaphorics of meshing or enwrapping functions to connote a related dimension of conceptions about the Atlantic cable. Contemporary discussions of the project made frequent reference to the cable's

FIGURE 169
Daniel Huntington, *The Atlantic
Cable Projectors* (detail).

ability to draw continents together in a communications network, or web, that revolutionized commerce and international relations. These sentiments find their pictorial expression in the *Projectors* in details that depict or suggest interlocking, interwoven forms. The highlight on the globe (see figure 169), located near the painting's center and commanding attention as its brightest accent, is rendered in just such a way, forming a network or grid pattern that is positioned exactly between the continents that the cable connects. Moreover, the majority of the individual lines comprising the grid are deployed so as to imply the actual direction of the Atlantic cable. Similar implications are made on a larger scale by the distinctive stand in which the globe rests, which twice completely encircles the sphere and, with its legs or supports, partially enwraps it several times more, recalling a more explicit expression of the theme in a Mathew Brady photograph of 1860 in which Field poses beside a globe while holding a section of cable wrapped around it (figure 170). And the use of a length of actual salvaged Atlantic cable as a decorative device encircling the painting's custom-designed Tiffany frame again picks up on the trope of enwrapping (see figure 140).[6]

Quotations and Sources, Pictorial and Ideological

Rather than being viewed as the transcriptive rendering of a specific historical event, the *Projectors* should be understood as evolving out of the mid-century phenomenon of the imaginary group portrait and the related interest in commemorative portraiture that arose after it, in the Centennial's historicizing wake. Beginning suddenly around 1860, as if to compensate for the actual coming apart of the nation, there appeared a spate of images with titles like *Authors of the United States* and *Merchants of America* (figure 171) in which noteworthy figures were brought together in fictive scenes of implicit unity and cohesion, usually with nationalistic themes. Remarking on the appearance of such imagery in a review of Huntington's imaginary grouping *Republican Court in the Time of Washington* (1861), a writer for the *New Path* noted, "The made-up look of the grouping of the figures, is a thing of course. It is almost unknown to American art as yet, the conceiving of a thing as it might have happened, the composition of a scene as it might have occurred." The efflorescence of this type of painting must in part have inspired Field's 1866 commission for the *Projectors*, which he knew would have to be a staged re-creation to depict simultaneously all the individuals involved and incorporate other desired features. Part group portrait, part history painting, such imaginary assemblages also opened up creative possibilities for Huntington, already practiced in the execution of such images, providing him pictorial license and ideological latitude in what he seems to have considered a capstone painting.[7]

FIGURE 170
Mathew Brady, *Cyrus Field*, 1860.
(From Isabella Field Judson,
Cyrus W. Field: His Life and Work
[New York: Harper, 1896])

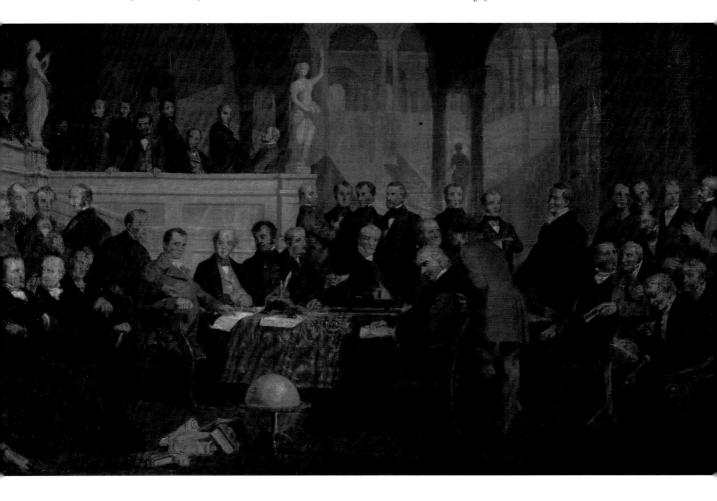

In evolving the painting's composition, Huntington turned first to an engraved vignette of the inceptive meeting in Field's dining room, which had appeared on a gold presentation box given to the entrepreneur by the city of New York following the cable's first success in 1858. Field evidently approved of this particular representation, as the identical scene was featured on an invitation he later issued to a party celebrating the twenty-fifth anniversary of the depicted meeting (figure 172). Huntington's preparatory sketch for the *Projectors* (figure 173) is clearly based on this scene, the only significant difference being the required addition of latecomer Wilson Hunt to the group. Between this mimetic preliminary sketch of around 1866 and the completed painting of 1895, however, there is a world of difference. The artist modulated his initial composition into the finished image through such major, and meaningful, changes as the addition of two sitters and the incorporation of quotes and references, art-historical and otherwise, that underscore ideological and other connections between the *Projectors* and its sources of influence. The highly

FIGURE 171
Thomas P. Rossiter, *Merchants of America* (study), 1857–ca. 1866. Oil on canvas, 14½ × 24 in. (Credit Suisse, New York [formerly collection of New York Chamber of Commerce])

traditional Huntington was just the sort of artist to include such references (and he did in other paintings), but whether they were consciously made or the unwitting result of familiarity with each of the images alluded to, their incorporation into the finished painting transforms the *Projectors* from the straightforward representation it pretended to be into something more complex and compelling, especially considering its context at the Chamber of Commerce.[8]

Huntington undoubtedly was aware of the progenitor in American art of the sort of painting the *Projectors* conjured up: a commemorative portrayal of a visionary group engaged in planning. As a college student in the 1830s already interested in art, he would have remembered from his year at Yale John Smibert's *Bermuda Group* (figure 174), memorializing Dean George Berkeley's unrealized plan to establish a missionary college in Bermuda (the painting had

FIGURE 172
Tiffany & Company, invitation to Cyrus Field's commemorative party (detail), 1878–79. (Manuscripts and Archives, Yale University Library)

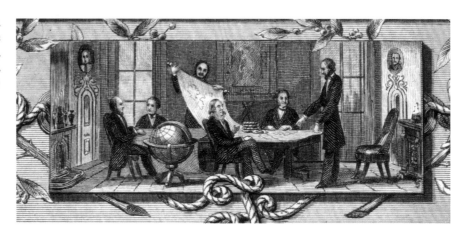

FIGURE 173
Daniel Huntington, sketch for *The Atlantic Cable Projectors*, ca. 1866. Pencil, 7⅛ × 4¾ in. (Daniel Huntington Sketchbook Collection, National Academy of Design, New York, 1986.15.45)

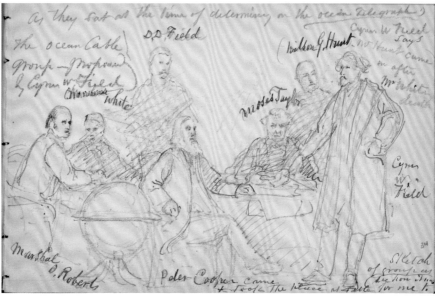

been donated to the university in 1808). And if his memory needed refreshing, he would certainly have recalled its prominent appearance in the first chronological exhibition of American art, held in 1872 at the Brooklyn Art Association. His commission in many ways called for a similar painting: a group of planners, one of them clearly the leader, shown in arrested discussion of their transatlantic project while gathered around a table covered with related documents and materials pertaining to the plan. Comparison of the preparatory sketch for the *Projectors* with the final painting indicates that Huntington adopted numerous pictorial devices from Smibert's iconic picture, including the attentive figure recording the leader's speech, and thus signifying the latter's position; the mediating figure who leans forward to compositionally link those seated around the table with those standing behind it; the nondescript landscape background, imparting a sense of timelessness to the scene; and, especially, the inclusion of the artist himself, depicted with a symbol of his profession (in *The Bermuda Group*, Smibert is the figure at left holding a rolled-up drawing). Collectively, these quotes allowed Huntington not only to suggest the artistic significance of himself and his painting, but also to imply the importance and, more particularly, the missionary, selfless zeal of its businessman subjects.[9]

An even more ideologically apt reference was Edward Savage's *Washington Family* (figure 175), widely familiar through successive print versions (one of which Rembrandt Peale described in 1858 as "known all over the United

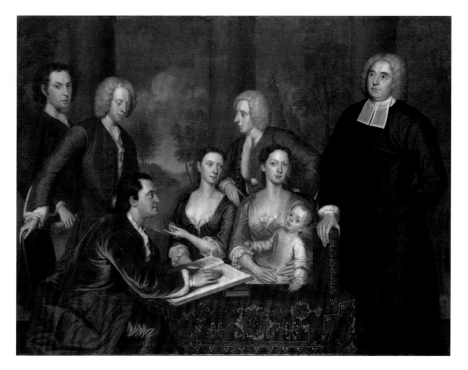

FIGURE 174
John Smibert, *The Bermuda Group*, 1729–31. Oil on canvas, 69½ × 93 in. (Yale University Art Gallery, Gift of Isaac Lothrop)

FIGURE 175
Edward Savage, *The Washington Family*, 1789–96. Oil on canvas, 84⅛ × 111¾ in. (Andrew W. Mellon Collection; image courtesy National Gallery of Art, Washington, D.C.)

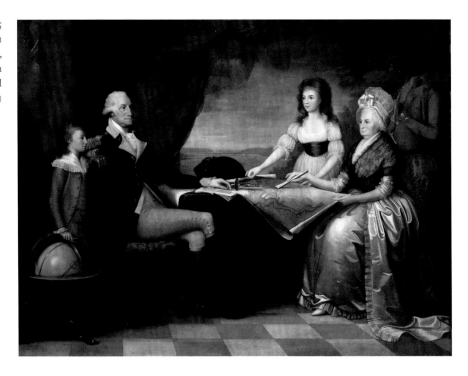

States—no engraving ever having a more extensive sale") and publicly exhibited in New York to broad press coverage at Samuel Avery's gallery in 1892 and 1893. Huntington had demonstrated in *The Republican Court* his interest in Washington iconography, and reverence for the president reached fever pitch following the centennial of his inauguration, just as the commission for the *Projectors* was revived. Both it and *The Washington Family*—in addition to their similar color scheme, near-identical dimensions, and numerous shared compositional and iconographic features—are narratively structured around a central figure's gesture of pointing to a map, in each case indicating a plan (in Savage's painting, Martha Washington refers to Pierre L'Enfant's design for the proposed capital) for the technological improvement of the existing, natural world, a realm figured in both paintings by a background vista revealed by drawn red drapes. In each image, this natural vista represents the undeveloped arena deemed waiting for the exercise of human mastery and control over space through the engineering advances abstracted in the maps and plans.[10]

Huntington's affiliation of the cable projectors with the First Family and the cable project with the construction of the nation's capital not only worked to imply the greatness of the sitters and the importance of their enterprise, but also insinuated the same rhetoric of selfless, patriotic duty in which the projectors— and later the press and the public—surrounded themselves. Their for-profit business venture, once successful, was transformed into an act of high, public-spirited

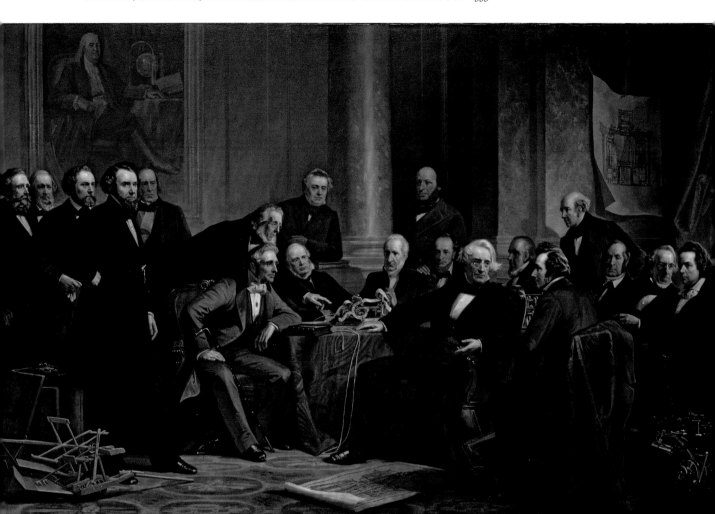

patriotism. As one speaker asserted at the painting's unveiling, "Though the most practical of businessmen, yet they could risk their money and their reputations upon a scheme which, in its beginnings, had little else to recommend it but patriotism and humanity." In referencing what was at the time among the most widely known *American* images, Huntington's painting both participated in and contributed to that heroicizing nationalistic discourse. At the Chamber of Commerce, whose members similarly recognized no conflict between their civic-minded posture and engagement in commercial affairs (indeed, just the opposite), such an idealized self-conception would have seemed both welcome and familiar.[11]

Given the country's fixation on early national heroes when Huntington composed the *Projectors*, it is perhaps not surprising that the painting delivers another, more overt reference to an American icon in the bust of Benjamin

FIGURE 176
Christian Schussele, *Men of Progress: American Inventors*, 1862. Oil on canvas, 50½ × 75 in. (National Portrait Gallery, Smithsonian Institution, Washington, D.C.; gift of the A. W. Mellon Educational and Charitable Trust)

Franklin watching over the assembled figures from the mantle. Pictorially and conceptually, Franklin occupies the same position he does in an earlier imaginary grouping, Christian Schussele's *Men of Progress: American Inventors* (figure 176), popularly known through a John Sartain print and for many years on view in New York at Cooper Union, whose founder, Peter Cooper, Huntington positioned in the same location beneath Franklin as he occupies in the Schussele grouping. In that picture, it is a painted image of Franklin that oversees the group of inventors; for his version, Huntington incorporated a rendering of Jean-Jacques Caffieri's terra-cotta bust (1777), a standard source for images of Franklin, which he would have known from a plaster copy that he helped accession into the Metropolitan Museum in his role as vice president there. Franklin's inclusion in the *Projectors* references his famous experiments in electromagnetism, and his hovering presence implies his guidance and sanction of the projectors' enterprise in the same arena, even as it serves more generally to impute national, patriotic significance to their venture. It also makes explicit the allusion to *Men of Progress*, whose centrally featured figure of Morse and his telegraph made it both a logical *and* an ideological source for Huntington, reminding viewers of the primary importance of telegraphy in the American technological pantheon while implying that the businessmen in his later painting were the new "men of progress."[12]

Huntington loaded one final, exalting reference onto his canvas in its numerous allusions to Christopher Columbus, the man then regarded, in a similarly "global" context, as among history's greatest heroes. Field himself is shown looking much like contemporary depictions of the explorer, and his pose and distinctive attire, moreover, recall that of the subject of Emanuel Leutze's *Columbus Before the Queen* (figure 177), the last in that artist's widely known series on Columbus's life. Huntington would surely have seen Leutze's painting; it was owned by New York merchant Jonathan Sturges, who like Huntington had a long history with the Chamber and whose portrait—including one for the Chamber's own collection—Huntington painted several times. Leutze's subject, drawn from Washington Irving's best-selling *The Life and Voyages of Christopher Columbus* (1828), shows the navigator delivering, as with Field before his potential supporters, what Irving describes as "an eloquent and high-minded" oratory in the presence of Spain's King Ferdinand and Queen Isabella, the financial backers of his transatlantic undertaking, making the painting for Huntington both a thematically appropriate and a rhetorically potent allusion.[13]

Still more apposite a Columbus reference is the *Projectors*'s clear relationship to another renowned painting of the discovery narrative, Robert W. Weir's *Columbus Before the Council at Salamanca* (figure 178), the second version of which was exhibited at the National Academy's annual of 1878, during Huntington's tenure as president there. Weir's painting, also based on Irving's biography of Columbus, is concerned with very much the same subject as the

Projectors, a valiant figure theatrically proposing the crossing of the Atlantic in front of a group of interested individuals assembled to pass judgment on the plan. Accordingly, Huntington's painting is strikingly similarly structured, with the standing protagonist at right gesturing toward maps and globe before figures ranged around a covered table situated parallel to the picture plane, which separates him from them.[14]

Huntington developed his composition for the *Projectors* just as the nation was celebrating the four hundredth anniversary of Columbus's voyage, and he capitalized on the explorer's current notoriety as well as his explicit affiliation with Field, who was widely viewed as the latter-day analogue to the discoverer, telegraphically reuniting Columbus's New World with the Old. As Chamber of Commerce president Abiel Abbot Low said in toasting Field at an 1866 banquet, "The discovery of America in 1492, gave to Queen Isabella of Spain 'the brightest jewel of her crown,' and made the name of Columbus immortal! In the annals of our country, 1866 will alike be memorable as the year for uniting the continents by an indissoluble bond; our fellow-citizen and honored guest being the prime mover and acknowledged leader in the work."[15]

That Field was likened to Columbus, and was lauded both in Low's toast and in Huntington's painting as the "prime mover" of the cable enterprise, is revealing of how businessmen in late-nineteenth-century America were valorized as courageous achievers, even though, like the projectors, their risk taking was of a financial, not physical, sort. A closer analogue to Columbus would have been any one of the naval engineers or ship captains who actually laid the cable, often under severely adverse conditions, but it was Field and his financial backers who were most ardently praised. Their treatment in the *Projectors* both reflected and contributed to the broader cultural apotheosis of the businessman as the new American hero. While it is unlikely that most people would have recognized many of the *Projectors*'s sources or the complex of references that produced such an effect, they nonetheless signify beyond Huntington's seemingly recondite, in some cases probably unconscious, use of them. Like the images from which they were drawn, they imparted to viewers the look of heroic figures engaged in great deeds, and that was precisely the effect he sought.[16]

A Capital(ist) Character

If Huntington's painting figured the projectors as icons of capitalism, this visual reconstruction of history received a hearty welcome at the Chamber of Commerce. When the Honorable Chauncey DePew, esteemed orator and president of the New York Central Railroad, delivered his keynote address at the special meeting of the group called for the picture's unveiling, he remarked

that the men depicted in it "commenced life without fortune or influence, with no other capital than character and brains, and won power, fame, and fortune." Of none of the projectors was this said to be more true than Cyrus Field. The son of a clergyman whose family had been in America since 1629, Field "sprang from typical New England stock," as he was often described. At age fifteen, he left home to seek his fortune, a feat accomplished so quickly that he was able to retire from business at thirty-three. His scheme for the Atlantic cable drew him back in, however, and his remarkable perseverance with it in the face of repeated personal and business travails quickly became legendary. In an era deeply enamored of stories of manly, Yankee success, he was a prime candidate for hagiographic treatment, both literary and pictorial.[17]

These two modes of adulation came together in the January 1898 issue of *Success*, a magazine describing itself as "An Up-to-Date Journal of Inspiration, Encouragement, Progress and Self-Help," whose cover featured a reproduction of the *Projectors* (figure 179). Field appears here the very paradigm of contemporary conceptions of the outstanding man. Dominant and performative of pose, spatially and sartorially distinct, virile and fortified in body, Field as depicted in the *Projectors* was the ideal choice by the magazine's editors to illustrate the "successful man" topos documented and prescribed in its pages. A comparison of his representation in the painting of 1895 with the preliminary sketch of 1866 (see figure 173) shows how Huntington made subtle, but significant, alterations in portraying the famous entrepreneur that reflect and accommodate changing constructions of idealized manhood in the years separating them.

Between the two Fields, between Civil War–era sketch and fin-de-siècle painting, several cultural transformations occurred that together produced a pervasive shift in prevailing models of masculinity. Industrialization and the rise of bureaucratized corporate capitalism caused the separation of workers from control of their labor and the movement of women into the work force, subverting long-established notions of self-determination and sexual difference. Urbanization and the closing of the frontier diminished men's sense of expansiveness and opportunity. And the broad feminization of culture—the association of women's domestic sphere with culture at large—further foreclosed traditionally male prerogatives. Thus whereas mid-century exemplary manhood could still revolve around lingering republican ideals like compassion, selflessness, and good Christian behavior, the postbellum encroachments on male authority caused a retreat from the rhetoric of such outwardly directed conduct toward an increased focus on the self. The community orientation still esteemed at mid-century—perfectly expressed by the period's imaginary portrait assemblages, as indeed by the 1859 engraved vignette on which Huntington based his initial sketch (see figure 172)—gave way to the more individuated emulatory tropes of the lone rugged cowboy, the merchant prince, and the rags-to-riches, self-made man of Horatio Alger's success narratives.[18]

FIGURE 179
Cover of *Success*, January 1898.

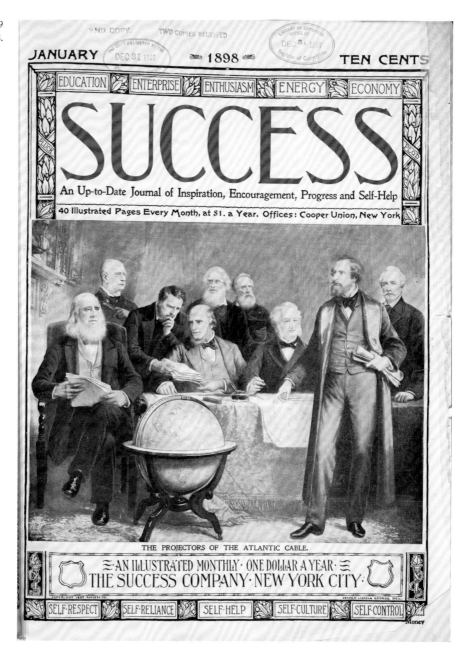

THE PROJECTORS OF THE ATLANTIC CABLE.

In 1895, Field was lionized as an exemplar of these latter types, and in the *Projectors* he has accordingly been pulled out from the crowd, separated from the other figures and spatially rendered more as a distinct individual than in Huntington's earlier sketch, where he seems truly a part of the group. By moving the seated Peter Cooper around the globe to the end of the table, the artist gave Field his own pictorial—and conceptual—space, closest to the viewer and apart from all the others (see figures 164 and 173). Similarly, by shifting the figure of project latecomer Wilson Hunt to the far edge of the composition and adding Morse and himself to it, Huntington consolidated what had been two undifferentiated clusters of sitters into one larger group, with the now meaningful exceptions of the visually marginalized Hunt and the newly prominent Field. The communal, meeting-like atmosphere of the sketch is suppressed as Field addresses the group from his own side of the table, performatively gesturing to the figures who, ranged behind the foreground in which he acts, are transformed from his peers into his audience. While the mid-century sketch depicted agency for the cable project flowing from the collective action of the group, Field alone is the hero in the finished painting.[19]

Huntington augmented Field's spatial and postural distinction by representing him as exemplary in body as well. The concentration of masculinity in the ample and solid virile form—literally, its embodiment—was one cultural response to men's contracted instrumentality at the close of the nineteenth century. As if in response to the attacks on their authority, and complementing the general turn toward the self, American men cultivated a new, Spartan conception of ideal manhood in which the present and disciplined male body served as a compensatory metaphor and illustration of the very power and control they felt themselves losing. By this definition, Field in the *Projectors* is more man than any of the others in the painting. Alone among them, his entire body is on display, and Huntington rendered it singularly robust, notwithstanding his actual insubstantial, even frail appearance in contemporary photographs (see figures 170 and 180). And although separated in age by only a few years from several of the sitters, he appears younger and more vigorous than the rest of the group, save Chandler White, whose relatively youthful face and still-brown hair signify his death at a young age, the opposite of Field's vitality. Field even seems to flaunt his embodied masculinity, opening his eye-catching red robe to reveal his torso and, in another sign of his compositional centrality, commanding the attention of Huntington, who is sketching in the background. That a businessman entrepreneur, whose success was due to cerebral and not bodily exertion, was portrayed against all evidence as the fine physical specimen Huntington conjured up for Field illustrates how, in late-nineteenth-century America, the figure of the successful capitalist was a potent enough emulatory model to co-opt broad cultural paradigms of ideal manhood, even those with which it had nothing to do. For the often all-too-flaccid men of the Chamber, such a

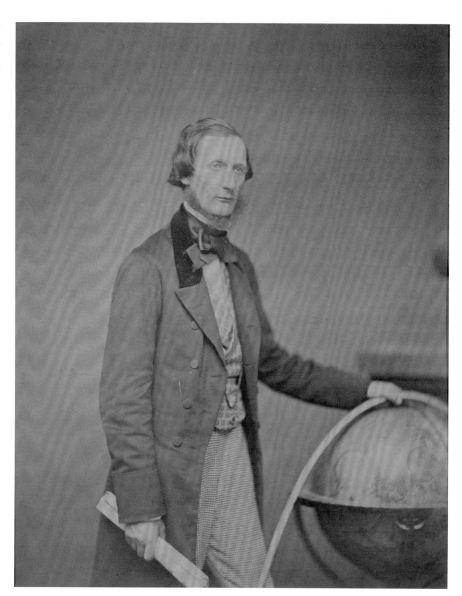

heroic construction of the virile man of business must have accorded well with their fondest self-imaginings.[20]

Chain, Cable, Cord

Field's gesture of pulling back his robe uncovers more than his midsection—it also exposes an equally substantial and unusually conspicuous watch chain, whose pronounced visibility forms a marked contrast with the delicate chain that Peter Cooper wears. Cooper's understated chain was more in keeping with contemporary taste than Field's outsize version, according to period fashion guides, one of which advised that a proper watch "is never *flashy*" and should be worn "with no useless ornament, paraded to the eye."[21] Field himself seems to have heeded this advice, as indicated by a portrait photograph in which he appears similarly dressed but wears a far less noticeable watch chain (see figure 180). The unusually thick, weighty chain depicted in the *Projectors* looks instead like the very cable that Field is shown proposing, an association—undoubtedly unconscious on Huntington's part—that is heightened by its twined, rope-like appearance, which repeats that of the nearby cable segment, as well as by its distinctive bar-shaped fob, whose enlarged ends and gold coloration make it resemble a miniaturized replication of the similarly detailed fragment of cable (figure 181). (Watch fobs made of actual segments of the Atlantic cable were in fact produced.) Extending from the area of Field's navel to an unseen pocket beneath his robe, the chain passes behind a roll of papers that Field holds in his hand, visually linking the initiator of the cable enterprise with the plans for its materialization by way of the symbolic representation of the object used to carry out the project.

FIGURE 181
Daniel Huntington, *The Atlantic Cable Projectors* (detail).

Field's watch chain also suggests an umbilical cord, an impression bolstered by the similar positioning of the painting's other, more overt representation of the cable directly in front of Marshall Roberts's navel. The *Projectors*'s incorporation of two veiled umbilical metaphors, each related to the cable, was Huntington's sublimated expression of the sort of organic and specifically bodily analogy made repeatedly throughout the late nineteenth century with reference to the Atlantic cable. Indeed, telegraphy generally, with its natural possibilities for organic representation, has been seen as responsible for—and not just participating in—the period's obsession with organicism and organic language. In this particular figuration, the *Projectors*'s embedded umbilical metaphors signal the widespread construction of America as the "child" of "mother" England, a connection symbolically "reborn" through the umbilical ocean "cord." Contemporary discussions of the cable abound in such familial, natal terms, often employed in the appropriately emblematic language of poetry. In "How Cyrus Laid the Cable," which appeared in *Harper's Weekly*, John Saxe wrote,

> Loud ring the bells—for, flashing through
> Six hundred leagues of water,
> Old mother England's benison
> Salutes her eldest daughter.

Still more suggestively, Ann Stephens's "Official Ode on the Cable," from the same publication, reads in part:

> When the sunset of yesterday flooded the west,
> Our old mother country lay far in the distance;
> But the lightning has struck!—we are close to her breast—
> That beautiful land that first gave us existence!
> We feel with a start, the quick pulse of her heart—
> And the mother and child are no longer apart.

The connotations of birth in the fourth line excerpted from Stephens's poem were more explicitly developed by Field himself, who declared at a banquet celebrating the cable's success, "I beg my countrymen to remember the ties of kindred. Blood is thicker than water. America with all her greatness has come out of the loins of England." Complementing the birth analogy was the frequent description of the cable as a cord linking the two nations together, as in John Greenleaf Whittier's "Cable Hymn":

> What saith the herald of the Lord?
> "The world's long strife is done;
> Close wedded by that mystic cord,
> Its continents are one."

And underscoring the umbilical trope, press accounts of the actual laying of the cable often described it as being payed out of the "belly" of the ship.[22]

Similar associations are raised pictorially by British artist Robert Dudley's painting *Landing the Shore End of the Atlantic Cable* (figure 182), part of a series that Field donated to the Metropolitan Museum of Art. Contracted by the *London Illustrated News*, Dudley was one of several painters who accompanied the various ships on their cable-laying voyages, documenting the enterprise. *Landing the Shore End* depicts the culminating moment when the cable was hauled from the ocean onto the beach, where it joined another line proceeding overland. In a speech delivered the year the painting was completed, Field

FIGURE 182
Robert Dudley, *Landing the Shore End of the Atlantic Cable* (large detail), 1866. Oil on canvas, 22½ × 33 in. (Image copyright © The Metropolitan Museum of Art / Art Resource, N.Y.)

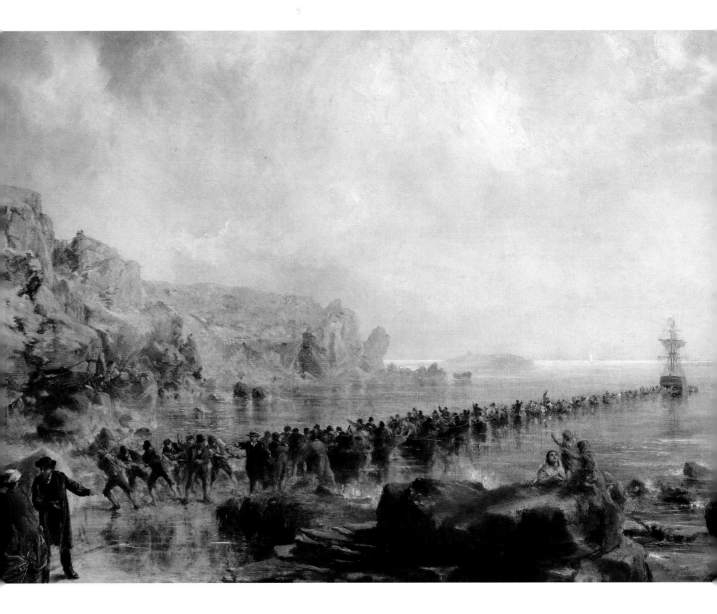

How do you keep your people connected when the workplace is the world? The AT&T Corporate Calling Card is their lifeline. It puts AT&T operators, conference calling, voice-messaging, even interpreters, within their reach. Which puts success within yours. The AT&T Corporate Calling Card is the most effective way of doing business, wherever it's being done. For more information, contact your Account Executive, visit us at www.att.com/business_traveler or call 1-800-222-0400.

It's all within your reach.

described the scene: "I see them now as they dragged the shore end up the beach at Heart's Content, hugging it in their brawny arms as if it were a shipwrecked child whom they had rescued from the dangers of the sea." His conspicuous use of the child simile is echoed in the painting's similarly incongruous inclusion, among the "brawny" sailors, of another symbolic child. Positioned atop a rocky outcropping along the rugged shore, the child faces the sea and opens his arms to the approaching cable as well as to the maternal figure represented directly below, metaphorically recapitulating both the larger theme of the painting and the persistent umbilical metaphor: America and England welcome each other

as a child greets his mother, the painting suggests, and they do so through the cable, a visually and psychologically displaced umbilical cord connecting the American child to the British mother.[23]

The enduring potency of the umbilical metaphor for connectedness by means of communications technology can be seen even today, as in a 1997 print advertisement for AT&T telephone calling cards (figure 183). Now referencing telephonic instead of telegraphic communication, the ad again draws on the resonance between the umbilical cord and wire-based communications as symbolically related means of interpersonal attachment. With the switch of a vowel, "umbilical cord" becomes "umbilical card," an affiliation emphasized in the accompanying text by reference to the card as a "lifeline" with which to stay "connected." Just as they were more than a century ago, communicative and umbilical linkages are visually conflated, the prominently visible "umbilical" telephone cord in the ad's photograph shown leading to the mouthpiece of the phone, literally enabling communication. Indeed, the entire symbolic arrangement of the image repeats that of the *Projectors*, with the telephone cord, like Field's "umbilical" watch chain, leading from the model's body through the calling card in his hand—the synecdochic representation, like the plans in Field's hand, of communication through technological means. And as if to further underscore the umbilical theme, the AT&T ad even includes the blurred image of a child.

The Price of Progress

The various symbolic passages in the *Projectors*—the umbilical connections, Field's masculinizing depiction, the ideological quotations and communications metaphors—take their places within a pictorial setting that is itself meaningful, largely because it is so odd. In keeping with other details of the painting, the space that the sitters occupy is only a vague approximation of its actual referent—Field's dining room—and the differences are likewise significant. Although Huntington was clearly capable of rendering realistic volumetric space—indeed, he showed a specific interest in it, as indicated by his careful perspective studies for *Men of Science*, another proposed imaginary grouping—in the *Projectors*, he produced an interior remarkable for its decidedly unrealistic appearance. By placing Field and most of his associates close to the picture plane, and especially through the extreme foreshortening of the strangely narrow room's receding side walls, Huntington created an unconvincing, compressed, and cramped interior space that contrasts sharply with contemporary photographs showing the actual commodious proportions of Field's mansion (figure 184). These compositional devices bring the back of the room forward and highlight another compositional oddity, the incongruous landscape background, which appears prominently through the room's inexplicably nonexistent rear wall.[24]

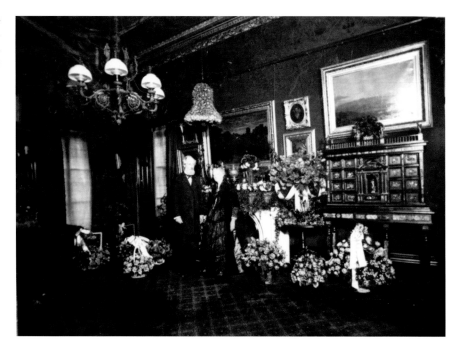

In the most literal interpretation, the forest scene depicted at the back of the image is Huntington's allusion to the location of Field's home on the northeast corner of Lexington Avenue and Twenty-first Street, overlooking Gramercy Park. The artist did produce a rough sketch of the view to the park in 1866, when the commission was first proposed. But had he intended to be literal, he would not have included the view at all, since the meeting took place in the dining room, described as behind the house's front parlor and, hence, without a view to the park. Nor, given the building's fenestration—suggested by interior photographs and the engraved vignette of 1858 (see figures 184 and 172) and articulated in an exterior drawing (figure 185)—would Huntington have made the background view look as it does in the *Projectors*, where it looms much larger than it would have had a window been there, and where the absence of mullions or framing and the presence of heavy red curtains make it look more like a stage drop than a window view. Rather, the artist seems to have been freed by the long lapse of time between the commission and the completion of the painting to render the background in a symbolic manner apart from and beyond the literal. One interpretation of such symbolism is the art-historical one mentioned earlier, wherein the background scene makes meaningful reference to two iconic American paintings, Smibert's *Bermuda Group* and Savage's *Washington Family*. But in addition to and existing alongside these meanings, the landscape background on some basic level must also signify what it in fact depicts—the natural world.[25]

In this interpretation, the distinct realm of nature is situated at the far end of a continuum leading pictorially from background to foreground while moving

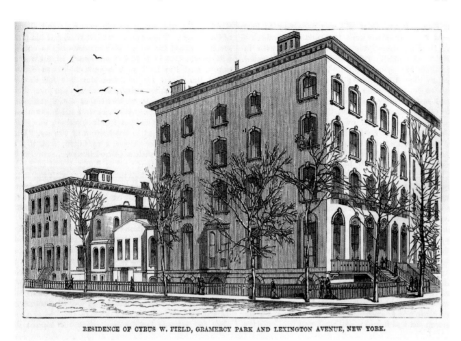

RESIDENCE OF CYRUS W. FIELD, GRAMERCY PARK AND LEXINGTON AVENUE, NEW YORK.

FIGURE 185
"Residence of Cyrus W. Field, Gramercy Park and Lexington Avenue, New York." (From *Frank Leslie's Popular Monthly*, August 1886)

conceptually through a progression of symbols and agents of the natural at the rear extreme to the technological at the fore. From the background representation of nature, the sequence proceeds through the figure of Huntington, as artist-creator both culturally and self-perceived as falling between the domains of the natural and the constructed; forward to the artist-inventor Samuel Morse, who by virtue of his intermediate spatial position and dual status as artist and scientist functions as compositional and symbolic fulcrum; on to the projectors themselves, the agents of technological advance; before culminating in the maps and globe, scientific abstractions of the natural world from which the progression begins. In this scenario, nature is constructed as farthest away, and the projectors have turned their backs to it, focusing instead on its abstract representation and their scheme to transform it, which is just what telegraphy and the Atlantic cable were seen to have done. Moreover, these agents of technological development, these "men of progress," compositionally block and conceptually deny access to that world, which appears crowded out by them, an impression bolstered by the heavy drapes that add another interdicting barrier and further evoke a sense of separation from nature. Unlike in *The Bermuda Group* and *The Washington Family*, where the landscape background seems present and accessible, in the *Projectors* the weighty folds of the drapes seem to want to close of their own accord, literally drawing the curtain on the natural world. That their coloration and triangular shape visually echo the distinctive robe worn by Cyrus Field, chief agent of the technological progress at the time widely feared as vanquishing nature, is a correlation both aesthetically and symbolically apt.

In rendering the landscape background as he did, Huntington tapped into one of late-nineteenth-century America's central debates, the dialectical contest between progress and despoliation, technology and the natural world. The simultaneous embrace and rejection of industrialized development in the postbellum era enacted the century's great animating drama between the espousal of civilization—of forward-minded capitalist materialism, of the belief in progress descended through the Protestant ethic from Calvin and the Puritans—and the Thoreauvian advocacy of wilderness and the transcendental deity of nature. The remote and seemingly receding natural realm pictured in the *Projectors*, rendered inaccessible by the agents and symbols of technological advance threatening its demise, is Huntington's sublimated expression of this debate, suggesting the price of progress.[26]

Huntington's patron was itself heavily involved in the nature versus progress debate. From 1883 on, the Chamber steadily addressed the issue, holding meetings, consulting experts, and dispatching numerous tracts on the subject, especially as it related to its parochial concerns in the Adirondack woodlands. As might be expected given its business orientation, its interest in preservation was of a utilitarian sort, at least initially. Indeed, the Chamber's early stance on conservation reflects the original pragmatic orientation of the national movement, which gained critical momentum in the 1880s. Both expressed in practical terms the same paradox of the nature–culture debate suggested by the *Projectors*—the competing desire for the development of nature as against an awareness of the fearful consequences of its mismanagement. Just such a tension was articulated by guest speaker Franklin Hough in an address to the Chamber's committee on Adirondack preservation, which begins, "The subject of forest conservation, which is now attracting so much attention in the country, owes its origin to no theoretical idea as to the importance of the woodlands in the economy of nature, but to a growing realization of their necessity, as well for the supply of materials absolutely indispensable to our wants, as from an apprehension of the injurious effects that may follow, when they are cleared away." Later, both the Chamber and preservation advocates generally would expand their narrow focus on conserving resources necessary for sustaining progress and begin to embrace aesthetic considerations as well. This was in part a political move to broaden support, made in recognition of the growing romantic, spiritual, and nationalistic appeal of the preservation movement, which had evolved from the dire practical predictions of George Perkins Marsh's influential manifesto *Man and Nature* (1864), to the more elevated concerns of individuals like John Muir, whose soulful conservation ethic derived from transcendentalist thinking.[27]

Huntington may well have had nature and its preservation on his mind while he painted the *Projectors*—he was surrounded by both. A January 1894 entry for the painting in the artist's account book notes "painted all summer on this at Mohonk," referring to the Mohonk Mountain House, a rustic resort in the Sha-

wangunk Mountains of eastern New York that Huntington frequented. While
lodging at the retreat, established in 1869 by the preservation-minded Smiley
family, he would likely have discussed and surely thought about the previous
year's legislation that created an enormous state park in the Adirondacks just to
the north, a conservation milestone considered so important that it was written
into the state constitution the following year. The creation of the park culmi-
nated a long campaign to preserve the region, considered vital by a coalition
with interests as varied as the resource-management concerns of the Chamber
and the recreational desires of artists like Huntington and Winslow Homer,
whose contemporary series of Adirondack paintings showing crudely defor-
ested woodlands also carried a veiled pro-conservation message (figure 186).[28]

In constructing the relationship between civilization and the natural world
as one of incompatibility, with the forces of progress implicated as respon-
sible for it, the *Projectors* reflects the increasingly pessimistic tenor of late-
nineteenth-century thinking on the issue. Whereas at mid-century the two
were not widely viewed as in conflict, and America's nature was considered
adequately bounteous to facilitate advance of its culture without threat to
itself, the accelerating pace of industrialization later in the century and the
unchecked consumption of natural resources resulted in the transformation
of such conceptions and the growing sense that the one advanced only at the
expense of the other. The earlier ideal is manifest visually in any number of
mid-nineteenth-century paintings that portray nature and civilization yoked
together in fulfilling the nation's destiny, probably the most ambitious of which
is Asher B. Durand's ideological *Progress* (figure 187), in which not only the
cultural and the natural peaceably coexist, but the very stuff of nature—forests
and water—is shown transfigured through technology into tools—telegraph

poles and canal—for the advancement of civilization. Contemporary portraits show a similarly synergetic relationship. In the Chamber's own *Thomas Tileston* (figure 188), a portrait by Thomas Hicks, the shipping entrepreneur appears before an expansive view of the marine activity that made his success possible, and in an 1866 portrait of William Cullen Bryant (figure 189)—a version of which was later produced for the Chamber—Huntington himself rendered the poet, journalist, and general agent of culture as literally enveloped in nature. The contrast between these mid-century portrait constructions of the nature–culture relationship and its later expression in the *Projectors* illustrates how what Hicks was able to depict as an untroubled, productive partnership between the natural world and the interests of business, technology, and progress, Huntington was compelled to portray more problematically, with nature in abeyance as a result of the disequilibrium engendered by those same pursuits.[29]

The sense of the costs of progress and technology gave rise to a diffuse late-century antimodernism, expressed in medical discourse in George Beard's influential article, "Causes of American Nervousness" (1881)—which specifically blamed the telegraph and its quickening effects on trade as "the scourges of businessmen"—and in literary terms by Mark Twain, whose *A Connecticut*

Yankee in King Arthur's Court (1889) ends with its characters taking refuge behind their technological invention, only to be destroyed by it. The corruption and demonization of the rhetoric of the technological sublime was complemented by nostalgia for a rural, agrarian, naturalized past that, once unreclaimable, was promptly sentimentalized in all manner of cultural productions. Further contributing to the malaise was the notion, advanced by Frederick Jackson Turner and others at the turn of the century, that American exceptionalism was due largely to direct experience of a wilderness now recognized as fast disappearing.[30]

Seen in the context of such grave concerns, Huntington's reorganization of reality to incorporate a natural background into the *Projectors* seems his unwitting expression of pervasive, historically specific themes. Like the symbol of the train passing through a pastoral landscape, an earlier trope in American painting of the nature–culture dialectic, the wooded backdrop in the *Projectors* is the sign of a larger entity—only now, at the end of the century, an inversion has taken place. Whereas in mid-century pictures like George Inness's *Delaware Water Gap* (figure 190), the train intrudes only slightly into the prevailing natural order, in the *Projectors* just the opposite is the case—amid fears about the

FIGURE 188
Thomas Hicks, *Thomas Tileston*, 1865. Oil on canvas, 40 × 32 in. (Credit Suisse, New York)

FIGURE 189
Daniel Huntington, *William Cullen Bryant*, 1866. Oil on canvas, 39¹⁵⁄₁₆ × 32 in. (Brooklyn Museum, 01.1507, Gift of A. Augustus Healy, Carll H. de Silver, Eugene G. Blackford, Clarence W. Seamans, Horace J. Morse, Robert B. Woodward, James R. Howe, William B. Davenport, Frank S. Jones, Abraham Abraham, and Charles A. Schieren)

end of nature, it is the trope of the natural that appears shut out by progress, technology, and civilization.

Such a transformative conception of the relationship between the two is reflected in Henry James's similar inversion of the train metaphor at the end of *The American Scene* (1907), where it stands as the antithesis of its earlier meaning as positive instrument of cultural advance. Speaking of the Pullman car, which he refers to as "the great symbolic agent" of progress, James writes, "Beauty and charm would be for me in the solitude you have ravaged, and I should owe you my grudge for every disfigurement and every violence, for every wound with which you have caused the face of the land to bleed. . . . Your pretended message of civilization is but a colossal recipe for the *creation* of arrears, and of such as can but remain forever out of hand." For James, the train and all it signifies has become a reckless, voracious trespasser in the arcadian American garden; for Huntington, that garden no longer really exists. As if to underscore this, as if to complete the process of foreclosure on the natural world already suggested in the painting, in the *Projectors*'s otherwise faithful reproduction on the cover of *Success* (see figure 179), the natural background has been completely eradicated—replaced by a blank expanse of gray. The decision of a journal describing itself as promoting "success" and "progress" to remove this single feature of the otherwise celebratory image suggests the degree to which the natural

FIGURE 190
George Inness, *Delaware Water Gap*, 1857. Oil on canvas, 32 × 52 in. A train is visible to the left of the bridge. (Collection of Max and Heidi Berry)

background carried disquieting associations, ones that had to be erased to en-sure that a painting about communication transmitted only positive signals.[31]

Epistemological Encapsulation

The messages embedded within the *Projectors* can be seen to extend even beyond the era's elemental nature–culture debate to embrace cognition itself, through the painting's allusions to the three principal modes of perceptual advance in contemporary epistemological constructions: artistic creation, divine inspiration, and scientific or technological invention. The first of these is figured in the image by the artist Huntington, self-depicted in the act of creat-ing the very painting that we as viewers now behold. Divine inspiration is signi-fied iconographically, through Chandler White's more subtle gesture of raising his left forearm and pointing his index finger upward, making a conventional reference to heaven that not only indicates his early death and departure from the group, but has traditionally served to signal the present assistance of the supernatural. And the theme of technological innovation is immanent through-out the painting, visibly and concretely in the papers, charts, and cable segment prominently arrayed about the foreground.[32]

In referencing these various types of cognition, the *Projectors* ideologically reinforces its major theme of inspired commercial invention, metaphorically rehearsing and flattering that subject by relating it to the different varieties of perceptual enlightenment. By their incorporation, they also inflect one another, enabling commentary on the relationships among the three broad modes of cognitive advance and so contributing to the ongoing discourse on the subject during the nineteenth century.

Widely accepted throughout the period was the notion of divine providence in guiding technological invention, including telegraphy. The first words publicly transmitted using that technology, after all—by Samuel Morse to the assembled members of Congress in 1844—were "What hath God wrought!" In 1868, Morse elaborated this conception of divine influence at a banquet in his honor: "If not a sparrow falls to the ground without a definite purpose in the plans of Infinite Wisdom, can the creation of an instrumentality, so vitally affecting the interests of the whole human race, have an origin less humble than the Father of every good and perfect gift?" The success of the Atlantic cable, specifically, was viewed in similarly providential terms, from its initial mid-century completion (figure 191) through the commissioning of the *Projec-tors* more than three decades later. In Field's dispatch to the Associated Press announcing the project's fulfillment, he stressed the spiritual forces felt to be at work: "By the blessing of Divine Providence it has succeeded." And in 1895,

the year the *Projectors* was unveiled, Field's brother, Supreme Court justice Stephen J. Field, wrote of Cyrus's undertaking, "[T]he mere conception was almost a Divine inspiration."[33]

As if to manifest this notion visually, the painting constructs Chandler White as the enabling conduit of the supernatural, showing him, the iconographic signifier of heavenly assistance, passing a sheaf of project-related documents along to partner Marshall Roberts and thus facilitating its development. In portraying divine aid in this way, Huntington adopted a pictorial trope in use at least since the eighteenth century, as in ecclesiastical portraits like Jacob Eicholtz's well-known *Bishop John Stark Ravenscroft* (figure 192), which similarly depicts a channel of supernatural inspiration through the linking of a raised arm and upward-pointed finger with the earthly manifestation of that otherworldly presence (in this case, a religious text). Compositionally closer to Huntington's employment of the device is Charles Willson Peale's *Self-Portrait with Angelica and a Portrait of Rachel* (figure 193), which shows the artist's aptly named daughter, Angelica, in a quite similar arrangement, making the same

FIGURE 191
"Glory to God in the Highest, and on Earth Peace, Good Will Toward Men!" (From *Harper's Weekly*, Telegraph Supplement, September 4, 1858)

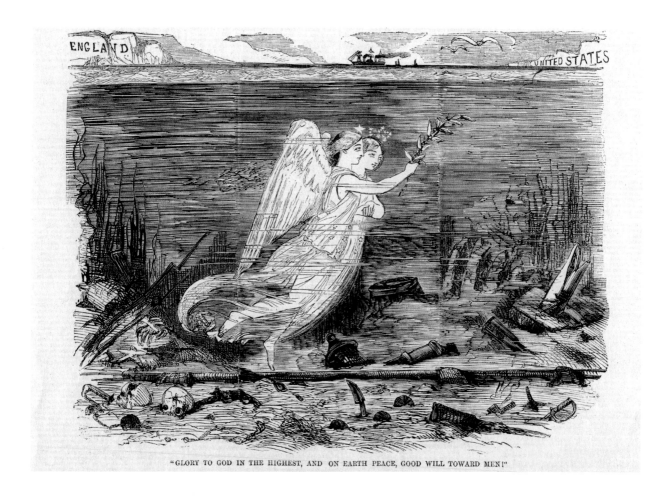

"GLORY TO GOD IN THE HIGHEST, AND ON EARTH PEACE, GOOD WILL TOWARD MEN!"

gesture that White does with her left hand while guiding the creation of her father's portrait-within-a-portrait with her right. A deeply spiritual man, Huntington, who had originally hoped to be a religious painter (and both of whose siblings were clergymen), had in fact made his reputation with an image of heavenly visitation (*Mercy's Dream* [1841], the artist's visualization of a scene from John Bunyan's *Pilgrim's Progress*), and the history paintings he later produced were very much informed by his religious beliefs. Although the cable project responded to earthly needs and concerns, his picture seems to say, ultimate credit for it and for technological advances, generally, must be accorded to a higher being, outside and "above" the picture frame.[34]

The relationship between art and technology, and the nature of innovation in the two, was more contested, with some maintaining their similarity and others insisting on an essential disparity. A pair of articles appearing in 1865 under the title "Science in Its Relations to Art" in the journal *New Path* attests to the conflicted character of the debate, arguing for their basic affinity in a publication whose Pre-Raphaelite affiliations would strongly suggest an opposite stance.

FIGURE 192
Jacob Eicholtz, *Bishop John Stark Ravenscroft*, 1830. Oil on canvas, 96 × 66½ in. (St. Mary's School, Raleigh, North Carolina)

FIGURE 193
Charles Willson Peale, *Self-Portrait with Angelica and a Portrait of Rachel*, 1782–85. Oil on canvas, 36⅛ × 27⅛ in. (Museum of Fine Arts, Houston, The Bayou Bend Collection, Gift of Miss Ima Hogg)

Over time, though, prevailing opinion seems to have regarded advances in both as ultimately the product of divine guidance and thus fundamentally alike in impetus. As might be expected from the devout Huntington, this appears to be the position taken in the *Projectors*, which shows artistic creation transpiring simultaneously and in the same space as the technological innovation enacted in the foreground. Indeed, the two are explicitly linked through the exact visual rhyme established between Huntington's sketching right hand, clearly engaged in artistic production, and Moses Taylor's pen-wielding hand, engaged in the implementation of the technological enterprise (figure 194).[35]

A key figure in the art–science debate—both generally and as constructed in the *Projectors*—was Samuel Morse, uniquely significant in both arenas. For him, artistic and technological innovation sprang equally from divine origins, uniting them at their core. As he succinctly put it at his 1868 fête, "Science and art are not opposed!" Elaborating this sentiment was Huntington himself, Morse's onetime student, who said in speaking of his teacher, "Professor Morse's world-wide fame rests, of course, on his invention of the electric telegraph; but it should be remembered that the qualities of mind which led to it were developed in the progress of his art studies. . . . Every studio is more or less a laboratory." Huntington's verbal conflation of Morse's dual creative pursuits is echoed pictorially in his posthumous portrait of his mentor (figure 195), painted in 1900 for the Chamber, in which the aged Morse is represented as a painter, seated before an easel with palette in hand, even though he had abandoned painting thirty-five years before his death. For Huntington to have rendered Morse in this way, against all evidence, suggests that for him, art and science were not incompatible opposites but rather conjoined, even interchangeable, manifestations of creative impulse. Morse's compositional placement in the *Projectors* between Huntington and Field's associates corroborates this, positioning him as a mediating figure between the realms of art and nature in the background and rational science at the fore.[36]

Huntington's self-depiction—in the fiction of the painting, making preparatory sketches for it and thereby beginning the process of creating the image viewers behold as a finished work—offers a final gloss on the creative act. Befitting a picture about invention, embedded within it is a metaphor that works spatially and conceptually to encapsulate the creative process from beginning to end, from the artist initially sketching at the rear of the painting to the viewer apprehending it, completed, from the "opposite" side. Its internal discourse thematizes the creative, inventive activity it nominally depicts, so that the painting itself functions as a metaphor for its subject, and the act of viewing it reenacts the very process it celebrates. In so incorporating his type of artistic creation into the image along with references to the sitters' divinely inspired, technological variety, Huntington politically suggests the equivalence of each while imbuing a painting about commercial pursuits with an all-encompassing

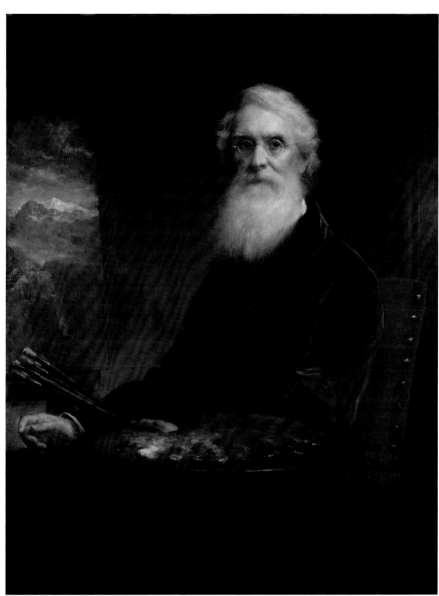

FIGURE 194
Daniel Huntington, *The Atlantic Cable
Projectors* (detail).

FIGURE 195
Daniel Huntington, *Samuel F. B. Morse*,
1900. Oil on canvas, 50¼ × 40½ in.
(New York State Museum, Albany)

scope and ambition that, in the context of the Chamber of Commerce, would have been welcome indeed.

Micro-Chamber

If the *Projectors* gestured appealingly outward in its references to the various kinds of cognitive advance, an even greater part of its attractiveness within the Chamber must have been its powerful allusions inward, toward the group itself, which lent the painting a special stature in the collection. From the moment it was commissioned for an unprecedented sum, the *Projectors* enjoyed a unique status as a signature image for the organization. Its arrival in the Chamber's rooms was commemorated in a rare "special" meeting of the group—an occasion normally reserved for more substantive concerns—to which two Supreme Court justices and the presidents of the Metropolitan Museum and the New-York Historical Society were invited. Attendees heard Chamber president Alexander E. Orr wax effusive about the painting, ending his speech by saying, "[W]e shall honor it, and we shall honor ourselves by giving to it the place of honor on our walls." Orr's eulogizing address subsequently reappeared in the elaborate catalogue that the Chamber, in another unprecedented accolade, published on the painting (figure 196). While a certain degree of attention was inevitable for a picture of its scale and scope (the *Projectors* is the Chamber's largest and only multifigure commission), the numerous gestures of identification with it suggest that it held a significance for the group that goes beyond such superficialities, one that, moreover, was sustained over time. More than twenty years after its unveiling, the official sesquicentennial history of the organization, *A Chronicle of One Hundred & Fifty Years: The Chamber of Commerce of the State of New York, 1768–1918*, devoted an entire chapter to the painting, and when the collection was first publicly exhibited in 1924, the *New York Times*'s announcement of the event highlighted it among the selected illustrations, indicating that the image's identification with its owners extended beyond their walls.[37]

Certainly part of the *Projectors*'s appeal had to do with its forthright heroicization of businessmen and celebration of the entrepreneurial spirit, which not only validated the institution, its constituency, and business interests at large but also provided prescriptive models of ideal (business)manhood for present and future members and generations. In another speech at the painting's unveiling, Chauncey DePew referred to the sitters as "splendid examples of American success," underscoring the emulatory function alluded to in the introduction to the *Projectors*'s catalogue, which concludes, "It will remind those who come after us what manner of men they were who achieved so great a work for the country and for the world."[38] In lionizing its subjects, the painting

FIGURE 196
Title page of *The Atlantic Cable Projectors: Painting by Daniel Huntington* (New York: Press of the Chamber of Commerce, 1895)

THE ATLANTIC CABLE PROJECTORS.

PAINTING BY DANIEL HUNTINGTON,

PRESENTED TO THE

CHAMBER OF COMMERCE OF THE STATE OF NEW-YORK,

MAY 23d, 1895,

By **MORRIS K. JESUP**, Chairman of the Committee,

AND RECEIVED BY

ALEXANDER E. ORR, President of the Chamber.

ADDRESS BY THE Hon. CHAUNCEY M. DEPEW.

NEW-YORK:
PRESS OF THE CHAMBER OF COMMERCE.
—
1895.

politically confirmed their pursuits as worthy and laudable, in this way both following and extending the Chamber's long-standing strategy of cloaking the fundamental self-interest of its members and of business, generally, in preachy terms of moral rectitude and self-help, much like the culture at large during the same period. Moreover, by proclaiming itself as the embodiment and keeper of standards of exemplary male behavior, the Chamber was able to help define, according to its own terms, what such behavior was.

More than anything, though, looking up at the painting during one of their meetings, Chamber members must have seen themselves, for what the *Projectors* fundamentally depicts and what the Chamber in essence was are really the same thing: a group of businessmen gathered in an interior setting to discuss strategies for their mutual financial gain (figure 197). The affiliation of the scene in the painting with the Chamber itself becomes all the more compelling considering that, before being ensconced in the Great Hall of the Chamber's new building on Liberty Street, the image hung for years in—indeed, was conceived and executed for—the group's previous quarters in the Mutual Life Building on Nassau Street. There, in the three relatively modest rooms that the Chamber occupied (figure 198), the more intimate scale of the surroundings accorded closely with the domestic interior represented in the painting. Hence the patron's unusually strong identification with its picture, which, in portraying a meeting of businessmen in familiar surroundings, served as metaphor and microcosm of the defining event in its institutional life while illustrating the positive benefits that accrue from such activity. The sitters in Huntington's painting, represented in pictorial attendance at just the sort of cooperative business meeting by which the Chamber defined itself, were rewarded not only with financial success but with broad cultural approbation for their accomplishment. Like similar commemorative group portraits of seventeenth-century Dutch culture (figure 199), products of a mercantilist society, the *Projectors* celebrates the mutual affiliation of men in business, and it does so in a way that replicates the determinative act of the organization that called forth its existence. What better, more institutionally affirming message to be broadcast from the Chamber's walls?

Even the name of the *Projectors*'s patron, unlike such prosaically titled peer institutions as the New York Merchants' Association, evokes a physical space, a room, and conjures up the meetings, like the one in the painting, that take place within it. The resonance of the group's name in the formation of its institutional identity must in some way have played a role in the prolonged campaign and eventual dedication of enormous resources for the construction of its ceremonial Great Hall—the Chamber's chamber—to which the *Projectors* was moved following the completion of its new building in 1902. In that elaborate space, surrounded by scores of portraits ranged about the room, suggesting a virtual meeting of the Chamber always in progress, the *Projectors* was centrally hung

FIGURE 197
Meeting in the Great Hall,
with *The Atlantic Cable Projectors*
on the back wall.
(New York Chamber of Commerce
Archives, Columbia University Rare
Book and Manuscript Library)

FIGURE 198
"Committee Room, New York
Chamber of Commerce." (From
New York Times, January 24, 1897)

FIGURE 199
Rembrandt van Rijn, *Syndics of the
Amsterdam Drapers' Guild*, 1662.
Oil on canvas, 73 × 108 in.
(Rijksmuseum, Amsterdam;
photo Bildarchiv Preussischer
Kulturbesitz / Art Resource, N.Y.)

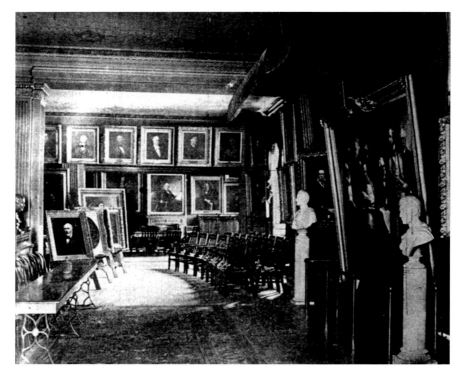

FIGURE 200
"Interior of the New York Chamber of Commerce" (Nassau Street). (From *New York Times*, January 24, 1897)

FIGURE 201 (*over*)
Meeting in the Great Hall. (New York Chamber of Commerce Archives, Columbia University Rare Book and Manuscript Library)

on the wall opposite the presiding officer's desk, as it had been in its less expansive location on Nassau Street (figures 200 and 201). In both installations, the siting of the picture meant that it "holds the place of honor," as the *New York Times* observed, echoing Alexander Orr's address. Its position in the Great Hall also allowed the image to function more literally as an institutional mirror, furthering its symbolic replication of the Chamber by compositionally reflecting, in microcosm, the scene beneath it when the group was in session, with a crowd of businessmen facing an individual leader who addresses them from the other side of a table or desk, just as in the painting. During what frequently appear to have been interminable meetings, it must have reassured Chamber members to sense in the picture installed above them a historic precedent for their own activity and the implied sanction that goes along with it. Daniel Huntington's grand rendering of business entrepreneurs in the guise of modern-day heroes, straddling the globe to make the world a better place for commerce and civilization, delivered just the sort of message they wished to receive.[39]

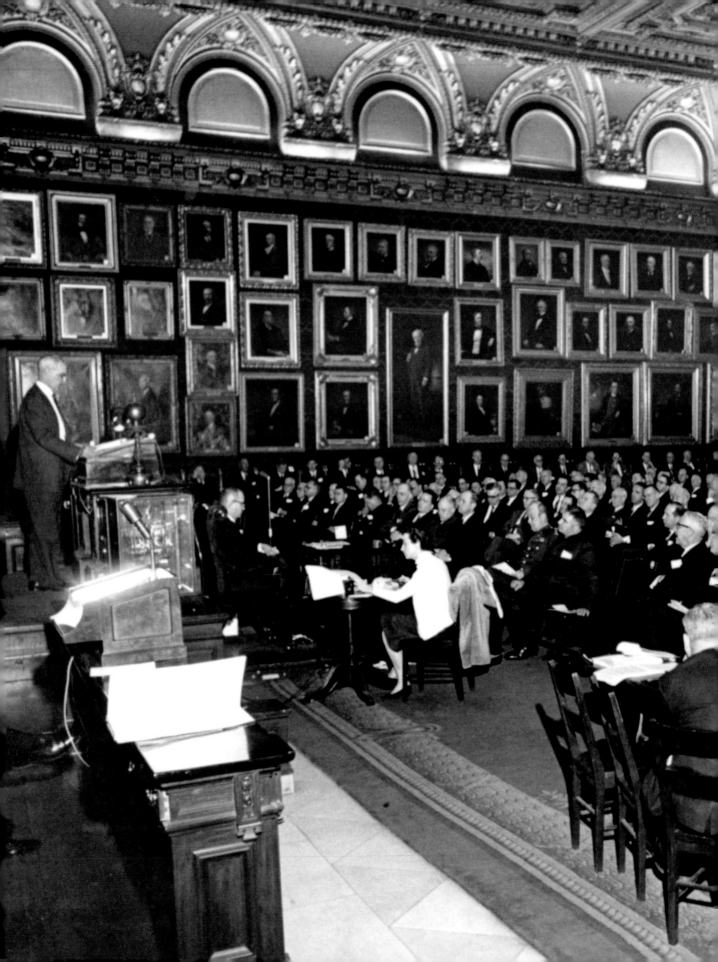

NOTES

1. The commission's long gestation is detailed in a letter from Huntington, reprinted in *The Atlantic Cable Projectors: Painting by Daniel Huntington* (New York: Press of the Chamber of Commerce, 1895), 8–10. Quotations from meetings are in Minutes 10:25 (October 6, 1892) and Minutes 10:92 (April 6, 1893), both in New York Chamber of Commerce Archives, Columbia University Rare Book and Manuscript Library [hereafter, NYCC Archives]. For committee member Morris K. Jesup's initial suggestion that Huntington's commission be revived by the Chamber, see Minutes of Committees 1:269 (Executive Committee Meeting, April 4, 1893). Huntington recorded his fee in January 1894 in his "Inventory of Effects and Accounts," 61, National Academy of Design, New York. The conflicting information that it actually cost $20,000 was reported in "Honor to Cable Layers: Painting of the Promoters Presented to Chamber of Commerce," *New York Times*, May 24, 1895.

2. The statement regarding the magnitude of cable-related celebrations was made by scientist Joseph Henry, quoted in Bern Dibner, *The Atlantic Cable* (Norwalk, Conn.: Burndy Library, 1959), 88. The expansive press attention devoted to the cable, often said to "erase time" by collapsing the period required for information to cross the Atlantic from almost two weeks to mere minutes, focused especially on its implications for trade and diplomacy. On the cable and its transformative effects, see Dibner, *Atlantic Cable*; John Steele Gordon, *A Thread Across the Ocean: The Heroic Story of the Atlantic Cable* (New York: Walker, 2002); Arthur C. Clarke, *Voice Across the Sea* (New York: Harper, 1958); Samuel Carter, *Cyrus Field: Man of Two Worlds* (New York: Putnam, 1968); David Axelrod, *The Great Transatlantic Cable* [video produced for *American Experience*, aired April 11, 2005], http://www.pbs.org/wgbh/amex/cable/; and Smithsonian Institution Libraries, *The Underwater Web: Cabling the Seas* www.sil.si.edu/Exhibitions/Underwater-Web [Web site accompanying 2001/2002 exhibition at the National Museum of American History]. On technology and American selfhood, see Leo Marx, *The Machine in the Garden: Technology and the Pastoral Ideal in America* (New York: Oxford University Press, 1964); John F. Kasson, *Civilizing the Machine: Technology and Republican Values in America, 1776–1900* (New York: Grossman, 1976); and David E. Nye, *American Technological Sublime* (Cambridge, Mass.: MIT Press, 1994). Although it preferred to claim otherwise, the Chamber's role in assisting the cable project was actually minimal, limited to a March 1863 meeting organized "to further the enterprise of the Atlantic cable" and to the formation of an ineffectual "Ad Hoc Committee on the Atlantic Cable." Following the project's success, however, the group's involvement knew no bounds: in addition to granting Field honorary membership and commissioning the *Projectors*, it sponsored an elaborate celebratory banquet in November 1866 (*The Atlantic Telegraph: Report of the Proceedings at a Banquet Given to Mr. Cyrus W. Field by the Chamber of Commerce of New-York* [New York: Amerman, 1866]); issued solid-gold medallions

to key participants (see *First Annual Report of the Corporation of the Chamber of Commerce of the State of New-York* [1858] [New York: Press of the Chamber of Commerce, 1888], 336 [hereafter, 1 AR (1858), etc.]); and generally, "with excellent reason," as the chapter on the project in the organization's official history begins, "regarded the first Atlantic cable as an enterprise in which it took a leading and valuable part" (Joseph Bucklin Bishop, *A Chronicle of One Hundred & Fifty Years: The Chamber of Commerce of the State of New York, 1768–1918* [New York: Scribner, 1918], 128–131).

3. "Cyrus W. Field the Central Figure," *New York Times*, May 23, 1895; "Honor to Cable Layers," *New York Times*, May 24, 1895. The painting's enormous size would itself have been viewed as significant; as Arthur Danto has noted, "Until largeness of scale became a commonplace of painting in the past few decades, the selection of a canvas of more than ordinary size was a declaration on the artist's part of the intended importance of the work" ("Big Bungalow Suite," *Nation*, March 28, 1994, 422).

4. James B. Townsend, review of National Academy exhibition, *New York Times*, Supplement, April 4, 1897; Alexander E. Orr, quoted in *Atlantic Cable Projectors*, 30.

5. Capitalizing on the cable mania that followed the project's initial success in 1858, several New York silver and jewelry firms marketed souvenir pieces of cable salvaged from earlier unsuccessful attempts. Tiffany & Company was perhaps the most ambitious: most of the 20 miles of cable that Chamber member Charles Tiffany purchased from Cyrus Field was sold—for fifty cents apiece—in 4-inch segments like the one in the painting, along with a facsimile letter of authenticity from Field himself. Tiffany's also fashioned Atlantic cable paperweights, canes, umbrellas, whip handles, and watch charms, as well as larger decorative loops for mounting on walls. Public enthusiasm for these items was such that a police presence was required to maintain order when they were first offered for sale. See Charles H. Carpenter Jr. and Mary Grace Carpenter, *Tiffany Silver*, rev. ed. (1978; San Francisco: Alan Wofsy Fine Arts, 1997), 12–13; and Deborah Dependahl Waters, "'Silver Ware in Great Perfection': The Precious-Metals Trades in New York City," in *Art and the Empire City: New York, 1825–1861*, ed. Catherine Hoover Voorsanger and John K. Howat (New York: Metropolitan Museum of Art, 2000), 374–375. The painting's sitters—all of whom, except Wilson Hunt, the artist had painted previously—are identified in *Atlantic Cable Projectors*, 32.

6. On the effect of the cable and telegraphy, generally, on communications, and their broad social and political implications, see James W. Carey, "Technology and Ideology: The Case of the Telegraph," *Prospects* 8 (1983): 302–325.

7. For imaginary assemblages, see William H. Gerdts, "Natural Aristocrats in a Democracy, 1810–1870," in Michael Quick, Marvin Sadik, and William H. Gerdts, *American Portraiture in the Grand Manner, 1720–1920* (Los Angeles: Los Angeles County Museum of Art, 1981), 27–60, esp. 54–55. Most of these large-scale images were widely known through prints produced after them. On the contemporary appeal of historical portraiture, see Richard H. Saunders, "The Eighteenth-

Century Portrait in American Culture of the Nineteenth and Twentieth Centuries," in *The Portrait in Eighteenth-Century America*, ed. Ellen G. Miles (Newark: University of Delaware Press, 1993), 138–152, esp. 140–142. Anonymous review of "Mr. Huntington's 'Republican Court in the Time of Washington'" *New Path* 2, no. 11 (1865): 178. Huntington viewed the historical allegory as the loftiest type of painting and enjoyed much success with it. See Wendy Greenhouse, "The American Portrayal of Tudor and Stuart History" (Ph.D. diss., Yale University, 1989), and "Daniel Huntington and the Ideal of Christian Art," *Winterthur Portfolio* 31 (1996): 103–140; and William H. Gerdts, "Huntington's 'Mercy's Dream': A Pilgrimage Through Bunyanesque Imagery," *Winterthur Portfolio* 14 (1979): 171–194.

8. The gold testimonial box, made by Tiffany & Company, is discussed and reproduced in Waters, "'Silver Ware in Great Perfection,'" 374–375, 572. Tiffany's also produced the invitation to Field's party, probably from the same template used for the box.

9. Smibert's picture was given to Yale by Isaac Lothrop; for information on it, see Richard H. Saunders, *John Smibert: Colonial America's First Portrait Painter* (New Haven, Conn.: Yale University Press, 1995), 80–86, 171–173. On Huntington's early interest in art, see S. G. W. Benjamin, "Daniel Huntington, President of the National Academy of Design," *American Art Review* 2 (1881): pt. 1, 224. For *The Bermuda Group*'s appearance in Brooklyn, see Saunders, "Eighteenth-Century Portrait," 139; and Kate Nearpass, "The First Chronological Exhibition of American Art, 1872," *Archives of American Art Journal* 23, no. 3 (1983): 24.

10. Peale, quoted in Ellen G. Miles, cat. entry for *The Washington Family*, in *American Paintings of the Eighteenth Century: The Collections of the National Gallery of Art, Systematic Catalogue*, ed. Ellen G. Miles (Washington, D.C.: National Gallery of Art, 1995), 154. For additional information on the painting's extensive exhibition history, broad reproduction in various media, and wide renown during the nineteenth century—in particular, during the time of Huntington's original sketch for the *Projectors*, in 1866, and again on his return to the commission in 1893 to 1895—see Miles, *Washington Family*, 146, 153–154, 156; Susan Danly, *Facing the Past: Nineteenth-Century Portraits from the Collection of the Pennsylvania Academy of the Fine Arts* (New York: American Federation of Arts, 1992), 49; Harold Holzer, *Washington and Lincoln Portrayed: National Icons in Popular Prints* (Jefferson, N.C.: McFarland, 1993), 21–26; Barbara J. Mitnick, *The Changing Image of George Washington* (New York: Fraunces Tavern Museum, 1989), 32–38; Saunders, "Eighteenth-Century Portrait," 140; and Wendy C. Wick, *George Washington, an American Icon: The Eighteenth-Century Graphic Portraits* (Washington, D.C.: National Portrait Gallery, 1982), 43–44, 122–124. For the painting's exhibition in 1892 and 1893 at Avery Galleries, see *Exhibition of the Important Oil Painting "Washington and His Family" by Edward Savage* (New York: Avery Galleries, 1892); and "Savage, Edward," entry in *Kindred Spirits: The E. Maurice Bloch Collection of Manuscripts, Letters, and Sketchbooks of American Artists . . .* , pt. 1, *Books and Printed Matter* (New York: Ars Libri, 1992), 40–42.

11. All of this even though, while spearheaded by Field and initially funded largely by Americans, in the end the project was principally financed by the British, whose involvement and expertise in the overall enterprise was at least equivalent to that of the Americans—a reality studiously avoided both in the painting and in America itself. For the quote at the unveiling, see *Atlantic Cable Projectors*, 13–14. On the Chamber's vaunted sense of itself, see Thomas Kessner, *Capital City: New York City and the Men Behind America's Rise to Economic Dominance, 1860–1900* (New York: Simon and Schuster, 2003), 198.

12. Huntington must have known Schussele personally through the latter's tenure as professor of drawing and painting at the Pennsylvania Academy of the Fine Arts from 1868 to 1879, a period bracketed by Huntington's first and second tenures as head of the rival National Academy and one during which he exhibited regularly at the Philadelphia institution. He certainly knew Cooper, who apparently acquired Schussele's painting from the New Yorker who commissioned it, Jordan Mott, and displayed it in appropriate surroundings in his "Cooper Union for the Advancement of Science and Art." The bust of Franklin entered the Metropolitan as part of the William H. Huntington (no relation) Collection. See Albert Ten Eyck Gardner, "Huntington's Franklins," *Metropolitan Museum of Art Bulletin* 15, no. 1 (1956): 16–24.

13. On Sturges's ownership of *Columbus Before the Queen*, see Barbara S. Groseclose, *Emanuel Leutze, 1816–1868: Freedom Is the Only King* (Washington, D.C.: Smithsonian Institution Press, 1975), 74. Leutze's picture had been in the renowned collection of Abraham M. Cozzens, like Huntington a founder of the Century Association, providing the artist with another opportunity to have seen the image. See John K. Howat, "Private Collectors and Public Spirit: A Selective View," in Voorsanger and Howat, *Art and the Empire City*, 101. For additional information on the painting, see Mark Mitchell, cat. entry for *Columbus Before the Queen*, in *Rave Reviews: American Art and Its Critics, 1826–1925*, ed. David B. Dearinger (New York: National Academy of Design, 2000), 183–184. Washington Irving, *Columbus: His Life and Voyages* (1828; repr., New York: Putnam, 1893), 270.

14. The third version of *Columbus Before the Council at Salamanca* (1884), now in the West Point Museum, is reproduced here (see figure 178); the location of the second version, of 1877, with Hirschl & Adler Galleries in 1995, is currently unknown. Each is a near replica of the original, painted in 1841. For information on all three versions, see David B. Dearinger, cat. entry for *Columbus Before the Council at Salamanca*, in Dearinger, *Rave Reviews*, 181–182.

15. Quoted in *Atlantic Telegraph*, 15.

16. Field did in fact accompany the vessels on their various cable-laying voyages, but in the guise more of interested observer than of active participant; his actual role, it has been said, was not unlike that of a modern-day film producer, financing without directly carrying out the project.

17. DePew, quoted in *Atlantic Cable Projectors*, 13. For Field's biography, the most comprehensive account is Carter, *Cyrus Field*.

18. On the trend toward self-interest and individualism, see Scott Casper, *Constructing American Lives: Biography and Culture in Nineteenth-Century America* (Chapel Hill: University of North Carolina Press, 1999). On masculinity and the social and cultural forces shaping changes to it, see Gail Bederman, *Manliness and Civilization: A Cultural History of Gender and Race in the United States, 1880–1917* (Chicago: University of Chicago Press, 1987); Michael S. Kimmel, "The Contemporary 'Crisis' in Masculinity in Historical Perspective," in *The Making of Masculinities: The New Men's Studies*, ed. Harry Brod (Boston: Allen and Unwin, 1987), 121–154, and *Manhood in America: A Cultural History* (New York: Free Press, 1996); and E. Anthony Rotundo, *American Manhood: Transformations in Masculinity from the Revolution to the Modern Era* (New York: Basic Books, 1993).

19. In terms of differing conceptions of masculinity, the *Projectors* must have represented an ideal commission for the elderly Huntington. An inveterate joiner (and, more than once, founder) of clubs and organizations, he reached his prime when the rhetoric of collaboration and communality still held sway as a model of male behavior, yet by the time he completed the painting he was immersed in a masculine culture whose defining paradigms were individualistic competition and dominance. Although in the *Projectors*'s final composition Field is clearly the leader, its simultaneous depiction of men joined cooperatively in furtherance of mutual goals of renown and enrichment allowed Huntington to accommodate and celebrate both ideals. Indeed, the painting reconciled—if only pictorially—the paradox between fraternalism and individualism, collegiality and competition, that characterized and complicated not only the cable enterprise but the Chamber of Commerce itself.

20. Huntington's disavowal of Field's actual bodily appearance is underscored by his rendering of Field's head, which is, by contrast, a close copy of a photograph in the artist's possession, one of dozens he owned of his various sitters. See Sandra Markham, "The Many Faces of Daniel Huntington," *New-York Journal of American History* 66, no. 3 (2006): 82–93, photograph on 84. On masculinity's concentration in the body, see Michael Kimmel, "Consuming Manhood: The Feminization of American Culture and the Recreation of the Male Body, 1832–1920," in *The Male Body: Features, Destinies, Exposures*, ed. Laurence Goldstein (Ann Arbor: University of Michigan Press, 1994), 12–41; and John F. Kasson, *Houdini, Tarzan, and the Perfect Man: The White Male Body and the Challenge of Modernity in America* (New York: Hill and Wang, 2001); for its pictorial manifestation, see Michael Hatt, "Muscles, Morals, Mind: The Male Body in Thomas Eakins' *Salutat*," in *The Body Imaged: The Human Form and Visual Culture Since the Renaissance*, ed. Kathleen Adler and Marcia Pointon (Cambridge: Cambridge University Press, 1993), 57–69.

21. Henry Lunettes [Marg Conkling], *The American Gentleman's Guide to Politeness and Fashion* (New York: Derby and Jackson, 1858), 33.

22. The Anglo-American relationship had been conceived in familial terms since at least the Revolutionary era, when political cartoons depicted America as England's

rebellious child. More specifically anticipating the perception of the Atlantic cable as a transatlantic umbilicus, a decade before it was first proposed, sculptor Horatio Greenough asserted in a letter to R. C. Winthrop that a distinctly American character would emerge only when Americans "cut the umbilical cord" stretching "three thousand miles across the Atlantic" (quoted in Lillian B. Miller, *Patriots and Patriotism: The Encouragement of the Fine Arts in the United States, 1790–1860* [Chicago: University of Chicago Press, 1966], 9). On organicism and telegraphy, see Carey, "Technology and Ideology," 302–325, esp. 314. John Saxe, "How Cyrus Laid the Cable," *Harper's Weekly* [undated clipping], Field Family Papers, Manuscripts and Archives, Yale University Library; Ann Stephens, "Official Ode on the Cable," *Harper's Weekly*, September 4, 1858, 562; Field, quoted in *Atlantic Telegraph*, 36; Whittier, "Cable Hymn," quoted in Carter, *Cyrus Field*, 252. In both prose and poetry, Walt Whitman described telegraphy, generally, and the Atlantic cable, specifically, in similarly organic language, as in *I Sit and Look Out: Editorials from the Brooklyn Daily Times*, ed. Emory Holloway and Vernolian Schwarz (New York: AMS Press, 1966), 159–160, 228. For an example issuing from the Chamber of Commerce itself, see President Abiel Abbot Low's address of August 21, 1858, proclaiming "the delivery of this child of Science and of Commerce" (*Annual Report of the Proceedings of the Chamber of Commerce of the State of New York for the Year 1858* [New York: Wheeler and Williams, 1859], 335). The sociocultural connotations of America's return to mother England by way of the umbilical ocean "cord" suggest a sort of Freudian separation anxiety writ large. On mother–infant attachment, see Alan Wolfe, "Only Connect," review of *The Moral Sense*, by James Q. Wilson, and *Mother–Infant Bonding: A Scientific Fiction*, by Diane E. Eyer, *New Republic*, October 4, 1993, 33–38.

23. Field, quoted in *Atlantic Telegraph*, 47. Dudley's painting *Landing the Shore End of the Atlantic Cable* is from his group of six scenes documenting the fifth and final cable-laying expedition. The image shows the laborious process of landing the cable's thicker, heavier shore end—designed to protect it from both stray anchors and the grinding surf—which was spliced together with a lighter variant some 30 miles out at sea. Describing this process in his popular narrative of the project, Field's brother, Henry, similarly employed birth and child metaphors: "Thus stripped bare this new-born child of the sea was wrapped in swaddling clothes . . . and the splicing was complete" (*The Story of the Atlantic Cable* [New York: Scribner, 1892], 319). For Field's donation of cable-related art and paraphernalia, see Josephine C. Dobkin, "The Laying of the Atlantic Cable: Paintings, Watercolors, and Commemorative Objects Given to the Metropolitan Museum by Cyrus W. Field," *Metropolitan Museum of Art Journal* 41 (2006): 155–170.

24. Studies for *Men of Science*, part of an unrealized commission from United States Senator William Wright for four large group portraits of eminent Americans, are at the Cooper-Hewitt, National Design Museum, New York. (Another study for the Wright commission, T. P. Rossiter's oil sketch *Merchants of America*, eventually entered the Chamber of Commerce collection [see figure 171].)

25. Huntington's evocation of Gramercy Park from Field's home is in the National Academy of Design, along with other sketches for the *Projectors*; related studies for the painting are at the Cooper-Hewitt, National Design Museum.

26. On the historical tensions between nature and progress, see Marx's foundational *Machine in the Garden*; and, updating it, Jeffrey L. Meikle, "Leo Marx's *The Machine in the Garden*," *Technology and Culture* 44, no. 1 (2003): 147–159. See also Lee Clark Mitchell, *Witness to a Vanishing America: The Nineteenth-Century Response* (Princeton, N.J.: Princeton University Press, 1981); and Roderick Nash, *Wilderness and the American Mind* (New Haven, Conn.: Yale University Press, 1967).

27. For examples of the Chamber's involvement in the growing conservation movement during the period leading up to the completion of the *Projectors*, see 30 AR (1887–1888), 107; 33 AR (1890–1891), 115–116; 37 AR (1894–1895), 71–72; Minutes of Committees 1:356 (Committee on Internal Trade and Improvements, December 17, 1894), and Minutes of Committees 1:360–361 (Committee on Internal Trade and Improvements, January 2, 1895), both in NYCC Archives; and *Save the Adirondack Forests and the Waterways of the State of New-York—Opinions of the Press* (New York: Press of the Chamber of Commerce, 1883). Hough's speech was reprinted as *Address by Dr. Franklin B. Hough on State Forest Management before the . . . Chamber of Commerce . . .* ("Pamphlet Publications, Chamber of Commerce, 1884," NYCC Archives); an article on the Chamber in *Harper's* several years later similarly stressed the utilitarian aspect of the group's conservation concerns: "The preservation of the Adirondack forests is regarded as of vital commercial importance" (Richard Wheatley, "The New York Chamber of Commerce," *Harper's New Monthly Magazine*, September 1891, 516). On the transformation of the conservation movement, generally, from a pragmatic to a more aestheticized orientation, see Roderick Nash, "The Roots of American Environmentalism," in *Perceptions of the Landscape and Its Preservation: Indiana Historical Society Lectures, 1983* (Indianapolis: Indiana Historical Society, 1984), 29–50, and *Wilderness and the American Mind*; and Paul Brooks, *Speaking for Nature* (Boston: Houghton Mifflin, 1980).

28. On Huntington at Mohonk, see his "Inventory of Effects and Accounts," 61; see also the manuscript recording a 1904 "parlor talk" by Theodore L. Cuyler, which notes that the artist "painted in the Rock Building several of his most famous pictures, including 'The Atlantic Cable Projectors,'" Mohonk Mountain House Archives, New Paltz, N.Y. On Mohonk itself, see Larry Burgess, *Mohonk, Its People and Spirit: A History of One Hundred Years of Growth and Service* (Fleischmanns, N.Y.: Purple Mountain Press, 2007), and *David Smiley of Mohonk: A Naturalist's Life* (Fleischmanns, N.Y.: Purple Mountain Press, 1998). For the creation of the Adirondack park, see Nash, *Wilderness and the American Mind*, 108–121, esp. 119–121; and Mitchell, *Witness to a Vanishing America*, 58. Homer's Adirondack paintings are described in terms of their conservation message in Sarah Burns, "Modernizing Winslow Homer," *American Quarterly* 49, no. 3 (1997): 624; for other artists' pro-nature, anti-technology coded messages, see Nicolai Cikovsky Jr., "'The Ravages of the Ax': The

Meaning of the Tree Stump in Nineteenth-Century American Art," *Art Bulletin* 61, no. 4 (1979): 611–626.

29. The shift from the perceived mid-century balance between nature and progress and its later tilt toward the latter exists as part of a continuum of views on the relationship extending across the nineteenth century, during the first part of which, by contrast, the wilderness was regarded as an impediment to civilization that was necessary to control and overcome—a perspective evident in early American landscape paintings in which picturesque pictorial conventions are employed well beyond their stylistic currency to bring a sense of order to an otherwise threatening world. For a discussion of this phenomenon, see Karl Kusserow, cat. entry for *Two Indians and a White Man in a Canoe*, by Pavel Petrovich Svinin, in *American Drawings and Watercolors in the Metropolitan Museum of Art*, vol. 1, *A Catalogue of Works by Artists Born Before 1835*, ed. Kevin J. Avery (New York: Metropolitan Museum of Art, 2002), 132–134; for examples of paintings expressing it, see Edward J. Nygren, with Bruce Robertson, *Views and Visions: American Landscape Before 1830* (Washington, D.C.: Corcoran Gallery of Art, 1986); and for a discussion of mid-century compatibility in nature–culture representations, see Barbara Novak, *Nature and Culture: American Landscape and Painting, 1825–1875* (New York: Oxford University Press, 1980), 157–200, esp. 166–184. The eventual questioning of the primacy of progress and technology was fraught, as Americans perceived a special relationship between development and democratic ideals. See Kasson, *Civilizing the Machine*; Marx, *Machine in the Garden*; Nye, *American Technological Sublime*; and, for an overview of all three, Meikle, "Marx's *Machine in the Garden*," 147–159.

30. On antimodernism generally, see T. J. Jackson Lears, *No Place of Grace: Antimodernism and the Transformation of American Culture, 1880–1920* (Chicago: University of Chicago Press, 1981); on its expression in relation to the natural world, see Mitchell, *Witness to a Vanishing America*; and Nash, *Wilderness and the American Mind*. George Beard, "Causes of American Nervousness," in *Popular Culture and Industrialism, 1865–1890*, ed. Henry Nash Smith (New York: New York University Press, 1967), 57–70. *A Connecticut Yankee in King Arthur's Court* is frequently discussed in terms of its antimodern message, as in Marx, *Machine in the Garden*. Frederick Jackson Turner's essays appeared beginning in the 1890s, following the official closing of the frontier, and were collected in *The Frontier in American History* (New York: Holt, 1920).

31. Since at least the time of Thomas Cole, Nathaniel Hawthorne, and Henry David Thoreau, the train in the landscape has served as an emblem of technology's intrusion, problematically or not, into the natural world. See Susan Danly and Leo Marx, *The Railroad in American Art: Representations of Technological Change* (Cambridge, Mass.: MIT Press, 1988); Marx, *Machine in the Garden*; Novak, *Nature and Culture*, 166–184; and Alan Wallach, "Thomas Cole's *River in the Catskills* as Antipastoral," *Art Bulletin* 84, no. 2 (2002): 333–350. James's diatribe against the train was preceded in 1901 by an equally fervent condemnation in Frank Norris's *The Octopus*:

A Story of California, in which it is described as a "galloping monster, the terror of steam and steel, with its single eye, Cyclopean, red . . . the symbol of a vast power, huge, terrible, flinging the echo of its thunder over all the reaches of the valley, leaving blood and destruction in its path" (quoted in Emily Stipes Watts, *The Businessman in American Literature* [Athens: University of Georgia Press, 1982], 115).

32. The proximity of the clouds and sky opening up above and behind White (and him alone) provides a further suggestion of the other, more ethereal realm his presence signifies.

33. Morse's initial telegram was a quote from the Bible itself (Numbers 23:23). Morse's statement at the banquet is quoted in Paul J. Staiti, *Samuel F. B. Morse* (Cambridge: Cambridge University Press, 1990), 222–223; Field, quoted in Isabella Field Judson, *Cyrus W. Field: His Life and Work* (New York: Harper, 1896), 97; Stephen Field, quoted in 38 AR (1895–1896), 9.

34. Like Eicholtz's *Bishop Ravenscroft*, Horatio Greenough's monumental sculpture of George Washington, famously exhibited between 1843 and 1908 on the east lawn of the Capitol in Washington, D.C., similarly signifies divine inspiration through the device of a raised forearm and finger. For the iconographic identification of the gesture made by White and its pictorial function, discussed with reference to Peale's *Self-Portrait with Angelica and a Portrait of Rachel* (and adducing several other examples of the trope), see David Steinberg, "Charles Willson Peale: The Portraitist as Divine," in *New Perspectives on Charles Willson Peale: A 250th Anniversary Celebration*, ed. Lillian B. Miller and David C. Ward (Washington, D.C.: Smithsonian Institution, 1991), 131–143. On Huntington's religiosity, Greenhouse notes, "[Art critic S. G. W. Benjamin in 1881] characterized Huntington as 'essentially a moralist and a preacher,' and the artist seems to have viewed his art as a visual counterpart to his brothers' preaching" ("American Portrayal of Tudor and Stuart History," 115). On *Mercy's Dream*, see Gerdts, "Huntington's 'Mercy's Dream.'"

35. "Science in Its Relations to Art," *New Path* 2, no. 11 (1865): 169–172, and 2, no. 12 (1865): 185–188. Although the Pre-Raphaelites manifested a strong interest in geology—on which see Rebecca Bedell, *The Anatomy of Nature: Geology and American Landscape Painting, 1825–1875* (Princeton, N.J.: Princeton University Press, 2001)—articles in the *New Path*, its official organ, are liberally strewn with assertions of the essential separateness of art and science.

36. Morse's and Huntington's statements were made at the same banquet honoring Morse, held on December 30, 1868, at Delmonico's restaurant in New York (quoted in Staiti, *Morse*, 207). Huntington continued his address, "The painter is a chemist delving into . . . occult arts by which the inward light is made to gleam from the canvas, and the warm flesh to glow and palpitate. The studio of my beloved master . . . was indeed a laboratory" (quoted in William Kloss, *Samuel F. B. Morse* [New York: Abrams, 1988], 11). For more on the event, at which art and science were construed as closely interconnected, see Staiti, *Morse*, 230–232, and, for a discussion of Morse's linkage of the two, 224–228.

37. The "special" meeting convened for the unveiling of the *Projectors* was called for by the Chamber's Executive Committee a month before the event. See Minutes of Committees 1:380 (Executive Committee Meeting, April 30, 1895), NYCC Archives; a complete account of the remarks made at that gathering appears in 38 AR (1895–1896), 6–17, and in the catalogue produced on the painting, *Atlantic Cable Projectors*, in which Orr is quoted on 30. Bishop describes the evolution of the painting and its presentation to the Chamber in *Chronicle of One Hundred & Fifty Years*, chap. 26. For the painting's appearance in the *Times*, see "The Founders of Industrial America," *New York Times*, Rotogravure Picture Section, November 23, 1924.

38. Quoted in *Atlantic Cable Projectors*, 14; introductory quote on 6.

39. "The Chamber of Commerce," *New York Times*, Magazine Supplement, January 24, 1897, 11.

INDEX

Numbers in *italics* refer to pages on which illustrations appear.